Red & White Quilts
Infinite Variety

Presented by the
American Folk Art Museum

First published in the United States in 2015 by
Rizzoli Electa, A Division of Rizzoli International Publications, Inc.
300 Park Avenue South, New York, New York 10010
www.rizzoliusa.com

in association with American Folk Art Museum
2 Lincoln Square, New York, New York 10023
www.folkartmuseum.org

2023 2024 2025 / 10 9 8 7 6 5 4

For Rizzoli Electa:
Publisher: Charles Miers
Editors: Megan Conway and Tanya Heinrich
Associate Publisher: Margaret Rennolds Chace
Project Manager: Julie Schumacher Grubbs
Managing Editor: Lynn Scrabis
Production: Alyn Evans and Maria Pia Gramaglia
Designer: Emily CM Anderson
Principal Photographer: Gavin Ashworth, New York

For the American Folk Art Museum, 2023 reprint:
President: Elizabeth V. Warren
Becky and Bob Alexander Director & CEO: Jason T. Busch
Deputy Director and Chief Communications Officer: Christopher Gorman
Director of Collections and Exhibition Production: Ann-Marie Reilly
Director of Design: Kate Johnson
Director of Publications and Editorial: Margarita Sánchez Urdaneta

The American Folk Art Museum extends its sincere appreciation to Fleur S.
Bresler for her generous support of the 2023 reprint.

Rizzoli would like to thank Dorian Arrich, John Deen, Jerry Hoffnagle,
Kayleigh Jankowski, Gerard Nudo, Loren Olson, Justin Pruden, Lynn
Schumacher, and Chris Steighner.

Image credits: pages 12–13, photo by Gavin Ashworth; page 14, image
courtesy the Special Collections Department, Bryn Mawr College
Library; page 16 (top and bottom), photos by Gavin Ashworth; page 18,
image © Oleg Golovnev; pages 20–23, all images courtesy Tom Hennes,
Thinc Design; page 25 (top), image © Deborah Howcroft; page 25 (middle
and bottom), images from the Deborah Harding Redwork Collection
at Michigan State University Museum.

Cover Image: *Kaleidoscope Quilt* (detail, fig. 71, page 73)

Hardcover ISBN: 978-0-8478-4652-8
Paperback ISBN: 978-0-9121-6125-9

Library of Congress Control Number: 2015931681

Printed in China

Red & White Quilts
Infinite Variety

Presented by the
American Folk Art Museum

Elizabeth V. Warren
with **Maggi Gordon**

IN ASSOCIATION WITH
AMERICAN FOLK ART MUSEUM
NEW YORK

Contents

The Enchantment of Red & White Quilts

Anne-Imelda Radice, PhD

The American Folk Art Museum has always been a pioneer in highlighting our nation's cultural heritage. I have had the honor to serve as its executive director since 2012, and was pleased to visit the spectacular and immersive *Infinite Variety* exhibition—which ran six days, March 25–30, 2011—each day it was on view. Within the first seconds of my initial visit to the exhibition, held at the Park Avenue Armory in New York City, I was transfixed and couldn't stay away. The unprecedented event was in perfect sync with the caliber of American Folk Art Museum presentations. What a remarkable gift for Mrs. Rose to share her red and white quilt collection with the people of New York and the world beyond—and admission was free!

Coauthors Elizabeth V. Warren, a valued member of the museum's board of trustees and guest curator for the exhibition, and Maggi Gordon, veritable quilt expert, have achieved a monumental feat by compiling information on each quilt, organizing the quilts into pattern and design classifications, and providing narratives on each resulting category. Their research provides vital scholarship to this collection that would not have been possible within the time constraints of presenting the exhibition. I thank them both for their lengthy commitment to the museum and their dedication to this special project.

Among the countless individuals who contributed to the exhibition and publication, I especially thank Joanna S. Rose, whose collection and love for quilts made everything possible. I express my sincere gratitude to Mrs. Rose for promising fifty of her exquisite quilts to the museum's collection, an act of generosity that will benefit many generations to come. I thank Stacy C. Hollander, deputy director for curatorial affairs, chief curator, and director of exhibitions at the museum, for her invaluable curatorial and design guidance in producing the exhibition; Tom Hennes, principal at Thinc Design, who directed the vision for what became a breathtaking installation; and Martha Stewart, for her thoughtful contribution to this book and continued support of the museum. At the museum, I am grateful to Ann-Marie Reilly, chief registrar and director of exhibition production, who organized the installation with skill and efficiency, and to Megan Conway, director of publications and website, who managed the production and editing of this publication with great care.

To me *Infinite Variety* was a special gift from Mrs. Rose and the museum, and the publication preserves this historic moment, making its enchantments available to all.

Collecting Infinite Variety

Joanna S. Rose

These 653 American quilts from three centuries (most nineteenth century) are not the prizewinners at fairs nor ones that have been passed down in families, cherished by several generations. They are, rather, ordinary coverings, their creators largely anonymous, their provenance obscure, not meant for company beds or "best use."

While the industrial revolution swept through England in the 1800s and American pioneers pushed ever westward settling our continent, their women stayed at home raising children, cooking, cleaning, farming, and often piecing quilts from leftover scraps of material and socializing at quilting bees. Their imaginations took flight in the patterns and variations of traditional shapes. The quilter found her subjects in nature, in the Setting Sun and Feathered Star, in the Wild Goose Chase, the Garden Maze, in Lightning, and the Melon Patch. In her kitchen she found models in Flower Pots and Fruit Baskets. Oak Leaf, Pine Tree, and Hickory Leaf were traditional New England themes drawn from the landscape. Burgoyne's Surrender came from battle plans in history books. Delectable Mountain derives its name from the passage in John Bunyan's *Pilgrim's Progress*, which describes the promised land (in the settler's mind, the United States). Friendship Baskets is covered with moral and religious maxims; Drunkard's Path is an admonition. Tithing Reel was created to raise money for a Pennsylvania church.

When my husband asked what I would like for my eightieth birthday, I said, "Something I've not seen before and something that would be a gift for New York City." Seeing all of these quilts at the same moment would be the ideal gift. I did not set out to collect quilts. I have the instincts of a treasure hunter, not a collector. I had no clue how many red and white quilts I owned. They came up at flea markets in the 1950s and sold for five and ten dollars or were often used to wrap purchases. In the latter decades of the twentieth century came the realization of their originality and graphic beauty.

Shows at the American Folk Art Museum and the Whitney Museum of American Art in New York and in smaller cities and towns across the United States rekindled an interest in quilts. My visual memory was tested because I never checked to see if I already possessed a particular pattern before acquiring it.

Happily, now, interest in this particular folk art has gone beyond mine, which is about pattern and social history. It includes scholarly studies of textiles, needlework, dyes, and political history. Museums have expanded and professionalized the field, but for me, the fun of finding a treasure, the pleasure of thinking of those nineteenth-century women not "doomed to drudgery" but letting their minds and needles wander is sufficient.

It is my hope that the show will travel far and wide—inquiries have come from several continents. As more and more technology expands the world, it narrows mine. But books and paintings and quilts tell me that imagination is alive and well.

I am grateful to the American Folk Art Museum, Thinc Design, the Park Avenue Armory, and my husband for making this wild idea a reality. I hope you enjoy the collection. We had a great time assembling it!

American Optimism

Martha Stewart

I met the wonderful and matriarchal Joanna S. Rose more than twenty years ago on Lily Pond Lane on the eastern end of Long Island. She and her husband lived across the street from me and I was introduced to her larger-than-life personality, her interest in folk art, and her astute "gathering" instinct during visits to her Shingle-style East Hampton beach cottage, filled with American art.

But I had no idea that Joanna was a collector, and that she was amassing one of the most incredible collections of quilts ever assembled. Joanna herself admits that she did not know how many red and whites she bought, but I do believe that this brilliant woman had a good idea that she was putting together a unique collection that would one day be valued for its historical and social significance, its variety, and its unifying theme: red and white.

When I walked into the Park Avenue Armory with my television crew to record the *Infinite Variety* quilt exhibition for my daily show, my colleagues and I stared in disbelief at the vastness of the collection, the originality and cleverness of the display, and the joyous nature of the entire undertaking. We marveled at the genius of the idea, and the genius and expertness of the women who labored weeks and months to sew each and every one of the 653 American quilts over a period of three hundred years. And we were astonished that although some of the quilts were based on similar themes, not one quilt was really anything like any other quilt. Each was differentiated by fabric, stitchery, number of pieces, color, design, and size. Each was beautiful in its own personal way, a reflection of the woman, or women, who labored with needle and thread and scissors and cloth to create original and beautiful and meaningful everyday covers for someone's bed.

As I study the images in this book I keep thinking of M. C. Escher (1898–1972), the Dutch graphic artist, who is known for his mathematically inspired woodcuts and lithographs. He explored infinity, architecture, intricacy, and "impossible reality," along with order and simplicity, much like the designers of the patterns displayed on these red and white masterpieces. Polyhedra, geometric distortion, and infinite symmetry on a two-dimensional plane were not foreign concepts to the makers of these quilts.

I also think of Victor Vasarely (1906–1997), the Hungarian French artist, who was a leader of the Op Art movement, in which optical illusion and geometric abstract art result in complex and sometimes endless permutations of geometric forms within a strict color and form palette—not unlike many of the quilts illustrated in the pages of this book.

And the art of Constructivist Josef Albers (1888–1976), the German-born Bauhaus abstract painter and theorist, reminds me of the more simple constructions and that such overt simplicity conceals immense restraint and concentration to make patterns and designs that are impossibly complex.

Congratulations to Joanna Rose and congratulations to each and every one of the hands and minds of the women who labored for untold hours over quilting frames, often in candlelight, to sew for us this incredible array of American Optimism, all in red and white.

A New Home: The Joanna Rose Red and White Collection at the International Quilt Museum

Carolyn Ducey, PhD
Ardis B. James Curator of Collections
International Quilt Museum, University of Nebraska

Listening recently to the words of Joanna Rose's family, as they shared anecdotes about her at the celebration of the 2022 exhibition of the Red and White Collection at the International Quilt Museum (IQM), all of those in the audience were given a deeply personal glimpse of the remarkable woman who died in 2021. She was funny, smart, and accomplished and cared so deeply about her family.

Through our interactions, we knew her as the amazing collector of the largest collection of red and white quilts in existence and as the curator of the *Infinite Variety* exhibition. And, of course, we knew her as an astonishing benefactor who generously donated her red and white collection to the IQM in 2019. It was in that moment, however, as her family relayed thoughtful discussions they shared as she made the decision to donate her quilts, that we truly understood what it meant personally to Joanna Rose to donate her quilts. We are deeply honored to be the new home of the Joanna S. Rose Red and White Collection.

Joanna Rose's relationship with the IQM began before the museum became a reality. Her love of quilts was well known among quilt collectors and dealers in New York, and she became acquainted with fellow collectors Ardis and Robert James. Both shared a deep passion and, more importantly, for establishing American quilts as icons of women's art. When Ardis and Robert James donated their collection to the University of Nebraska in 1997, Rose agreed to serve on the first IQM international advisory board, imparting valuable advice and helping solidify a connection between the IQM and the American Folk Art Museum.

I first met Joanna at her home in New York City. She served tea and snacks on an ornate silver tea service, surrounded by books—on shelves, on tables, and stacked on the floor. Mrs. Rose explained that she and her husband were insatiable readers and they had simply run out of space! She graciously showed us the many treasures she and her husband had accumulated. Her collections—though she did not consider herself a collector as much as a "treasure hunter"—were fascinating and diverse. They ranged from the stacks of books, including a vast number of divine cookbooks, gorgeous copper molds, a phenomenal collection of silver *besamim* (spice boxes) and, of course, quilts. The two quilts hanging in her home at that time were spectacular, though they were not red and white.

A few years later, during a visit, Joanna shared a gift from her long-time employees—a photograph album of every quilt she'd collected. Her team had also attached numbers to each of the quilts for better record keeping. It was quite a revelation, for this was the first actual count of the collection and highlighted the predominance of red and white quilts in the collection. Shortly thereafter, the *Infinite Variety* exhibition was held. It was a quilt "happening!" People were talking about it and making plans to see the display during its brief run. Those who couldn't visit during the event hoped to see the exhibition travel—but where else could 653 quilts be exhibited? The sheer size of the collection simply made further display impossible.

In 2017, during another visit, the discussion turned to quilts. We mentioned plans to have an exhibition of quilts that contained the vibrant bright orange fabric of the late nineteenth century, commonly referred to as "cheddar quilts," and Mrs. Rose offered to loan us her collection. She had initially begun collecting these quilts for decorating her home for the annual Rose family Thanksgiving celebration—her favorite holiday. Mrs. Rose told us her fondness for cheddar quilts stemmed from the unique color itself. She marveled at "what it could express, without representing anything. The bright orange has that feeling; it has a warmth."

The exhibition, *Cheddar Quilts from the Joanna S. Rose Collection*, opened at IQM in October 2018. Though Mrs. Rose wasn't able to attend, her granddaughter visited and created a short video for her. Mrs. Rose loved the exhibition design.

The exhibition provided us the opportunity to work together and for Mrs. Rose to become more fully informed about the IQM's mission, how we care for our collection, and our philosophy towards quilt stewardship. It was then that she began to consider the IQM as a home for the *Infinite Variety* quilts. In 2019, Joanna Rose offered the collection to the museum as a gift in honor of her husband, Daniel, and their 63rd wedding anniversary.

We were thrilled and delighted to accept the donation of Mrs. Rose's red and white quilt collection. With the completion of additional storage and exhibition space in 2015, we are uniquely able to house the quilts. The gift was also consistent with our collecting priorities—to act as caretakers for significant exhibition groups and stewards of a diverse international collection. In addition, the IQM is part of the University of Nebraska, whose school colors are scarlet and cream. It was a match made in heaven!

Over the next two years, the gift was finalized and plans made to pack and move the large number of quilts. Our progress ground to a halt with Covid-19 restrictions. We waited impatiently, and finally in September 2021, a team traveled to Mrs. Rose's home in East Hampton to oversee the packing and shipping of the 653 quilts. It was a wonderful trip, and, much like our previous visits, we had engaging discussions with Mrs. Rose. It was also delightful to visit with Daniel, and converse with their granddaughter Rebecca. This time with Mrs. Rose and her family is especially precious to us as Joanna Semel Rose passed away on November 13, 2021.

The IQM opened *Red & White, the Joanna S. Rose Collection*, an exhibition featuring 81 bi-colored quilts in April 2022. IQM curator of exhibitions Camilo Sánchez designed an exhibition that drew upon elements of the 2011 *Infinite Variety* show: tall vertical racks holding quilts from floor to ceiling, free-standing frames with quilts hung back-to-back, and a large, long wall holding a jumble of quilt after quilt. Viewers entered the gallery and stopped in their tracks, awed by the sheer beauty and massive quantity of red and white quilts. Quilt lovers who remembered the original exhibition whether they had attended or not immediately recognized the references to the *Infinite Variety* exhibition, with its vast tall spirals and dramatic display. They relished the opportunity to enjoy a selection of one of the most exciting and impactful quilt exhibitions ever created.

Joanna Semel Rose, along with her husband, Daniel, leaves an amazing legacy. She and Daniel were avid, lifelong learners who impressed a love of learning upon their children and grandchildren, all of whom earned advanced degrees in their chosen fields. They gained an appreciation for philanthropy, watching their parents and grandparents give generously to programs in their home city of New York.

The gift of the Rose collection is a visual reminder of the entire Rose family's generosity and commitment to enhancing human lives. The quilts represent women who did not have a venue for their own legacy, and Mrs. Rose was acutely aware of the importance of preserving and honoring their work. She was proud of the makers, and humble about her role in the heritage she helped save. The IQM is honored to care for the quilts she loved.

The *Infinite Variety* exhibition, a birthday gift to Joanna Rose from her husband was, in turn, meant to be a gift to New York City. Could Mrs. Rose have known when planning the exhibition, that in reality it was a gift to the entire world? As I write that, I can visualize her knowing smile—of course she knew what an incredible gift she'd planned for all of us!

Joanna S. Rose's legacy will live on through her quilts.

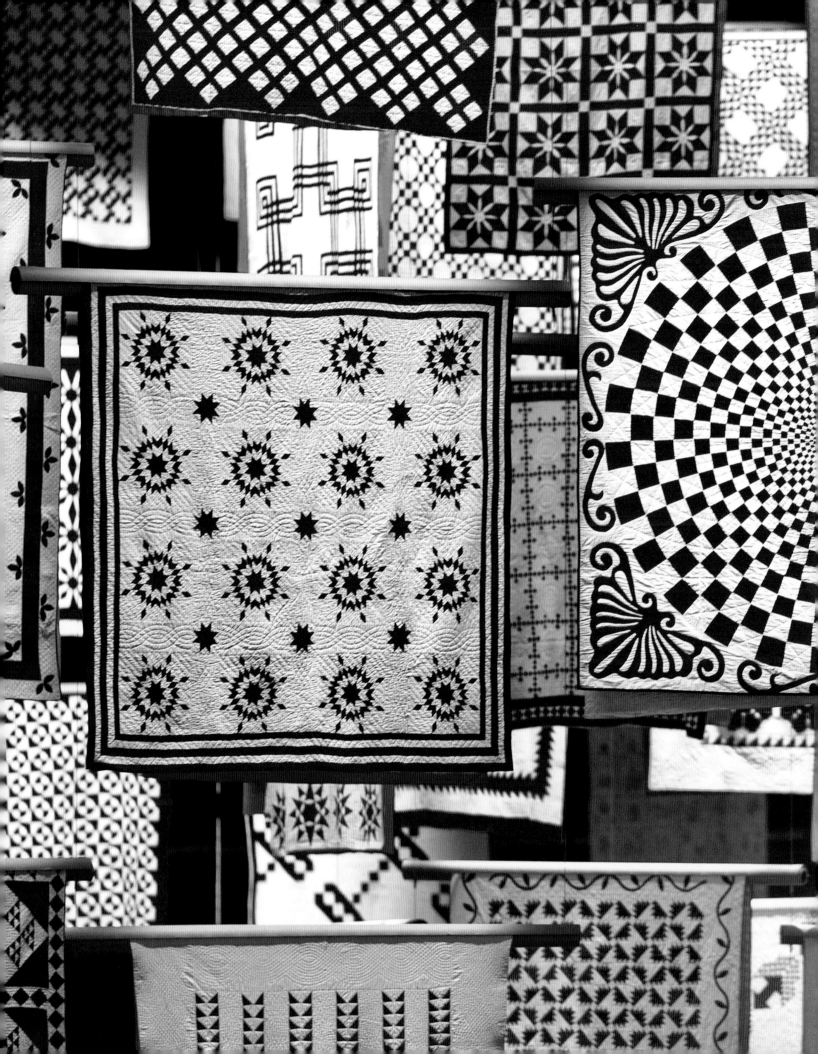

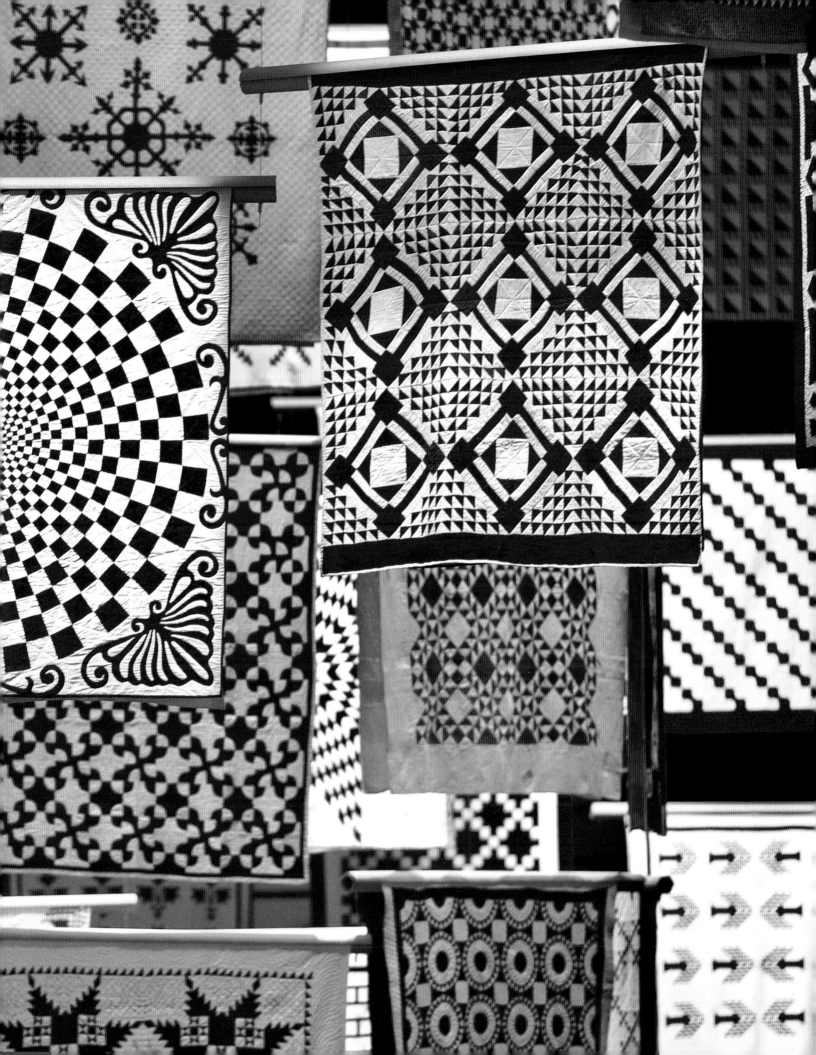

Infinite Variety: How It Happened

Elizabeth V. Warren

For many years, a thin, red and white brochure has been a gem hiding among the thicker volumes of my library. Titled "Quilts at Bryn Mawr," it served as a connection between two things I love—quilts and my alma mater—and Joanna Semel Rose, the owner of those quilts. Mrs. Rose and I are both alumnae of the college, and I had been aware of some of her collections for many years: I borrowed scrimshaw for *Young America* (1986), a traveling exhibition I organized for the American Folk Art Museum, and I had been a lucky guest at her home for alumnae receptions, where I had seen some of her treasures in situ. In the fall of 2008, I recommended that the museum invite Joanna to speak about quilt collecting at a symposium on textiles. Joanna graciously accepted, and she arrived at the museum with one of the most beautiful nineteenth-century album quilts I have ever seen. As soon as I saw the quilt I coveted it for the museum's collection, and from time to time I would write her to gently inquire whether she might be willing to donate the object.

My letters went unanswered until one day in January 2010, when Joanna invited me and Stacy C. Hollander, then the museum's senior curator, for lunch. Joanna wanted to do an exhibition of all of her red and white quilts, and she wanted the museum to produce the show. She was not sure how many quilts would be involved—at the time, she thought there could be as many as eight hundred in the collection—but she told us to start thinking about where and when this extravaganza could happen. No one—except, perhaps, Joanna—had any idea what we were getting into.

By the time we met again at the Rose residence, Stacy had identified a number of possible venues. Joanna declined all of them—none were of the size and scale she had in mind for this exhibition. There was only one place in Manhattan big enough to hold all the quilts, I offered: the 63rd Regiment Armory on Park Avenue. "That's right," Joanna responded. "And here are the dates it's available!" The exhibition was to be Joanna's eightieth birthday gift from her husband, and, in turn, her gift to the city of New York. From the start she stressed that no admission be charged—the show was to be open to all who wanted to attend.

The first steps in producing what became *Infinite Variety: Three Centuries of Red and White Quilts* (the title is Joanna's and refers to the "infinite variety" of Cleopatra's charms in Shakespeare's *Antony and Cleopatra*) were to photograph all of the quilts and to find a design team that could combine 55,000 square feet of empty space and some eight hundred quilts (the initial estimated number) in an exhibition that would be both visually exciting and informative. For the photography we called Gavin Ashworth, who has worked with the museum for twenty-five years and is the first choice for any exhibition or collection photography. Gavin set up a studio in the Roses' apartment, and, working with Ann-Marie Reilly, the museum's chief registrar

and director of exhibition production, began to take the outstanding photographs seen on these pages. Ann-Marie, occasionally aided by interns or Stacy or myself, unpacked, steamed, measured, and recorded each quilt and then repacked them all. The job was so large that only half could be photographed during the spring of 2010; the rest had to be shot separately in the fall. By the time the photography was finished, however, we finally had an accurate count of the quilts: 653.

Finding an exhibition designer was a more complicated process than hiring a photographer. Because we were not dealing with a traditional museum exhibition, we were free to solicit design firms with a variety of backgrounds. Stacy called on all her contacts and consulted architects, trade show designers, and exhibition designers, including one we had worked with in the past. Each was sent a small selection of Gavin's first batch of quilt photographs and was asked to find a creative way to fit up to eight hundred quilts into the historic drill hall of the Armory. Over the course of two days, five design teams presented a variety of inventive proposals to Joanna Rose and a group of representatives from the American Folk Art Museum. In the end, however, the decision was unanimous: Thinc Design of New York City, led by principal Tom Hennes, design director Steve Shaw, and digital strategist Sherri Wasserman, would be the *Infinite Variety* design team.

Thinc's original design rendering was so close to the final production that it is almost impossible to distinguish the computer rendering they submitted (page 22) from photographs of the actual show. Centered on a circle of chairs, meant to symbolize a quilting group, the design radiates outward in a series of double-sided spirals. Each quilt is paired with another of the same size and hung back to back by an ingenious system of cardboard tubes and clamps, essentially producing one double-sided quilt unit meant to be viewed from either side. In general, the quilts were hung with attention to size and visual variety as the underlying principals rather than any pattern, chronology, or geography. However, curatorial input was essential in choosing which quilts were positioned at eye level and which were displayed on the wide platforms that partially encircled the exhibition space.

Once a core design and curatorial team was in place, planning the event's many facets could begin. With each meeting at the museum, the working group grew ever larger, and it eventually comprised the entire museum staff. I would handle the research on some specific quilts, as well as a history of red and white quilts in general, but we needed to arrange for public relations and advertising; a temporary museum shop; educational lectures and workshops; volunteers and security; cell phone tours; brochures and signage; floor management; a café; and an opening-night gala, at which guests would be encouraged to dress in red and white. The museum staff effectively took on a second job, even as exhibitions and programming at the museum continued on a full schedule. The museum's fall 2010 exhibition season ushered in "The Year of the Quilt," three back-to-back presentations of masterwork quilts from the collection, accompanied by the publication of *Quilts: Masterworks from the American Folk Art Museum*. The quilt exhibitions provided a wide variety of textile-related activities for the quilt enthusiasts attending any or all of the three shows.

Thinc's *Infinite Variety* team also continued to expand, as graphic and concept designers, lighting specialists, fabricators, and installers were all asked to participate in our meetings. Eventually, even members of Joanna's family became involved in the process, with her son, David S. Rose, developing a mobile app with high-resolution images of each quilt and providing free tablets for loan to *Infinite Variety* visitors, so that they could zoom in on specific pieced blocks and quilted details as they roamed the exhibition floor.

Planning, however, had to continue with no estimate of the show's expected attendance. Because the exhibition was free to the public, there were no tickets sold or reservations made ahead of time, except for educational programming. (The varied programs at the Armory were also quite a draw: Tom Hennes and Steven Shaw from Thinc Design discussed the making of *Infinite Variety*; I lectured on the history of red and white quilts; and Alex Anderson and Paula Nadelstern, two of the most important figures in contemporary quiltmaking, engaged in an interactive conversation moderated by quilt journalist Meg Cox.) Promotion for the show was limited to lamppost banners along a few blocks of Manhattan's Upper East Side that were put up about two weeks before the opening, and a single advertisement in the *New York Times* during the run of the show. Advance word of the exhibition first circulated through the quilting networks. Quilt and textile magazines around the world included stories about the planned event and quilters from as far away as Japan, Australia, and Europe made arrangements to fly to New York to see the show, along with many others from all over the United States. But until the opening day, the potential large volume of visitors was just hearsay, gleaned from comments on blogs and quilt-world rumors. No one (except Joanna!) expected the approximately 26,000 people who kept the Armory full from the show's opening at 11:00 a.m. on March 25, 2011, through its closing at 5:00 p.m. on March 30.

Crowds began to gather well before the official opening hour. When Maria Ann Conelli, the museum's executive director at the time, cut the red ribbon to open the event, the doors to the Drill Hall swung open wide and gasps were heard. Most people just stood still and looked up, in awe, taking in

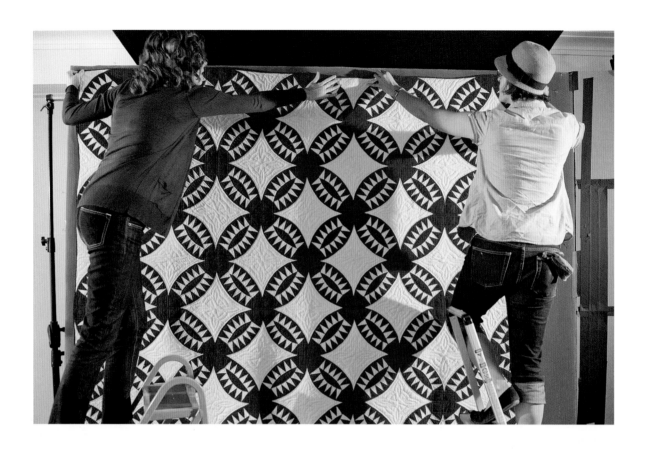

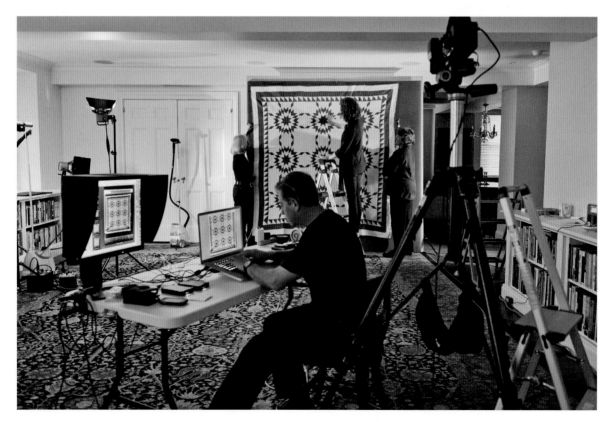

Above: Photographer Gavin Ashworth and museum staff steam, measure, and photograph the *Infinite Variety* quilts.

the sight of the 653 quilts, no two alike, arrayed in spirals reaching up high into the air. Many visitors headed straight for the shop to load up on tote bags, postcards, magnets, and anything else displaying red and white quilts; the shop sold out of themed merchandise on the first day and had to replenish its stock of related souvenirs daily. Others began phoning friends, entreating them to drop everything and get to the Armory immediately. E-mails and text messages and tweets were sent around the world, and camera phones flashed nonstop.

Most heartwarming to me were the conversations I overheard daily as I wandered through the exhibition or sat on the benches observing the crowd. Strangers bonded over a quilt pattern. Children danced inside the quilt spirals, and no one had the heart to restrain them. It was a happening, a place to be, and an important moment in the cultural and aesthetic life of the city. Some likened the event to an indoor iteration of Christo's and Jeanne-Claude's 2005 Central Park installation *The Gates*. As one woman I overheard noted, "It was like walking into a huge valentine."

Equally endearing to me were those people who went to extraordinary lengths to help out, in part because they were so inspired by what they saw. A woman approached the show office to ask if she could volunteer as a "quilt watcher," one of many people stationed around the space to remind visitors not touch the quilts (and she is still a volunteer at the museum). The museum's head security guard stepped forward to man a post in the Armory on his day off. And thousands, like this book's coauthor, dropped everything and flew halfway across the world to catch the show before it closed.

The art critics were equally enthralled. Simon Schama, for example, writing in the *Financial Times*, called the experience "pure, runaway, skipping-through-the-puddles joy," and added that the exhibition was "a monster of happiness that will have no competition anywhere this season for sheer sensory riot or ecstatic retinal shock…. Turning the vaulted space of the Armory into a vast tent of hangings, the show delivers more mind-blowing, optically smashing, time-space-altering exhilaration than anything offered by conventional museum shows right now." Jerry Saltz, in *New York Magazine*, included *Infinite Variety* on his list of the best art shows of 2011. The online reviews were just as enthusiastic, and Thinc has won a number of awards for the innovative design of the exhibition.

Many have asked why, given *Infinite Variety*'s popularity, it could not have been extended. The answer, quite simply, is that the Armory is normally booked years in advance and is expensive to rent. In order to have six days open to the public, we had to accomplish the entire installation in less than two days, and deinstallation in a day and a half. However, shortly before closing time on the last day, Joanna's son Gideon found me to say that the family did not want *Infinite Variety* to end, and that the museum should find a way to keep the exhibition intact. The Roses therefore ensured that as much of the exhibition furniture as possible and all of the hanging devices were put into storage rather than discarded, and the quilts were repacked in the order they were hung so that the exhibition could be re-created elsewhere. As of this writing, the idea of traveling *Infinite Variety* remains a dream: a tantalizing possibility, but one that requires immense time, talent, and financing.

As for the answer to the most frequently asked question—"Where does she keep all the quilts?"—rest assured they are safely residing in a cedar-lined closet in the Rose family's country home.

Infinite Variety:
A Personal
Recollection

Stacy C. Hollander

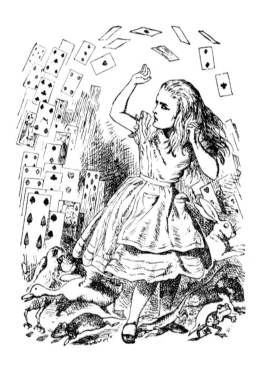

Above: Alice and a deck of cards. Engraving by John Tenniel (United Kingdom, 1872). Illustration from the book *Alice's Adventures in Wonderland* (Moscow: Nauka, 1979).

Imagine "Alice in Wonderland"–size playing cards—only the red ones—tossed into the air with joyous abandonment, and then frozen in their trajectory, upward or down. This was the vision painted in March 2010 for five design firms who were invited by the American Folk Art Museum to accept a unique challenge, the display of up to eight hundred quilts of only two colors in the exhibition *Infinite Variety: Three Centuries of Red and White Quilts*. The museum was no stranger to quilt extravaganzas. In 1986 the museum initiated the ground-breaking Great American Quilt Festival, a huge multiday event with dozens of vendors, workshops, demonstrations, lectures, and hundreds of quilts displayed simultaneously in multiple themed exhibitions and competitions, drawing visitors from all over the world. And in 1992, the museum marked the culmination of a major quilt documentation project held throughout New York State that identified 6,000 quilts and resulted in a publication and exhibition. In addition, the museum holds an internationally recognized collection of historical quilts and regularly organizes exhibitions that explore aspects of this important—and primarily female—art expression. But this was something else entirely; in both focus and magnitude the concept of the red and white quilt exhibition represented an opportunity for audiences from every sphere to engage with quilts in an unprecedented way.

When Joanna Rose first invited Elizabeth V. Warren and me to visit, we had no idea of the ambitious project she had in mind. But as she shared binder after binder of Polaroid photographs, and image after image of the red and white quilt collection, we both knew this was potentially a watershed moment in the history of quilts, art, design, and immersive experience. The staggering monumentality of the collection and the sheer space and engineering ingenuity that would be required to install it immediately removed the display of the collection from the realm of quilt exhibition and catapulted it into the category of art happening. As emissaries of the American Folk Art Museum, we were deeply honored that Mrs. Rose had approached us to bring her dream to fruition. And I was personally excited at the prospect of overseeing a project of this scale and contributing to the creation of a milestone event whose impact, I knew, would be felt for years to come.

Mrs. Rose, a woman of daunting intellect and clear-sighted objectives, was typically direct in articulating her desires regarding the project. In our subsequent meeting, after politely allowing me to suggest, on behalf of the museum, a few possible venues in which to mount the show, she waited patiently until Elizabeth V. Warren proposed the venue Mrs. Rose had in mind the entire time: the Park Avenue Armory. Mrs. Rose knew the space well and had already outlined the schedule, including the number of days to be allocated for installation, public viewing, and deinstallation. She was quite specific in her instructions: that each quilt must be seen in its

entirety; that there would be barely two days to install, a day and a half to deinstall; and, in a magnanimous gesture in keeping with the spirit of this "birthday gift" from Daniel Rose to his wife, that the presentation would be free to the public.

As the museum's chief curator and project coordinator for *Infinite Variety*, I had both the pleasure and the challenge of identifying a number of designers who would be invited to tackle the design task and present their ideas to Mrs. Rose and a team from the museum. Five firms (only one of which had worked with the museum previously) were ultimately identified from a field of almost fifty designers, and invited to participate in the competition.

To my delight, all were intrigued by the unusual project and agreed to present their ideas. The compressed timeline, largely dictated by Mrs. Rose's birthday, meant that the designers had only two months to conceive their fundamental aesthetic and logistical approaches before making a formal presentation to Mrs. Rose and the museum team. After receiving the proposals, we then convened over the course of two days to hear the designers describe their solutions to this beautiful puzzle. Each firm had been provided with seventy-five digital images to help them shape their concepts. The resulting schemes were brilliant without exception and fell into three general categories: topographical displays forming a landscape of quilts, mazes that created complex walled paths of quilts, and individual pavilions that rose like gazebos. One installation resembled the interior of a ship's prow tiled with red and white quilts.

I had spent time with each design firm—answering questions, discussing the museum's and Mrs. Rose's visions, and commenting on their directions—before they finalized their presentations. They were urged to think of the Armory's 55,000-square-foot Wade Thompson Drill Hall in three-dimensional terms, utilizing the full volume afforded by the majestic space. The desire for an experience that was dramatic yet lyrical and the need to see each quilt in full was weighed against the almost impossible strictures of installing hundreds of quilts in under two days. The last firm I visited was Thinc Design. As I entered their conference room I was immediately confronted with a dizzying array of paper quilts pinned to a process board in long spirals that resembled DNA strands, torqued configurations, and geometric patterns. During each of my conversations with the various design teams, I had invoked the Alice in Wonderland metaphor. At the end of my session with Thinc, I described the vision of hundreds of quilts tossed into space like so many playing cards, where they would hover weightlessly, seemingly frozen in midair. Thinc founder and principal Tom Hennes grinned, asked if I would like a tour of their studio headquarters, and led me into a back room where there were further iterations of their preliminary ideas for *Infinite Variety*. There, pinned on an edge of the wallboard, was Sir John Tenniel's famous illustration of Alice standing inside a maelstrom of swirling playing cards. I knew we had found our team.

Through the design process, and as the estimated number of quilts decreased from eight hundred to 653, the plans submitted by Thinc were constantly refined to retain the attenuated gracefulness of their initial renderings. In addition, the museum staff met regularly to plan educational programming and collateral events, and to ensure that the event ran smoothly once it was open to the public. The installation itself was a fascinating exercise in extreme efficiency. As Tom Hennes details in his essay (page 20), the design hinged on minimal and low-impact materials, notably cardboard tubing and cable, forming several "mobile-like" pavilions to be suspended from the Armory ceiling, which had recently—and fortuitously—been reinforced. It was an impressively choreographed process that several of us from the museum watched unfold from the balcony overlooking the drill hall, with each team sweeping before the next in a highly planned sequence. Elizabeth V. Warren describes in her introduction (page 14) the arduous labor of steaming, measuring, and photographing each of the quilts before they were folded and packed into commercial bins for transport to the exhibition space. In a brilliant bit of foresight, given the extreme time constraints, the museum's chief registrar, Ann-Marie Reilly, consulted the detailed plans provided by Thinc so that the quilts were packed in the order in which they would be hung. Engaging in their own dance, the museum's art handlers faced each other across a cardboard dowel, removed a pair of quilts in synchrony, and fastened them together over the dowel with lined clips. As they stepped to the next dowel, Ann-Marie followed in their wake, steaming each quilt after it was suspended. Once a ring of back-to-back quilts was completed, the "mobile" was raised to the next rung.

The entrance to the Wade Thompson Drill Hall lies at the end of a moody, wood-paneled corridor that is flanked by Escher-like staircases under a lofty coffered ceiling. Every morning during the run of the show, hundreds of visitors would be plunged into near darkness as they lined up in the corridor, waiting for the exhibition space to be opened. When the clock struck the hour, the huge, heavy doors were flung wide before the blinking crowd, revealing a magical panoply of light, color, and spectacle. At its height, around one thousand people per hour entered the hall. Gratefully, the American Folk Art Museum will now be forever associated with this historic event. In the years since, I have heard from innumerable people who just want to testify that they saw the exhibition. But perhaps my favorite moment was the private opening for Mrs. Rose and her family the evening before *Infinite Variety* opened to the public. As Daniel and Joanna Rose stood just inside the entrance gazing into the depths of the hall, I asked Mrs. Rose what she thought. She smiled slightly and crisply replied, "It looks just the way it should."

Designing Infinite Variety

Tom Hennes

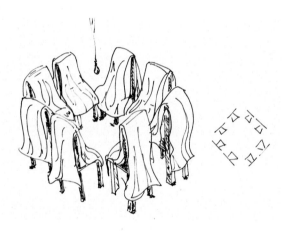

Above: Original sketch by Sherri Wasserman, digital strategist, of a "quilting circle" of chairs with quilts draped over them.

I'd given very little thought to quilts prior to encountering the collection that became *Infinite Variety*. My single point of reference was the quilt my grandmother, an avid and lifelong quilter, had given me, and which I treasured. But as an exhibition designer, the idea of displaying quilts had never crossed my mind.

That changed radically in 2010 when Thinc Design was invited by the American Folk Art Museum to submit a proposal for the design of an exhibition of close to eight hundred red and white quilts from a private collection at New York's Park Avenue Armory. It seemed too interesting a challenge to pass up.

About twenty-five people work at Thinc, and I invited them all to work alone or in small groups to generate ideas for the proposal. We would need to accomplish four main things, I reasoned. The first was to somehow embody the idea that these quilts were made by *people*, typically in groups and often anonymously, who really cared about the artistry, quality, and craft of what they made. Second, we had to find a way to draw the public through a large number of red and white quilts—objects that are superficially similar—without becoming fatigued after looking at one or two hundred. Third, we had been told that the collector, Joanna S. Rose, wanted people to be able to take in the entire collection at once; we had to come up with a way to create a breathtaking spectacle that could then be further explored in detail. And finally, we had to make something that could be rapidly installed in the Armory, hanging each individual quilt without a lot of fuss and expense.

Several people in the studio began to work with decks of cards and bits of paper to make models and to sketch out initial ideas. After a couple of days, we gathered to review what we had created: a variety of mazelike designs, cards stacked into enormous constructions, and scores of reference images of mazes, quilts, quilters, and quilt shows. I'd contributed a drawing of hundreds of floating mattresses draped with quilts, forming a landscape that rose toward the rear of the Armory into a vast wall of red and white—a spectacularly bad idea. Looking at these proposals, we agreed that none had the necessary spark. We regrouped around the core ideas of people and creativity, along with the need for a visually energizing space (not eight hundred beds), and went back at it.

When we reconvened a couple of days later, two of the new drawings jumped out at me. The first, by our digital strategist, Sherri Wasserman, showed a circle of chairs with quilts draped over their backs, a bare lightbulb hanging in the center. This struck me as a wonderful way to assert the presence of the now-absent people who had made the quilts with each other. The second, contributed by our materials specialist, Bix Biederbeck, showed quilts draped over a system of cardboard tubes suspended one over the other on

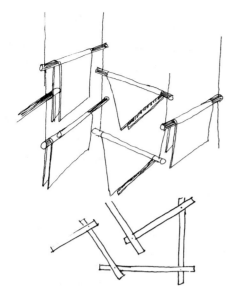

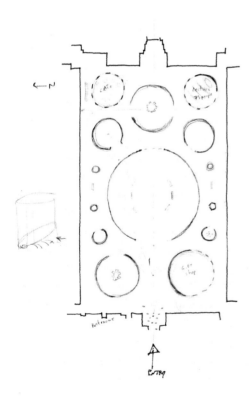

aircraft cables. This was a straightforward method of installation in which the quilts themselves would become the architecture of the exhibition.

I suggested a synthesis of these two sketches, with the circle of chairs placed at the center of the exhibition and a spiraling "tornado" of quilts rising directly out of it. Each chair would stand for a quiltmaker, the circle for their communities, and the spiral for the creative energy and productivity of the thousands who had created the hundreds of quilts in the show. A huge array of quilts would form a rotunda around this central feature, and the balance of the exhibition would be deployed as a series of smaller, cylindrical "rooms." These would provide a rhythm of experience ranging from wide vistas of color and pattern to intimate spaces for viewing quilts in detail. Gaps designed into the tall, permeable walls of quilts would visually connect each part of the experience to the whole, and at the same time enable people throughout to see where they were and where they were going.

Our design director, Steve Shaw, took these ideas and began to lay out possible configurations. He added an enormous, sweeping platform that curved around one side of the exhibition, providing space for showcasing a dozen special quilts at its outside perimeter and generous seating along its inside edge. We added a plinth at the exhibition's entrance for introductory remarks by Joanna S. Rose and Elizabeth V. Warren, the exhibition's guest curator, which would contextualize the collection rising around it in full view. We presented the design to Mrs. Rose and a committee of reviewers, and soon after we got back to the studio, the museum called to say our plan was unanimously accepted.

From Concept to Execution

While the idea was quite simple, its execution was not. The organization of the quilts themselves was the first challenge. Because most of the exhibition structures were two-sided, the quilts would have to be paired, in matching sizes, on the inside and outside of each structure. Aki Shigemori, our graphic designer, began the organizational work by making scale prints of all of the 653 quilts selected for the exhibition, arranging them by size. Then she worked with Steve to organize them into randomly patterned groups for display, front to back, placing 140 quilts that Elizabeth had selected for closer viewing on the lowest rows, at eye level. This process took several weeks. As the design came together we reviewed both the flat, symmetrical arrays of the quilt layouts and three-dimensional computer representations of the cylinders and other forms in the modeled space of the Armory. Working in this way enabled us to continually "walk" through the exhibition and refine the design until it worked as a graphic array, an urbanistic scheme of related spaces and individual exhibition "galleries."

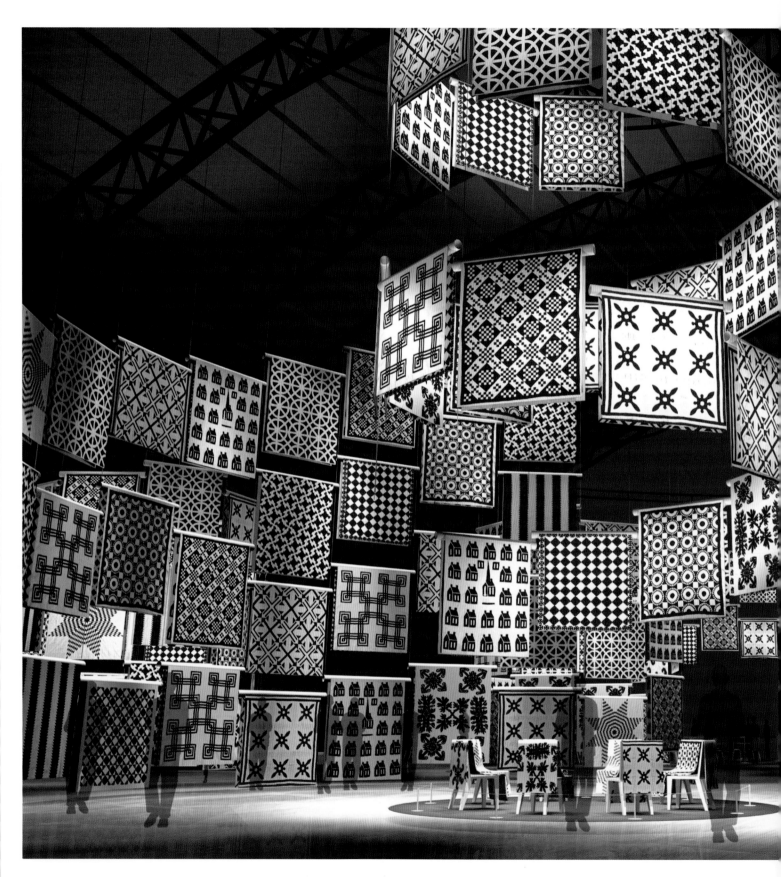

3-D computer visualization
of the center of the exhibition.
These views helped Thinc
fine-tune the design throughout
the development process.

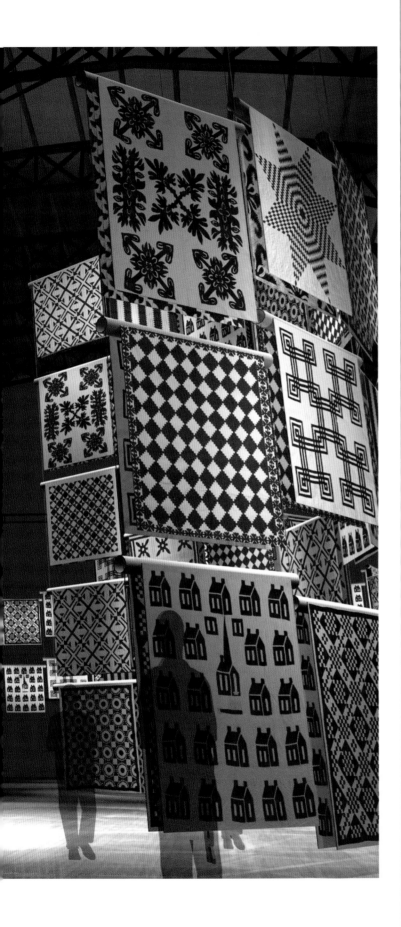

I invited Paul Palazzo, a close friend and longtime colleague, to design the lighting for *Infinite Variety*. Paul is a theatrical designer accustomed to working on a large scale, and he chose to light each quilt individually, framed as a luminous rectangle. Though not easy to execute, the scheme of one light to one quilt enabled Paul to create almost imperceptible waves of subtle variation in intensity that washed through the space. Paul's lighting would continually refresh the eye, while shifting people's visual attention from one area of interest to another, extending stay time and reducing fatigue.

In the weightless space of computer visualization, we had succeeded in creating a visual offering of impressive scale and scope. In the weighty space of the real world, however, over a hundred thousand pounds of exhibition materials would need to hang from the Armory's ceiling. For this I turned to John Wolf, a production manager I'd worked with for many years in the theater. To our conceptual design he added a massive infrastructure of rented trusses, chain motors, and lighting equipment, and a team of riggers, carpenters, and electricians who could execute the complex installation in less than two days, along with the art handlers and conservators who would hang the quilts themselves. John also focused on the details of hardware such as the clips that would affix the quilts to the cardboard tubes and the adjustable retaining sleeves he found to hold the tubes to the wires. He, more than anyone else, knew that the success of the installation would depend on thousands of small pieces coming together with ease. He planned the sequence of operations so that once the riggers hung the chain motors from the Armory's roof structure, the remaining installation, outside of the final lighting focus, could be done from the ground, rather than high in the air—saving hundreds of hours.

Without any one of these elements in place—or the people who made them possible—the effect of the exhibition would have been diminished. I believe *Infinite Variety*'s success arose from a simple idea that quiltmakers hold dear and that we were able to encode into its structure: quilts are a marvelous expression of creative energy and communal spirit. Each is a small piece of a much larger collective work, a global body of production that stitches fabric to fabric, person to person, and community to community, across time and space. This quilt of quilts, thrown exuberantly into three-dimensional space, came to embody that essence in a way that anyone—whether passionate quilters or those who had barely given a moment's thought to quilts—could fully experience and enjoy.

A History of Red & White Quilts

Elizabeth V. Warren

Red and white is a classic color scheme for American quilts, and has been since the early nineteenth century. The popularity of this deceptively simple color combination can be traced beyond its intrinsic aesthetic appeal to a basic scientific reality: the extraordinary colorfastness of Turkey red dye. In a time when most colored fabrics tended to fade or run when exposed to sunlight or washing, cloth dyed Turkey red was remarkable for its reliability.

Derived primarily from madder root, the Turkey red dye process, which was laborious and involved many steps, came to Europe from the eastern Mediterranean or India in the 1740s or '50s. ("Turkey" was a generic name for the exotic East in many European countries.) A few fabric manufacturers in England and France sent cotton yarn to specialists in the Levant for dyeing, and then imported the finished product. The exorbitant cost of both import and export made access to the formula even more desirable. The steep price was further due to the time and labor required for the dyeing process. In the nineteenth century the English Society of Dyers and Colourists described the basic steps, which had to be repeated several times and interspersed with rinsing and drying: clean the cloth or yarn by boiling with alkali; steep in rancid olive or castor oil, soda, and cow or sheep dung; treat with mordant alum and sumac; dye in a batch of madder, ox blood, and chalk; and, finally, wash one last time to brighten the color. Typically, this work would take three weeks or longer.

Some sources credit Jewish and Syrian dyers with bringing the complicated process to Europe. A few hardy souls traveled to the East to learn the procedure themselves. It has been documented that a small number of enterprising Frenchmen crossed the English Channel to teach the technique to cotton and wool manufacturers in northern England and Scotland in the 1780s. From there, the finished fabric was exported to the United States, where, although expensive, it was treasured by quiltmakers for its amazing colorfastness. In 1868 a synthetic version of the dye was invented, shortening the process and enabling the production of Turkey red cotton by American mills. One result of this wider availability was a vast increase in the number of quilt patterns, as new ones were created to take advantage of the vivid beauty of this more affordable colorfast fabric. Prices for fabric colored with the synthetic Turkey red dye, however, were still higher than for most other colors. (One exception was indigo blue, a similarly colorfast dye, and the basis for the large number of blue and white quits that were also popular in the nineteenth century.) It was not until the early twentieth century that a truly inexpensive synthetic Turkey red dye came to market, resulting in a second wave of red and white popularity during the "Quilt Revival" of the period.

The majority of the quilt designs in the *Infinite Variety* collection are geometric pieced patterns—imaginative combinations of rectangles, diamonds, triangles, and circles—

Top: Ad for Turkey red dye in *Manchester Mercury*, 1788.

Middle: Early twentieth-century ad promising that fabric dyed Turkey red will not run in the wash.

Bottom: Typical ad for stamping patterns that appeared during the late nineteenth century and the early twentieth century.

sewn together to form the top layer of the quilt "sandwich," which also includes a filling (or batting) and a backing fabric. The variety of patterns (and their names) was limited only by the quiltmakers' imaginations. In this book, the names given to most quilt patterns are usually the traditional titles that have been handed down or published many times in the past. In truth, however, a quilt pattern cannot be definitively named unless the maker herself had somehow identified it. By the end of the nineteenth century, periodicals were regularly printing quilt designs and mail-order houses were marketing patterns and kits. This practice tended to standardize quilt pattern names nationwide. However, as is seen here, even quilts constructed according to the same general pattern are individualized works, and although this collection includes many quilts that at first glance look identical, no two quilts are exactly alike.

Some traditional designs do seem to beg for the combination of only red and white fabrics. At the end of the nineteenth and the beginning of the twentieth centuries, when red and white quilts were at the peak of their popularity, the color scheme became a standard for a variety of pieced patterns, including Drunkard's Path, Ocean Waves, Carpenter's Square, Sawtooth, Schoolhouse, and many more.

Appliqué designs—shapes of one fabric sewn on top of another fabric—are not limited to geometric patterns. Many of the bedcovers in this category feature animals, flowers, hearts, and other images cut freehand or from patterns and sewn directly on the quilt top. Another favorite appliqué technique for the red and white color scheme was the "snowflake" method, in which shapes are cut out of folded pieces of fabric to create a symmetrical pattern when unfolded, just as children do to make seasonal paper decorations. Some quilts are composed of four, six, or more of these snowflakes, whereas on other quilts one large design covers the entire quilt top.

Similar to snowflakes are the more intricate cutouts created using the Scherenschnitte technique (see, for example, fig. 564, page 301). This paper-cutting craft was practiced by Germanic immigrants and their descendants, particularly in Pennsylvania, and was often used for decoration. Adapting the technique to cloth was natural for quiltmakers already skilled in paper cutting.

Similar, too, is the Hawaiian appliqué method (see figs. 576–591, pages 307–313), which features naturalistic designs often based on meaningful native Hawaiian plants. Breadfruit—a common Hawaiian plant believed to bestow a fruitful life—is an example of a favorite appliqué pattern. In the nineteenth century, missionaries began introducing mainland-American patchwork techniques to the islands. Native Hawaiians easily adapted these new techniques to *kapa moe*, the traditional Hawaiian bedcover made from thinly pounded sheets of bark. These kapa moe were decorated with printed geometric or snowflake-style designs, then sewn

together with a thick middle layer and smooth backing. The designs originally created for kapa moe were easily transferred to the kinds of quilts the missionaries taught the natives to sew. One significant difference in Hawaiian quilts, however, is the widespread use of reverse appliqué. This somewhat more complicated technique involves layering two fabrics, then cutting out a pattern in the top one, folding the raw edges under, and blind-stitching them to the layer underneath. In a quilt that features red designs and a white background, for example, it is the white fabric that is the top layer.

Some of the most intriguing red and white textiles in the *Infinite Variety* collection are the sampler quilts. Made of a variety of different patterns, and sometimes combining piecework and appliqué techniques, these were often made as gifts for friends, ministers, and loved ones, or to commemorate a special event. One intriguing example (fig. 612, page 324) includes an image of an apothecary's mortar and pestle, perhaps a clue to the recipient's chosen career. Another (fig. 611, page 323) features images ranging from the mysterious and allusive (symbols of secret societies and a Star of David) to the mundane (a coffee pot and a cat).

The most unusual red and white quilts are those that include words—sayings, homilies, names, and messages carefully worked in letters of red appliquéd onto or pieced into a white background. Those with names, places, and dates are a boon to quilt historians and provide a special window into American history, and especially the lives of women. Lavinia Rose, who clearly appliquéd her name on one quilt (fig. 133, page 106) and faintly signed her name in pen on another (fig. 134, page 107), was born Lavinia Sanford in Franklin, Connecticut, in 1787. She married Jehiel Rose in 1818 in Otsego, New York. Together they had ten children, but not one was named Charles, Cornelia, Daniel, or Amarilla, the names that appear on the two quilts. Their ninth child, however, was named Abigail Cornelia—it is possible she was known as Cornelia in the family, and she may well be the "Cornelia" on the *Charles & Cornelia Quilt*.

Daniel and Amarilla are similarly elusive to the modern genealogist. However, the 1880 United States census does list a Daniel Pomeroy Rose, born in Otsego and living in Falls Church, Virginia. He married Amarilla Ferris in 1846. Daniel, who was born in 1813, was the son of Jehiel and his deceased first wife, Deidema Maples. Lavinia evidently raised Daniel as her own son, as he was only five years old when she wed Jehiel, and cherished him enough to bestow this amazing quilt on him and his second wife, Amarilla.

By the end of the nineteenth century, red and white became a favored color combination for fund-raising quilts. These were often projects organized by ladies' aid societies, church or religious sewing societies, and other groups united for a common charitable cause. Donors would contribute money (often ten cents) to have their names included on a

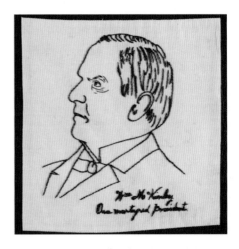

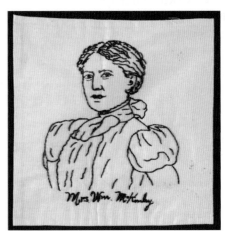

Top: Red Cross Nurse poster, Henry David Souter, 1914–1918.

Middle and Bottom: Details of the *Pan-American Exposition Penny Squares Quilt*, fig. 626, page 334.

quilt that might then be sold or raffled in order to raise more money. Usually the quilts, such as a Fleur-de-Lis quilt (fig. 620, page 329) and a Houses and Church quilt (fig. 608, page 321), were made of white fabric embroidered with colorfast Turkey red thread. Houses, churches, and schoolhouses, either embroidered, pieced, or appliquéd, were especially popular designs. A particularly poignant and unusual example is the quilt embroidered with a repeating pattern of child-size hands (fig. 615, page 327), each containing a name. After the *Infinite Variety* exhibition closed, the American Folk Art Museum received a letter from the granddaughter of one of the children named on the quilt: eight-month-old Frank Allison Smith, born October 6, 1881, in Barrington River, Nova Scotia. The quilt may have been used to raise funds for a school, or perhaps as a gift for a teacher.

The Red Cross quilt—a cause for which this color combination was undeniably well suited—became popular both as a fund-raising device and as a show of support for the troops during World War I. Unlike the Civil War soldiers—for whom women were encouraged to make quilts for warmth— WWI troops were supplied with blankets but needed knitted goods, such as socks, scarfs, and hats, instead. Therefore, the Red Cross quilts were more likely made to be sold to raise money than for a soldier's comfort. The most elaborate Red Cross quilt included in this collection (fig. 614, page 326) was made by the members of the Hudson River Day Liner Auxiliary for the Newburgh Chapter of the American Red Cross. Among the distinguished signers was E. E. Olcott, president of the Hudson River Day Line and a delegate to the Presbyterian Church World Missionary Conference in 1910. This quilt combines signatures with both freehand and stenciled decorative embroidery.

The Philadelphia Centennial Exposition of 1876 introduced America to art needlework, especially the outline embroidery stitch, and it quickly replaced the contemporary fad of canvas needlework. In the early 1880s, ladies' magazines began printing outline drawings that could be copied and embroidered on fabric, and by the end of the century one could purchase preprinted squares for embroidery singly or in sets. Again, red and white was a popular color combination because of the renowned colorfastness of the Turkey red thread used for embroidery. Many of the quilts, throws, pillow covers, and table covers decorated in this manner featured designs from storybooks (Kate Greenaway characters were especially favored), nature, national exhibitions, and famous personages (motifs also seen on many Crazy quilts sewn in the late nineteenth and early twentieth centuries). The *Pan-American Penny Squares Exposition Quilt* (fig. 626, page 334) features buildings, attractions, and important people, such as President William McKinley, who was assassinated at the 1901 fair. This quilt was made from a set of souvenir quilt blocks, or "penny squares," for outline embroidery. A title

describing the image was printed on each stamped muslin block, then, like the design itself, covered in Turkey red thread. A set of fifty blocks could be purchased for fifty cents, while individual nine-inch squares were available for five cents apiece. The existence of several remarkably similar bedcovers only hints at the great number of souvenir penny squares that were sold.

The most unusual embroidered quilt in the collection is made of bleached flour sacks (fig. 625, page 333). The seamstress used Turkey red thread to embroider the logos of twenty-five different flour brands and then sewed the sacks together to create an ingenious but inexpensive bedcover.

It was not until the 1920s that a synthetic Turkey red dye that was both reliable and inexpensive was finally developed. Not surprisingly, quiltmakers adapted the patterns popular during the era's Quilt Revival to the red and white color scheme. Many of these designs, attributed to fictitious seamstresses with Colonial-sounding names, were published in newspapers, magazines, and mail-order catalogs through which they were sold. The *Airplanes Quilt* (fig. 129, page 103) pattern, for example, was an "Aunt Martha" creation (although similar to those sold by other companies) first published in 1933. Many variations of other archetypal Quilt Revival patterns, such as Double Wedding Ring (see, for example, fig. 469, page 264) and Pickle Dish (fig. 471, page 265), were sewn in great quantity.

Although most of the quilts in the *Infinite Variety* collection have been classified according to sewing techniques and patterns, there remain others that are extremely unusual individual works of art and personal expression that defy categorization. Some quilts may look alike, but a side-by-side examination reveals variations. Clearly, quiltmakers are artists that we recognize for their desire to create works that are unique and personal, even when using published or widespread traditional patterns. Red and white continues to be a popular color combination for quilts today. Because of Joanna Rose's desire to document the history of this creative expression, her collection includes a few examples of commercially produced twentieth-century quilts (see figs. 462, 477, and 524, pages 261, 266, and 288). Quilts made by contemporary quiltmakers are also occasionally added to the collection. The 2011 exhibition and attendant publicity inspired many red and white quilt competitions, exhibitions, and tributes, and brought about a new era of popularity for the color combination. The latest addition to the collection, the *Infinite Gratitude Quilt* (page 347) was not conceived until after the exhibition had ended. Imagined and executed by Deborah Bingham, Mrs. Rose's niece, along with members of her "Dear Jane" quilting group, it is based on the well-known Civil War–era *Jane Stickle Quilt*, commonly known as the "Dear Jane" album quilt, which is made up of 169 blocks. It was a present for Joanna and Daniel Rose, a token of appreciation for their gift to New York City and the quilt world.

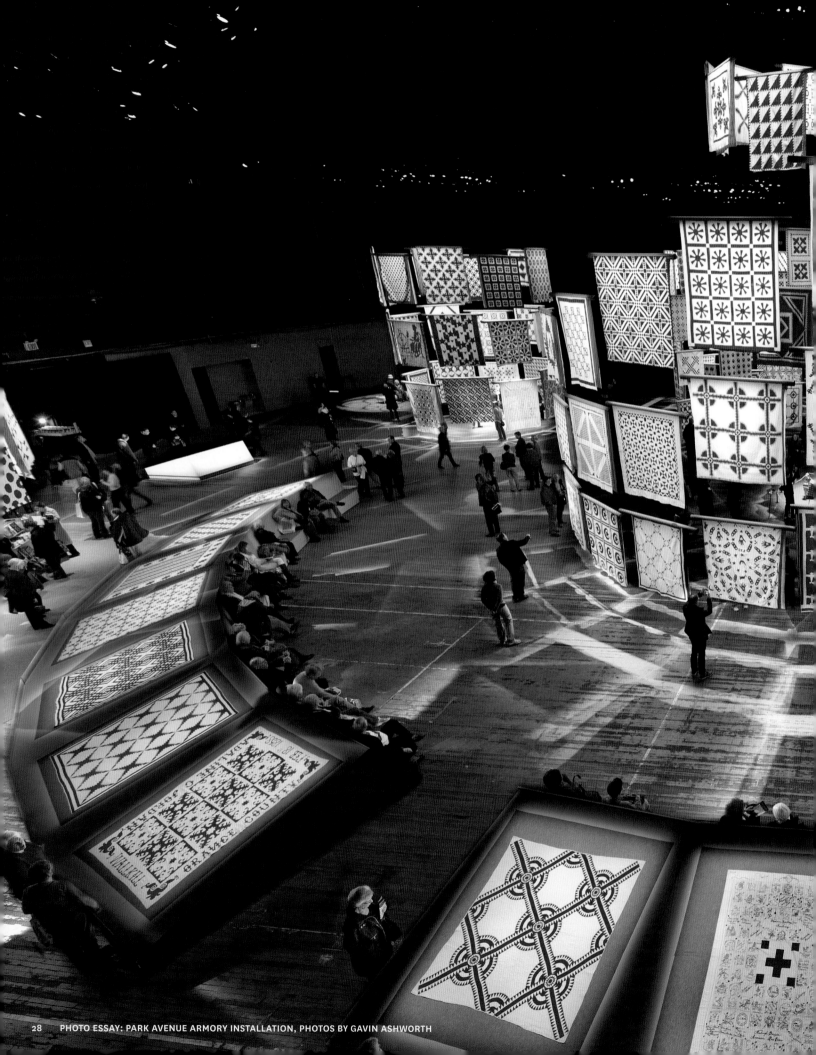

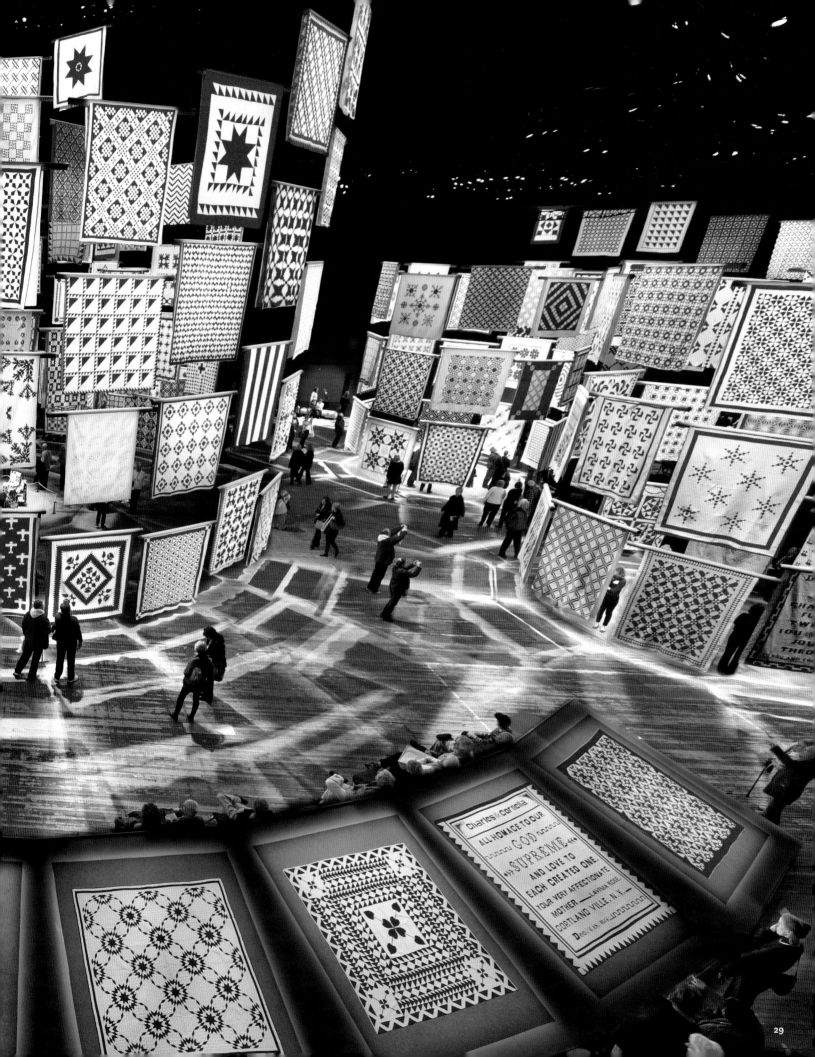

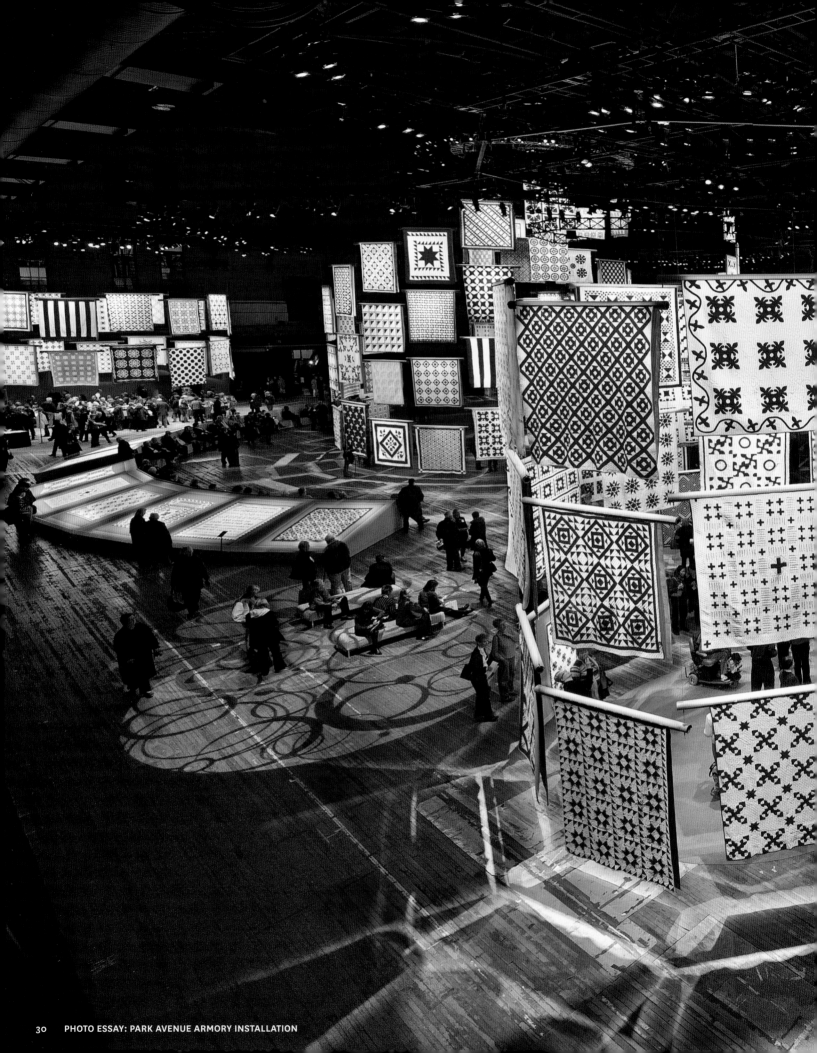

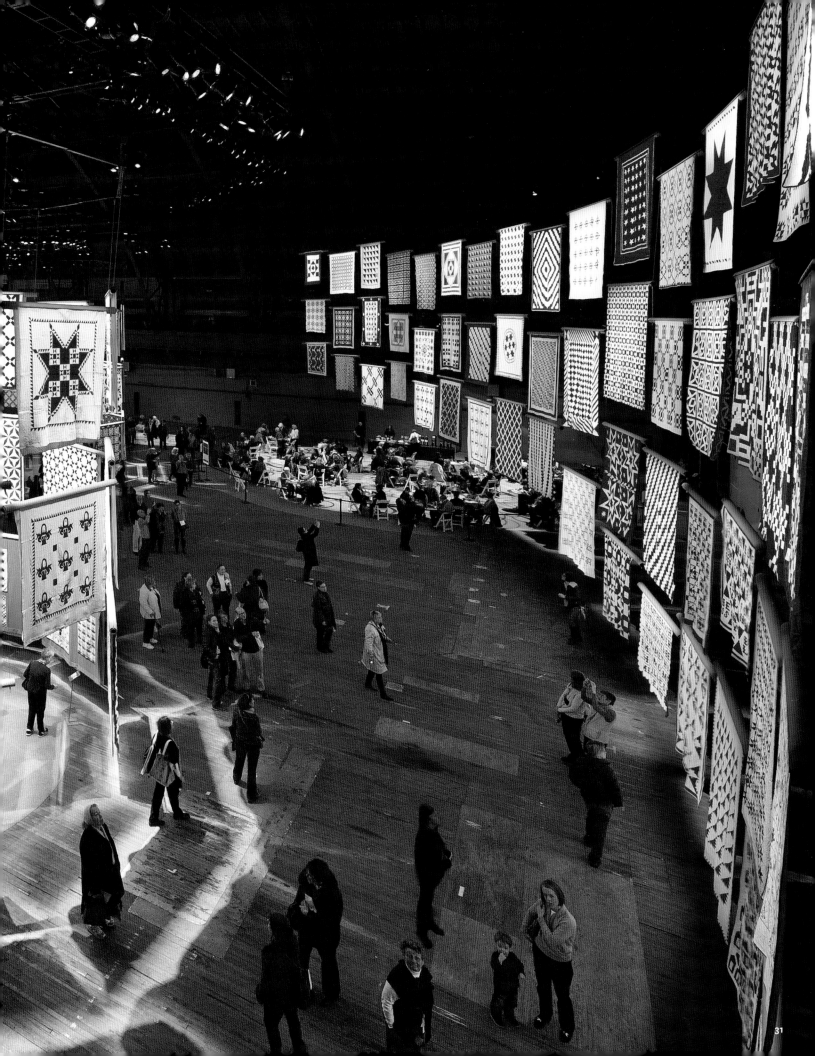

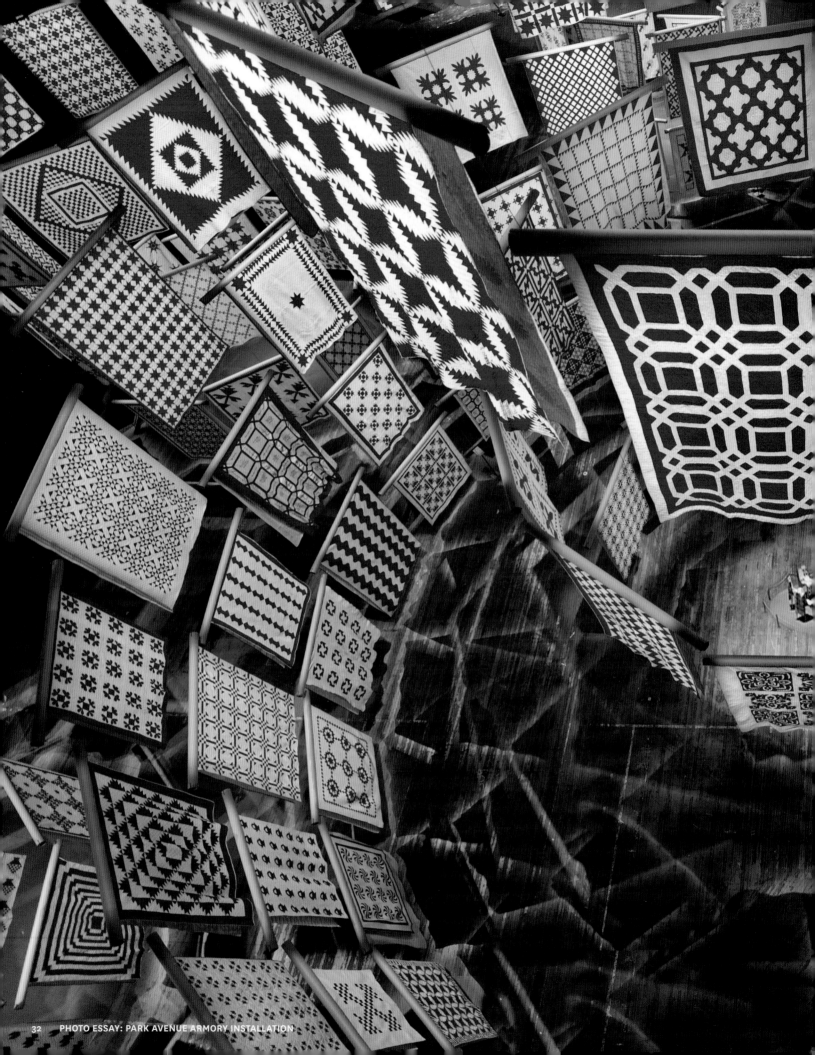

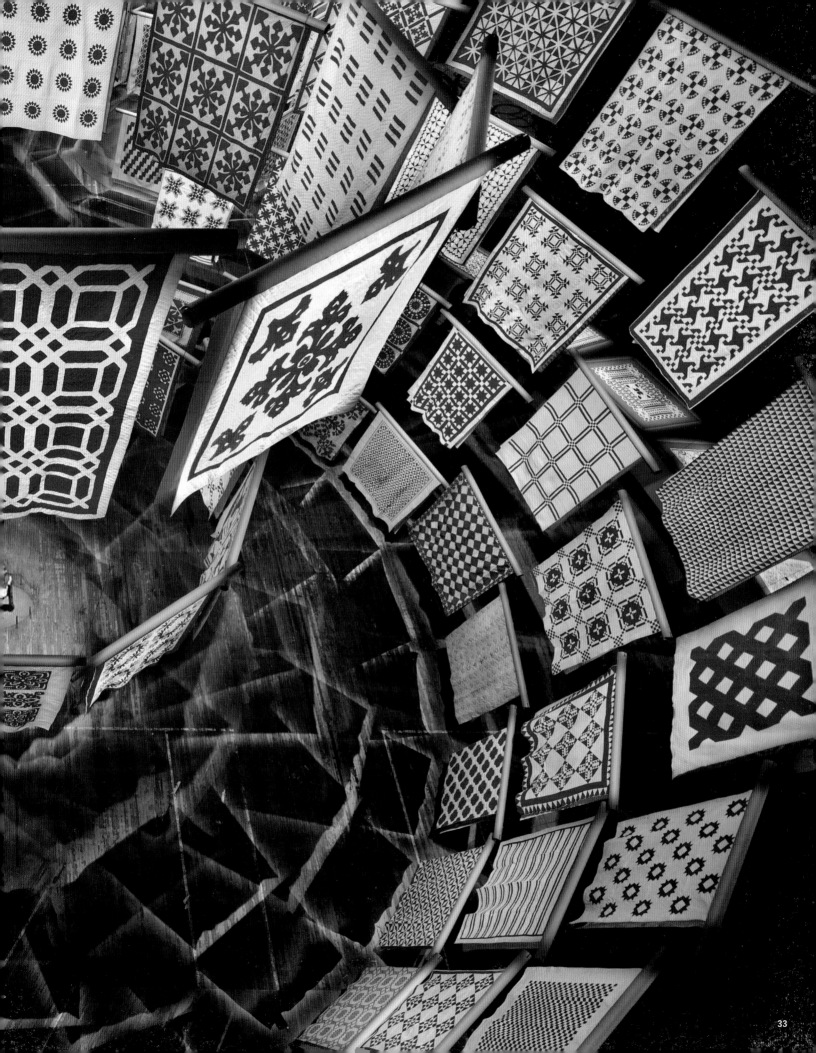

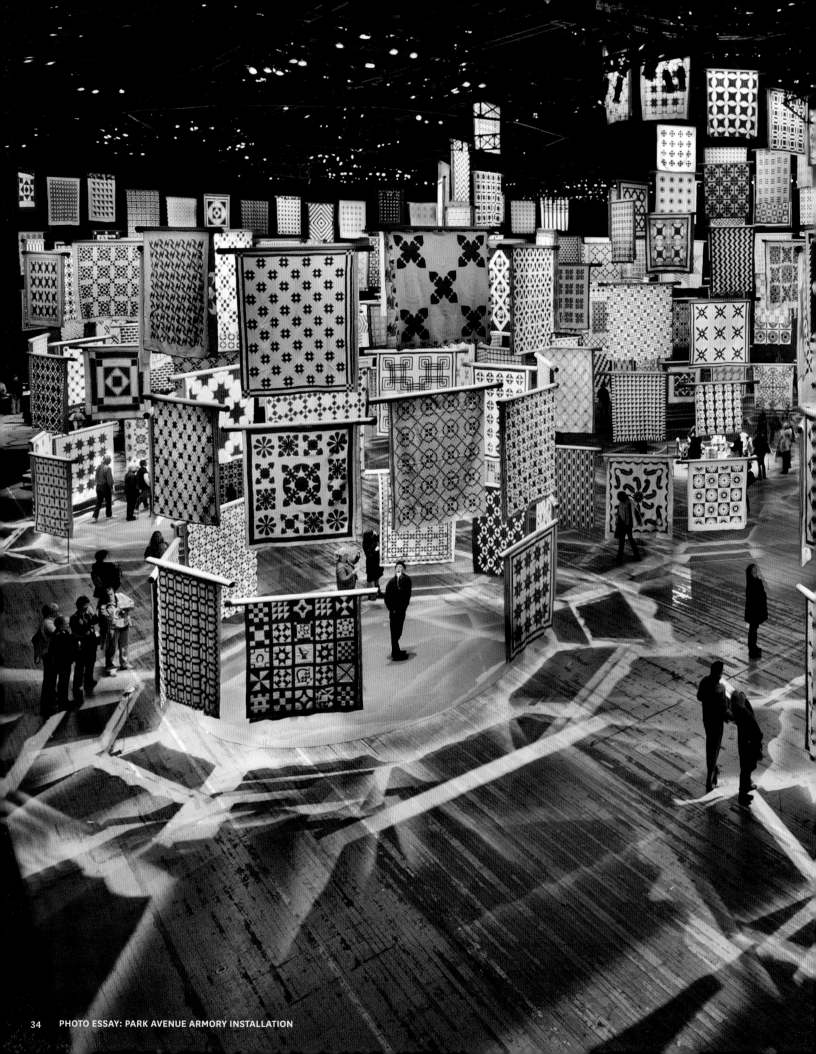

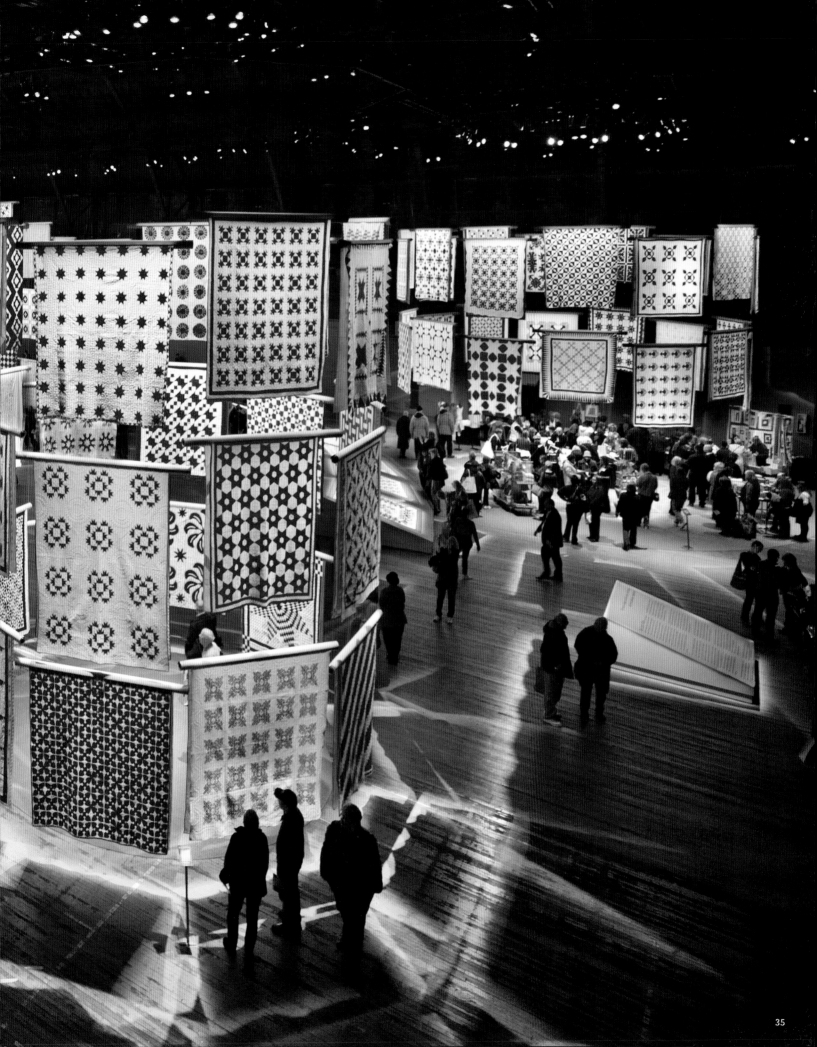

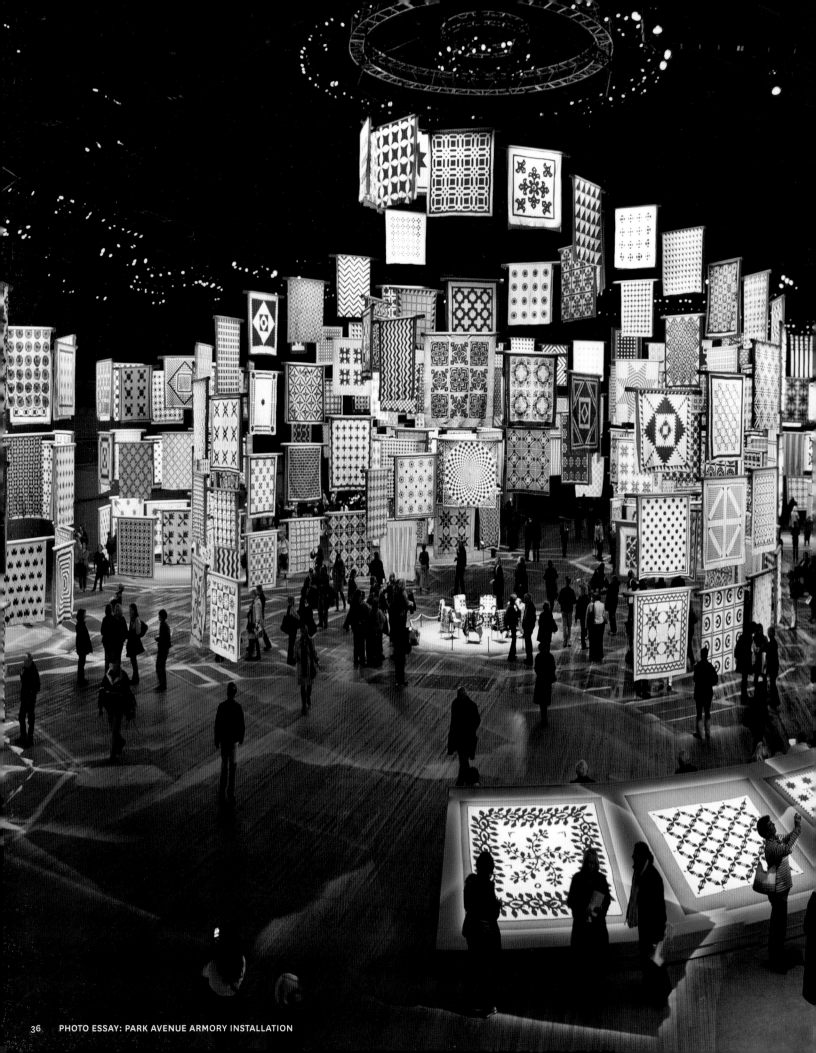

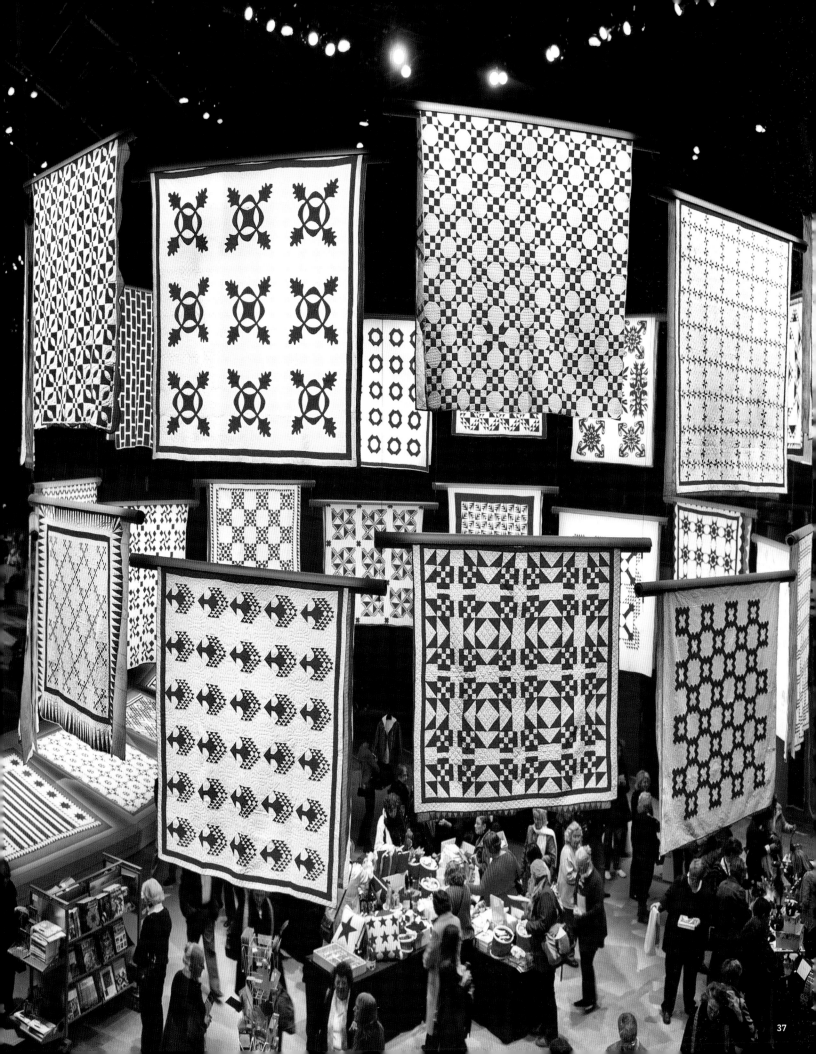

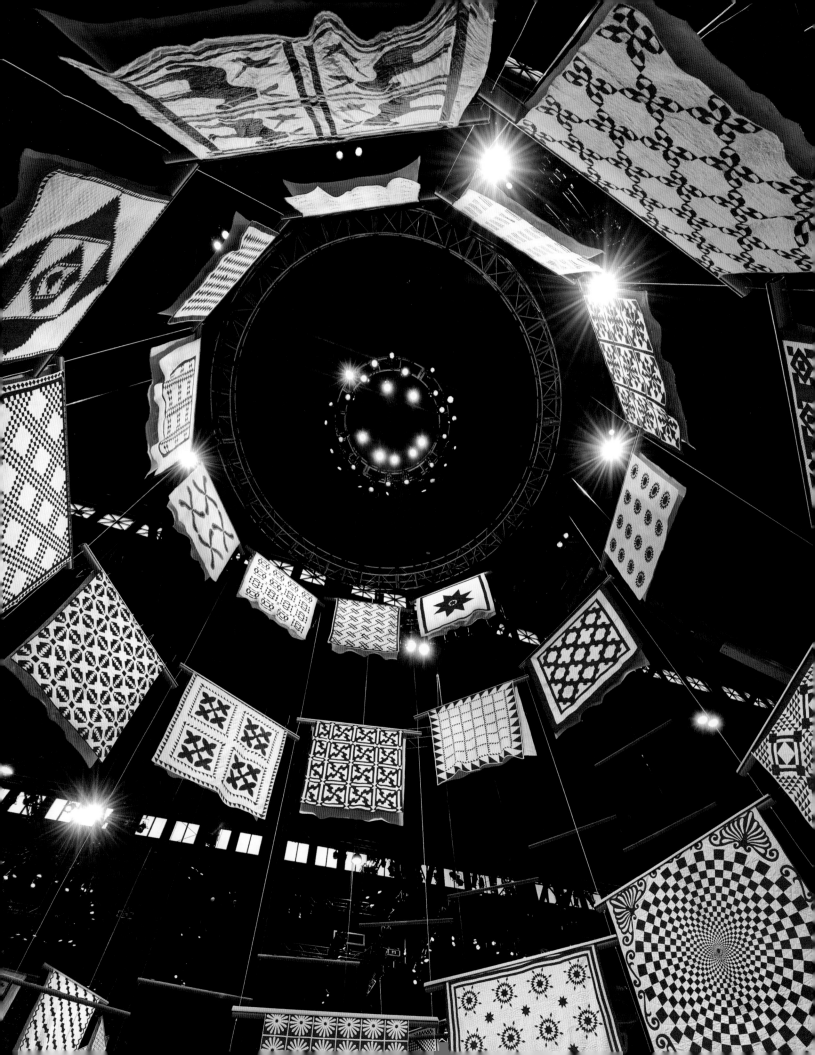

Methodology

In creating a book as complex as *Infinite Variety*, it has been necesary to make a number of decisions that at first glance might seem arbitrary. One of these is the naming of quilts and quilt patterns, a subject that is the bane of the quilt historian. Many patterns have more than one name, which can reflect regional or cultural differences. In some cases the maker has named the quilt to please herself. In others the dealer from whom the quilt was acquired has attributed a name. We have tried to include all the known names where relevant, with secondary names in parentheses.

Another issue is dating, which is more difficult with quilts such as these because solid colors, unlike prints, are almost impossible to date. Dated examples prove that the prime period for red and white quilts was between 1880 and 1920, which was when the use of synthetic Turkey red dye became widespread. Unless we have firm evidence of an earlier or later date, all the quilts in the book are assumed to be from that era. Also, unless otherwise stated, it is assumed that the quilts were made in the United States. All the quilts are made of cotton.

There are many ways to organize a group of quilts, and with 653 examples to be arranged, there were numerous decisions to be made. The order in which we have placed the quilts is our own, and is by necessity somewhat arbitrary. We have tried wherever possible to arrange them within each section in a progression from simple to complex.

In looking at the quilts, remember that secondary patterns abound, and when you focus, for example, on the white part of a pattern, you will often visualize a design entirely different from the one made by looking at the red areas. Sometimes you'll see stars, then a pinwheel—or a seemingly new block will appear. Many times, you can look at a quilt, see a pattern, then glance away, and when you look again, a quilt that appears completely different will present itself: just one of the aspects that makes these beautiful objects so fascinating.

In most cases, we were not able to handle the actual quilts for the documentation process, and so we worked from the excellent photographs and the accompanying notes that were taken prior to the exhibition. The dimensions for each quilt are supplied length by width.

We hope you will enjoy using this book as much as we enjoyed putting it together.

—Elizabeth V. Warren & Maggi Gordon

Wholetop Quilts

The term *wholetop* refers to the main surface layer of a quilt. There are many varieties of wholetop quilts. The best-known variety is the wholecloth quilt, in which the top surface is composed of a single piece of fabric (or, more often, an assemblage of a few pieces of fabric usually of one color or print). For example, a wholecloth quilt made of a single piece of white fabric is known as a whitework quilt.

Oftentimes, a wholetop quilt is composed of many units or blocks of patterns that create an overall design. The blocks are placed in repetitive patterns to create a greater design. Then, the layers of the quilt (top, batting or filling, and backing) are secured together with quilting stitches. The quilted stitches add additional graphics to the top, creating another element of texture and design to the quilt. Enhanced texture might further be added by the quilter through trapunto, a stuffed or padded detailing.

The quilts in this chapter are all red and white, of course, and represent variations of wholetop quilts with repetitive designs. These include patterns such as the single Lone Star or the greatly magnified, seven-star Seven Sisters quilt. The Bar, or Strippy, is composed of long strips of alternating colors, in this case red and white. Some Bars are pieced in intricate designs, and one (fig. 6, page 44) could have been assembled from a giantess's stash of rickrack. Still others are made up of the Bricks pattern—truly resembling a brick wall—or the Basketweave pattern, and one section contains tops with Sawtooth pattern enhancements in the design elements.

Many of the Bars are simply quilted in close rows of cross-hatching, whereas others have different quilting patterns in alternating rows. Cross-hatching, or straight-line patterns, are found most often, and cables are widely used, especially on borders.

Clamshells and fans are popular, and floral patterns enhance quite a few of the examples shown here.

Elaborate patterns based entirely on squares and rectangles, such as Colt's Corral and Puss in the Corner, are relatively rare. The Garden Maze pattern is also called Lattice. Gordian Knot and Carpenter's Square rely mainly on narrow strips assembled in seemingly interlaced designs.

One wholetop is perhaps the most spectacular quilt in the Rose collection. It is a red and white Kaleidoscope quilt, possibly more akin to Pop Art than to its nineteenth-century origins (fig. 71, page 73). The kaleidoscope, an amusement invented in 1816 by Sir David Brewster, a Scottish physicist, consists of a cylinder lined with angled mirrors and capped with a translucent panel, opposite a peephole, containing loose bits of colored glass. Complex symmetrical patterns are formed when the cylinder is rotated (and the glass shards regroup). The resulting designs, akin to snowflakes, served as inspiration for many beautiful quilt designs, none more striking than examples done in red and white. Wherever the eye alights, the quilt seems to vibrate.

The use of large pieces of fabric in many of these wholetop quilts indicates that they were made in or for a household with the means to purchase yard goods in some quantity. The white areas are often muslin, as are many of the backs. Muslin is a plain-weave cotton cloth of medium weight that is available both bleached (white) and unbleached (cream). In Great Britain this plain cloth was known as "calico" (from its origins in Calicut, India), but in the United States calico describes cotton that has been dyed and woven or printed, often in a small-scale pattern, and is ideal for use in quiltmaking.

BARS (figs. 1–14)

The quilts in this section are also known as Strippy quilts. The pattern is popular among the Pennsylvania Amish, where it is known as Bars.

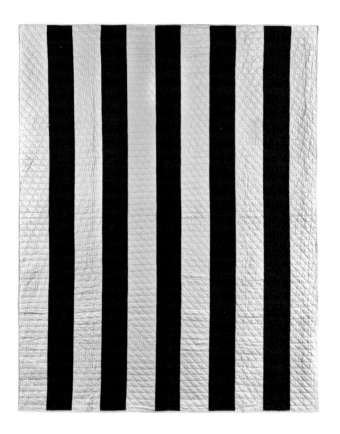

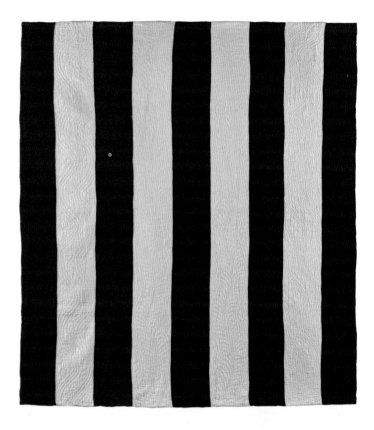

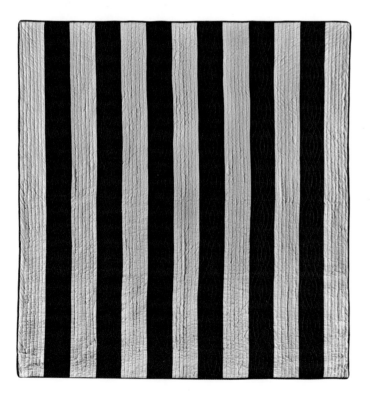

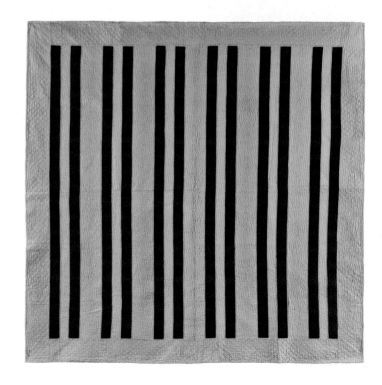

fig. 1
Bars Quilt,
84 x 67¼ inches.

fig. 2
Bars Quilt, China, c. 2000,
96 x 94 inches.

fig. 3
Bars Quilt,
86½ x 77 inches.

fig. 4
Double Bars Quilt with
single border, 71 x 75 inches.

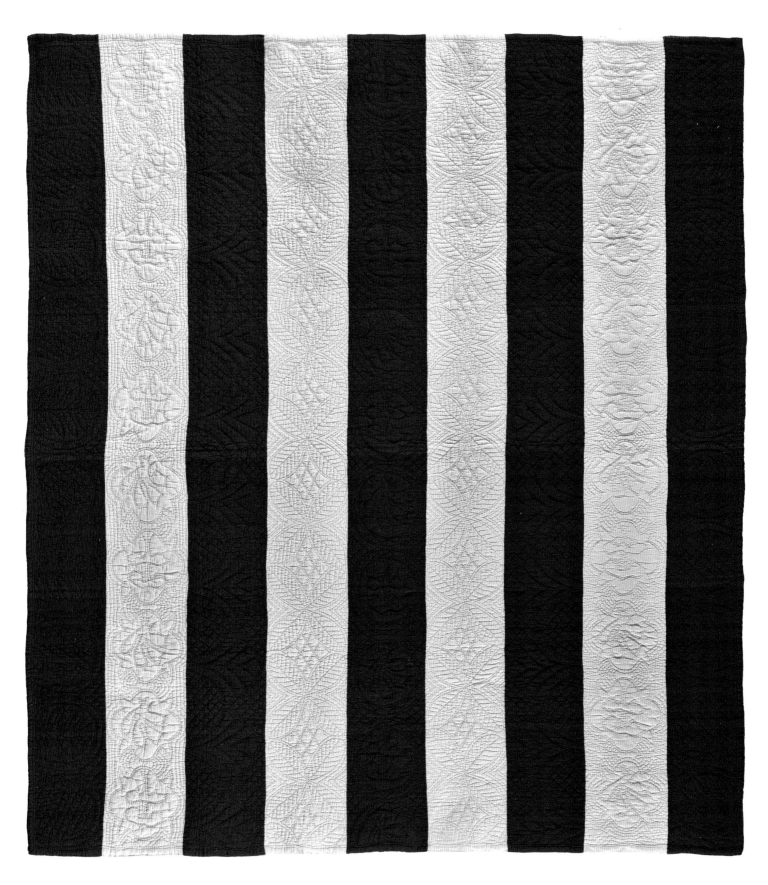

fig. 5
Bars Quilt with elaborate
quilting, 88 x 80 inches.

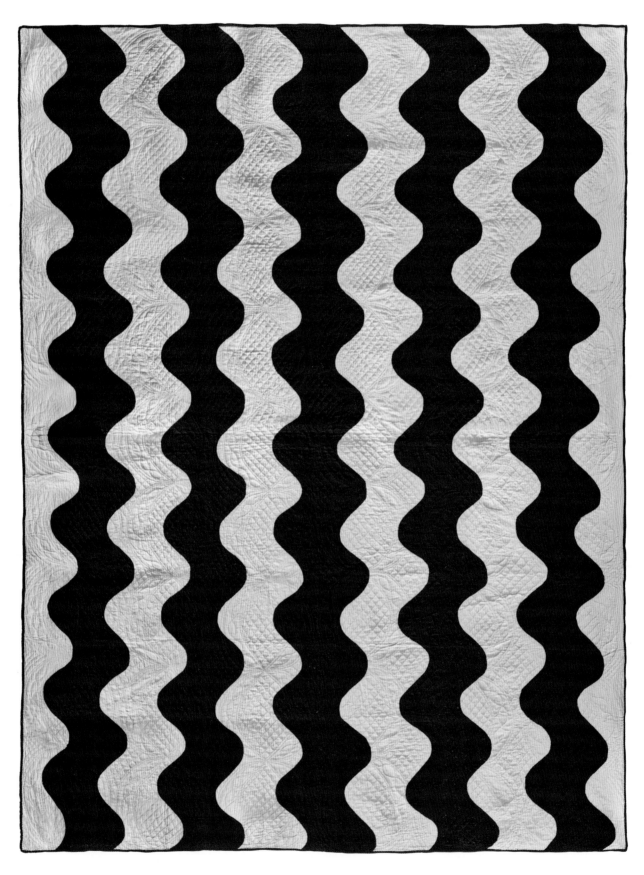

fig. 6
Waves Quilt,
100 ½ x 76 inches.

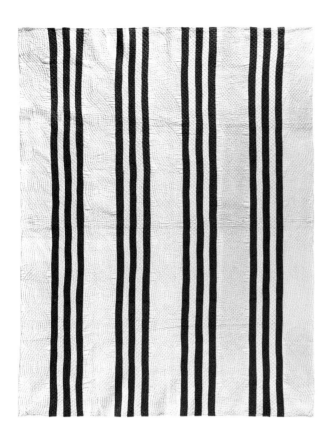

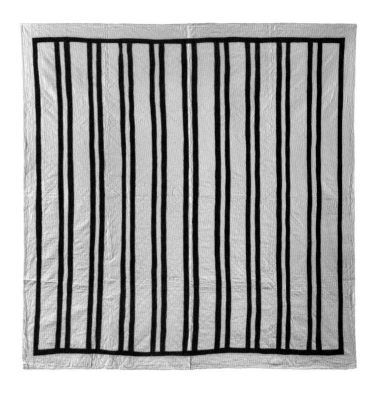

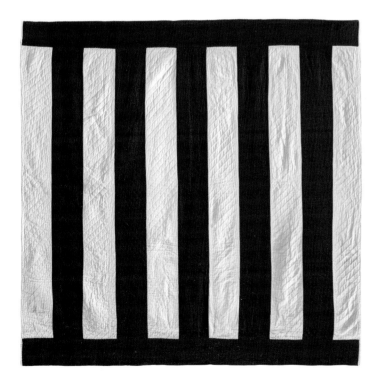

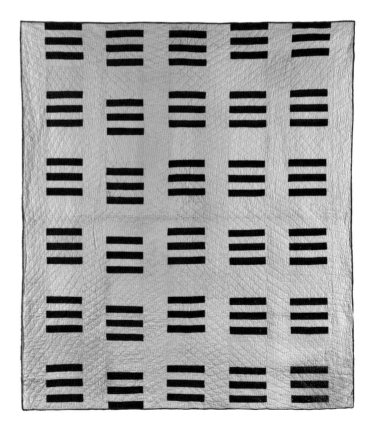

fig. 7
Triple Bars Quilt, Pennsylvania, 81 x 65 inches.

fig. 8
Bars Quilt with single top and bottom borders, 85 ½ x 87 ½ inches.

fig. 9
Double Bars Quilt with double border, 77 x 77 inches.

fig. 10
Triple Stripes Quilt, 81 ½ x 72 ½ inches.

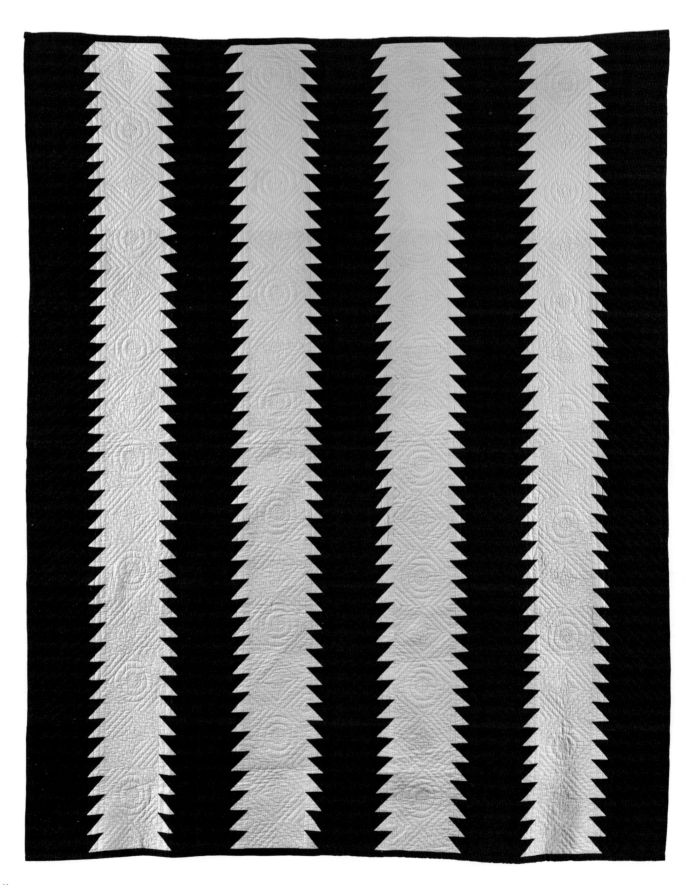

fig. 11
Tree Everlasting Quilt,
84 ½ x 68 ¼ inches.

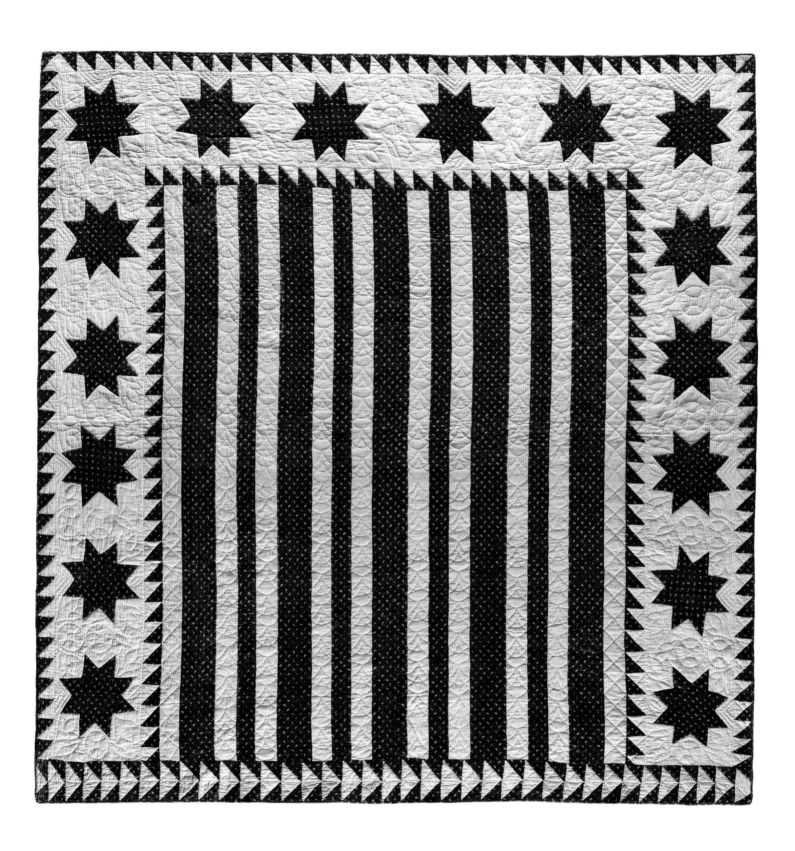

fig. 12
Stars and Bars Quilt
with sawtooth and flying
geese border, 1860–1880,
92 ½ x 90 ¾ inches.

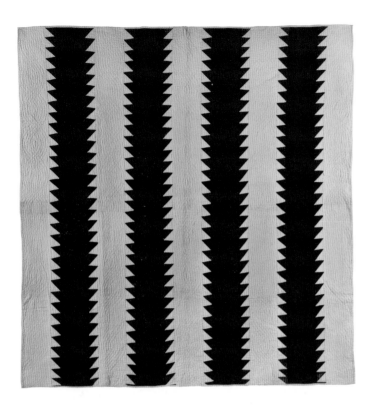

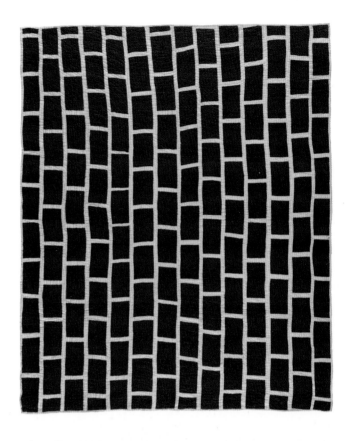

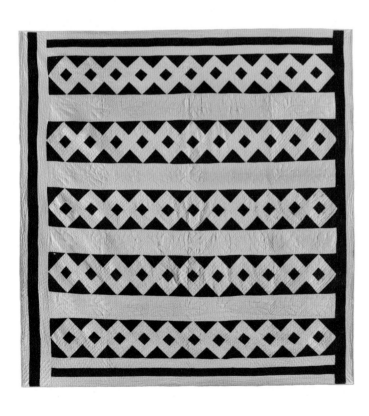

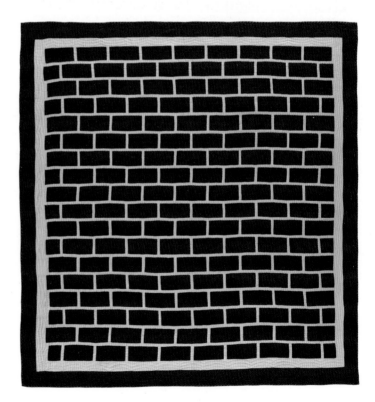

fig. 13
Tree Everlasting Quilt,
73 x 69½ inches.

fig. 14
Greek Key Quilt,
77¾ x 77 inches.

fig. 15
Bricks Quilt,
79 x 65 inches.

fig. 16
Bricks Quilt with double
border, 76 x 72 inches.

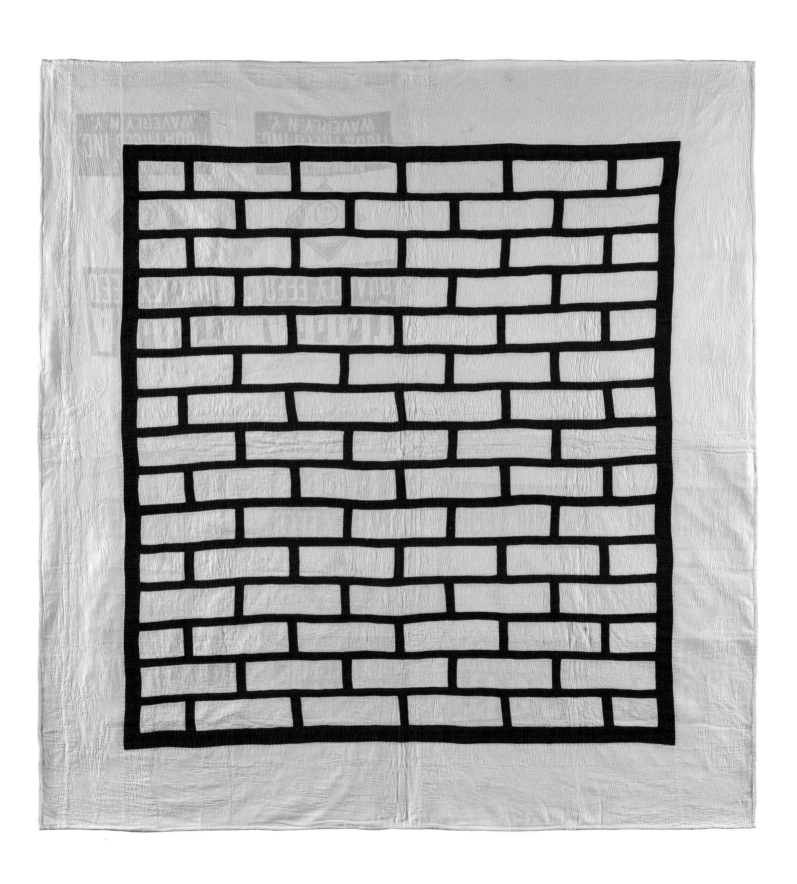

fig. 17
Bricks Quilt with double
border, cotton feed sacks
backing, 75½ x 72½ inches.

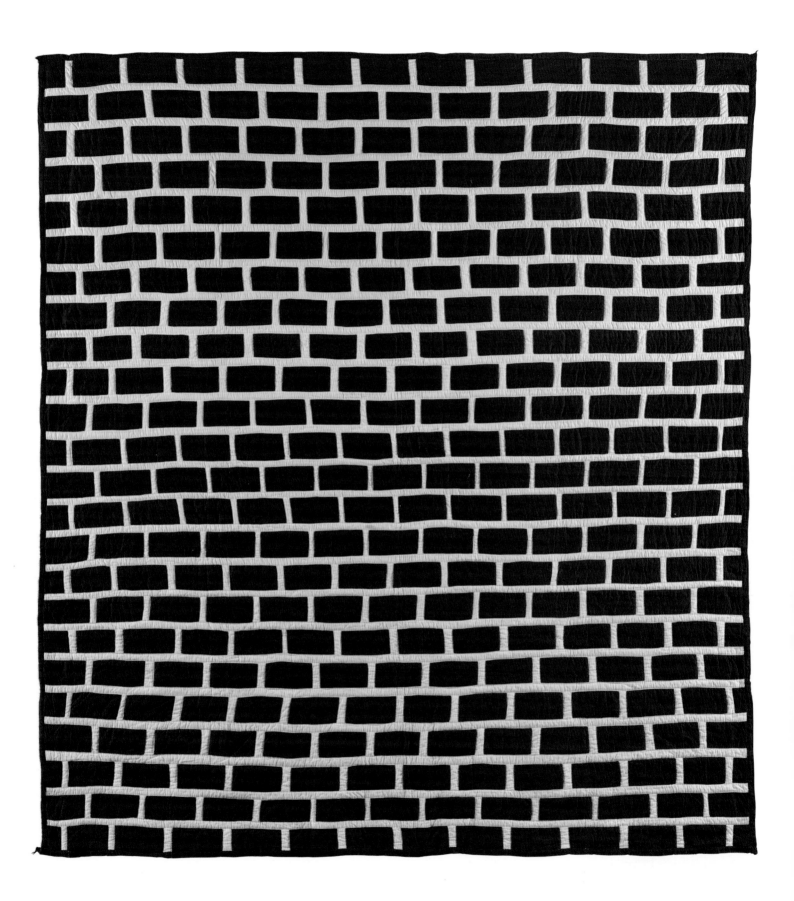

fig. 18
Bricks Quilt,
82 x 75 inches.

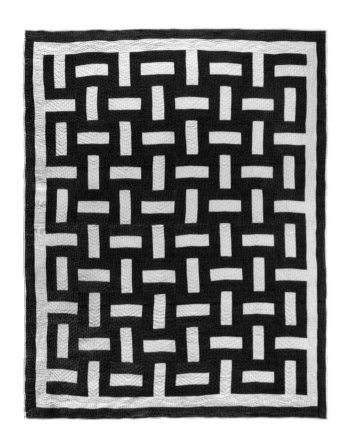

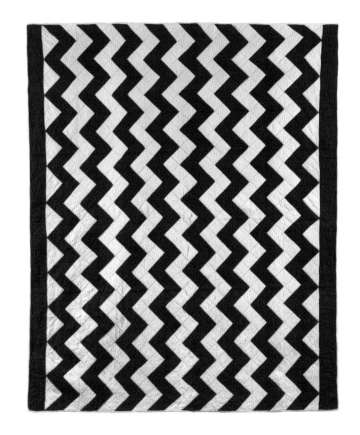

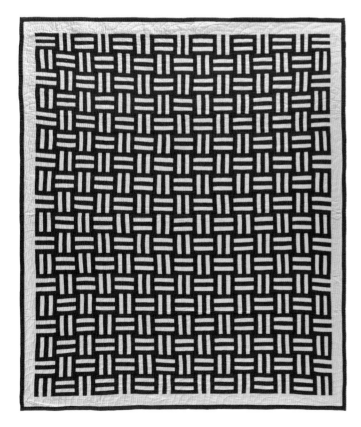

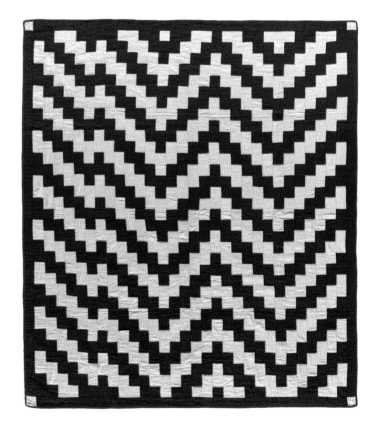

fig. 19
Basketweave Quilt
with double border,
86 ½ x 69 ½ inches.

fig. 20
Basketweave Quilt
with single border,
75 ½ x 65 inches.

fig. 21
Streak of Lightning Quilt
with single side borders,
Berks County, Pennsylvania,
80 x 66 inches.

fig. 22
Streak of Lightning Quilt
(Horizontal Zigzag Variation)
with single border and corner
squares, 78 x 69 inches.

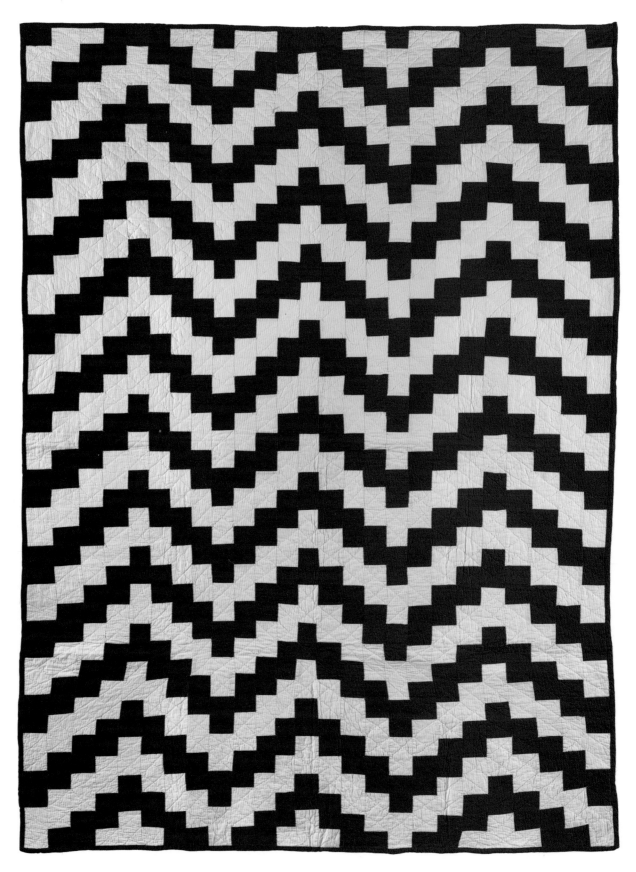

fig. 23
Streak of Lightning Quilt
(Horizontal Zigzag Variation),
Lancaster County, Penn-
sylvania, 81 ½ x 60 inches.

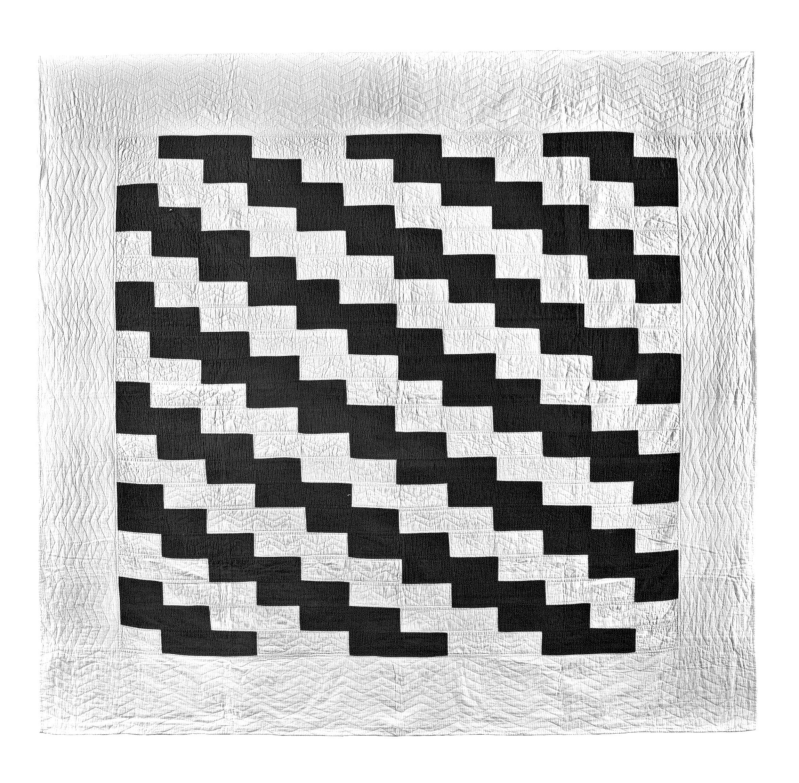

fig. 24
Streak of Lightning Quilt
(Bricks Variation) with wide
border, 75¾ x 82¾ inches.

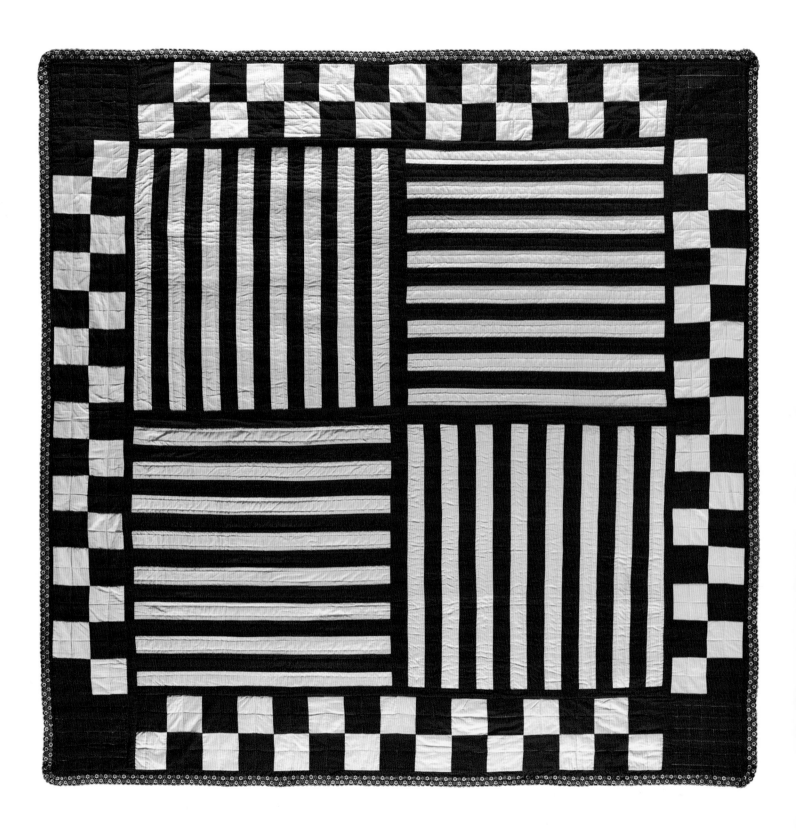

fig. 25
Colt's Corral Quilt (Four
Flags Variation) with single
pieced border, Quarryville,

Lancaster County, Penn-
sylvania, 80 x 78 inches.

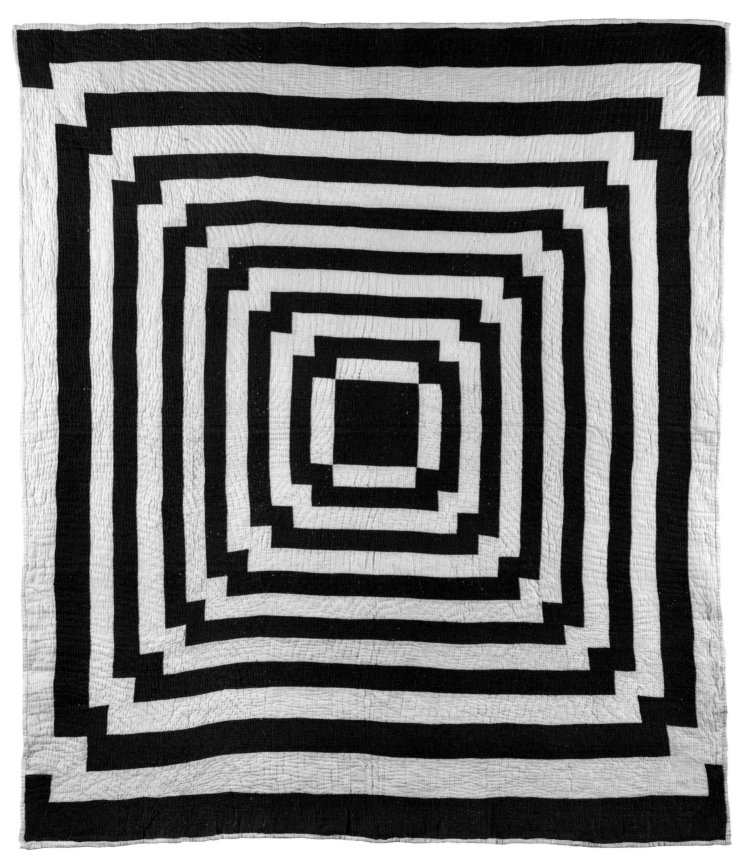

fig. 26
Puss in the Corner Quilt
(Concentric Frames
Variation), Kentucky,
79 x 69 ½ inches.

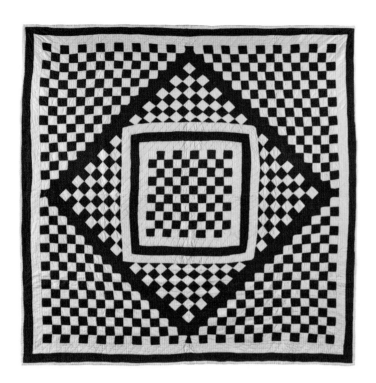

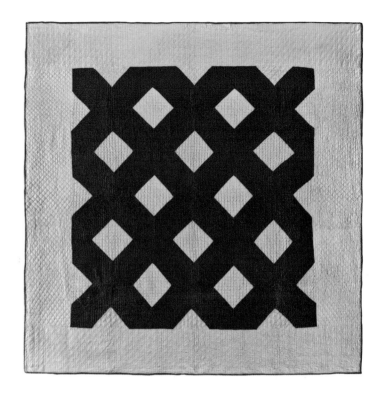

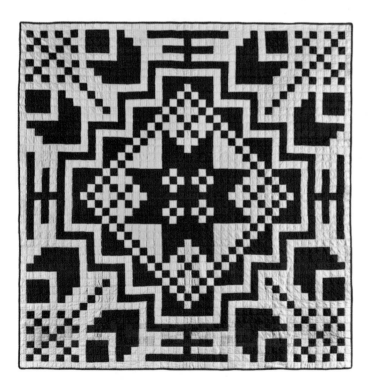

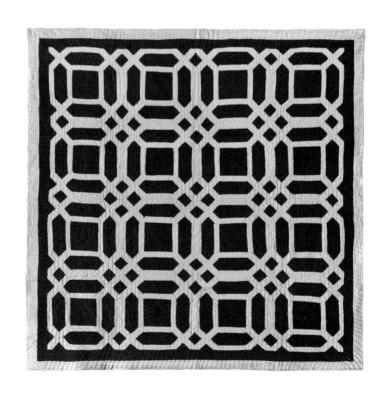

fig. 27
Checkerboard Square in
a Square Quilt with double
border, 73 x 71½ inches.

fig. 28
Postage Stamp Center
Star in Diamond Quilt
with single border,
92½ x 88 inches.

fig. 29
Lattice Quilt with wide
border, 81 x 80 inches.

fig. 30
Garden Maze Quilt
with double border,
79½ x 79½ inches.

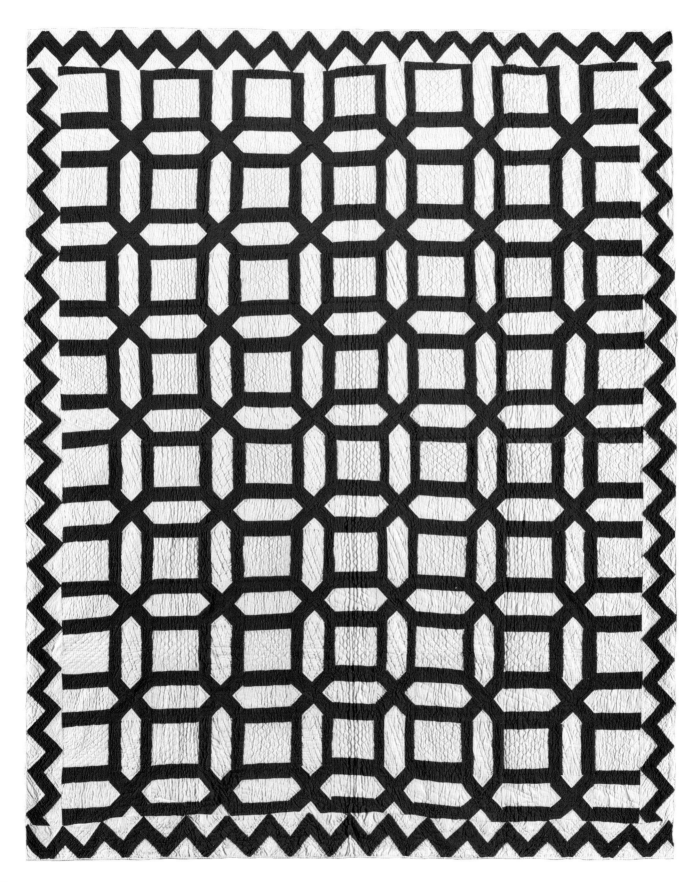

fig. 31
Garden Maze Quilt with zig-
zag border, 84 x 69 inches.

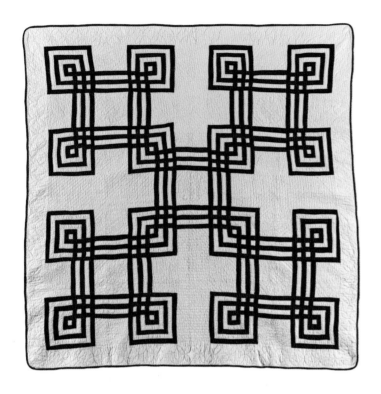

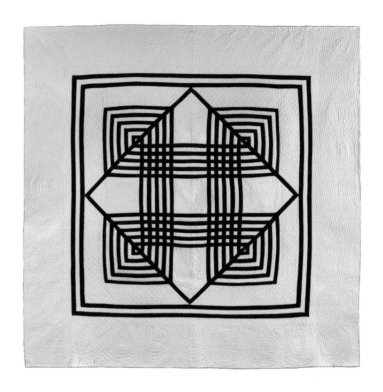

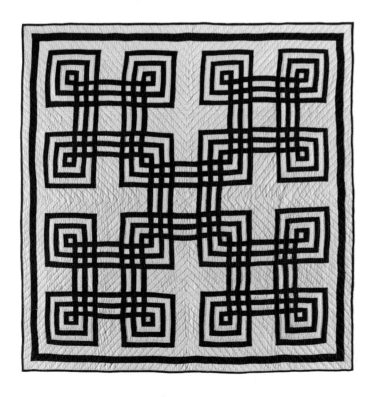

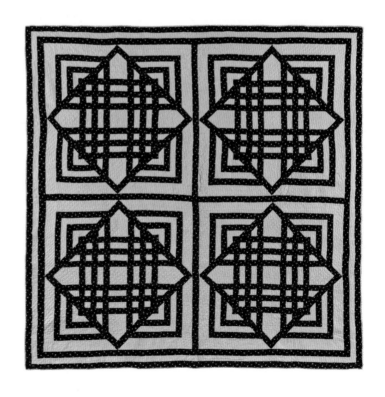

fig. 32
Gordian Knot Quilt
with single border,
78 ½ x 76 inches.

fig. 33
Gordian Knot Quilt
with triple border,
74 x 74 inches.

fig. 34
Gordian Knot Variation
Quilt with wide border,
Pennsylvania, c. 1870,
69 x 68 inches.

fig. 35
Gordian Knot Variation
Quilt with triple border,
75 x 75 inches.

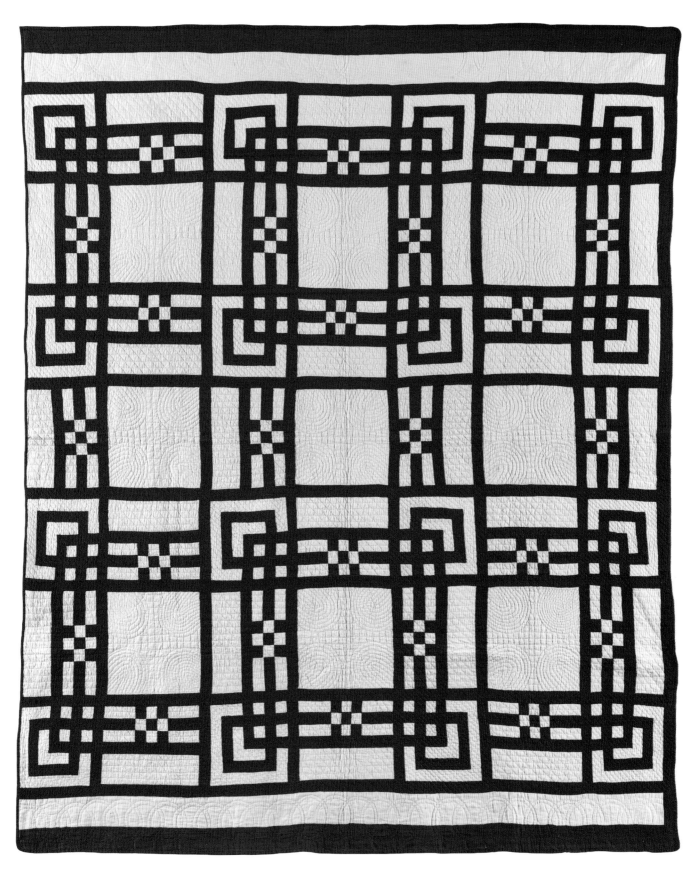

fig. 36
Gordian Knot Variation
Quilt with three-sided
border, 87 x 66 inches.

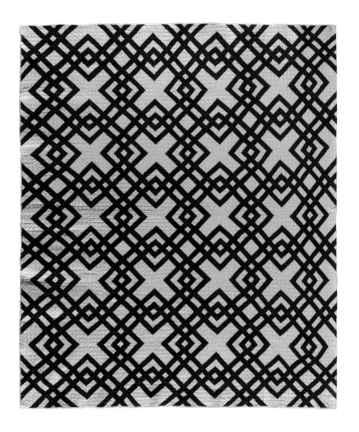

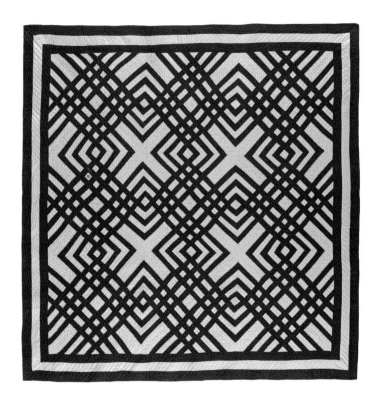

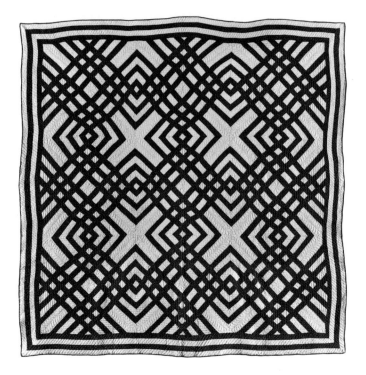

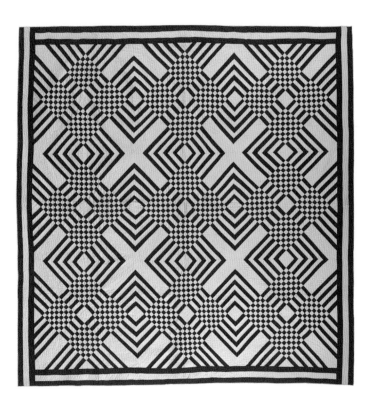

fig. 37
Carpenter's Square Variation
Quilt, 91 x 77½ inches.

fig. 38
Carpenter's Square Variation
Quilt with quadruple border,
signed and dated "Mary
Coffland, 1879," 83 x 83 inches.

fig. 39
Carpenter's Square Var-
iation Quilt with triple
border, signed "Della,"
83 x 80½ inches.

fig. 40
Carpenter's Square Variation
Quilt with triple bars border,
87½ x 84 inches.

STARS (figs. 41–53)

Stars are popular designs for wholetop quilts, and are particularly striking in red and white. See Chapter Six, page 209, for the history of Star patterns.

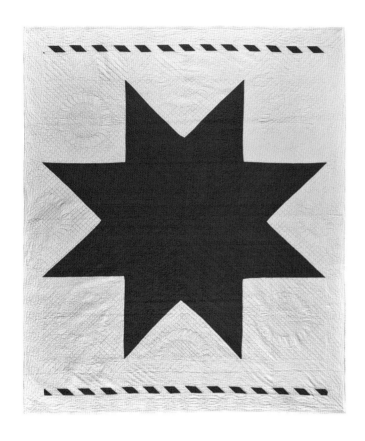

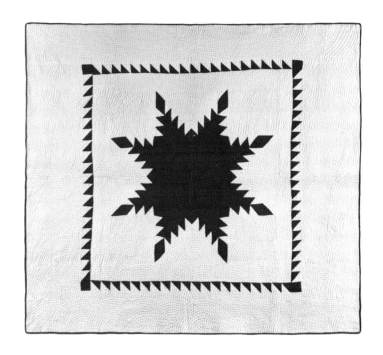

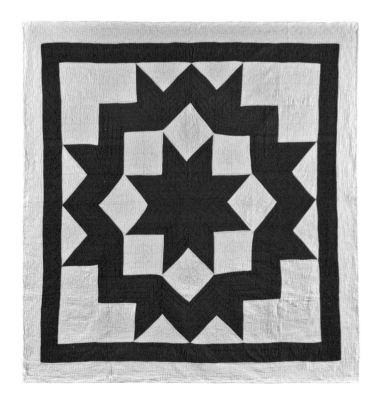

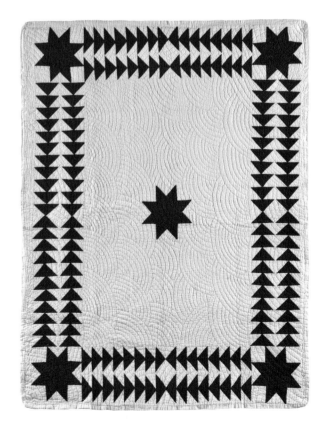

fig. 41
Eight-Point Star Quilt with top and bottom ribbon border, 91 x 79 inches.

fig. 42
Broken Star Quilt with double border, 75 x 71 inches.

fig. 43
Sawtooth Star Quilt with sawtooth inner border and wide outer border, 66 ½ x 74 ½ inches.

fig. 44
Five-Star Wild Goose Chase Variation Quilt with single border, Kentucky, 77 x 63 inches.

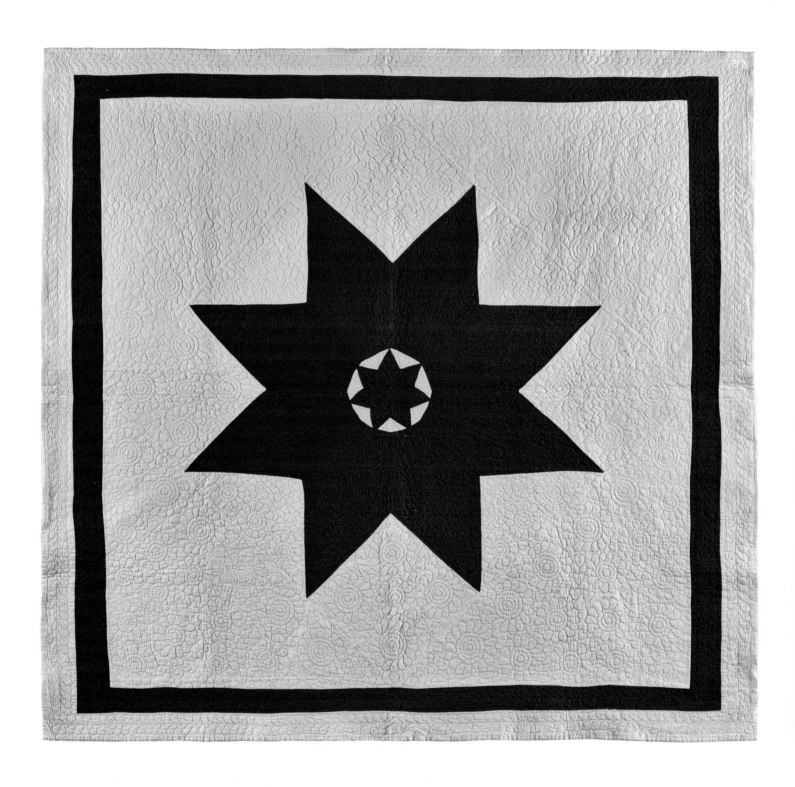

fig. 45
Seven-Point Star in an
Eight-Point Star Quilt
with double border,
80 ½ x 74 inches.

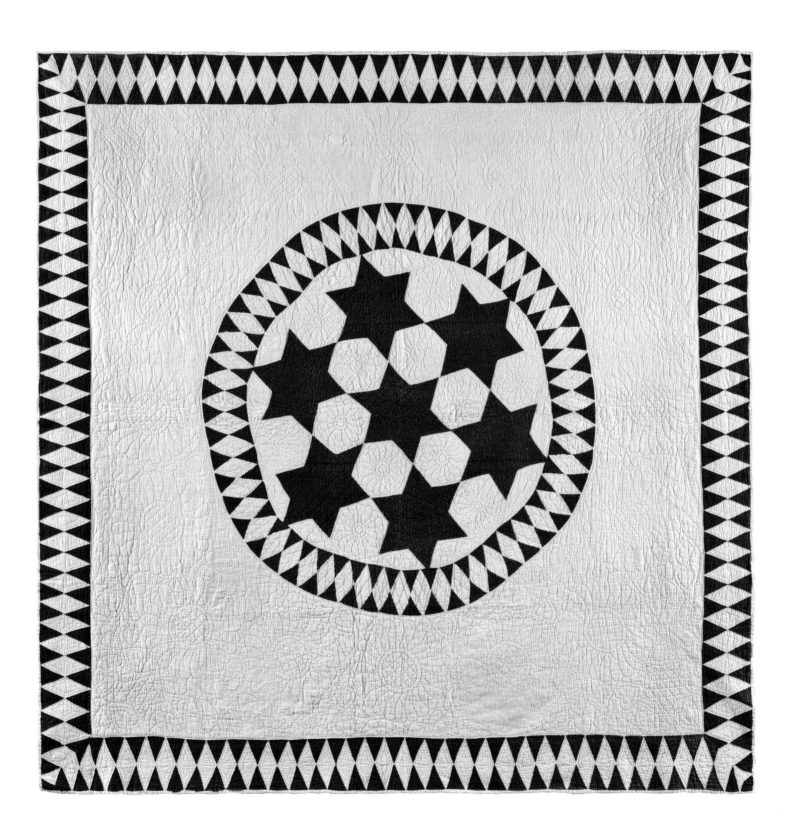

fig. 46
Seven Sisters Quilt
with diamond border,
80 x 78 inches.

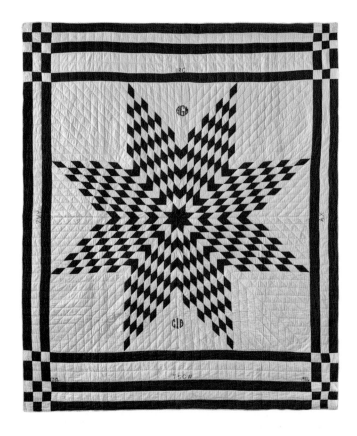

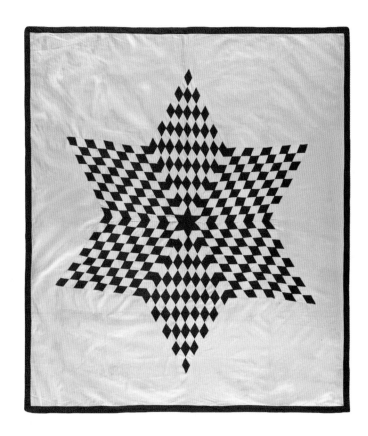

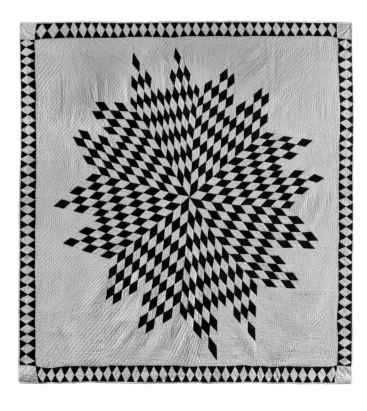

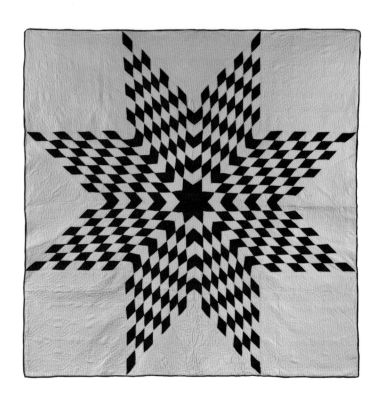

fig. 47
Lone Star Quilt with complex border, initialed "IRC," "AGM," "CIA," and "TSCW," dated 1932 and 1936, 88 x 74 inches.

fig. 48
Lone Star (Sixteen-Point Starburst) Quilt with diamond border, Adams County, Pennsylvania, 73½ x 73 inches.

fig. 49
Lone Star Quilt Top, 79 x 71 inches.

fig. 50
Lone Star Quilt, Wichita, Kansas, 82½ x 81 inches.

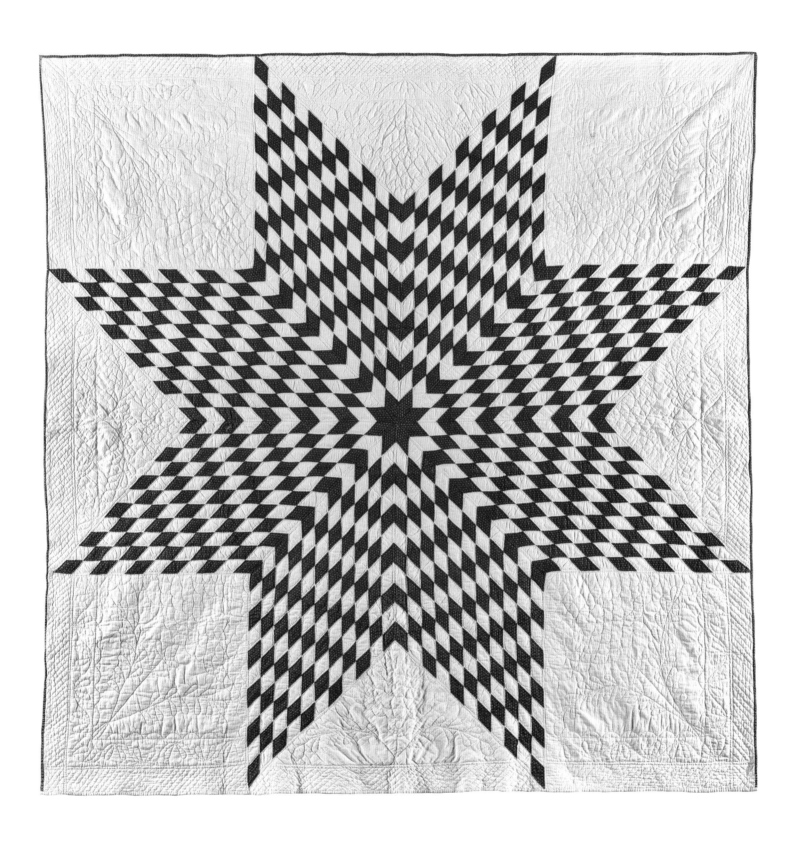

fig. 51
Lone Star Quilt,
82 x 81 inches.

The Sawtooth pattern, made up of a row of triangles, is primarily used to outline a shape or pattern to create intricate jagged-edge designs.

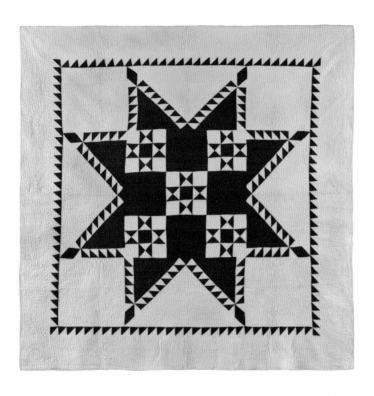

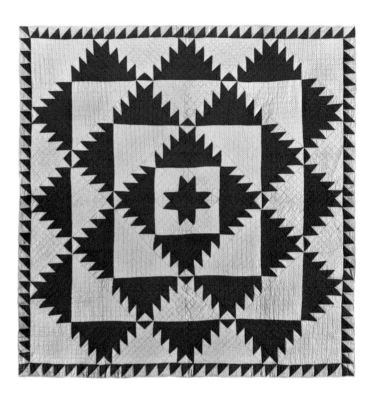

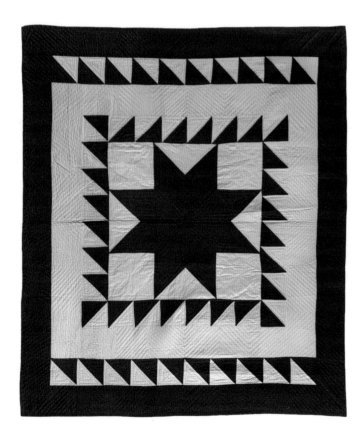

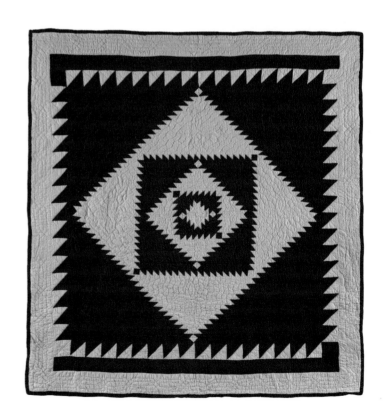

fig. 52
Sawtooth Star Variation
Quilt, 76 x 72 inches.

fig. 53
Star Quilt with sawtooth
inner borders and single
outer border, Maine, c. 1930,
92 ½ x 79 ¼ inches.

fig. 54
Sawtooth Squares Quilt
with sawtooth border,
70 x 69 ½ inches.

fig. 55
Sawtooth Square in a Square
Quilt with complex border,
c. 1930, 69 x 64 ½ inches.

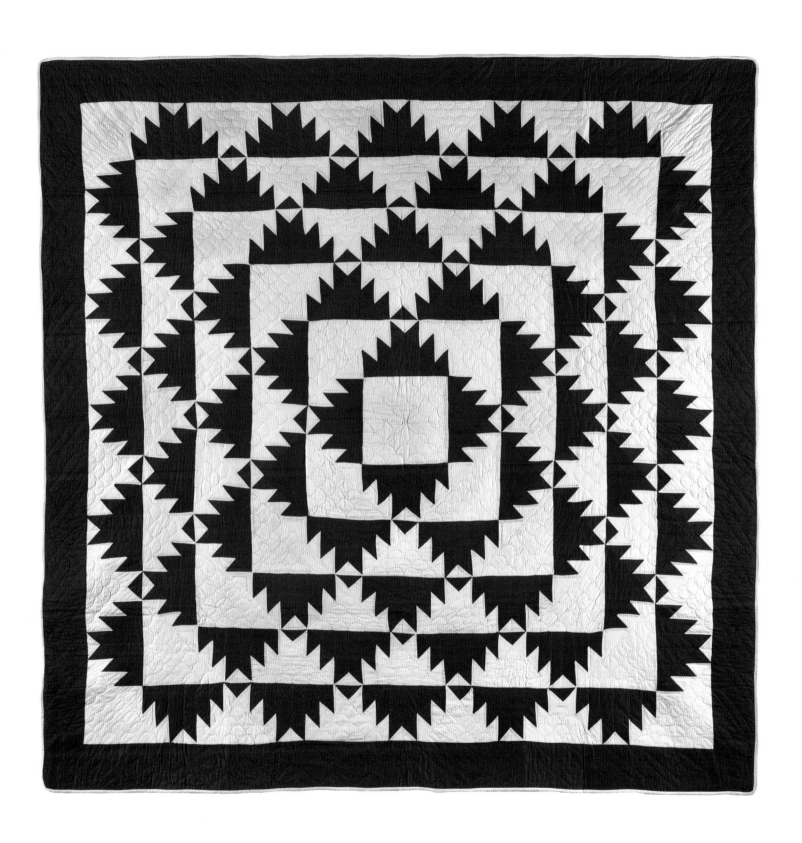

fig. 56
Sawtooth Squares Quilt
with single border, Ohio,
77 x 77 inches.

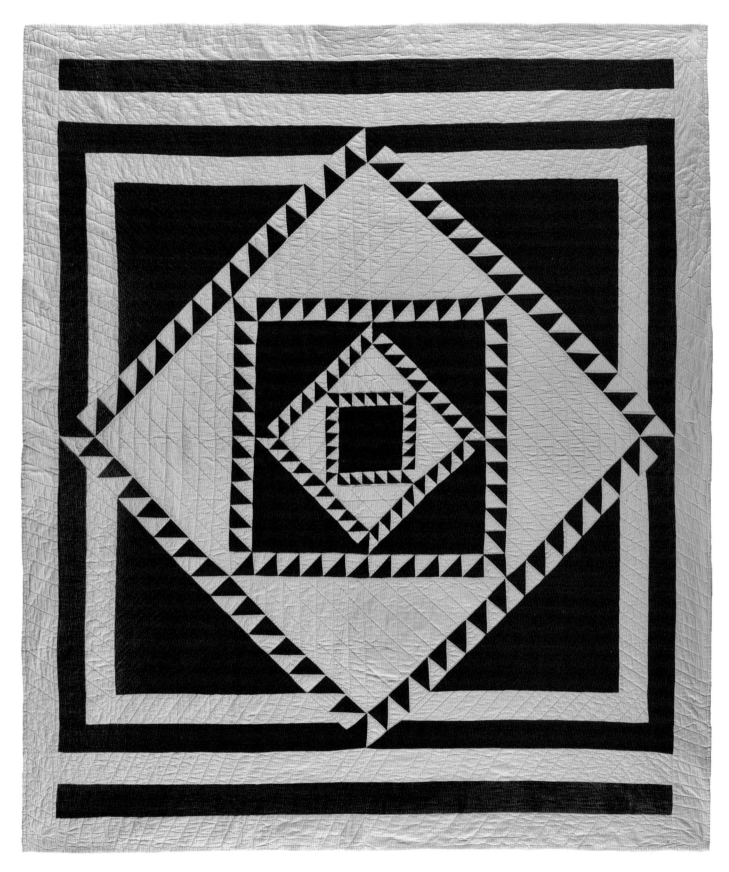

fig. 57
Sawtooth Square in a Square
Quilt with triple top and
bottom borders and single
side borders, 78 ½ x 67 inches.

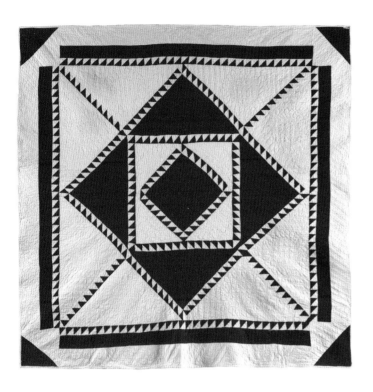

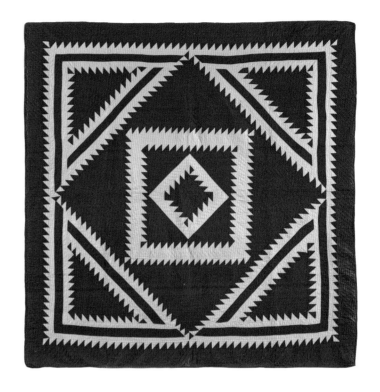

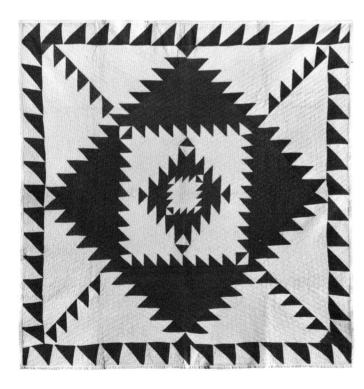

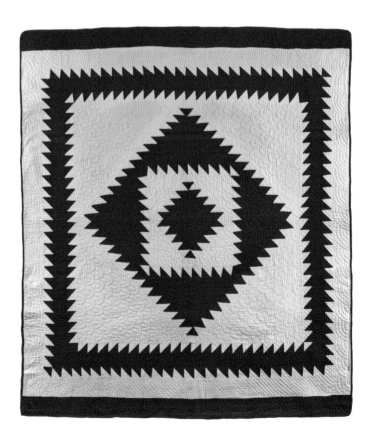

fig. 58
Sawtooth Square in a Square Quilt with double border and corner triangles, labeled "Florence Rogers," 66 x 66 inches.

fig. 59
Sawtooth Square in a Square Quilt with sawtooth border, 68 x 65 inches.

fig. 60
Sawtooth Square in a Square Quilt with sawtooth border, 81 x 80 inches.

fig. 61
Sawtooth Square in a Square Quilt with single top and bottom borders, 74 ½ x 64 ½ inches.

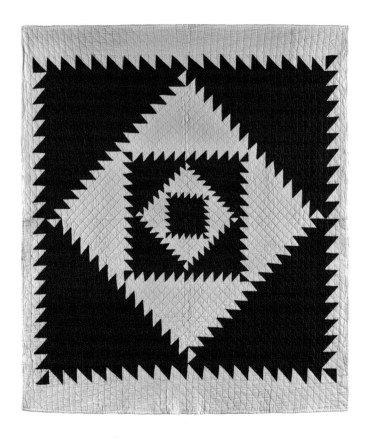

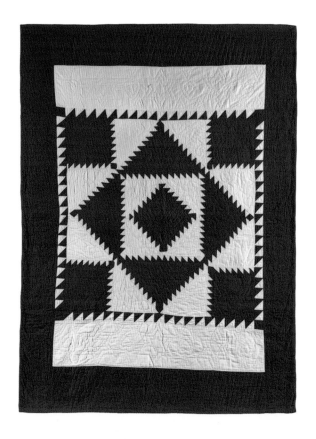

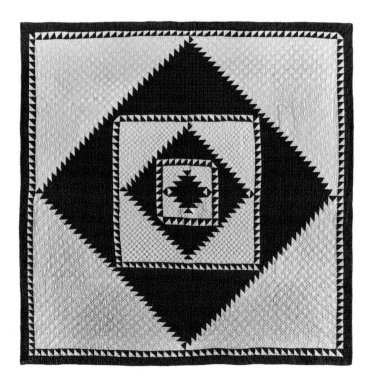

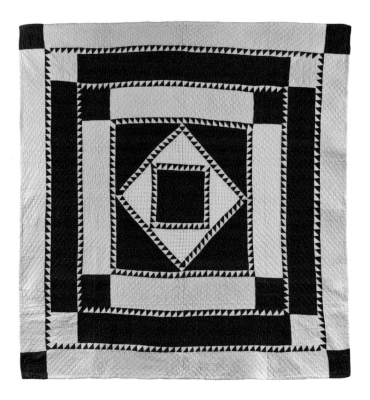

fig. 62
Sawtooth Square in a Square
Quilt (Solomon's Temple Variation) with single border, New
York State, 75 x 66 inches.

fig. 63
Sawtooth Square in a Square
Quilt with double border,
71 x 71 inches.

fig. 64
Sawtooth King's Crown
Variation Quilt with wide
border, 70 x 50 inches.

fig. 65
Sawtooth Center Medallion
Quilt with single border and
corner squares, 73 x 67 inches.

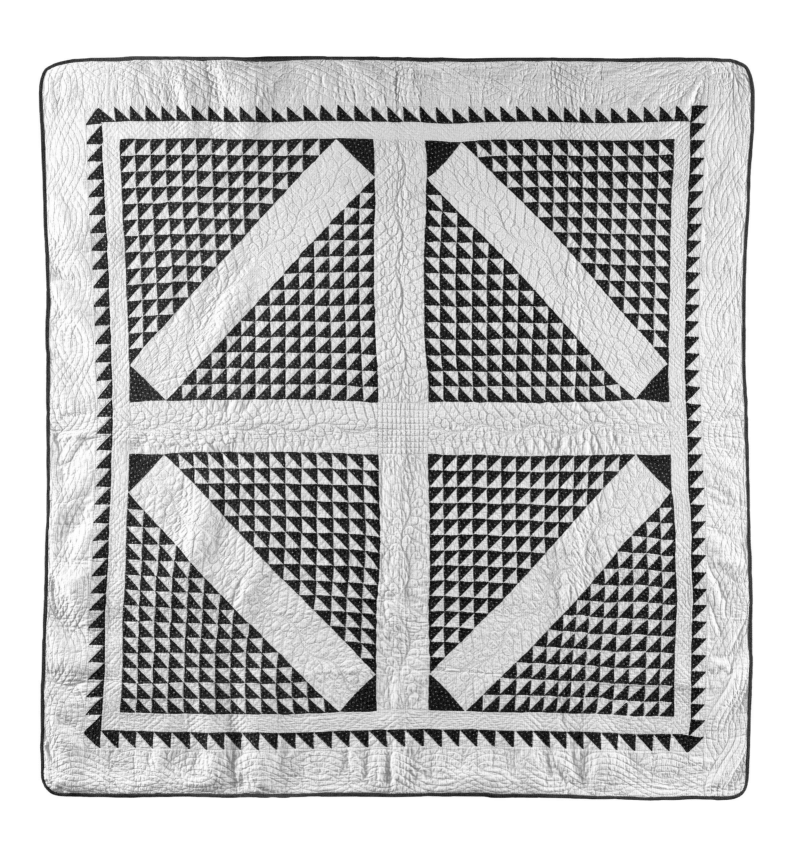

fig. 66
Square Deal Variation
Quilt with sawtooth border,
78 x 77 inches.

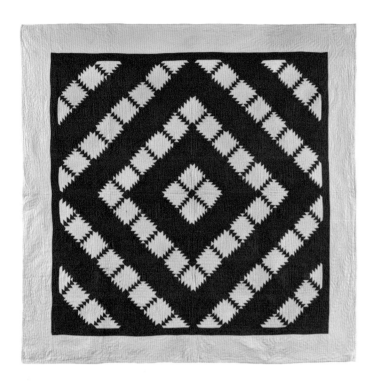

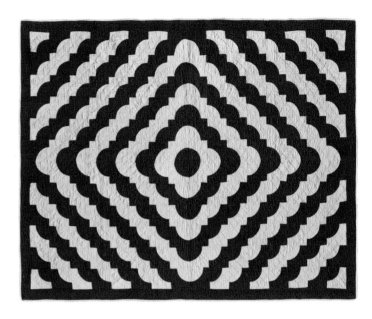

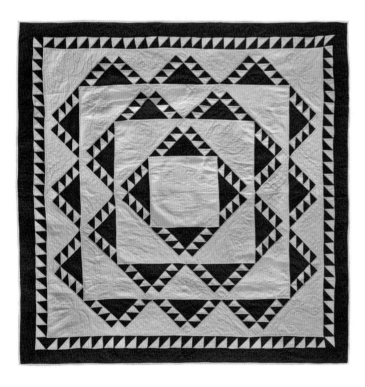

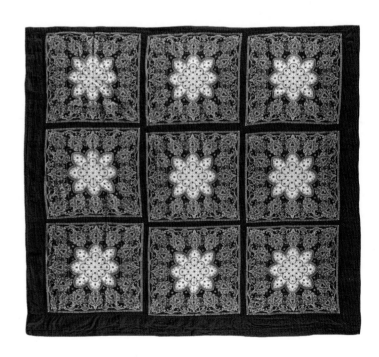

fig. 67
Sawtooth Center Diamond Quilt with wide border, 72½ x 71½ inches.

fig. 68
Concentric Sawtooth Economy Patch Quilt with sawtooth inner border and single outer border, 70 x 70 inches.

fig. 69
Trip Around the World Quilt with single border, c. 1930, 91 x 74 inches.

fig. 70
Bandanna Blocks Quilt with three-sided border, 78½ x 75 inches.

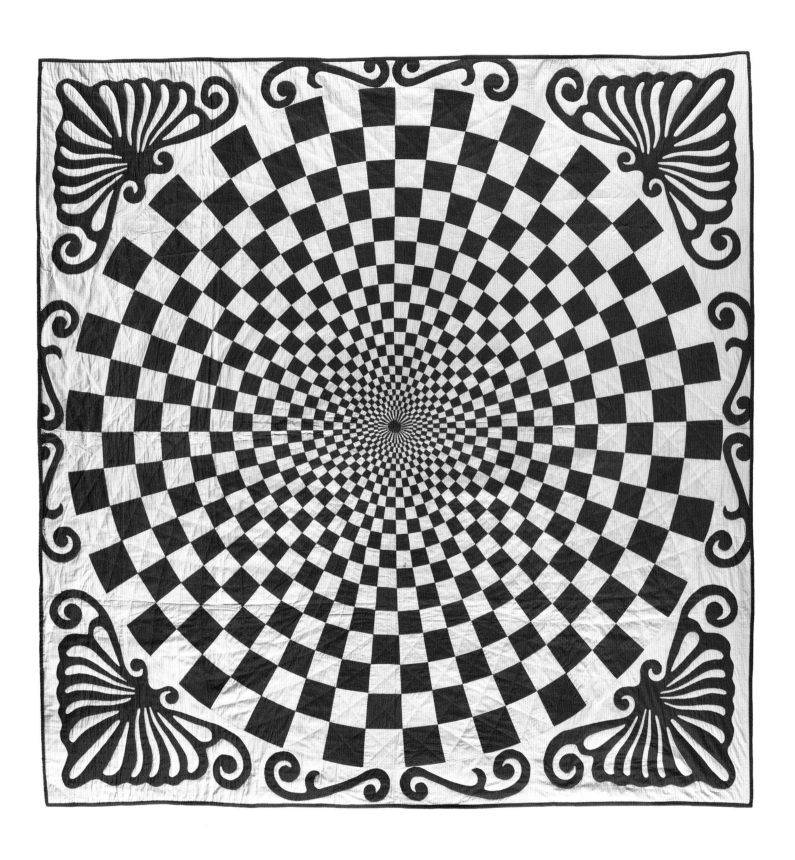

fig. 71
Kaleidoscope Quilt,
82 x 80 inches.

Log Cabin Quilts

Though the Log Cabin pattern is thought of as the quintessential American quilt pattern, its origins may date much farther back in time than the formation of the nation. It has remained popular partly because of the simplicity of its basic construction and perhaps mainly because of the amazing variety of ways in which the blocks can be combined to create an array of so-called secondary patterns.

These combinations of blocks, called "setts," or "settings," have their own names, and this chapter contains four of the major types: Light and Dark, also known as Sunshine and Shadow; Straight Furrow; Barn Raising; and Pineapple, or Windmill Blades.

The basic blocks are constructed from strips of contrasting fabrics arranged concentrically around a central shape, usually a square, though any shape can be used. Pineapple blocks typically contain a center square or octagon, but examples can be found with the pattern constructed around triangles, rectangles, pentagons, hexagons, or irregular shapes. The effectiveness of the blocks derives from the contrast between the fabrics used on the various rows of strips or the sides of the center.

An early example of a Log Cabin quilt in the New World is documented in Jean Dubois's book *Patchwork Quilting with Wool* (1978). Mary Morgan, an Englishwoman, brought with her a Barn Raising quilt in the 1830s when she immigrated to the United States. The pattern can be found on quilts dating to the mid-eighteenth century, especially from the British regions of the north and west of England, along the Scottish border, and on the Isle of Man in the Irish Sea, where it is known as Rooftop.

Log Cabins found their way into the American consciousness with the presidential campaign of Abraham Lincoln in 1859–60, but the pattern was fashionable before that and endures to this day. In the post–Civil War period the pattern's immense popularity led to special judging sections in the category at county and state fairs.

There are several methods for assembling a Log Cabin block. The oldest begins with a large square of a lightweight foundation fabric, such as muslin or shirting, on which the central shape is pinned or basted in place, with strips added in a stitch-and-flip technique. For the basic traditional block, strips are applied to the edge of the center piece on the foundation, either clockwise or counterclockwise, with two lights then two darks (or vice versa). Subsequent rows are added in the same order until the block reaches the desired size. In the variation known as Courthouse Steps, lights and darks are placed on opposite sides of the center. The Pineapple block is more complex: eight strips instead of four are arranged around the central shape.

The contrast provided by the use of only red and white fabrics makes the resulting quilts outstandingly graphic.

LIGHT & DARK (figs. 72–73)

Alternated light (white) and dark (red) blocks are also called Sunshine and Shadow. These examples are the Courthouse Steps variation.

BARN RAISING (figs. 74–75)

Here two dark, then two light sides touch, and each quadrant of the quilt is turned to create concentric rows of red and white around a central square.

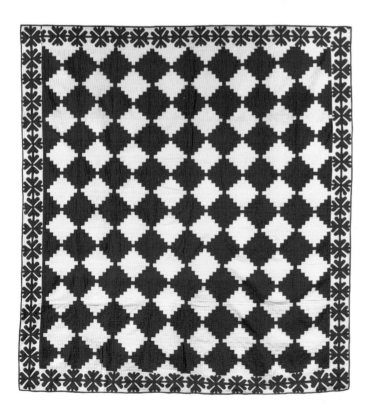

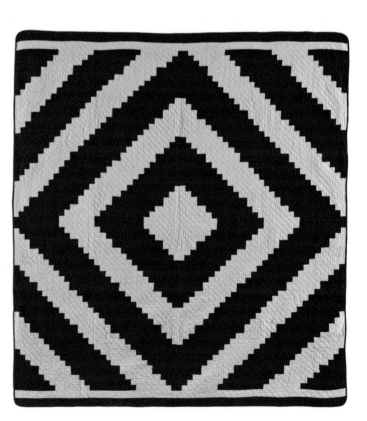

fig. 72
Log Cabin Quilt (Courthouse Steps Variation) with striped border, 99 ½ x 88 ½ inches.

fig. 73
Log Cabin Quilt (Courthouse Steps Variation) with appliqué border, 91 x 83 inches.

fig. 74
Log Cabin Quilt (Barn Raising Variation), 77 x 72 inches.

fig. 75
Log Cabin Quilt (Barn Raising Variation) with double top and bottom borders, Ohio, 81 x 73 ½ inches.

STRAIGHT FURROW (figs. 76–77)
Blocks are positioned to create straight diagonal rows of alternating red and white, reminiscent of a newly plowed field.

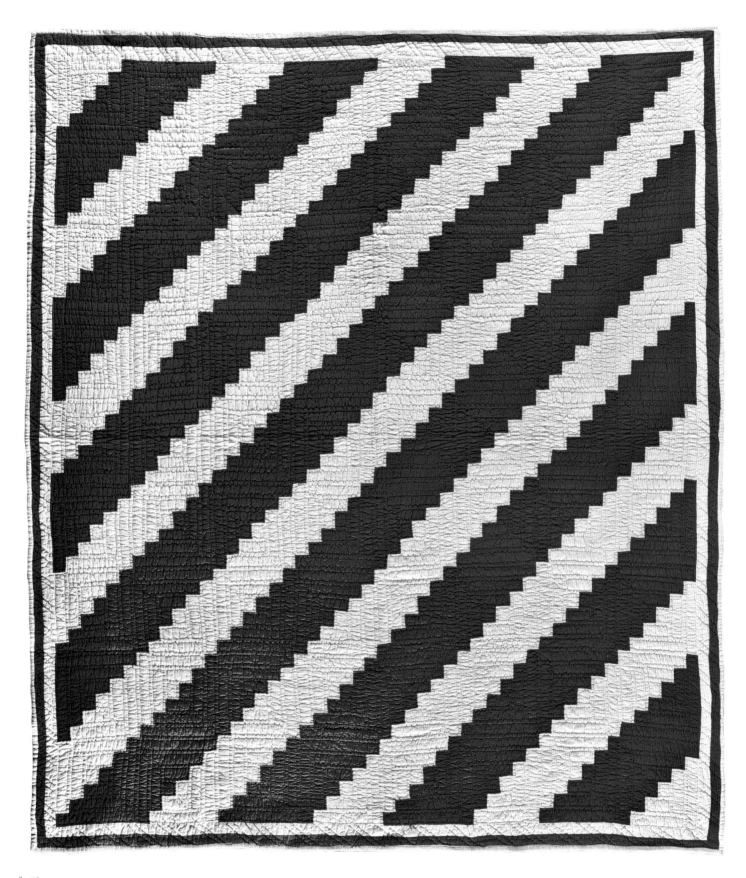

fig. 76
Log Cabin Quilt (Straight Furrow Variation) with double border, 81 x 70 inches.

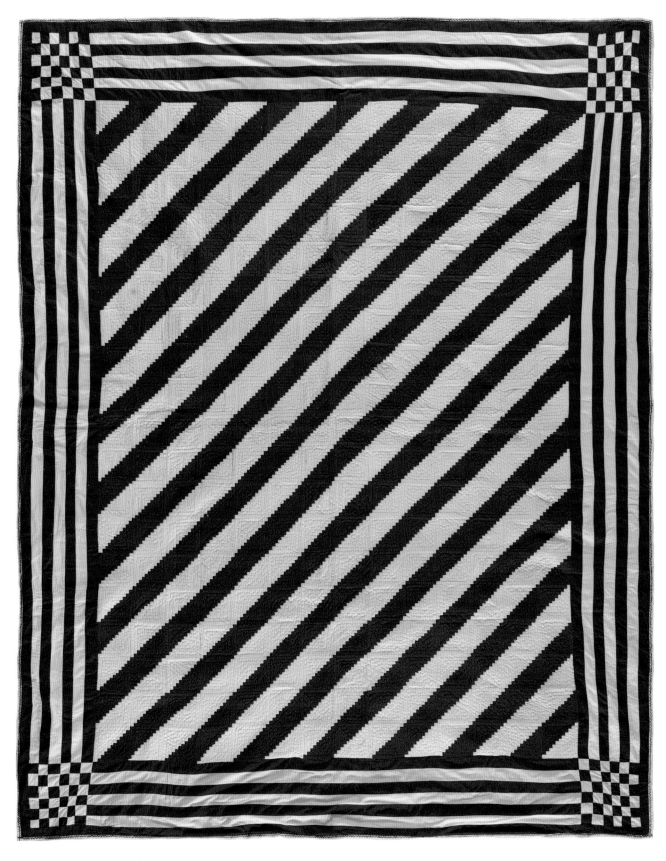

fig. 77
Log Cabin Quilt (Straight Fur-
row Variation) with striped
border and double nine patch
corners, 85 ½ x 68 inches.

PINEAPPLE (figs. 78–83)

In this variation, four strips are placed parallel to the edges of the center square with four contrasting strips positioned across the corners.

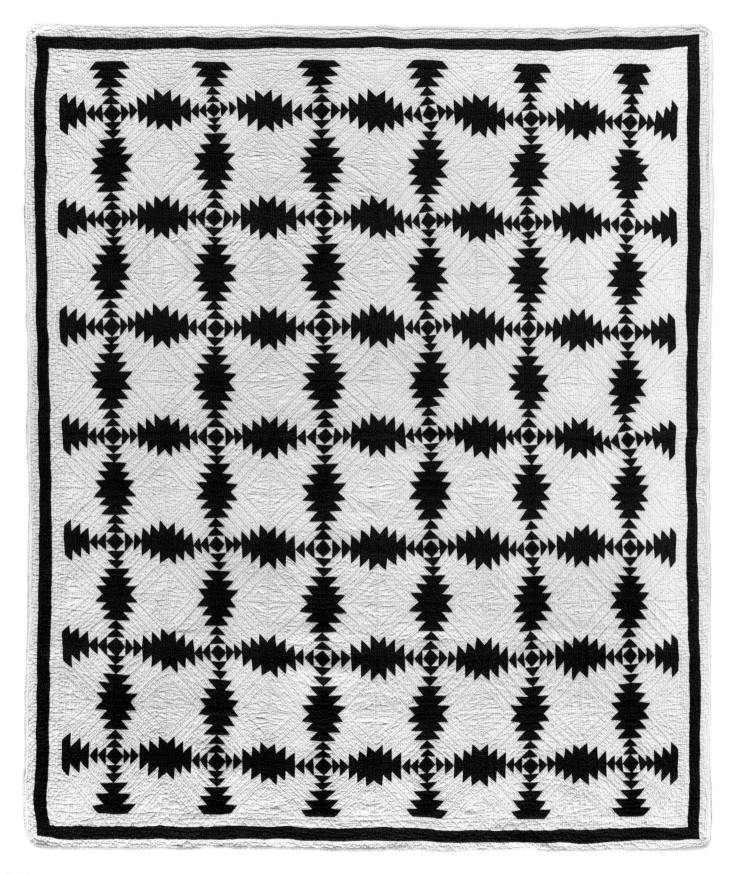

fig. 78
Log Cabin Quilt (Pineapple Variation) with triple border, 80 x 70 inches.

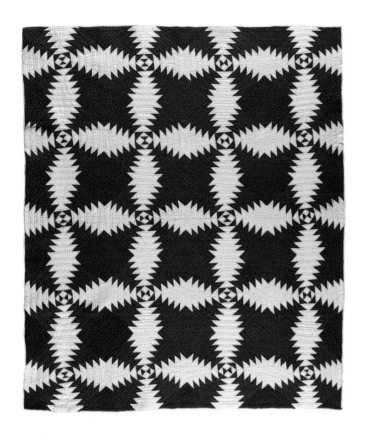

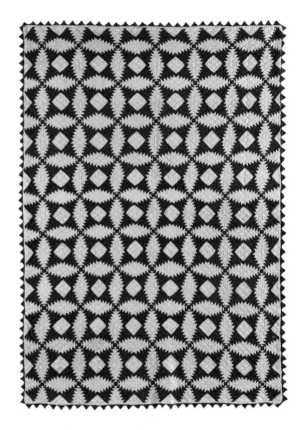

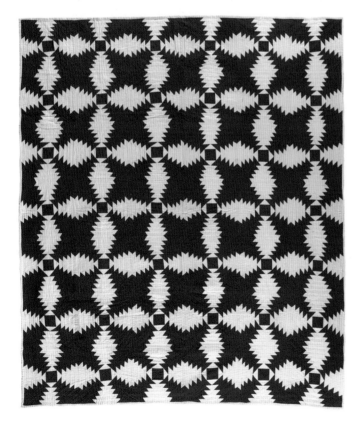

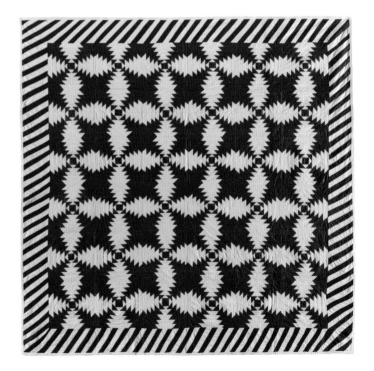

fig. 79
Log Cabin Quilt (Pineapple Variation), 81 x 69½ inches.

fig. 80
Log Cabin Quilt (Pineapple Variation), 90 x 78 inches.

fig. 81
Log Cabin Quilt (Pineapple Variation) with prairie point binding, 79 x 55½ inches.

fig. 82
Log Cabin Quilt (Pineapple Variation) with striped border, 69½ x 68½ inches.

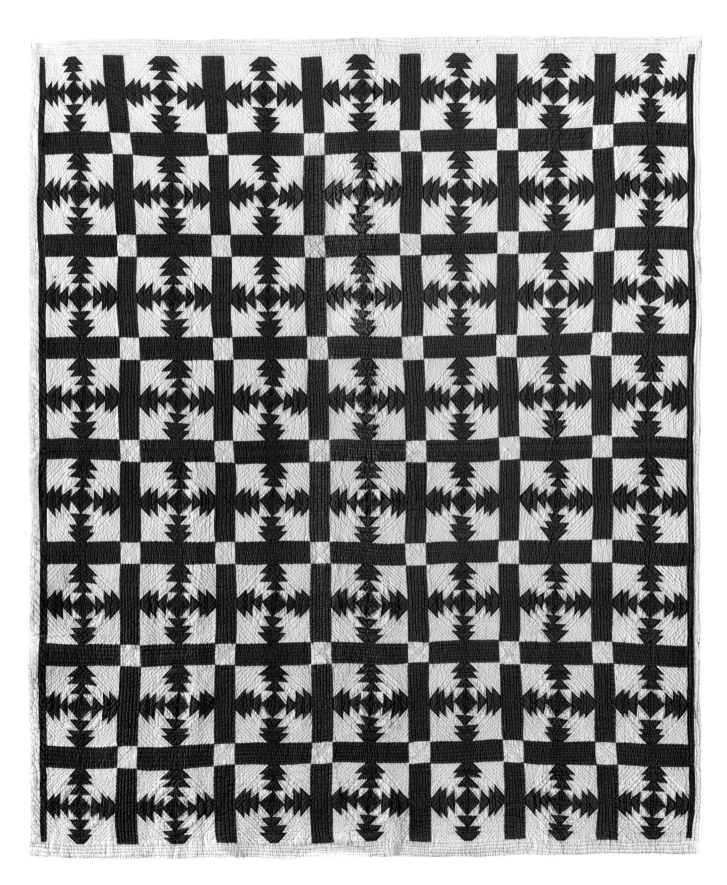

fig. 83
Log Cabin Quilt (Pine-
apple Variation) with
corner-block sashing and

double side borders and
single top and bottom
borders, 80 x 68 inches.

Pictorial Quilts

Some of the most popular and enduring patchwork designs contain representational images. These pictorial blocks can be found in quilts from all eras.

Various plant forms are widely seen, including maple leaves, palm trees, and flowers such as lilies and tulips. Pines and other trees—some tree-shape, and others more abstract—appear particularly in quilts from the late nineteenth century. Baskets are also common, both in patch-work and appliqué, as well as houses, especially schoolhouses. Both forms tend to be more representational than some of the floral blocks.

Also included in this chapter are sev-eral unique word quilts that contain letters formed from squares or hexagons to create names, phrases, verses, or prayers. Letters appear more curved with the use of hexagons rather than squares, and are therefore more visually appealing, though they are more time-consuming to piece. The *Charles & Cornelia Quilt* and the *Daniel & Amarilla Quilt* (figs. 133 and 134, pages 106–107) are by the same maker, Lavinia Rose of Cortland-ville, New York. The *Charles & Cornelia Quilt* is clearly signed and dated, and the *Daniel & Amarilla Quilt* has a tiny written signature at the bottom, which was discovered when the quilts were being hung for the *Infinite Variety* exhibition. Pieced letter quilts have a strong association with New York State, and were particularly popular there during the mid-nineteenth century.

In a couple of quilts (fig. 132, page 105 and fig. 273, page 171) it appears that a tan or yellow-toned fabric has been used instead of the expected red fabric. These are examples of fabrics that have faded over time. In the case of fig. 273, it is likely that a red fabric that was not dyed with Turkey red was used to complete the pattern, while fig. 132 was probably red and green when it was new. Greens are especially known to fade to tan when exposed to light and washing, and red, green, and white would have been a popular color combination when this quilt was made.

Many pictorial motifs became popular during the heyday of the so-called Quilt Revival, which occurred between 1900 and 1940. Blocks were often made using com-mercial patterns and depict everything from sailboats and ships, planes and trains to farm animals and household pets, insects and sea creatures. Others, like the figure of a woman at a spinning wheel (fig. 130, page 103) that appears almost pixelated (or like cross-stitch on the grandest scale), represent people and everyday objects.

More examples of recognizable images are worked in appliqué than in patchwork, but there are still vast numbers of figural and pictorial patchwork blocks.

Among the many leaf patterns on quilts, the Maple
Leaf is based on a simple Nine Patch of squares and
half-square triangles.

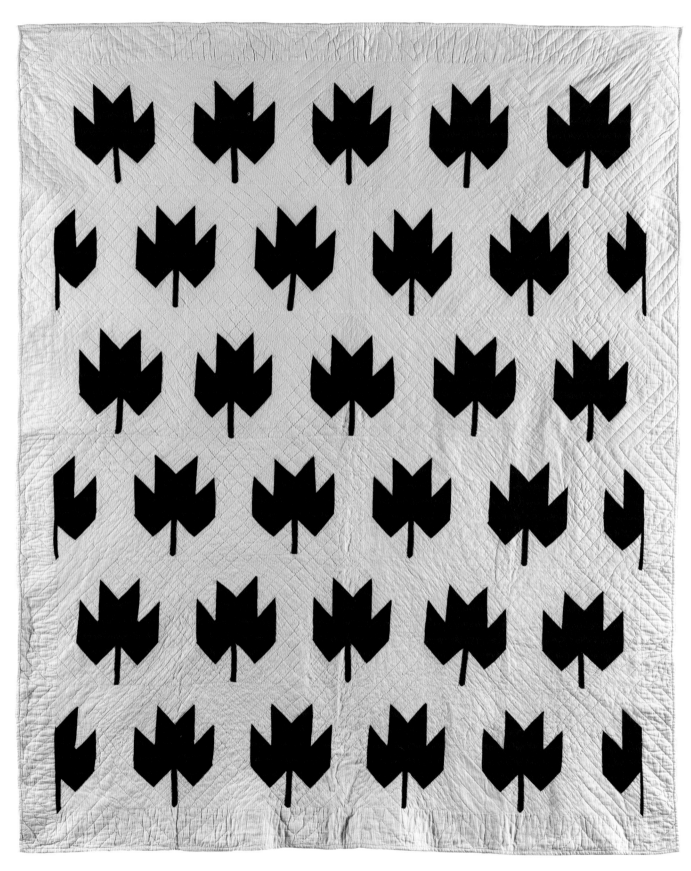

fig. 84
Upright Maple Leaf
Quilt with single border,
80 ½ x 68 inches.

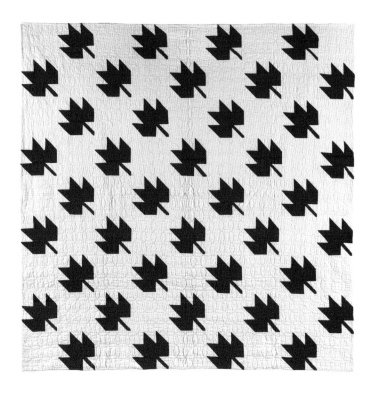

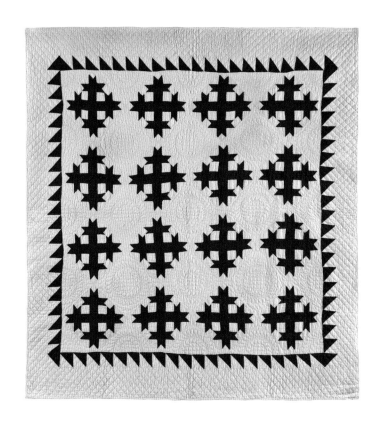

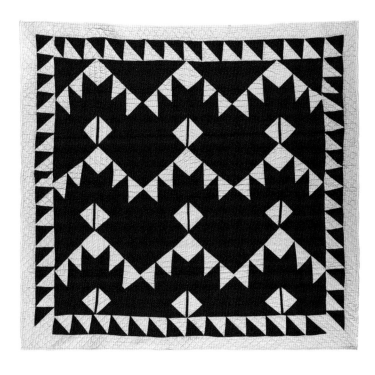

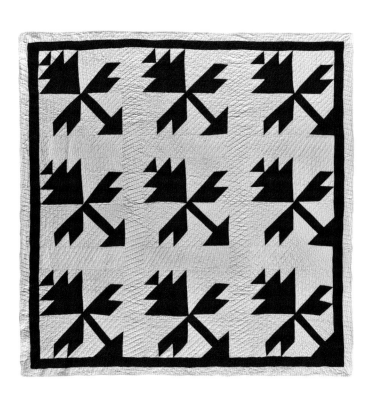

fig. 85
Windblown Maple Leaf
Quilt, 74 x 74 inches.

fig. 86
Maple Leaf Variation Quilt
with sawtooth border,
midwestern United States,
60 x 68 inches.

fig. 87
Lily Corners on Point Quilt
(Crossed Lilies Variation)
with sawtooth inner border
and wide outer border,
central Pennsylvania,
78 x 72 inches.

fig. 88
Lily of the Field Quilt with
double border, Pennsylvania,
79 x 79 inches.

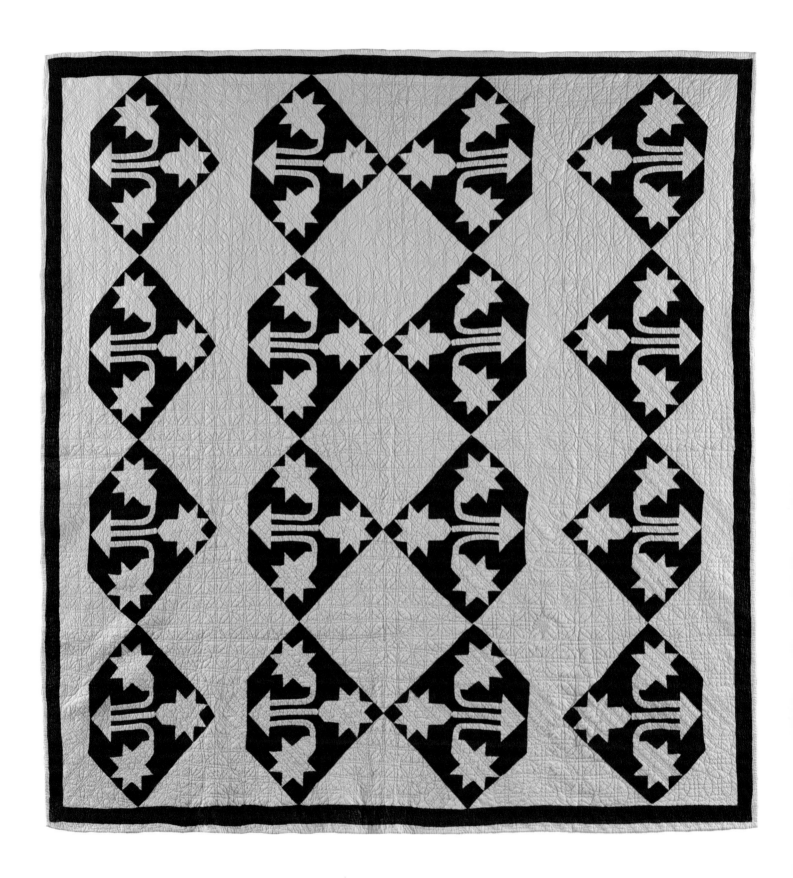

fig. 89
Carolina Lily in a Basket
Quilt with single border,
82½ x 80 inches.

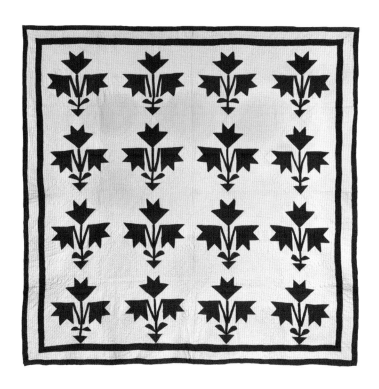

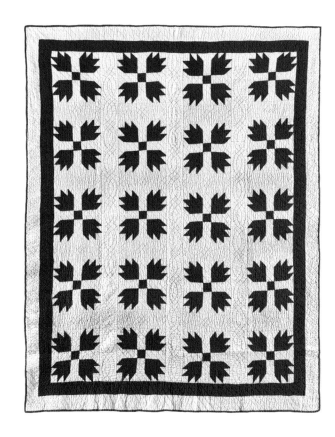

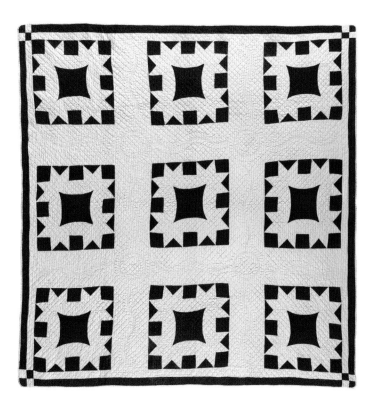

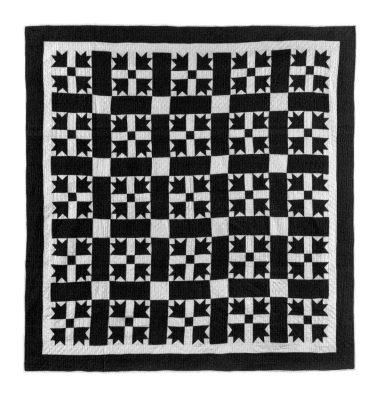

fig. 90
Carolina Lily Quilt with triple border, New Holland, Lancaster County, Pennsylvania, c. 1875, 74 x 71½ inches.

fig. 91
Lily Corners Quilt (Hands All Around Variation) with double border and four patch corners, midwestern United States, 75½ x 71 inches.

fig. 92
Lily Corners Quilt with simple sashing and double border, c. 1930, 84 x 67 inches.

fig. 93
Sashed Lily Corners Quilt with double border, Snowberger Farm, Morrison Cove, Bedford County, Pennsylvania, 77 x 77 inches.

TULIP (figs. 94–98)

Tulip patterns are created from simple Four Patch blocks. As with the Lily pattern, triangles are used to form the design.

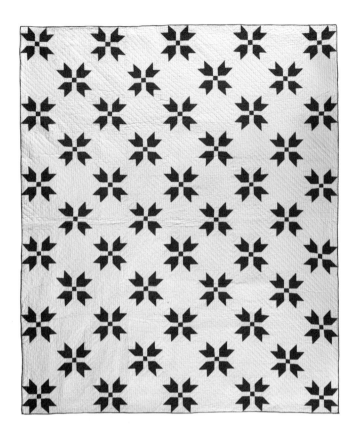

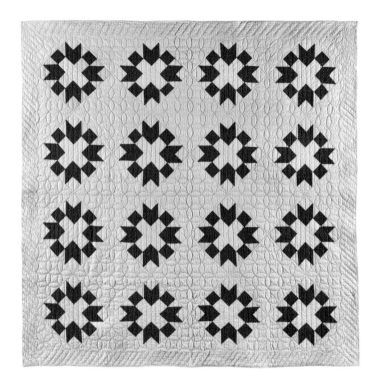

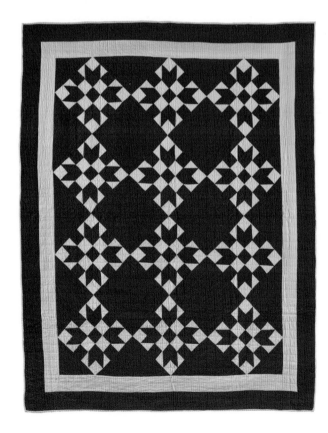

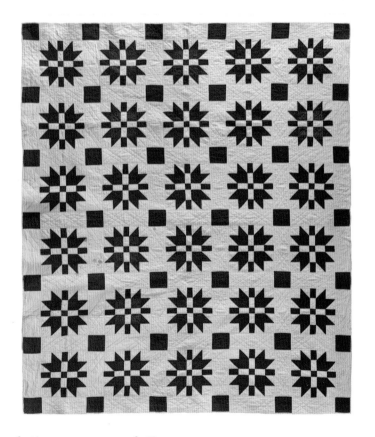

fig. 94
Crossed Tulips Quilt, Illinois, c. 1930, 94 x 80 inches.

fig. 95
Crossed Tulips Nine Patch Quilt with double border, 85 ½ x 68 inches.

fig. 96
Tulip Crosses on Point Quilt with single border, 77 x 77 inches.

fig. 97
Crossed Tulips Quilt with corner-block sashing, 89 x 76 inches.

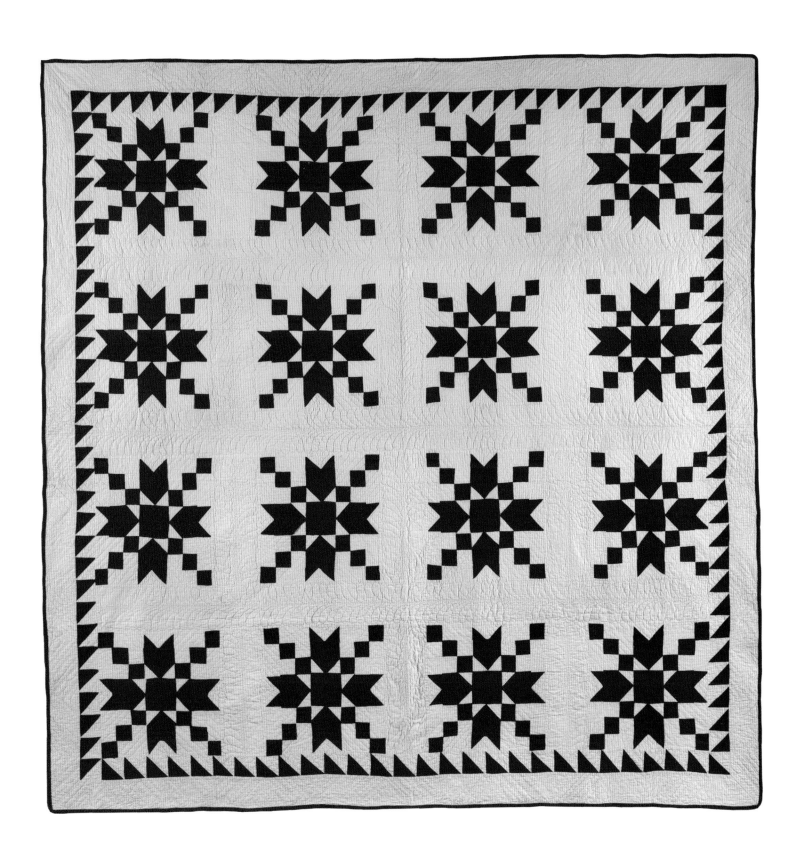

fig. 98
Arrowhead Tulips Quilt
with sawtooth border,
79 x 77 inches.

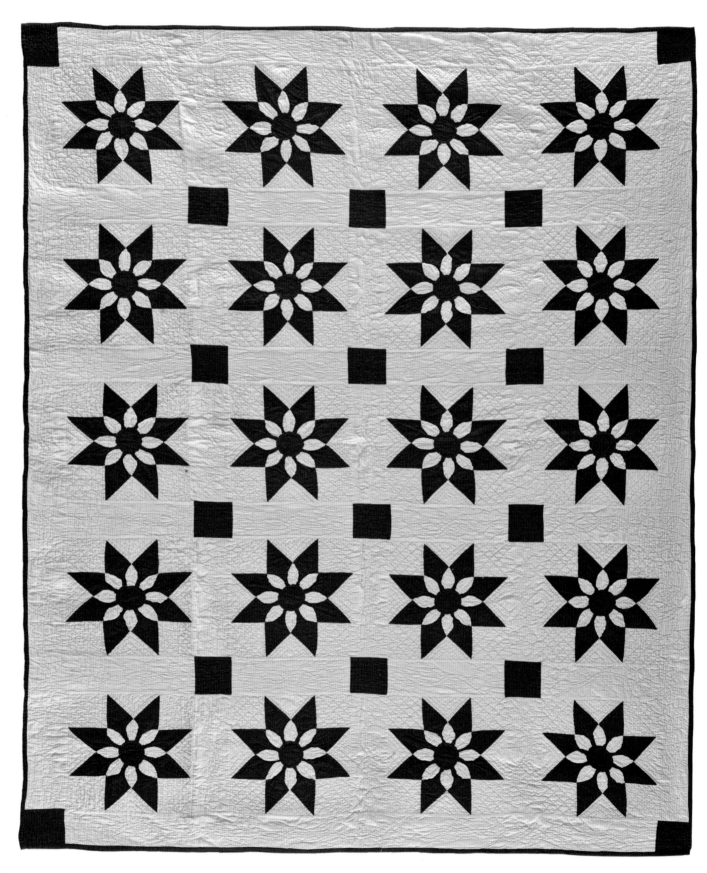

fig. 99
Dahlia Quilt with corner-block sashing, 77½ x 66 inches.

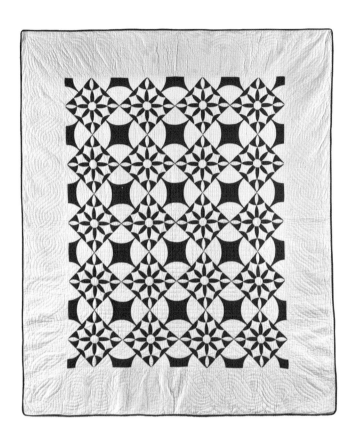

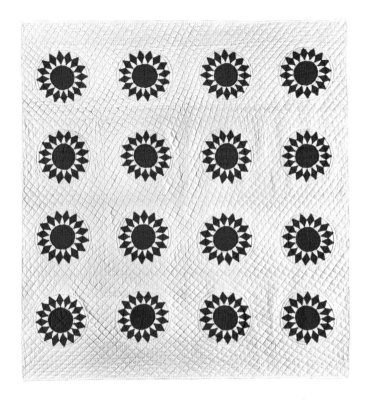

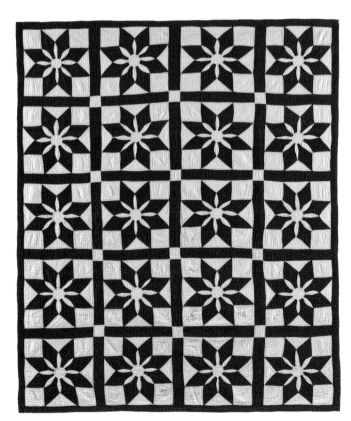

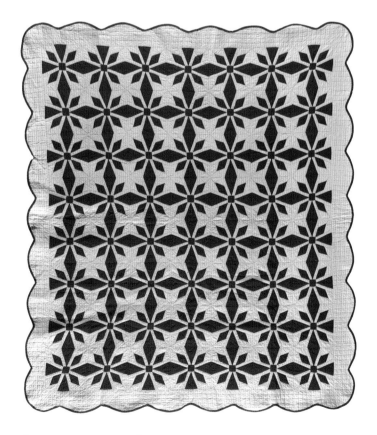

fig. 100
Daisy Chain Variation
Quilt with wide border,
89 x 73½ inches.

fig. 101
Daisy in Eight-Point Star
Quilt with corner-block
sashing, 78 x 65½ inches.

fig. 102
Sunflowers Quilt,
Carlisle, Pennsylvania,
71½ x 67½ inches.

fig. 103
Unnamed Floral Pattern
Quilt with scalloped edge,
c. 1930, 84 x 76 inches.

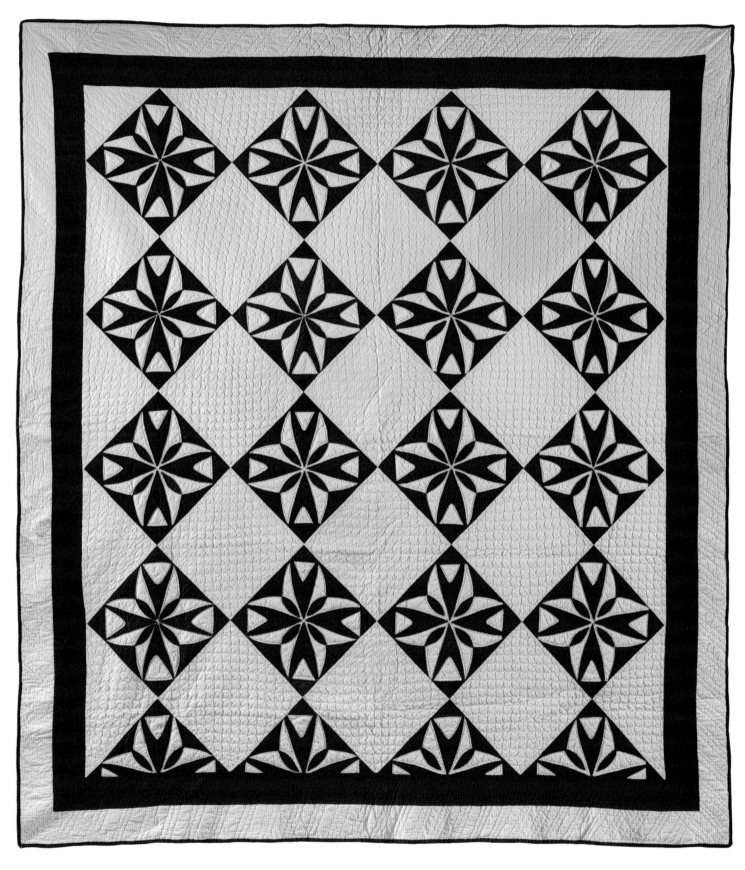

fig. 104
Mountain Pink Variation
Quilt with double border,
80 x 72 inches.

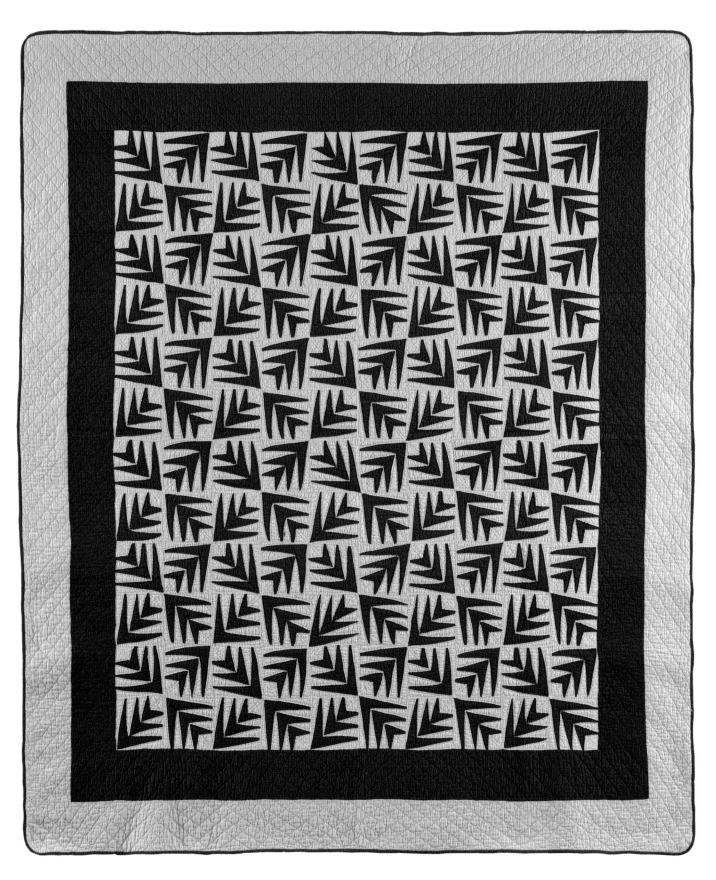

fig. 105
Palm Leaf Quilt with double
border, midwestern United
States, 82 x 72 inches.

PINE TREE (figs. 108–115)

Pine Tree patterns make good use of triangles to create a variety of elaborate designs. Rotating the blocks results in interesting secondary patterns.

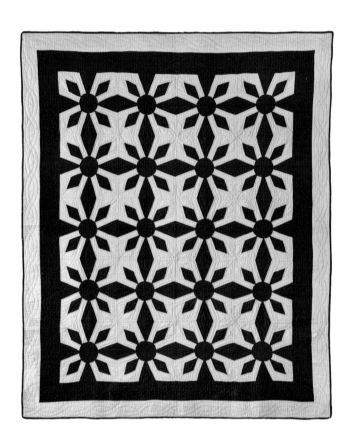

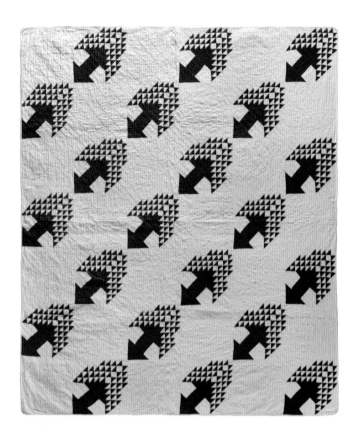

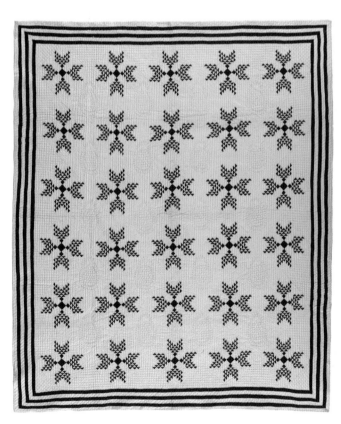

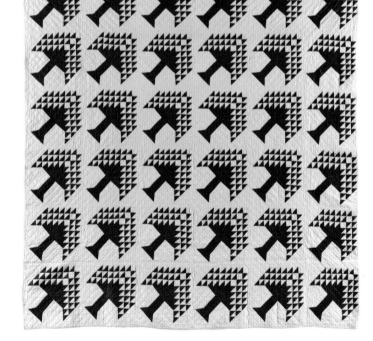

fig. 106
Unnamed Floral Pattern
Quilt with double border,
82½ x 70 inches.

fig. 107
Unnamed Floral Pattern
Quilt with bars border,
93 x 79 inches.

fig. 108
Tree of Paradise Quilt
with setting blocks,
85 x 71½ inches.

fig. 109
Tree of Paradise Quilt,
75 x 73½ inches.

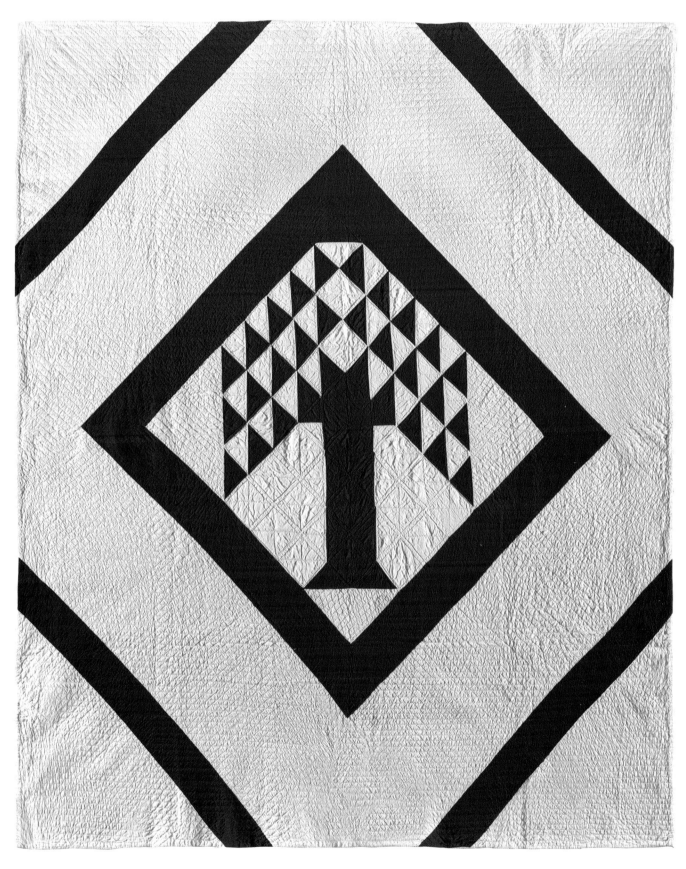

fig. 110
Pine Tree Medallion
Quilt with corner triangles,
82 x 68 inches.

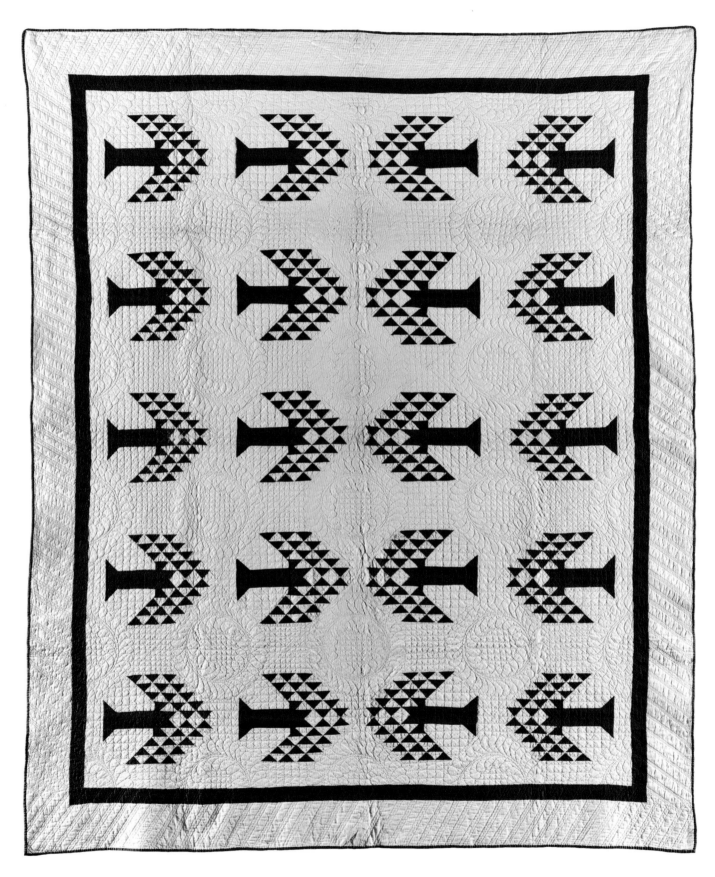

fig. 111
Tree of Paradise Quilt
with double border,
89 ½ x 79 inches.

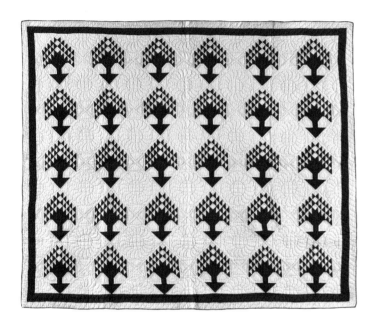

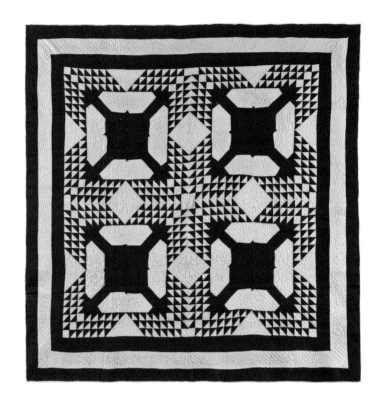

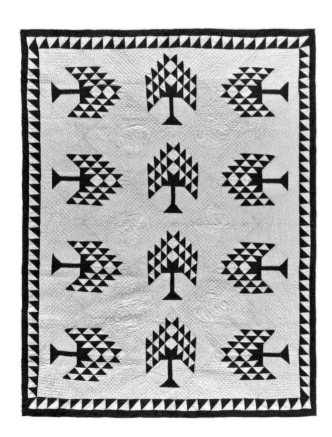

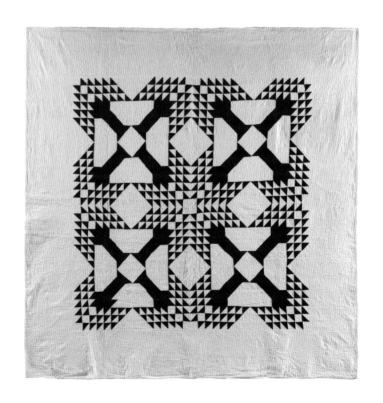

fig. 112
Tree of Paradise Quilt with
double border, c. 1930,
70 ½ x 84 inches.

fig. 113
Tree of Paradise Quilt with
sawtooth border, c. 1930,
88 x 68 inches.

fig. 114
Pine Tree Variation
Quilt with triple border,
72 ½ x 72 ½ inches.

fig. 115
Pine Tree Variation
Quilt with wide border,
83 x 82 inches.

BASKET (figs. 116–122)
Many Basket designs have applied handles and
can be set in different arrangements: base to base,
on point, in sashed rows, or facing each other.

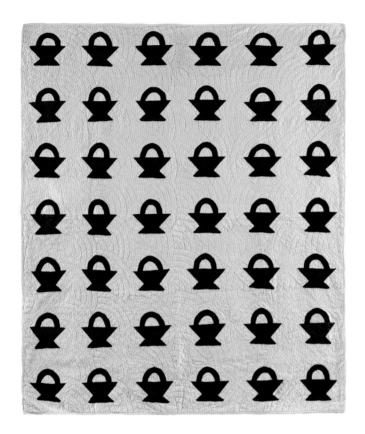

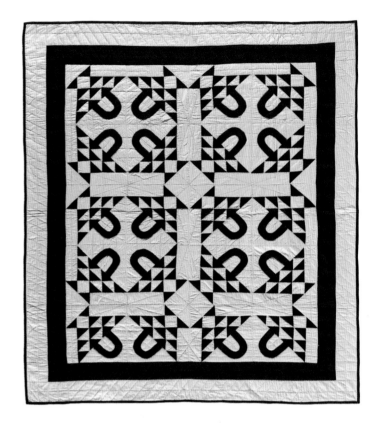

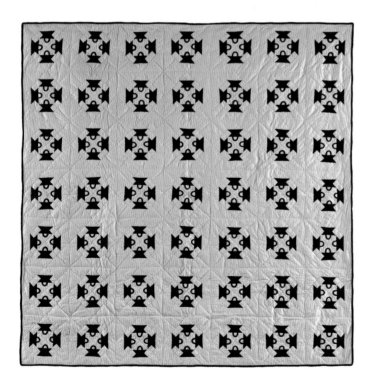

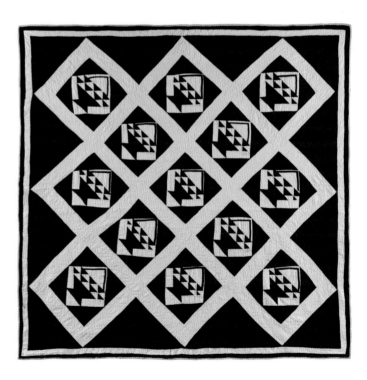

fig. 116
May Baskets Quilt,
69 ½ x 60 inches.

fig. 117
Basket Purses Quilt,
69 x 69 inches.

fig. 118
Corner Baskets Quilt
with double border,
76 x 65 ½ inches.

fig. 119
Sashed Baskets on Point
Quilt with double border,
76 ½ x 74 ½ inches.

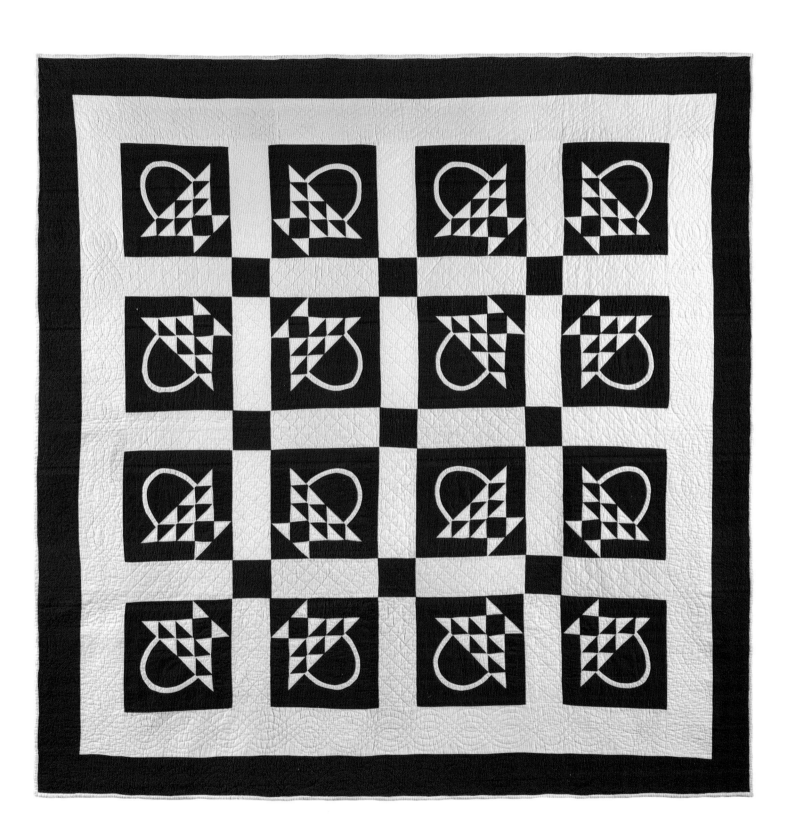

fig. 120
Sashed Baskets Quilt with
corner-block sashing and
double border, Pennsylvania,
74 x 74 ½ inches.

BASKET

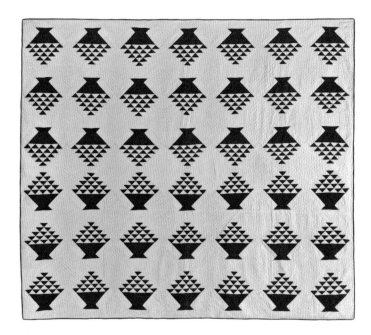

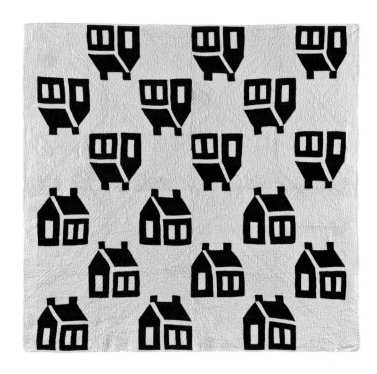

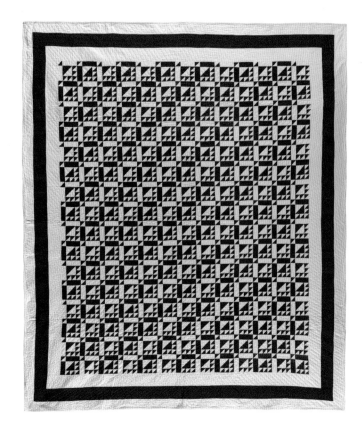

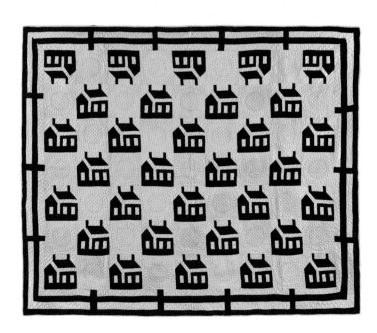

fig. 121
Basket of Chips Quilt,
84 x 73½ inches.

fig. 122
Alternating Baskets Quilt
with triple border, mid-
western United States,
89 x 79 inches.

fig. 123
Schoolhouses Quilt,
73 x 68½ inches.

fig. 124
Fenced Houses Quilt,
76 x 90 inches.

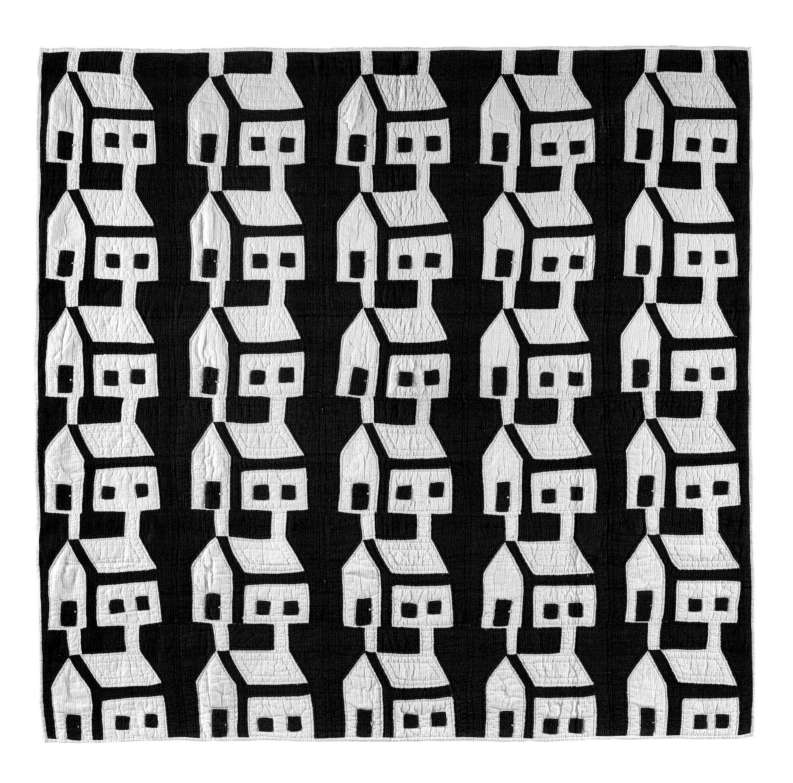

fig. 125
Stacked Houses Quilt,
53 ½ x 52 ½ inches.

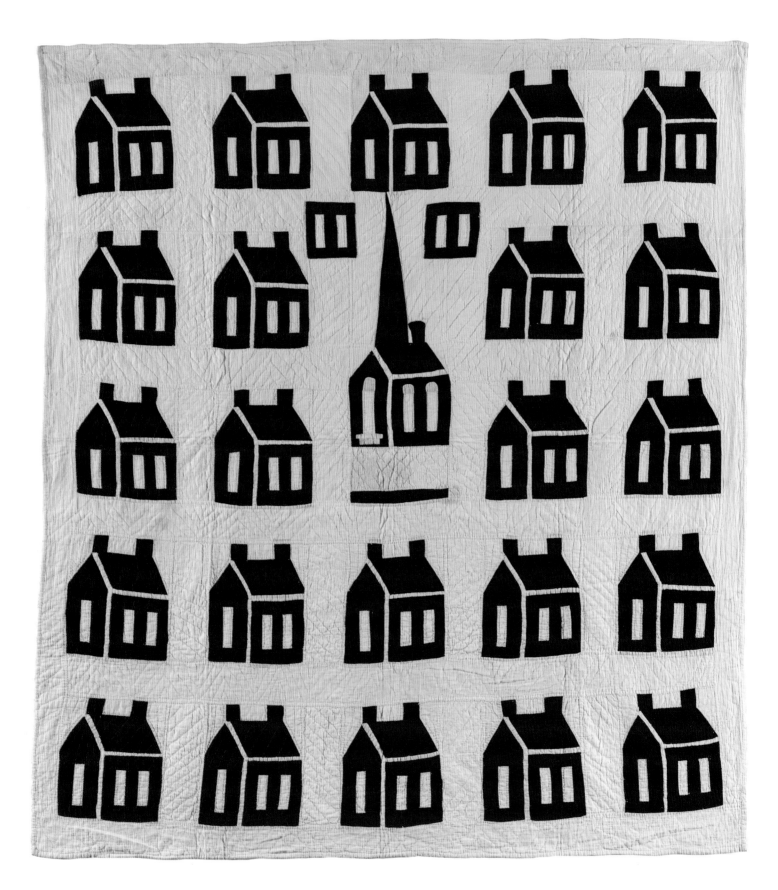

fig. 126
Houses and Church Quilt,
74 ¾ x 69 ¾ inches.

MISCELLANEOUS (figs. 127–130)
Pictorial patterns depict recognizable objects. The constraints of assembling patchwork mean images are generally stylized.

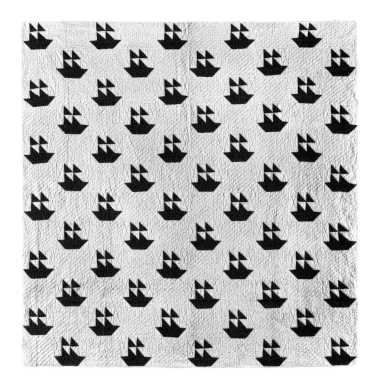

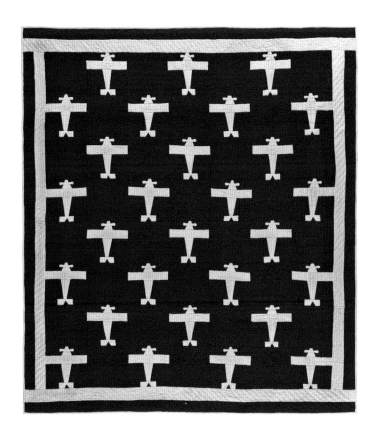

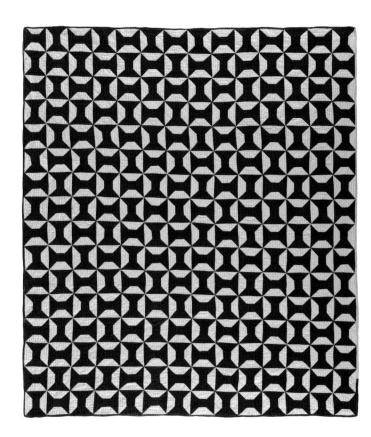

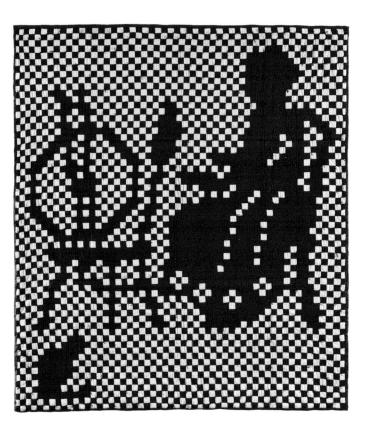

fig. 127
Sailboats Quilt, c. 1930, 77½ x 76½ inches.

fig. 128
Spools Quilt, Indiana, c. 1930, 74½ x 66 inches.

fig. 129
Airplanes Quilt with double border, labeled "J. Petuma," 94½ x 84 inches.

fig. 130
Lady at Her Spinning Wheel Quilt, 74½ x 67½ inches.

Word quilts are rare and usually unique. The two "couple" quilts made by Lavinia Rose were perhaps wedding gifts for two of her relatives.

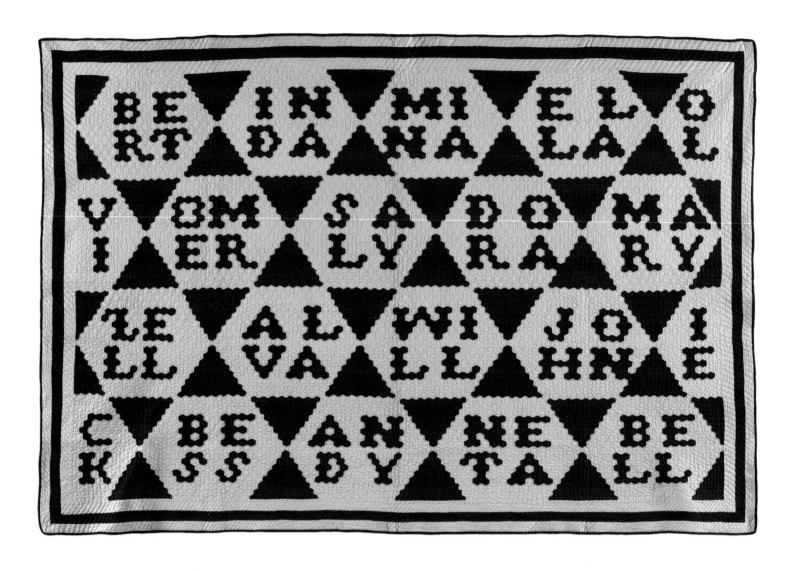

fig. 131
Mosaic Names Quilt
with triple border,
Amesbury, Massachusetts,
60 ½ x 90 inches.

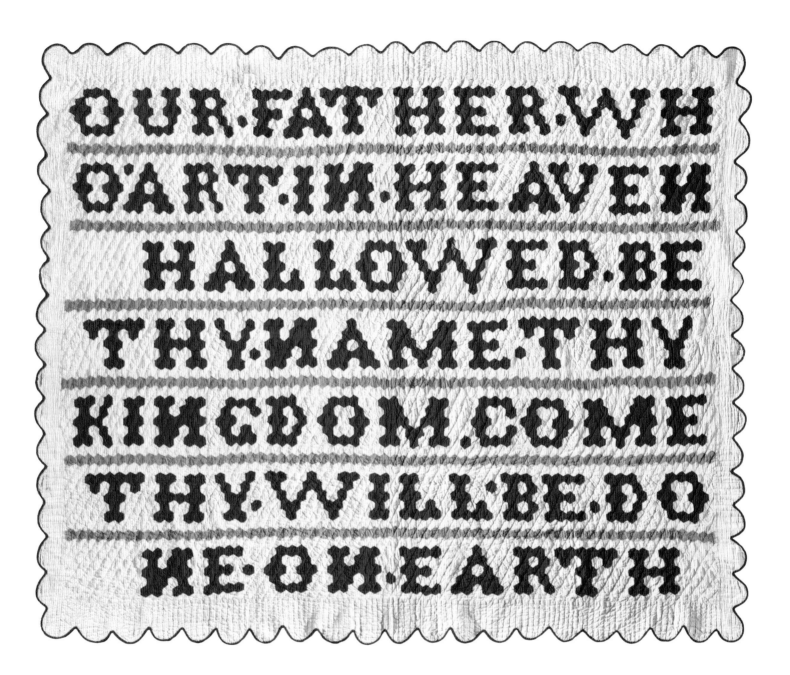

fig. 132
The Lord's Prayer Quilt
with scalloped edge,
65 x 81 inches.

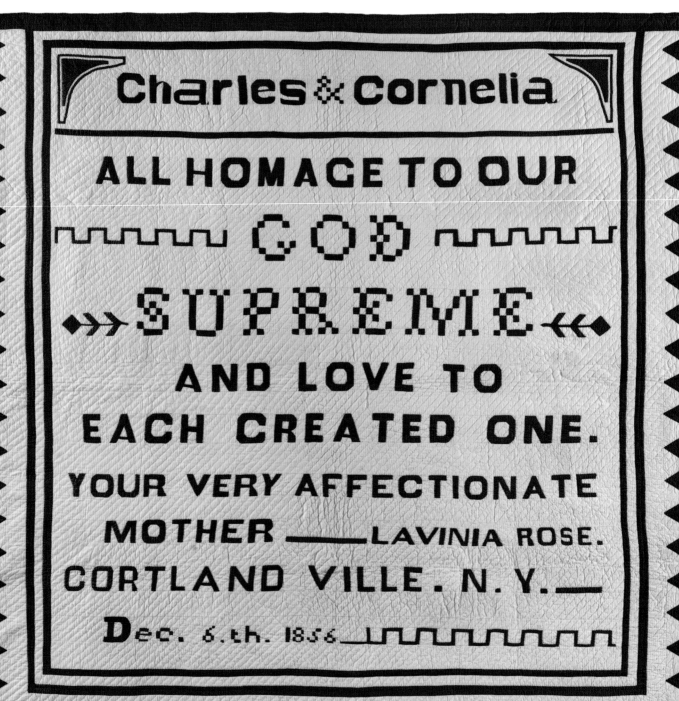

fig. 133
Charles & Cornelia Quilt with
sawtooth border, Lavinia Rose
(1787–1862), Cortlandville, New
York, 1856, 84 x 83½ inches.

fig. 134
Daniel & Amarilla Quilt with
pieced border, Lavinia Rose
(1787–1862), Cortlandville,
New York, 83½ x 80½ inches.

Traditional Patchwork Quilts: Strips, Squares & Rectangles

Traditional patchwork patterns vary depending on traditions and place of origin. Patchwork, or piecing, involves cutting fabric into shapes—usually geometric—and joining them to create new designs, both simple and complex. In the Victorian novel *The Mill on the Floss* (1860), George Eliot's tragic heroine Maggie Tulliver complains that she can't see any reason to cut up a perfectly good piece of cloth just to stitch it back together again. The reasons quilt-makers do this is because the process allows them to make glorious patterns using the concepts of art: shape, scale, or, most importantly, color and color value—the contrast in shading between light and dark. The contrast of red and white provides an intensity that is perhaps the brightest contrast possible.

Most patchwork quilts are made from many fabric blocks containing one or more carefully placed design pieces that have been sewn together. Then, when these blocks are sewn together, new or secondary designs emerge, oftentimes overpowering the individual building block pieces. Today's antique quilts were derived from styles brought to the New World by waves of settlers from Britain, France, Germany, and other European countries (the Low Countries and Scandinavia in particular). The foremothers of the United States so enthusiastically embraced the skills and creativity of quilting, enlarging the scope of design possibilities inherent in the blocks, that most of the world now thinks of the patchwork quilt as an American invention.

Many of the patchwork patterns are composed from combinations of strips, squares, and rectangles. The fabric edges for the shapes are relatively stable and easy to work with, as they are cut on the straight grain of the fabric and maintain their shape in the piecing process. Curved shapes — which have been cut on the fabric's bias (diagonally to the grain)—have more stretch and thus require additional attention in handling and piecing. Therefore, patterns based on strips, squares, and rectangles, such as the uniformly sized squares that make up a Checkerboard (figs. 135–140, pages 110–112) and the more intricate Irish Chain (figs. 178–203, pages 129–138), are made using a relatively straightforward process. But that does not confine their versatility: in Snail's Trail (figs. 226–229, page 147), strips of various sizes are joined to create a curling effect.

CHECKERBOARD (figs. 135–140)
When smaller units of alternating red and white
squares are used as part of a larger composition,
the results are intricate and can resemble lace.

fig. 135
Checkerboard Quilt with
wide border, 69 x 68 inches.

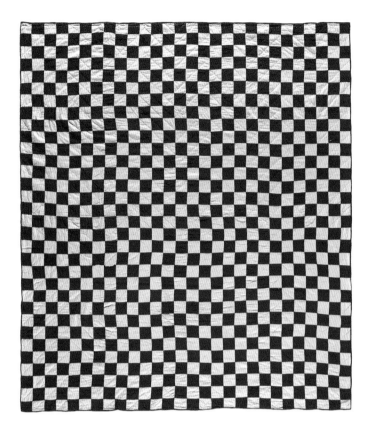

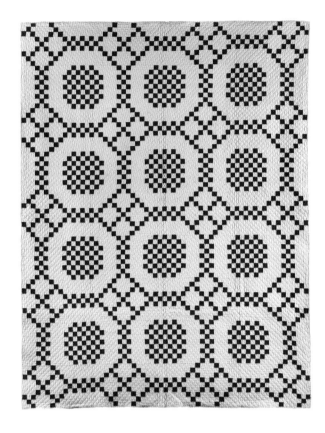

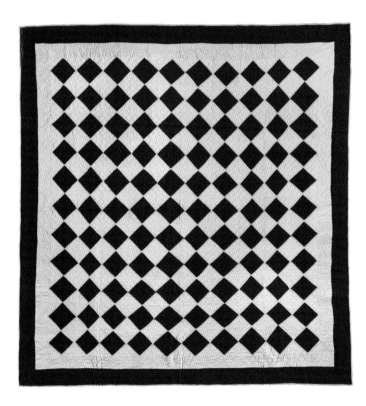

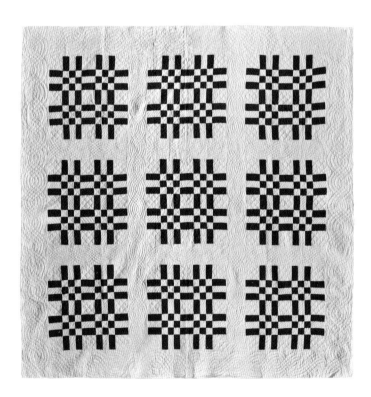

fig. 136
Checkerboard Quilt,
89 x 79 inches.

fig. 137
Checkerboard on Point
Quilt with double border,
74 x 71 inches.

fig. 138
Checkerboard Quilt
(Homestead Variation),
Detroit, Michigan,
85 x 66 ½ inches.

fig. 139
Checkerboard Quilt (Nine
Patch Variation) with single
border, 82 x 82 inches.

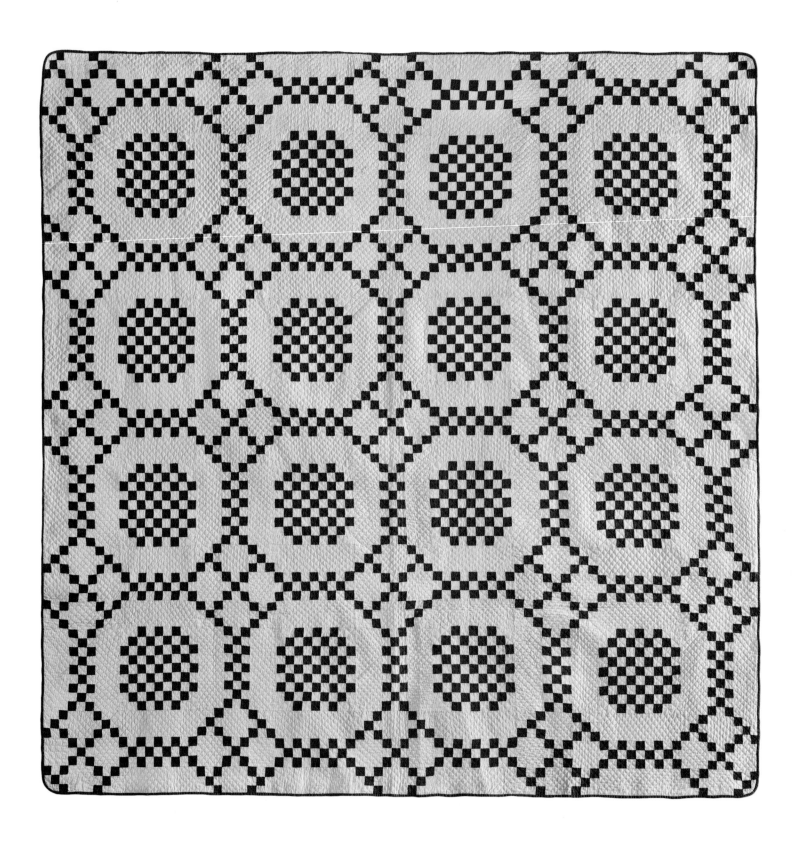

fig. 140
Checkerboard Variation
Quilt, New York State,
71 x 71 inches.

SUNSHINE & SHADOW (figs. 141–143)
Stepped rectangles arranged in concentric
rows create a pattern of lights and darks that
is sometimes called Trip Around the World.

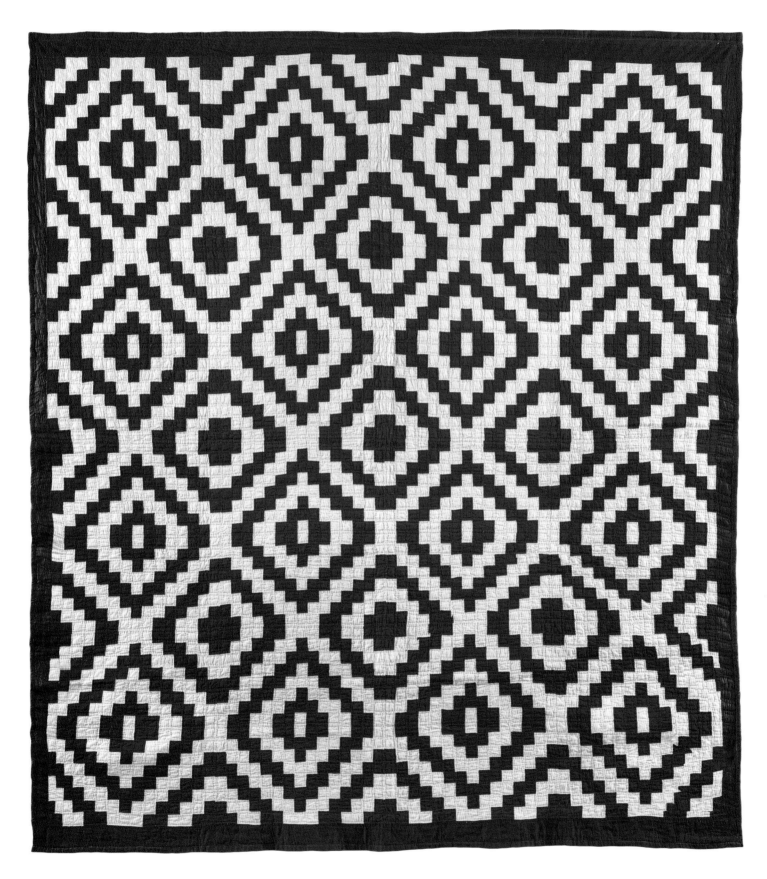

fig. 141
Sunshine and Shadow Quilt (Phil-
adelphia Pavement Variation)
with single border, midwestern
United States, 88 x 77½ inches.

SASHED SQUARES (figs. 144–150)
Squares bordered with sashing—simple or
elaborate—create dramatic overall patterns; var-
iations are limited only by the maker's imagination.

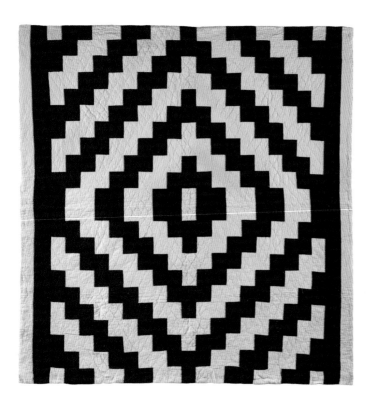

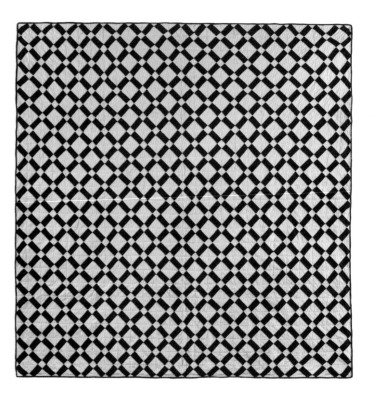

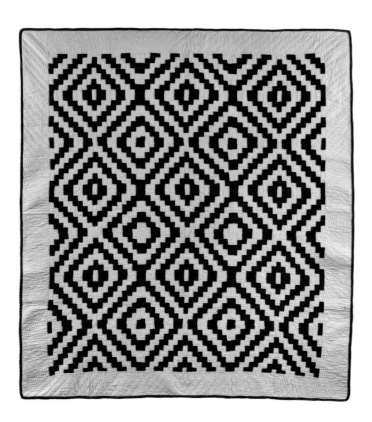

fig. 142
Sunshine and Shadow
Quilt with double side
borders, 79 x 77 inches.

fig. 143
Sunshine and Shadow
Variation Quilt with wide
border, 78 x 74 inches.

fig. 144
Sashed Squares on Point
Quilt, 80 x 78 inches.

fig. 145
Sashed Squares on Point
Quilt with triangle insets,
70 x 70 inches.

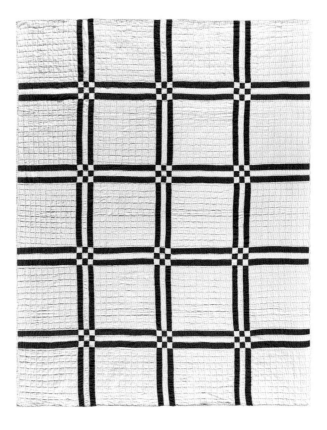

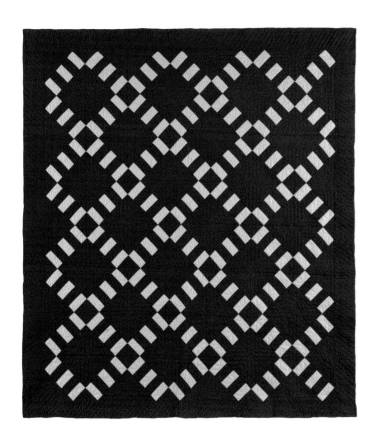

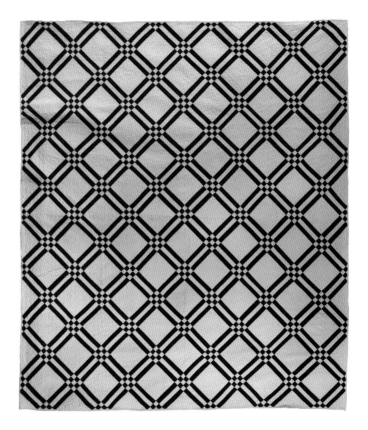

fig. 146
Sashed Squares on Point
Quilt with wide border,
83 ½ x 79 inches.

fig. 147
Squares Quilt (Tracks Varia-
tion) with striped sashing
and single border, Virginia,
80 x 69 inches.

fig. 148
Squares Quilt with triple
sashing and nine patch
corner blocks, Pennsylvania,
86 x 69 inches.

fig. 149
Squares on Point Quilt
with triple sashing and
nine patch corner blocks,
87 ½ x 77 inches.

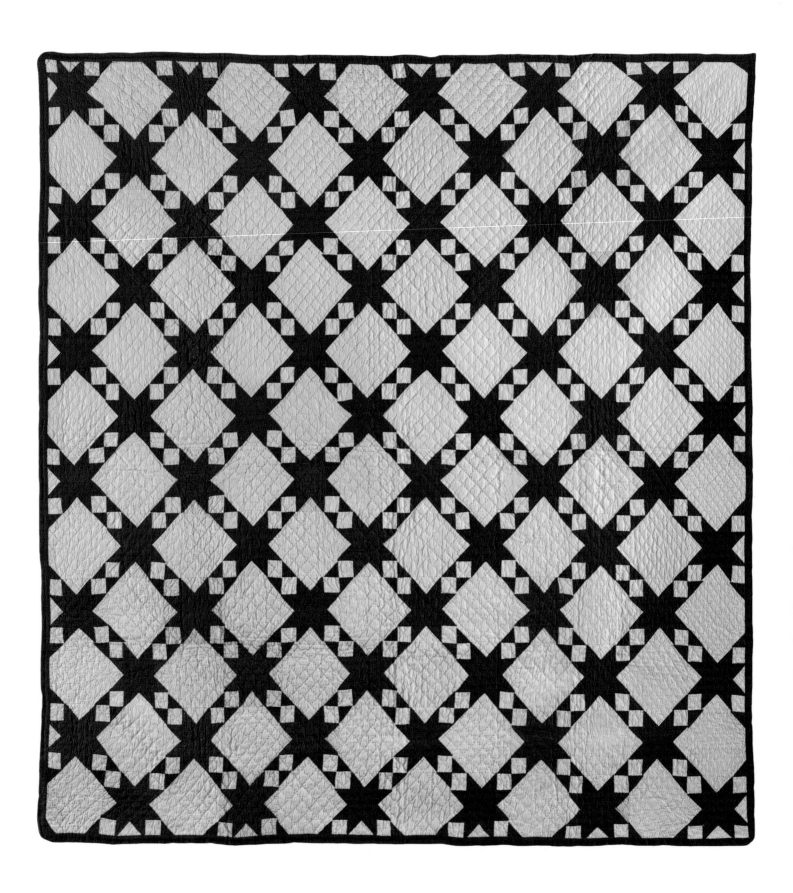

fig. 150
Sashed Squares on Point
with Eight-Point Star
Chain Quilt, Massachusetts,
73 x 69 inches.

Many traditional designs are based on squares
set diagonally inside larger squares. The variety
of patterns that result is astounding.

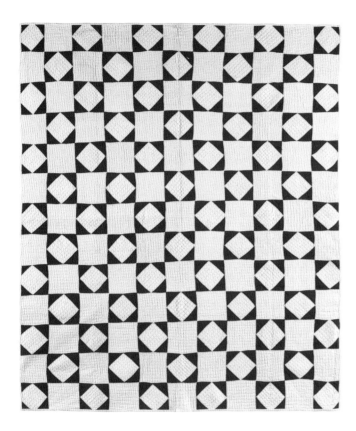

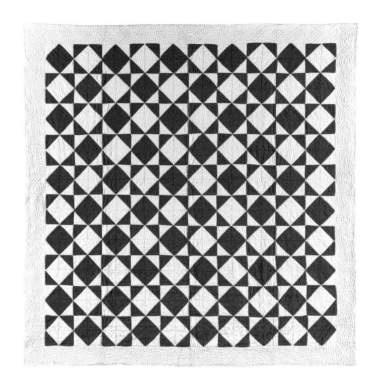

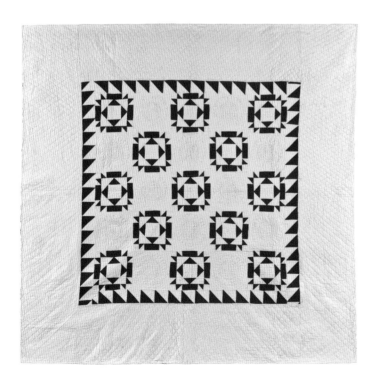

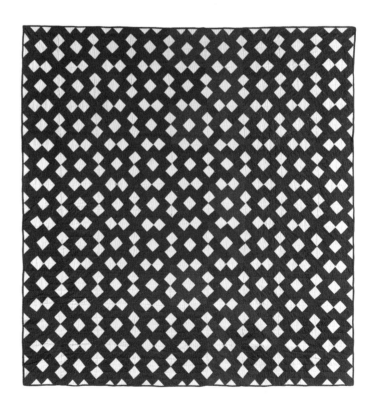

fig. 151
Square in a Square Variation
Quilt, 77 ½ x 66 inches.

fig. 152
Square in a Square Variation
Quilt with sawtooth inner
border, York County, Penn-
sylvania, 79 ½ x 79 inches.

fig. 153
Alternating Square in a
Square Quilt with single
border, 73 x 73 inches.

fig. 154
Lattice Square in a Square
Quilt, 76 ½ x 74 inches.

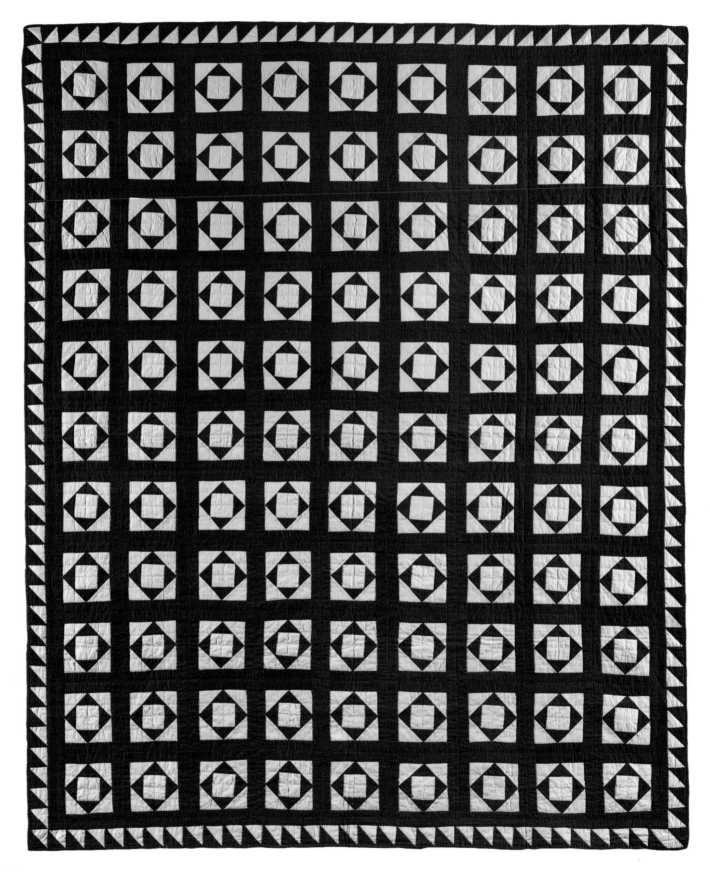

fig. 155
Economy Patch Quilt
with sawtooth border,
73 x 62 inches.

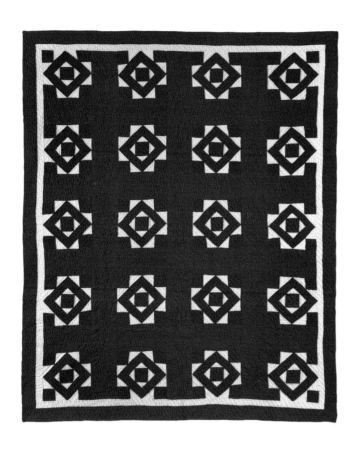

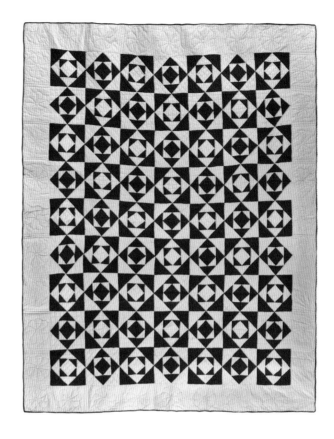

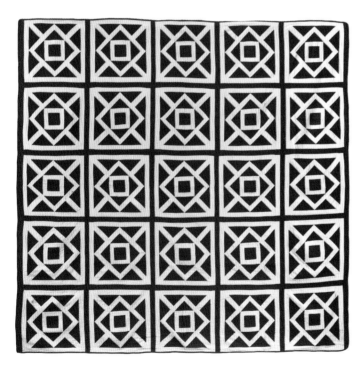

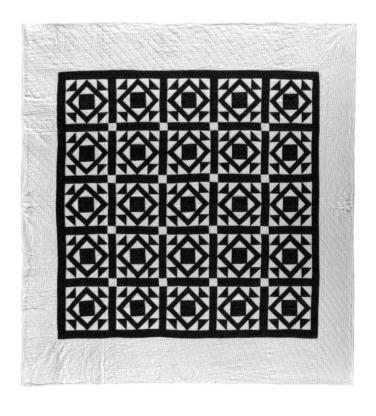

fig. 156
King's Crown Quilt (Diamond in a Square Variation), 84 x 69 ½ inches.

fig. 157
Square in a Square Variation Quilt with single side borders, 91 x 93 ¾ inches.

fig. 158
Economy Patch Quilt (Diamond in a Square Mosaic Variation) with single border, western Pennsylvania, 101 x 81 inches.

fig. 159
Jack in the Pulpit Quilt with corner-block sashing and wide border, 82 ½ x 78 inches.

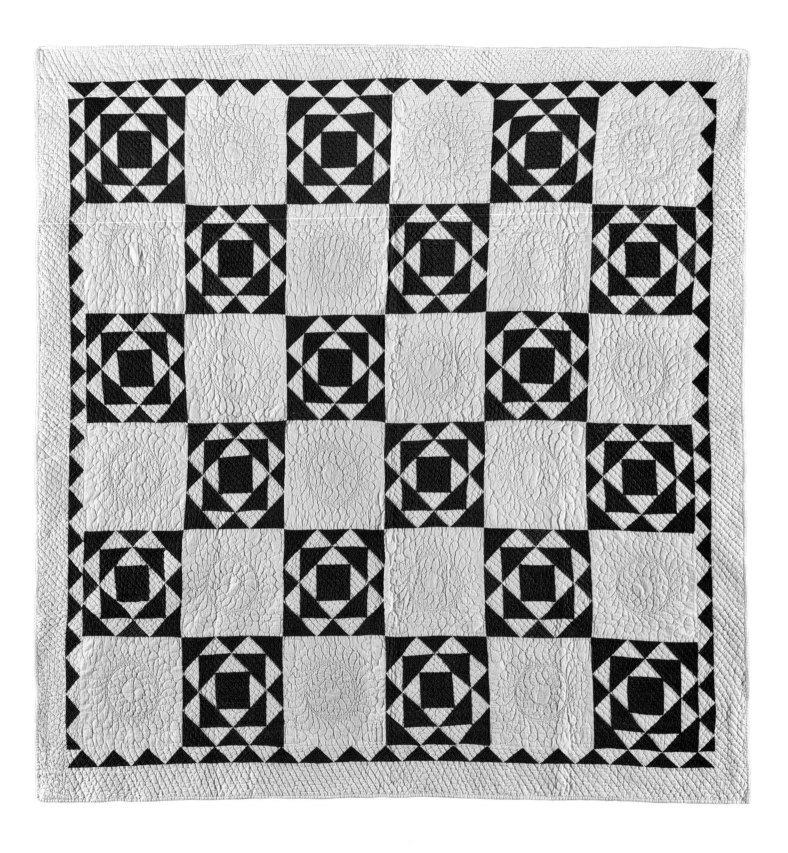

fig. 160
Gentleman's Fancy Quilt
with triangle border,
76 x 74 ½ inches.

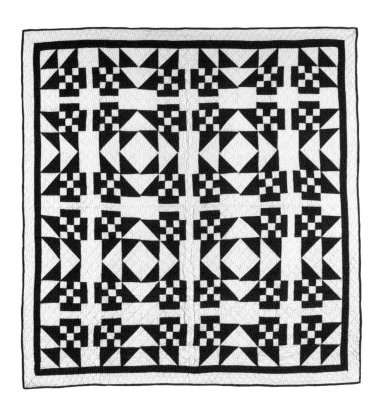

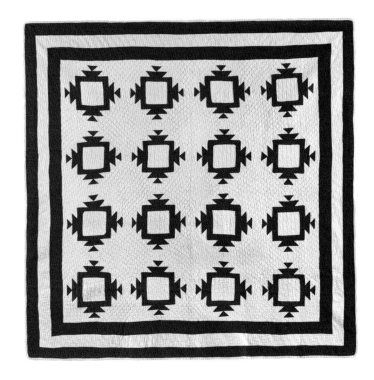

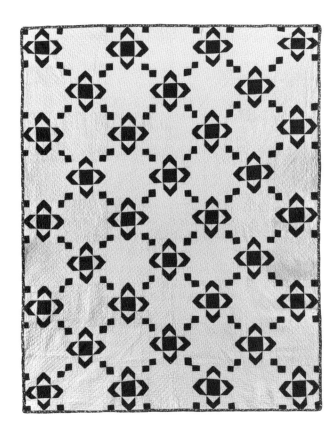

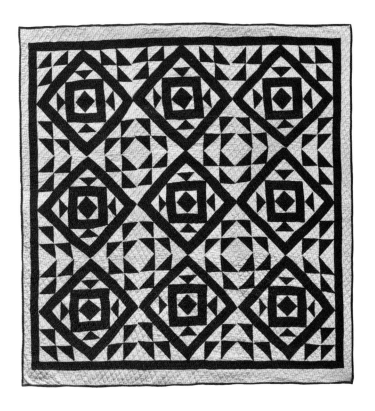

fig. 161
Square in a Square Variation
Quilt with double border,
73 x 71 inches.

fig. 162
Square in a Square Variation
Quilt, 87 x 70 inches.

fig. 163
Road to Paris Variation
Quilt with triple border,
69 x 68 inches.

fig. 164
Square in a Square Variation
Quilt with double border,
73 x 72 inches.

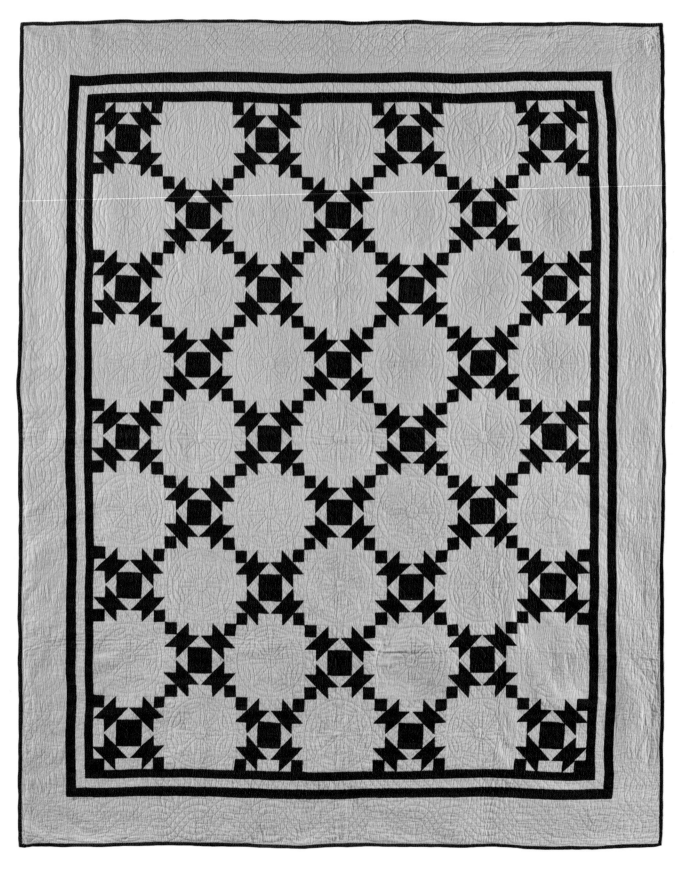

fig. 165
Mother's Favorite Variation
Quilt with quadruple border,
82 x 66 inches.

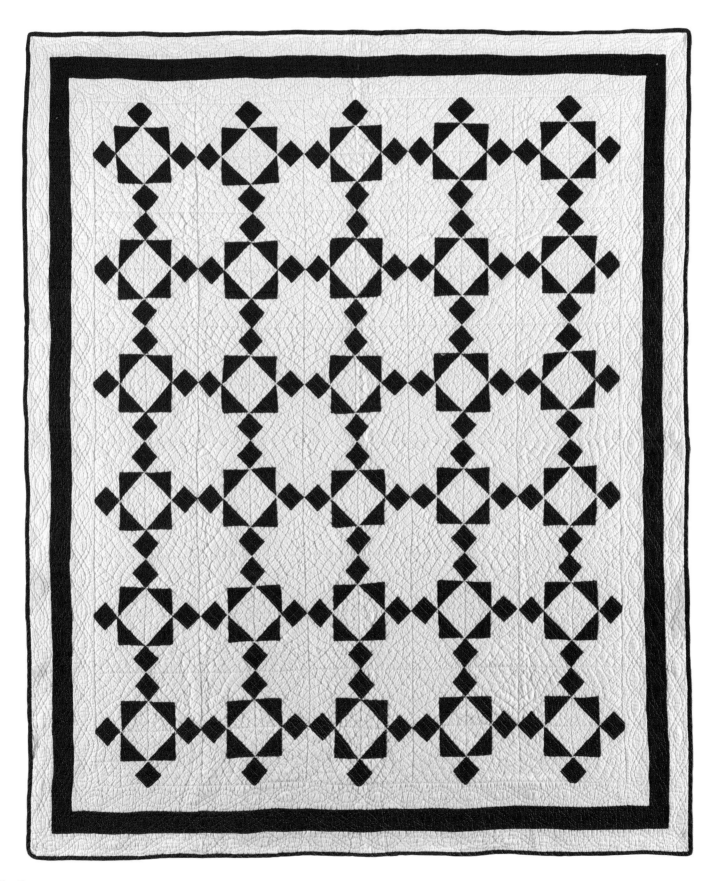

fig. 166
Grandmother's Favorite
Variation Quilt with triple
border, 82 x 67½ inches.

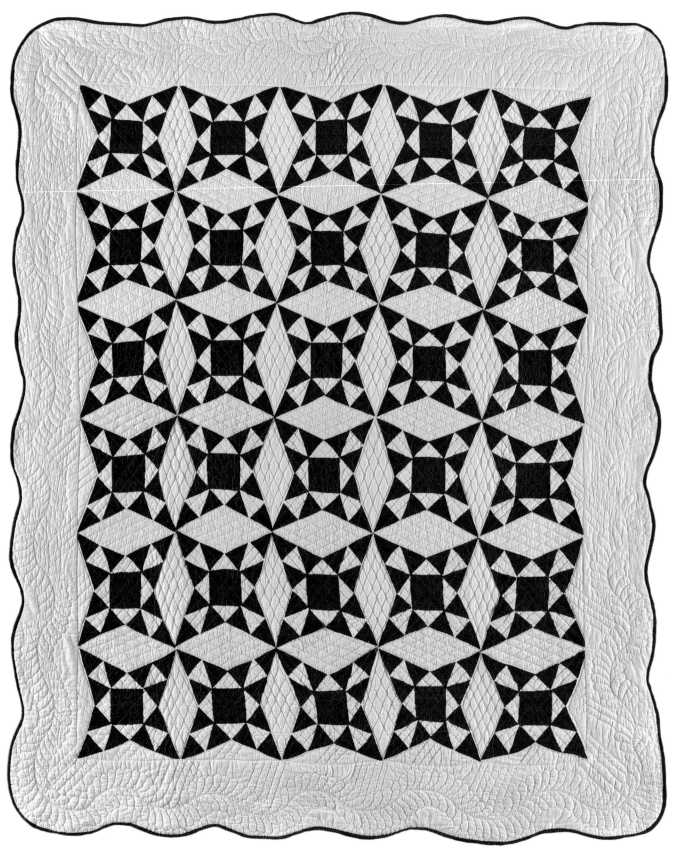

fig. 167
Square in a Square Variation
Quilt with scalloped edge,
c. 1930, 87 x 70 ½ inches.

CROSSES & GREEK CROSS (figs. 168–172)
Crosses are almost always based on squares or rectangles and are combined to create myriad patterns, named and unnamed.

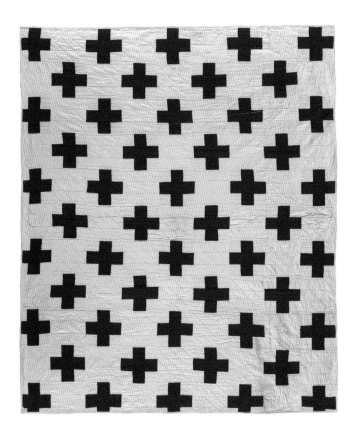

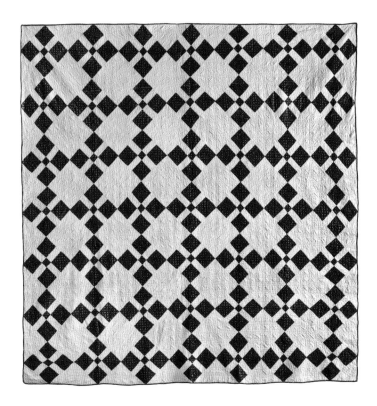

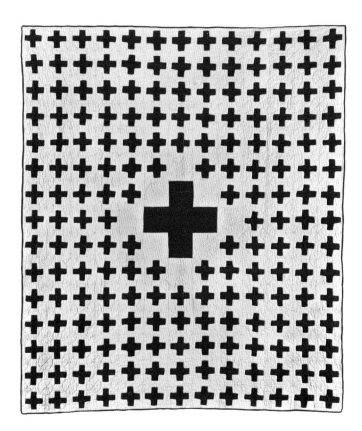

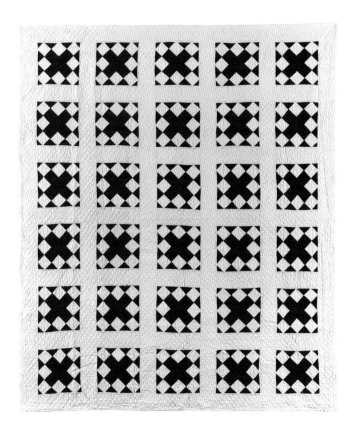

fig. 168
Red Cross Quilt,
78 ½ x 65 ½ inches.

fig. 169
Red Cross Center Medallion
Quilt, 79 x 68 inches.

fig. 170
Cross on Point Quilt,
87 x 85 ½ inches.

fig. 171
Sashed Cross and Blocks Quilt
with single border, signed
"Webber," midwestern United
States, 84 x 71 ½ inches.

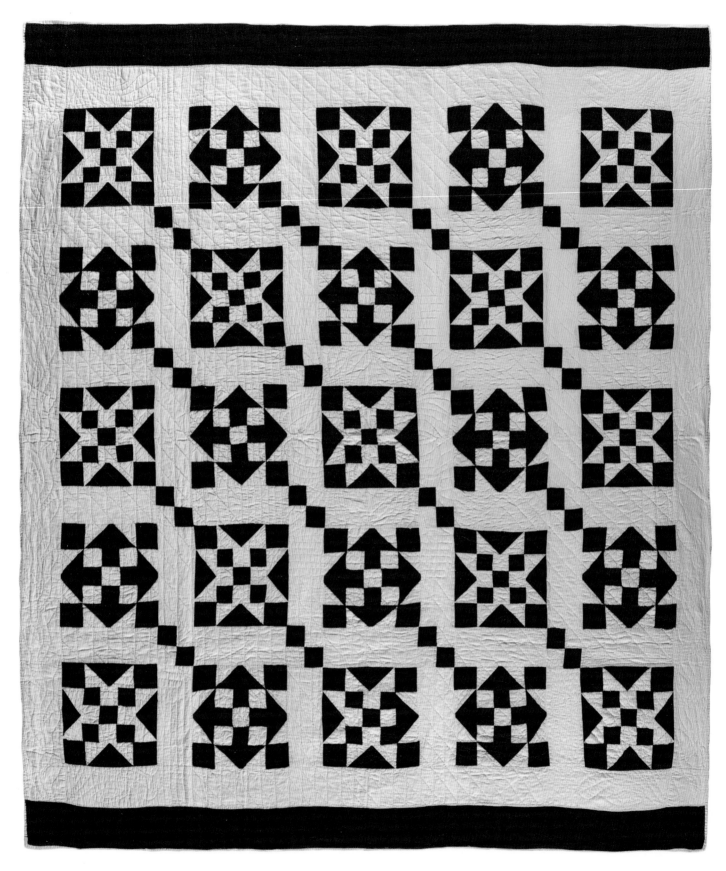

fig. 172
Farmer's Daughter and Greek
Crosses Quilt with single
top and bottom borders,
78 ½ x 67 ½ inches.

The Chimney Sweep block is also called Album block. Its central long strip made it a popular choice for signature or friendship quilts.

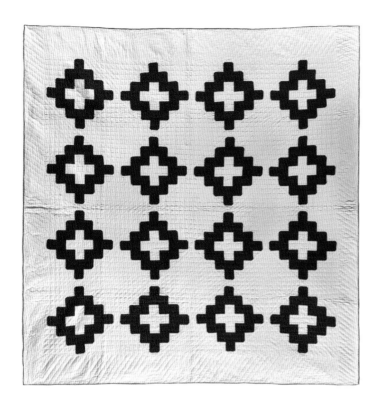

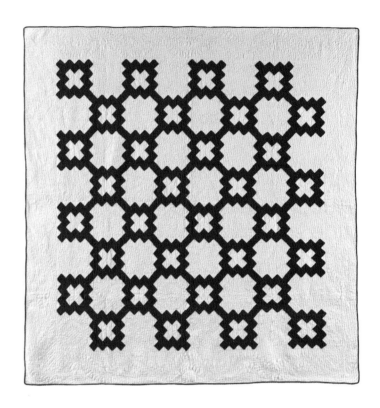

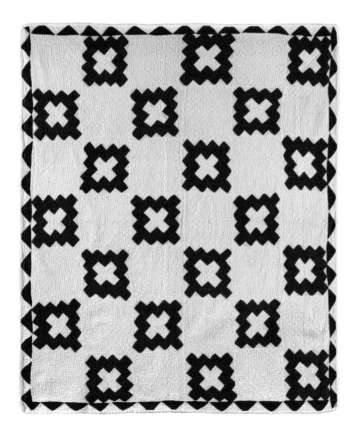

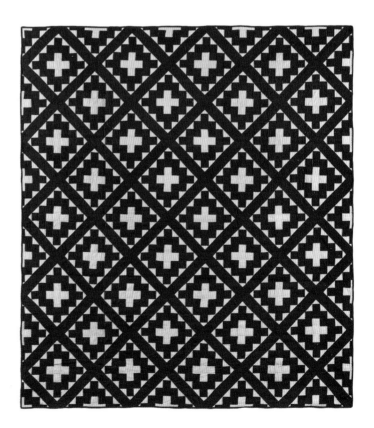

fig. 173
Chimney Sweep on
Point Quilt with setting
squares and wide border,
78 ½ x 76 ½ inches.

fig. 174
Chimney Sweep Quilt
with triangle border,
69 x 57 ½ inches.

fig. 175
Chimney Sweep Variation
Quilt with wide border,
75 ½ x 72 ½ inches.

fig. 176
Chimney Sweep on
Point Quilt with sashing,
88 x 80 inches.

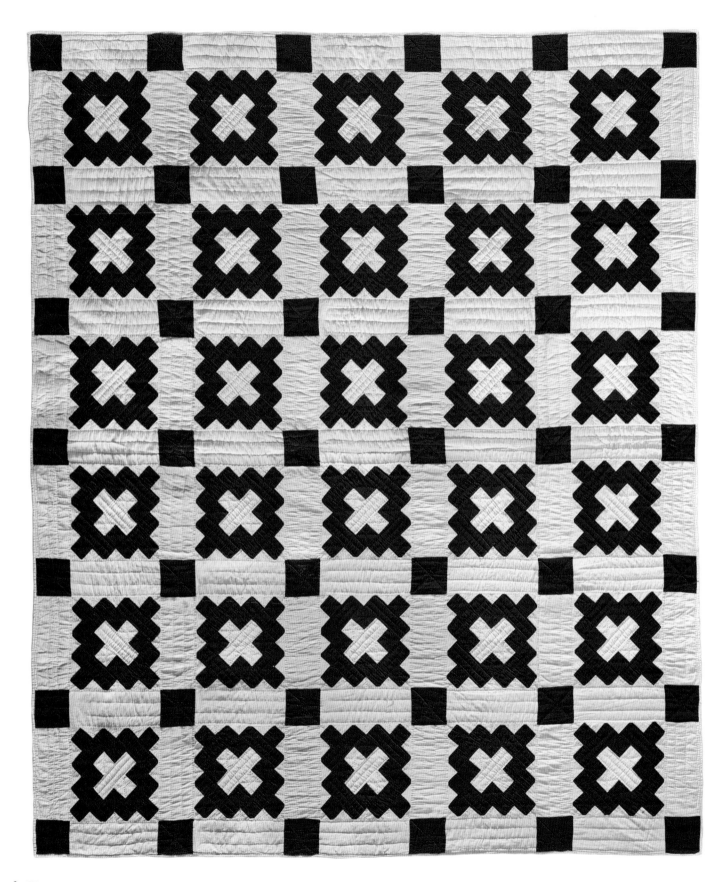

fig. 177
Chimney Sweep Quilt
with corner-block
sashing, Massachusetts,
83 x 69 ½ inches.

Blocks joined by chains are perennially popular, especially those known as Irish Chain, which uses units of different dimensions.

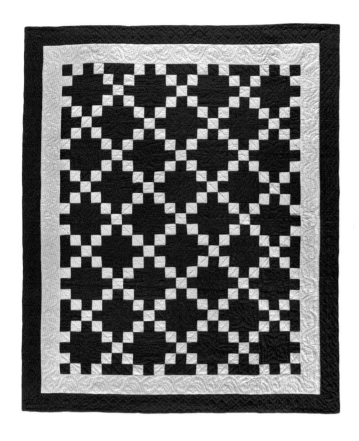

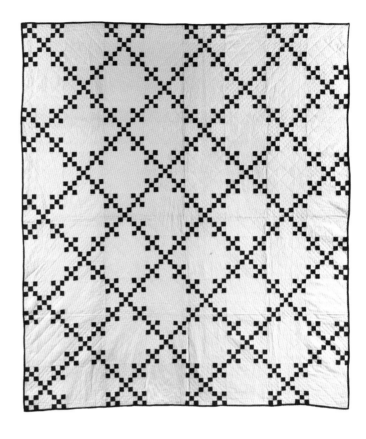

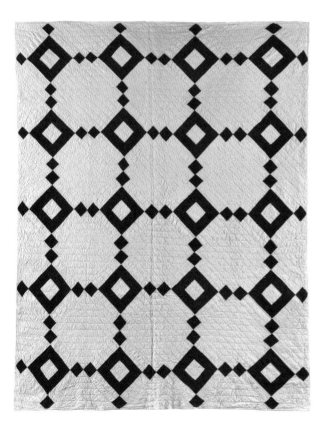

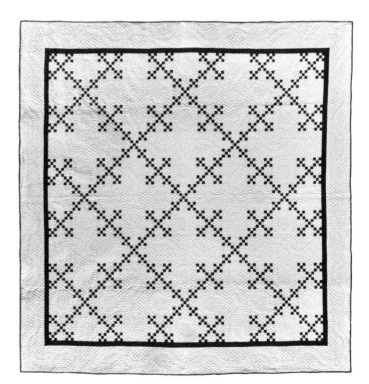

fig. 178
Single Irish Chain Quilt with double border, western Pennsylvania, 96 ½ x 81 inches.

fig. 179
Single Irish Chain on Point Quilt (Coxey's Camp/Diamond Mosaic Variations),

Cazenovia, New York, 86 x 64 ¼ inches.

fig. 180
Single Irish Chain Quilt, 92 ½ x 79 inches.

fig. 181
Single Irish Chain Quilt with double border, 84 x 81 inches.

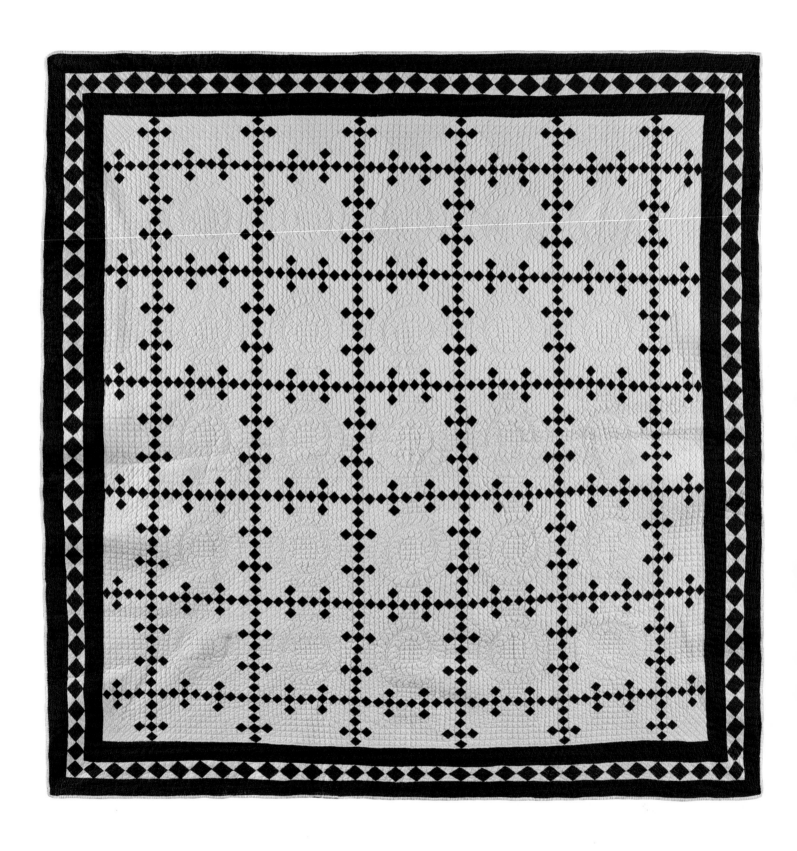

fig. 182
Single Irish Chain Quilt with
triple border with diamonds,
74 x 72 inches.

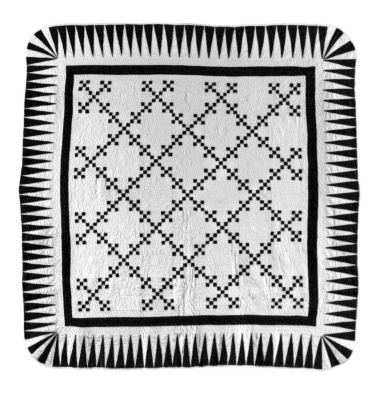

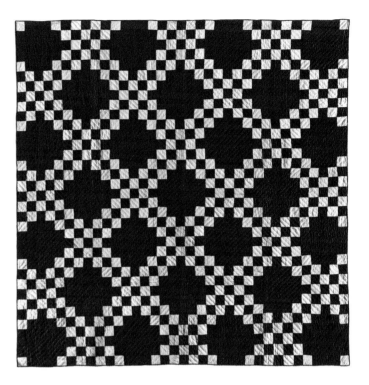

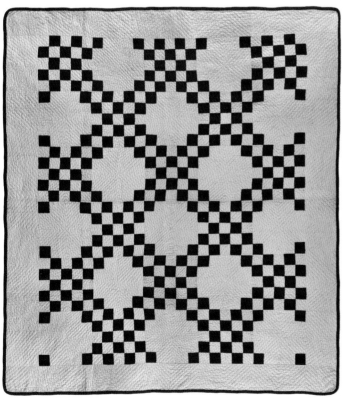

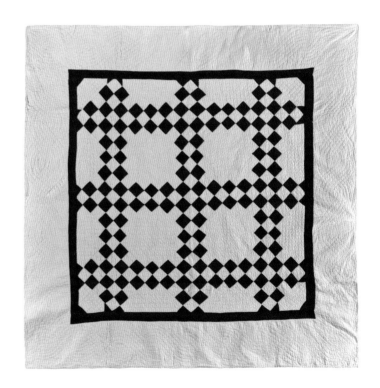

fig. 183
Single Irish Chain Quilt
(Double Nine Patch Variation)
with wide triangle border,
75 x 74 inches.

fig. 184
Double Irish Chain
Quilt with wide border,
84 x 75 inches.

fig. 185
Double Irish Chain Quilt,
88 x 86 inches.

fig. 186
Double Irish Chain
Quilt (Checkerboard Chain
Variation) with wide

border, Northampton
County, Pennsylvania,
77 x 79 inches.

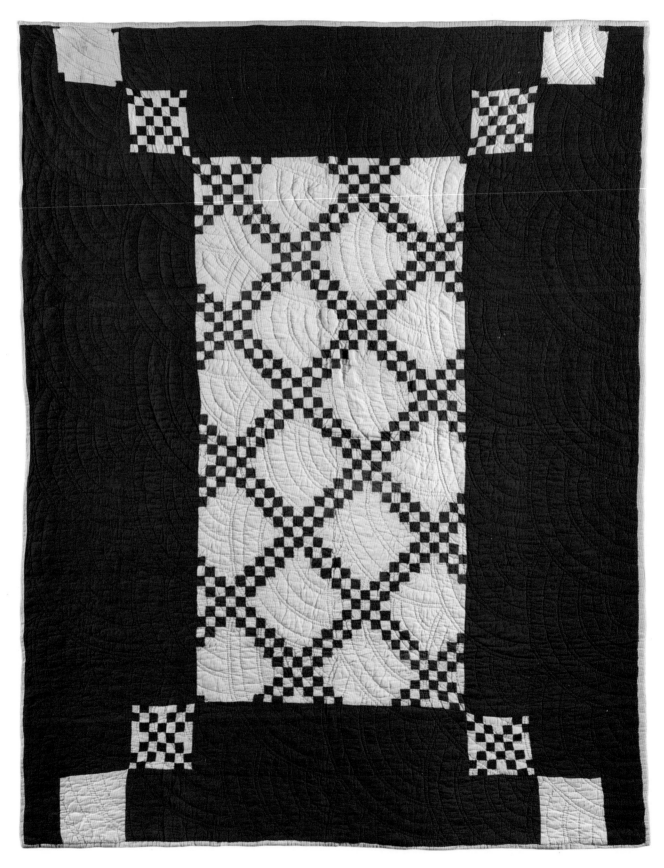

fig. 187
Double Irish Chain Quilt
with wide border and corner
squares, 81 x 62 inches.

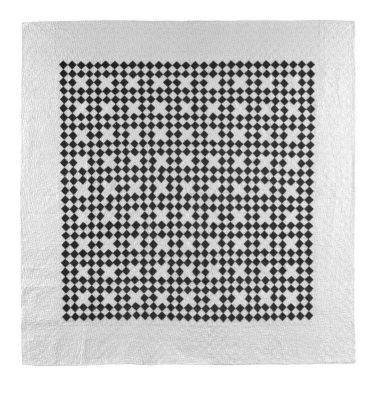

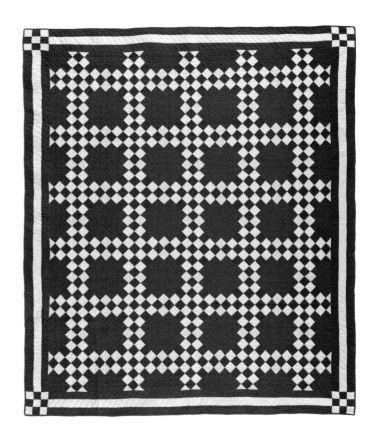

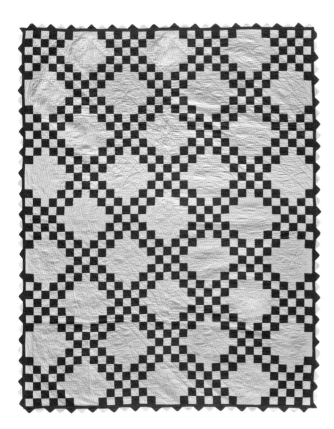

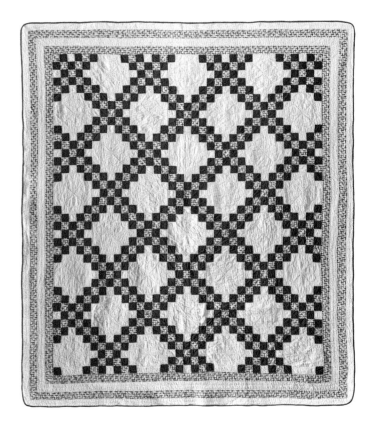

fig. 188
Double Irish Chain Quilt
(Chimney Sweep Mosaic
Variation) with wide
border, Lancaster County,
Pennsylvania, c. 1890,
77 x 76 inches.

fig. 189
Double Irish Chain Quilt
with prairie point binding,
midwestern United States,
c. 1930, 84 ½ x 68 ½ inches.

fig. 190
Double Irish Chain Quilt
with triple border and
nine patch corner squares,
83 x 73 inches.

fig. 191
Double Irish Chain Quilt
with quadruple border,
84 x 76 inches.

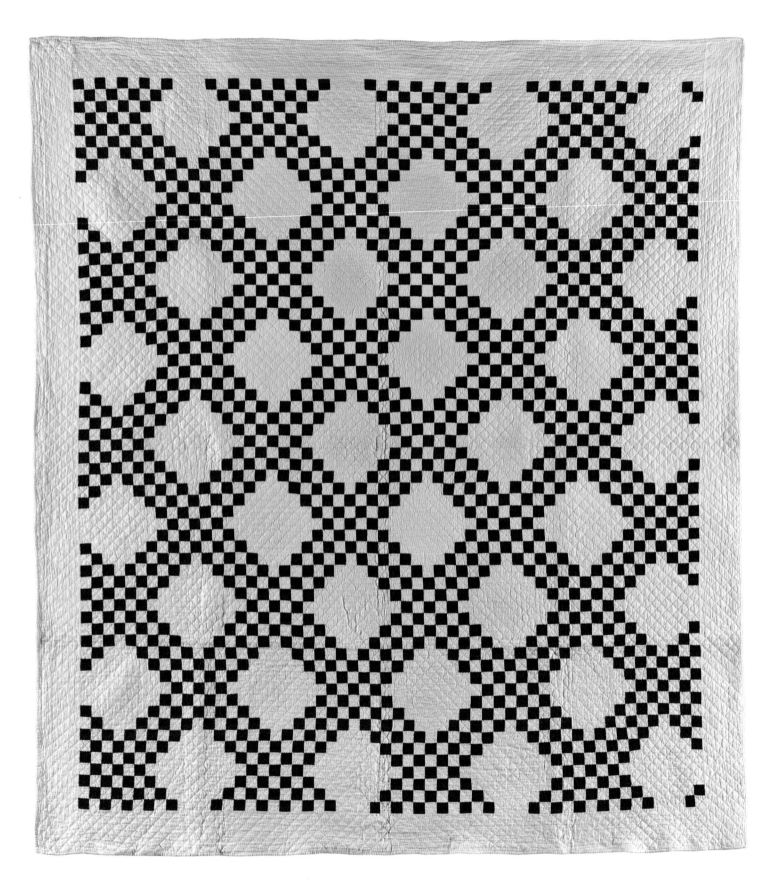

fig. 192
Triple Irish Chain
Quilt with single border,
74 x 65½ inches.

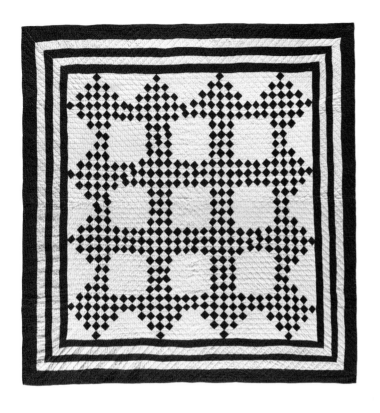

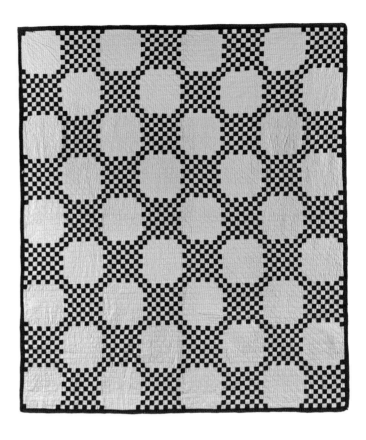

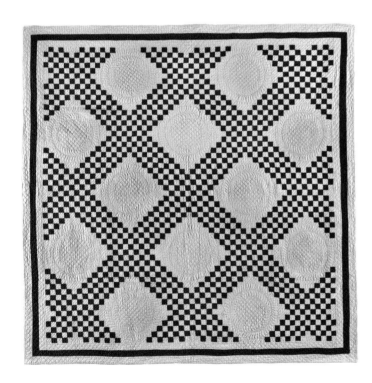

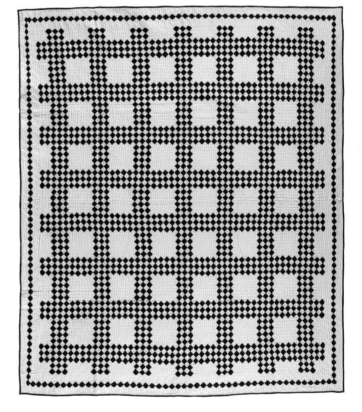

fig. 193
Triple Irish Chain Quilt
with quintuple border,
82 ¾ x 80 inches.

fig. 194
Quadruple Irish Chain
Quilt with triple border,
80 ½ x 79 inches.

fig. 195
Double Irish Chain Quilt
with triple Nine Patch blocks,
embroidered "GMC" in
center, 83 ½ x 73 ½ inches.

fig. 196
Triple Irish Chain Quilt
with diamond border,
76 ½ x 66 ½ inches.

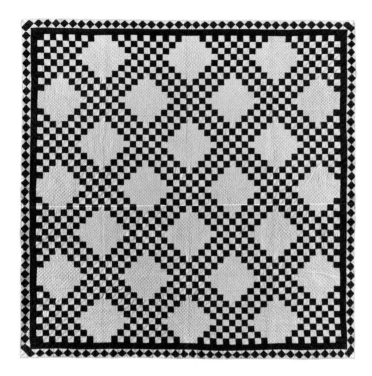

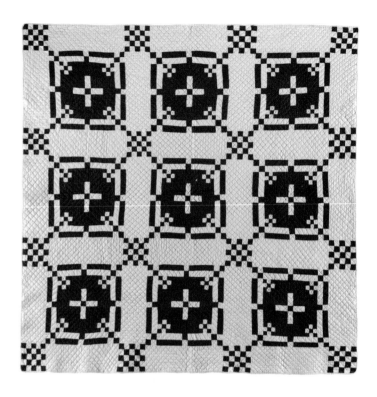

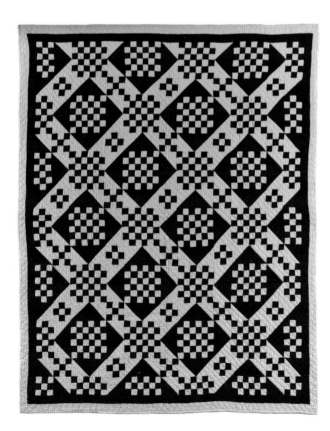

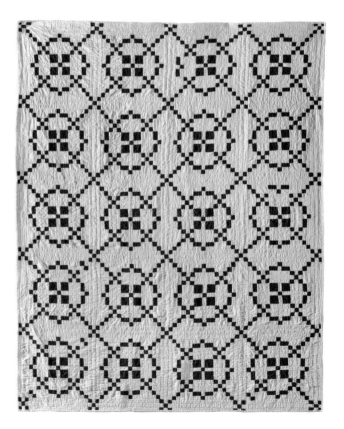

fig. 197
Triple Irish Chain Quilt with
double border with diamonds,
Berks County, Pennsylvania,
86 x 87 inches.

fig. 198
Irish Chain Variation
Quilt with double border,
84 ½ x 66 ½ inches.

fig. 199
Irish Chain Variation Quilt
with crosses, 82 x 80 inches.

fig. 200
Single Irish Chain Quilt
(Burgoyne Surrounded
Variation), c. 1930,
84 x 67 ½ inches.

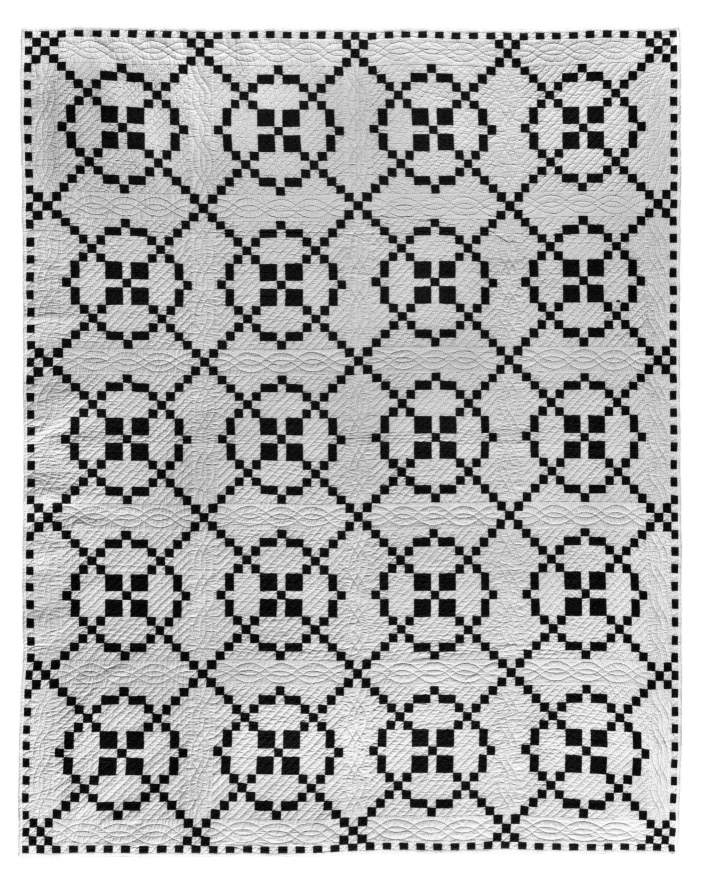

fig. 201
Single Irish Chain Quilt
(Burgoyne Surrounded Var-
iation) with single squares
border, 94 x 77 inches.

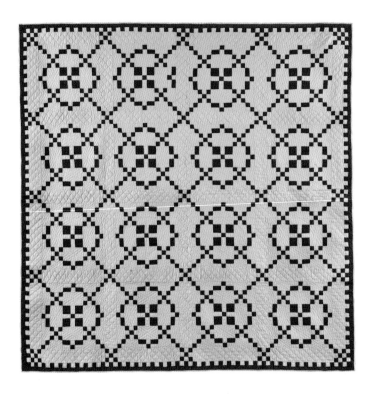

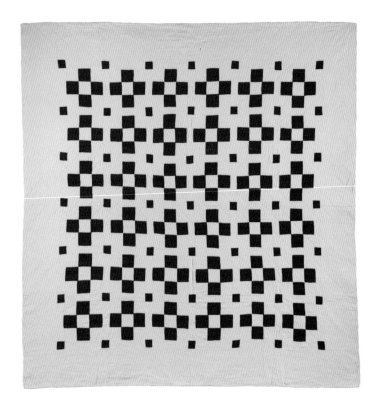

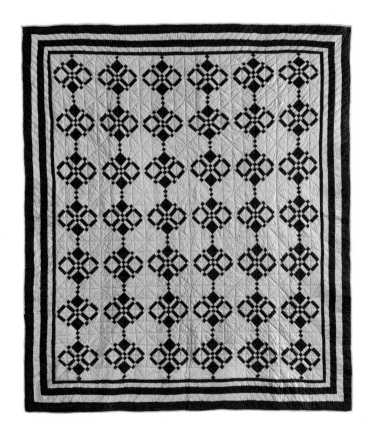

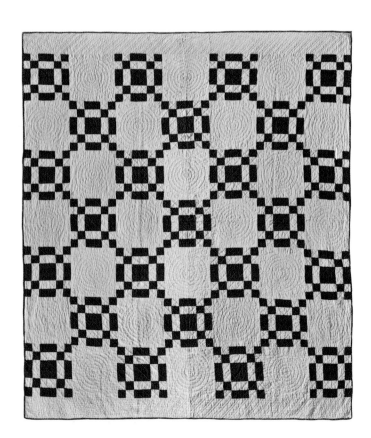

fig. 202
Single Irish Chain Quilt
(Burgoyne Surrounded
Variation) with pieced
border, Zullinger, Franklin
County, Pennsylvania,
85 x 85 inches.

fig. 203
Unnamed Pattern Quilt
with vertical chains
and quintuple border,
82½ x 72 inches.

fig. 204
Sashed Nine Patch Quilt
with wide border, Hamburg,
Berks County, Pennsylvania,
71 x 71 inches.

fig. 205
Building Blocks Quilt
with single top and bottom
borders, 80 x 70 inches.

RAILROAD & CROSSROADS (figs. 208–225)
"Road" patterns can run in any direction or more
than one way at a time. Railroad goes one way,
like tracks; Crossroads goes two ways.

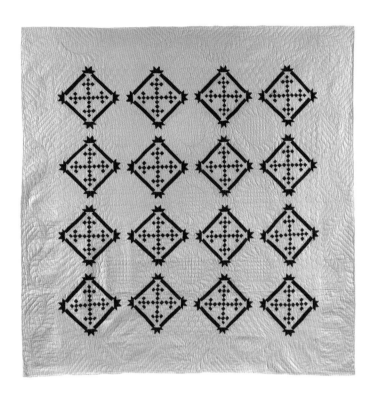

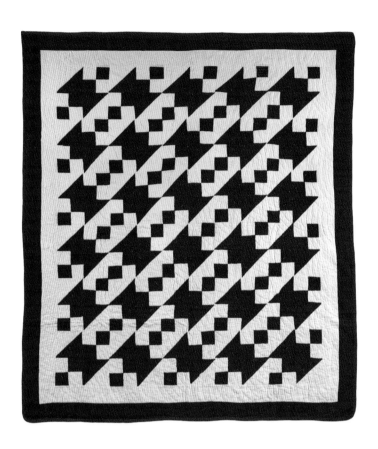

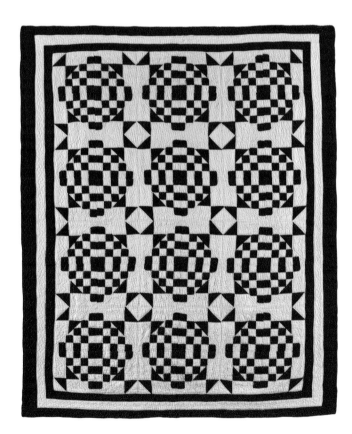

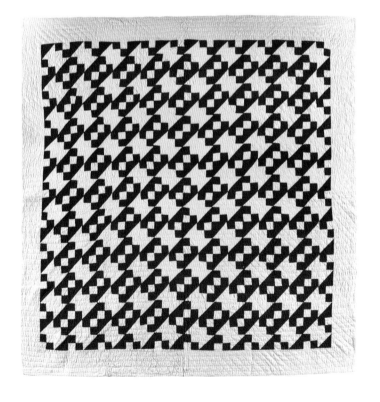

fig. 206
Double Nine Patch
Variation on Point Quilt
with setting squares
and wide border, New
Oxford, Pennsylvania,
82 x 81½ inches.

fig. 207
Unnamed Pattern
Quilt with triple border,
79½ x 65¼ inches.

fig. 208
Railroad Quilt with double
border, 84 x 74½ inches.

fig. 209
Railroad Quilt with single
border, 81 x 76½ inches.

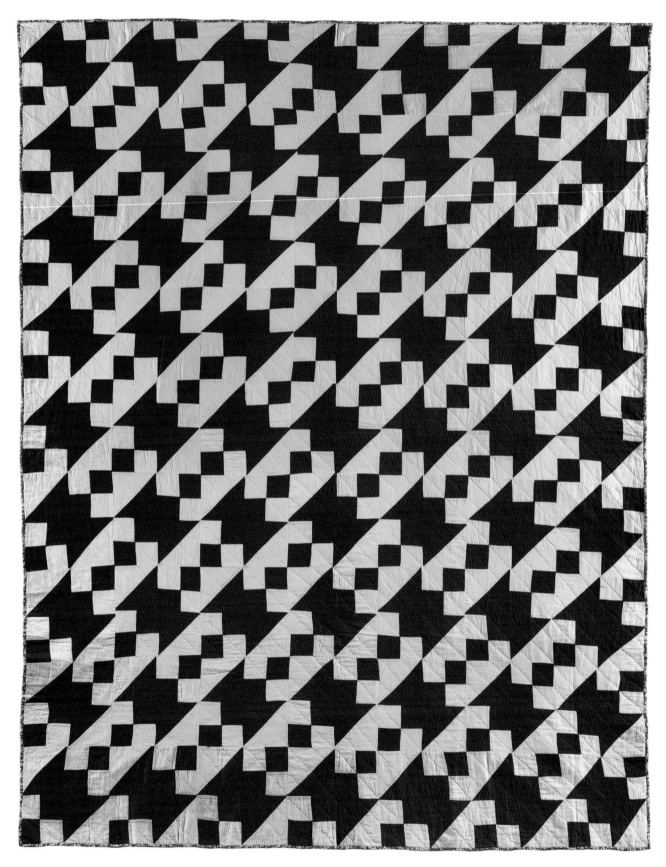

fig. 210
Railroad Quilt,
84 ½ x 66 inches.

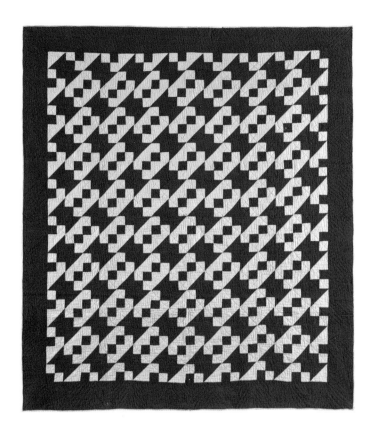

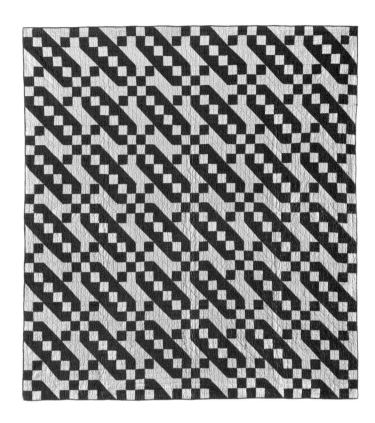

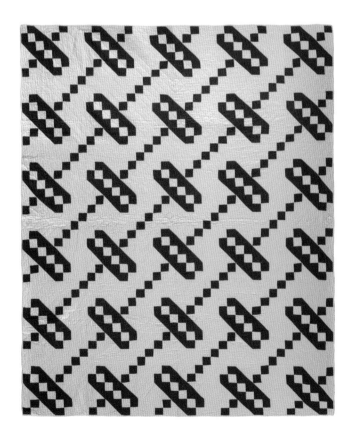

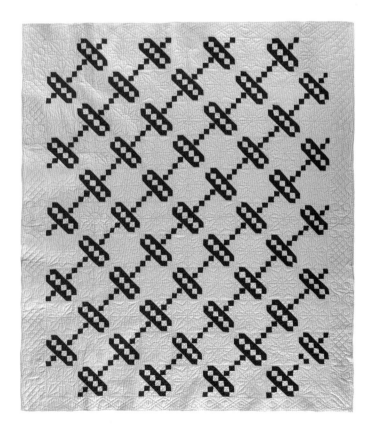

fig. 211
Railroad Quilt with single border, 74 ½ x 69 inches.

fig. 212
Railroad Quilt (Jacob's Ladder/Road to California Variations), Bethel, Maine, 82 ½ x 69 inches.

fig. 213
Railroad Quilt (Jacob's Ladder Variation), 78 x 74 inches.

fig. 214
Railroad Quilt (Road to California Variation) with single border, Lancaster County, Pennsylvania, 85 x 74 ½ inches.

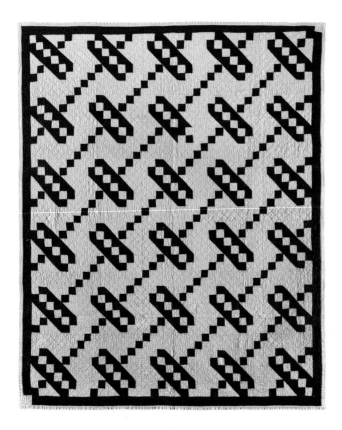

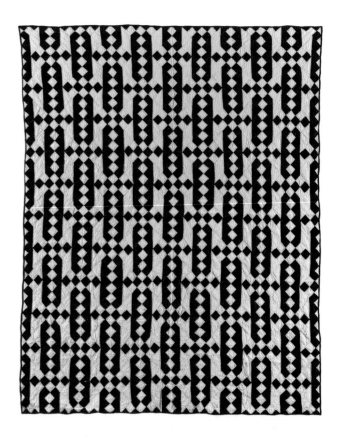

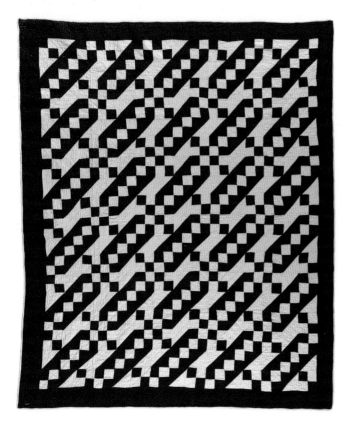

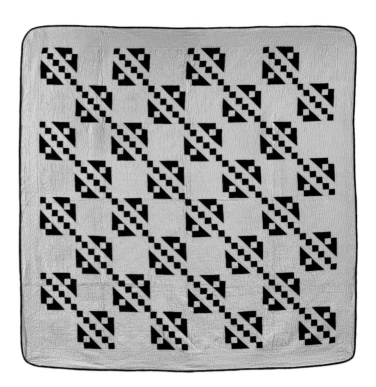

fig. 215
Railroad Quilt (Road
to California Variation)
with double border,
85 x 69½ inches.

fig. 216
Railroad Quilt with single
border, 77½ x 67½ inches.

fig. 217
Vertical Railroad Quilt
(Vertical Jacob's Ladder
Variation), Texas, c. 1930,
89 x 68 inches.

fig. 218
Jacob's Ladder Quilt
with single border,
78¼ x 78¾ inches.

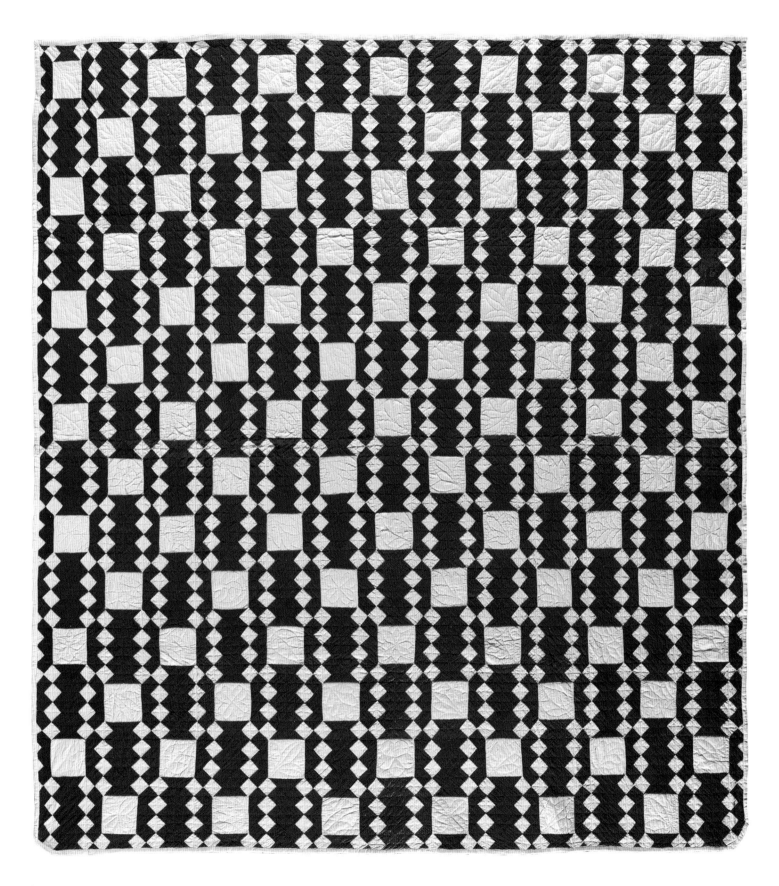

fig. 219
Double Railroad Quilt,
80 x 72 inches.

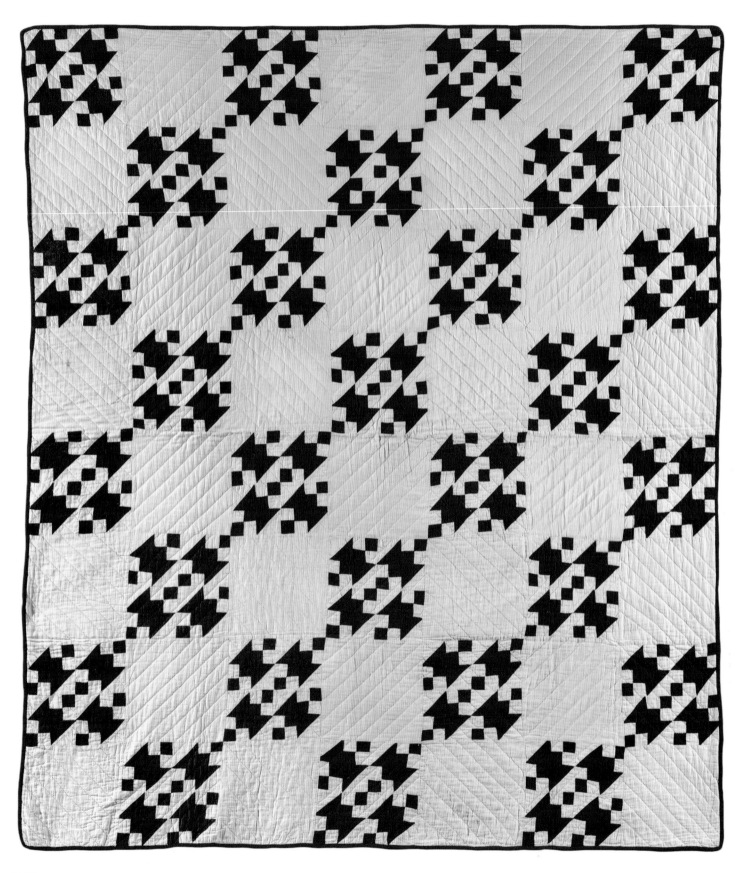

fig. 220
Railroad Quilt (Cups
and Saucers Variation),
76 ½ x 66 inches.

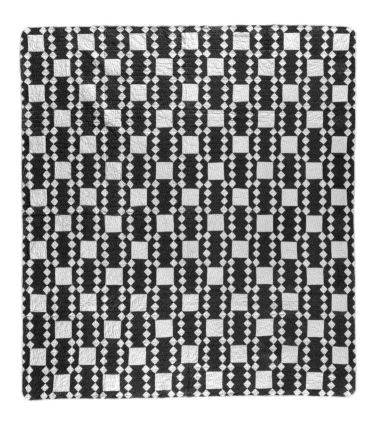

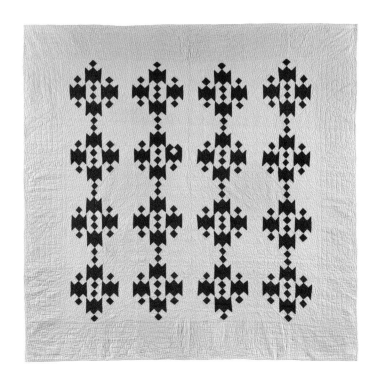

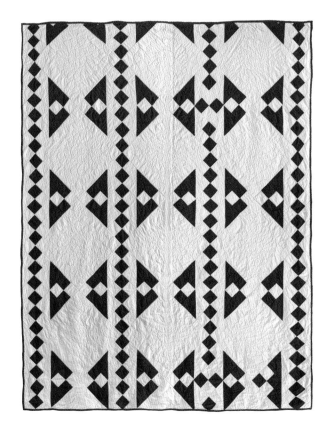

fig. 221
Double Railroad Quilt,
82½ x 78½ inches.

fig. 222
Vertical Jacob's Ladder
Quilt, 83 x 65 inches.

fig. 223
Railroad Quilt (Road to
California Variation) with
wide border, western Penn-
sylvania, 71 x 72 inches.

fig. 224
Railroad Variation Quilt
with double border,
78½ x 65 inches.

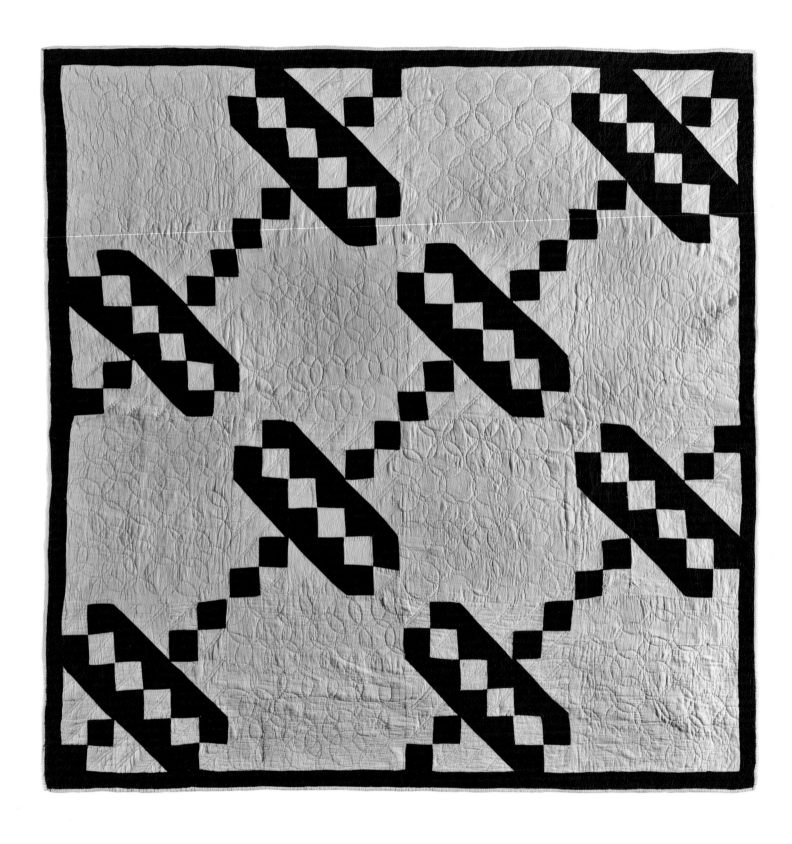

fig. 225
Jacob's Ladder Quilt with
single border, 79 x 76 inches.

Squares of various sizes interlock to create a sinuous design with various names. The Snail's Trail pattern is also known as Monkey Wrench or Indiana Puzzle.

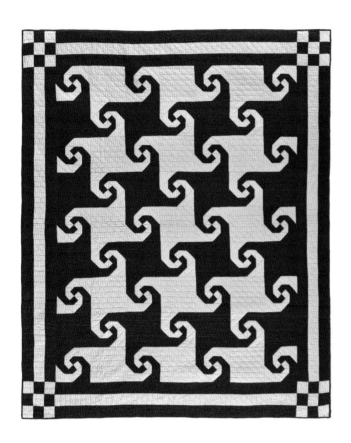

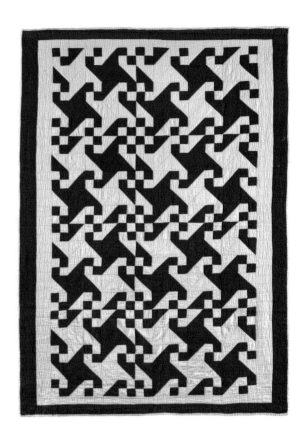

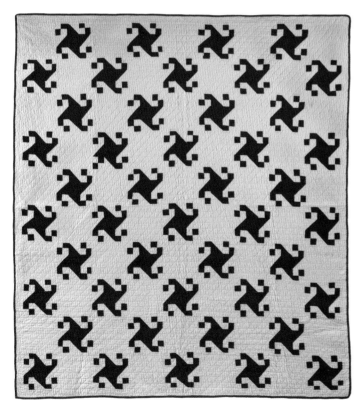

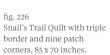

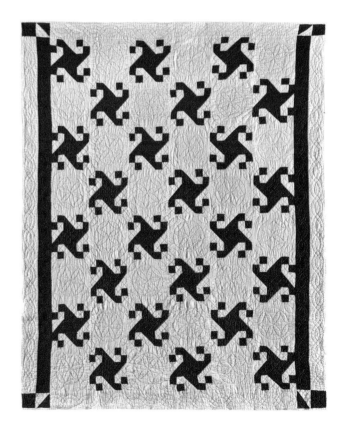

fig. 226
Snail's Trail Quilt with triple border and nine patch corners, 85 x 70 inches.

fig. 227
Indiana Puzzle Quilt with setting squares, 79 ½ x 71 ¾ inches.

fig. 228
Indiana Puzzle Quilt with double border, c. 1930, 89 ½ x 64 inches.

fig. 229
Indiana Puzzle Quilt with double side borders and corner squares, dated 1931, 75 ½ x 65 ½ inches.

Traditional Patchwork Quilts: Triangles

The blocks that make up traditional patchwork are often based on ancient geometric patterns found in mosaics from the Greek and Roman worlds. The triangles in the vast majority of these designs were adapted for use with cloth by quiltmakers in post-Renaissance Europe. Because at least one side of a triangle is always cut on the bias, which has a tendency to stretch when worked, these shapes, even those with right angles, are trickier to sew than squares or rectangles. But the shape lends itself to great variety in quiltmaking, as myriad patterns can be created. Depending on how they are combined, triangles can be the basis of both representational designs (Bow Tie and Arrow, for example) and those that are purely geometric and require some imagination to envision the named design (such as Lady of the Lake, Corn and Beans, and Wild Goose Chase).

The designs incorporating triangle shapes were carried to the New World by the early colonists, who worked them into quilt tops to make into warm bedding to ward off New England's chilly winter air. Access to fabric was limited because of the great distance to the motherlands; for a time, laws banned the private ownership of spinning wheels and looms in the North American colonies lest the lucrative cloth industry, particularly in the northeast of England, suffer trade losses. Therefore, every usable scrap of cloth, no matter how small, would be saved and put to use.

As the fledgling United States made its march westward, the necessity for hoarding all usable goods, including cloth, increased. Covered wagons had limited space for all the necessities for the many days and weeks of travel, and the distance and time increased between the points where supplies could be replenished and obtained on the frontier.

One-room cabins were built from available materials to meet basic living needs. Quilt blocks could be made one at a time and stored compactly until the maker had enough to finish a quilt. The blocks were also easily packed and portable, serving this pioneer population well.

Occasionally, a beautifully planned and executed quilt has an obvious mistake in a single block. Such an error, like the one in the middle row of fig. 250, page 158, is believed by some quilt historians to be deliberate: they label it a "superstition block," so-called because of the belief in some cultures that only God can make something perfect.

Because Turkey red dye was a luxury product until the early twentieth century, many of the nineteenth-century quilts in the *Infinite Variety* collection were most likely saved because they were made for "show"— for those times when company called, or one wanted to make a good impression—but there are undoubtedly quilts in this collection that were made for everyday use as well. Unfortunately, many everyday quilts have suffered the effects of time and hard wear, and no longer exist for historians to study.

TRIANGLE SQUARE (figs. 230–233)
Simple half-square triangles can be set side
by side or turned in opposite directions to create
dynamic patterns.

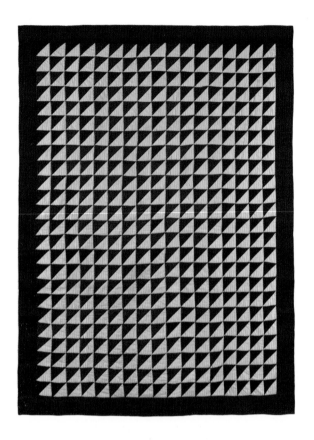

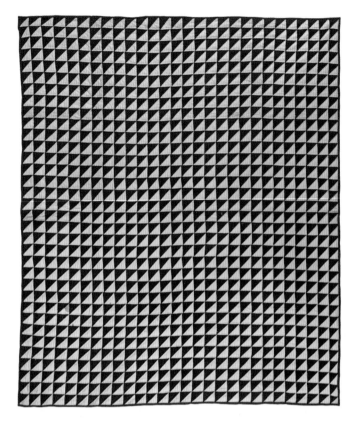

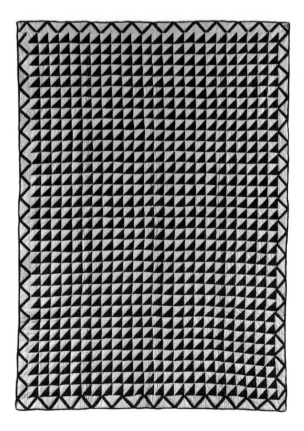

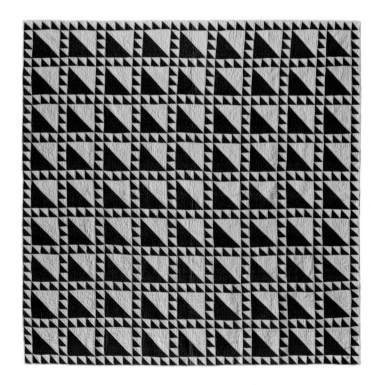

fig. 230
Triangle Squares Quilt
with single border,
81 ½ x 59 ½ inches.

fig. 231
Triangle Squares Quilt with
zigzag border, labeled "Quilt
hand made by Mrs. Sparling
Drake, great-grandmother

of Mrs. William J. Mackin,"
initialed "MD 83,"
New Hampshire, 1883,
78 ½ x 57 inches.

fig. 232
Triangle Squares Quilt,
89 x 74 ½ inches.

fig. 233
Dove in the Window Quilt
with sawtooth border,
Harriet Raydor Hotchkiss

(1836–1923), Whitehall,
New York, 76 x 76 inches.

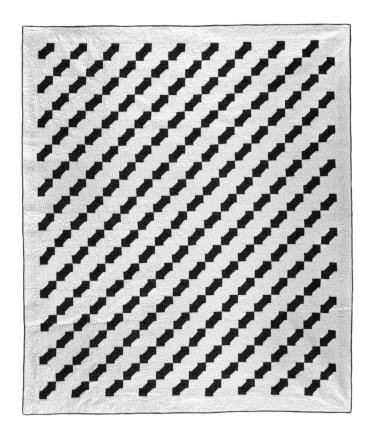

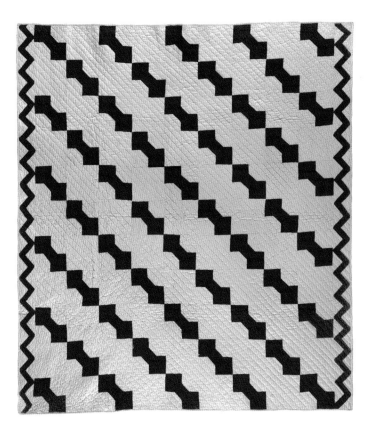

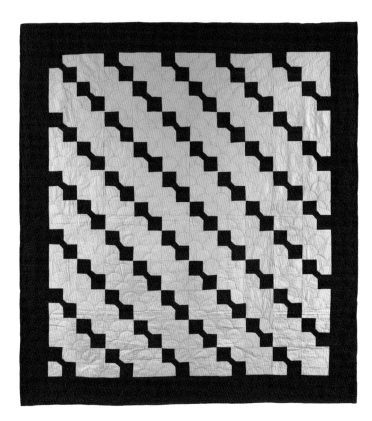

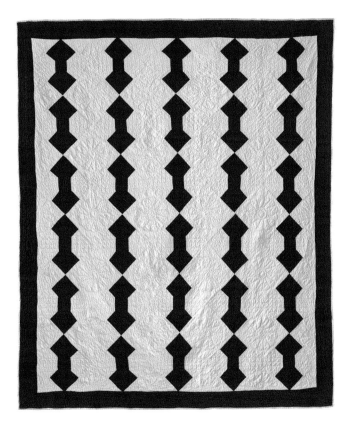

fig. 234
Bow Tie Quilt with single border, Indiana, 1920–1930, 90 x 79 inches.

fig. 235
Bow Tie Quilt with single border, 84 ½ x 77 ½ inches.

fig. 236
Bow Tie Quilt with zigzag side borders, 74 x 66 ¾ inches.

fig. 237
Vertical Bow Tie Quilt with single border, 78 x 64 inches.

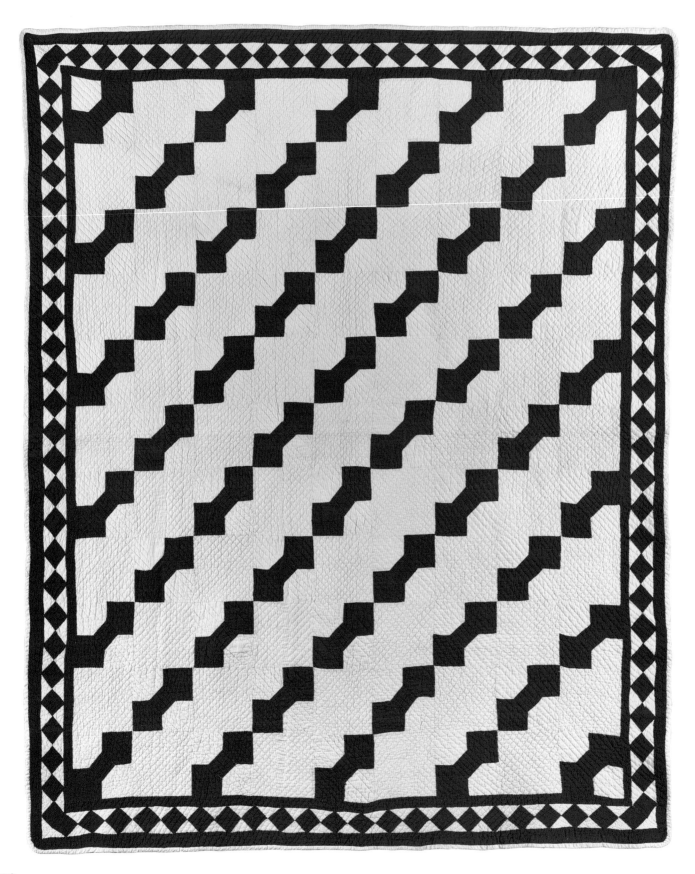

fig. 238
Bow Tie Quilt with triple
border with diamonds,
79 x 64 ½ inches.

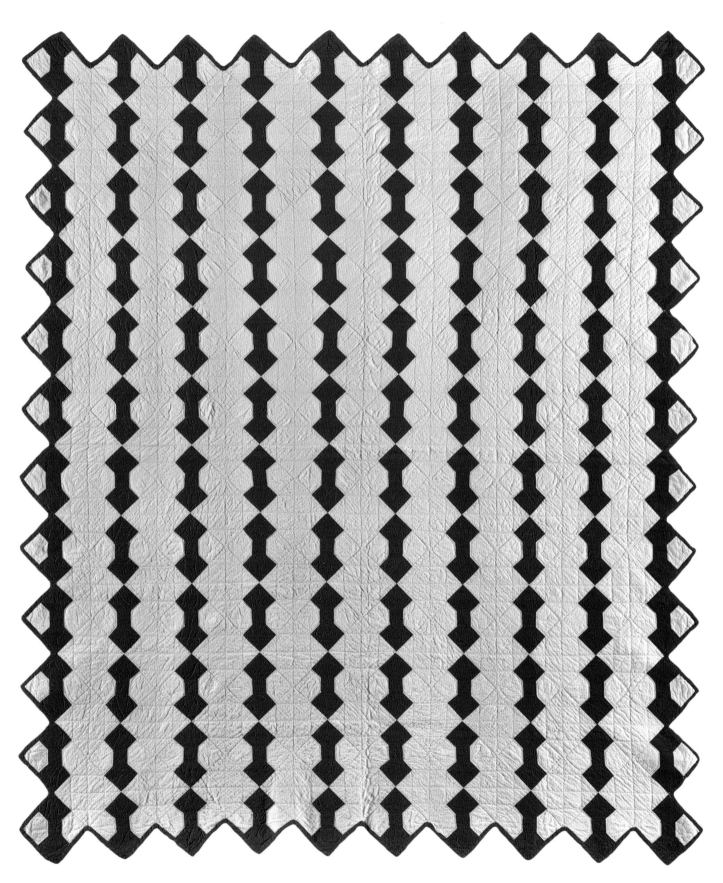

fig. 239
Vertical Bow Tie Quilt with
shaped diamond edge,
c. 1930, 88 x 74 ½ inches.

HOURGLASS (figs. 240-242)

The hourglass shape is highly versatile and can be combined with a second block to form chains, stacks, or other patterns.

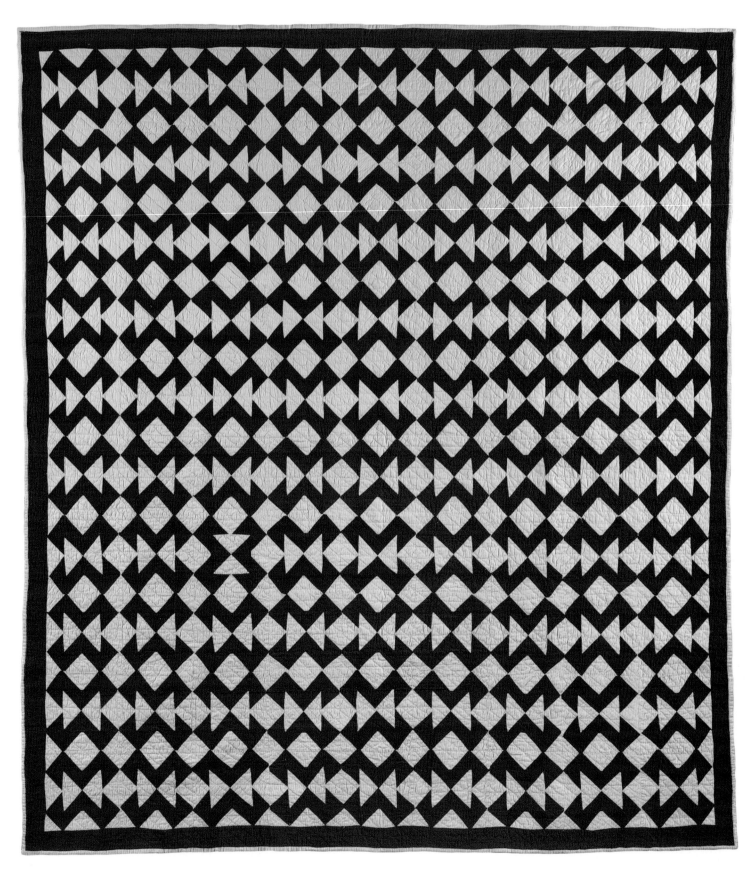

fig. 240
Hourglass Zigzag Quilt with single border, 87 x 78 inches.

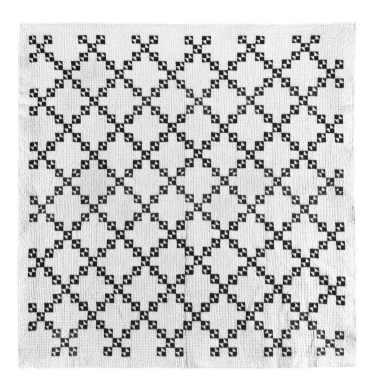

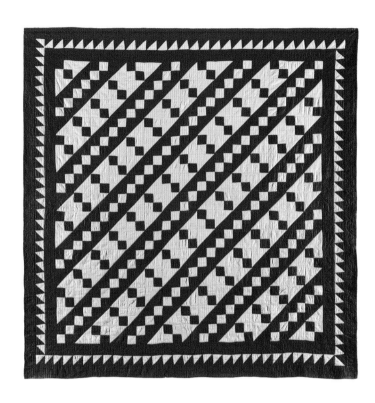

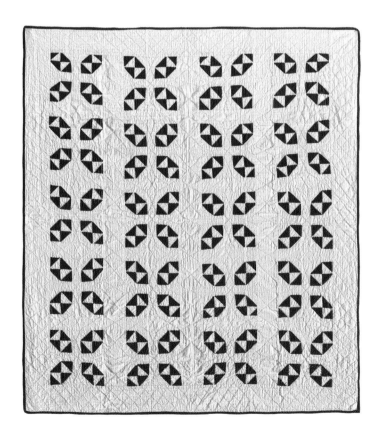

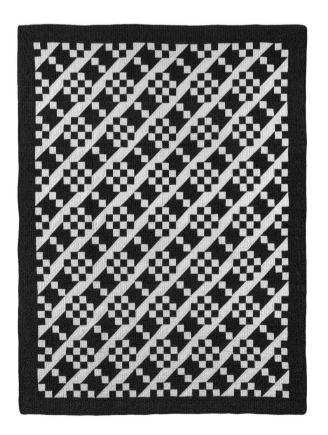

fig. 241
Hourglass Chain Quilt
with single border,
76 ½ x 70 inches.

fig. 242
Hourglass Variation
Quilt with single border,
62 x 55 inches.

fig. 243
Four Patch and Triangle
Squares Railroad Quilt
with sawtooth border,
84 x 84 inches.

fig. 244
Four Patch and Triangle
Squares Railroad Quilt with
single border, 87 x 67 inches.

SHOOFLY, CHURN DASH & HOLE
IN THE BARN DOOR (figs. 245–251)
At its simplest, this design (with variations) is
a Nine Patch and works well turned on point.

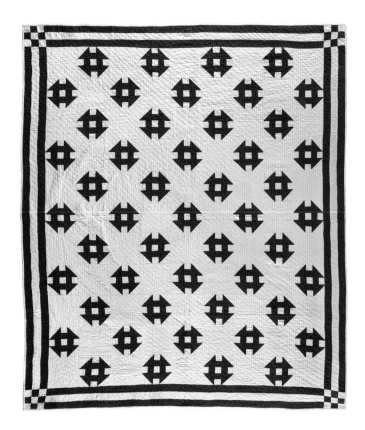

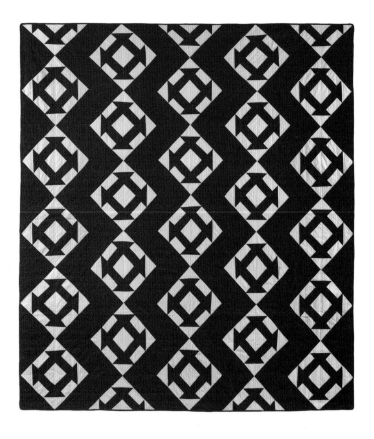

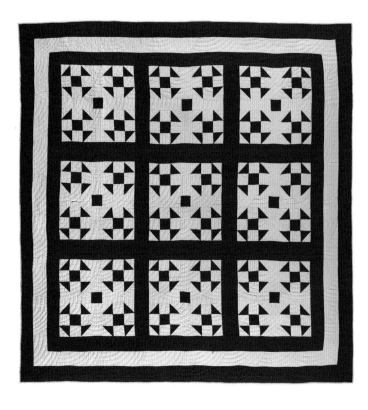

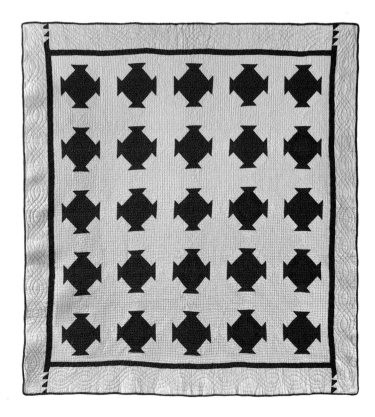

fig. 245
Shoofly on Point Quilt with
diagonal sashing, triple
border, and nine patch corner
squares, 85 x 73 inches.

fig. 246
Shoofly Variation Quilt
with sashing and triple
border, 82 ½ x 78 inches.

fig. 247
Hole in the Barn Door Quilt
(Lightning Variation), Lan-
caster County, Pennsylvania,
89 ½ x 78 ½ inches.

fig. 248
Sherman's March Quilt
(Churn Dash Variation)
with double border, Kansas,
75 x 69 ½ inches.

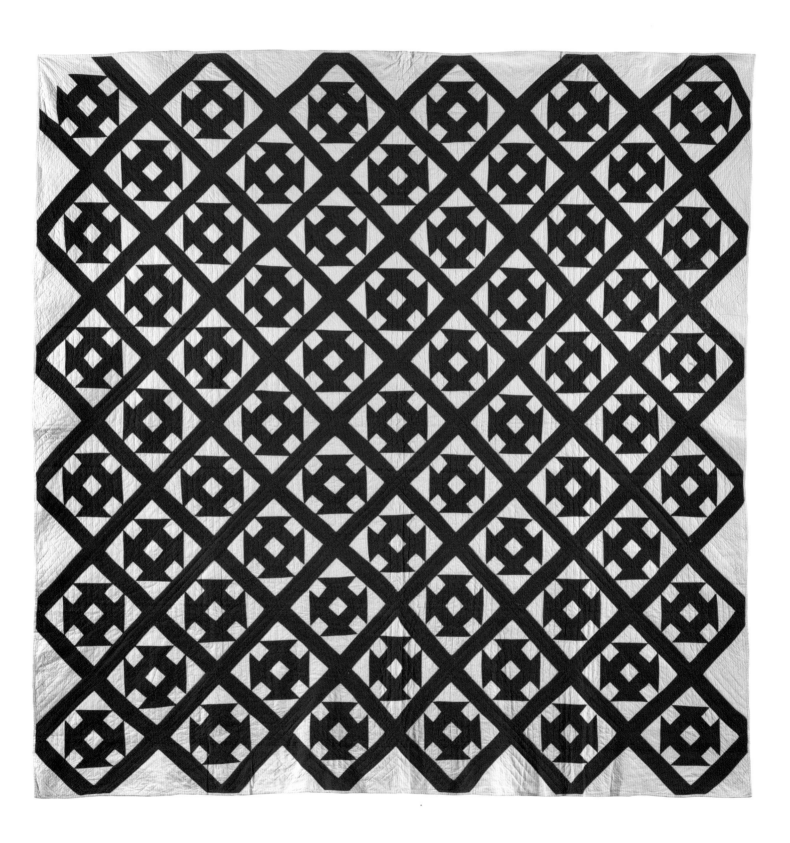

fig. 249
Shoofly Quilt with diagonal
sashing, 83 x 82 inches.

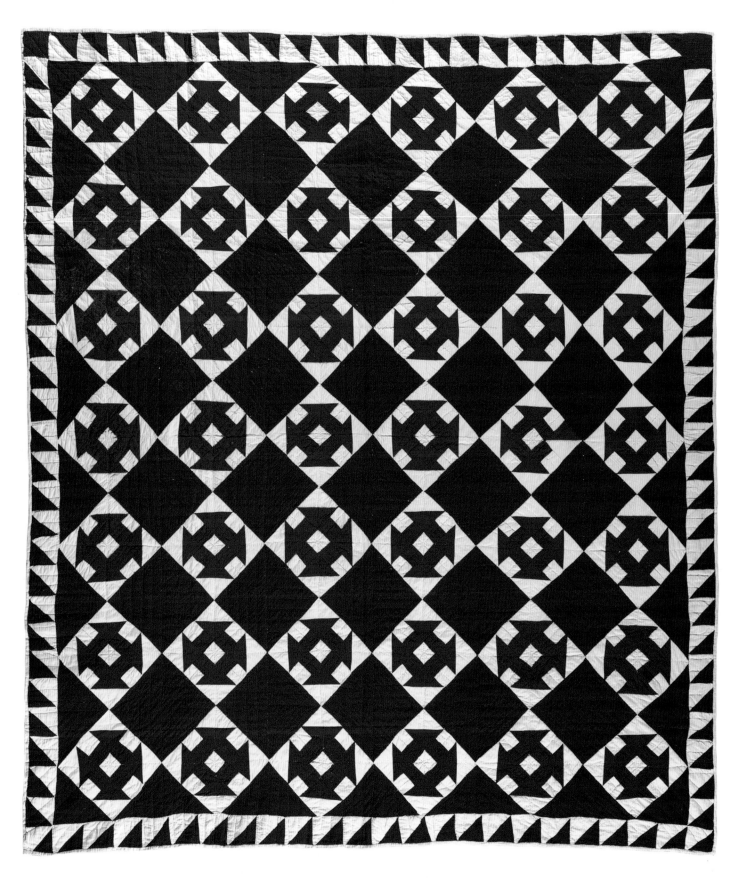

fig. 250
Shoofly on Point Quilt
with setting squares
and sawtooth border,
78 x 68 inches.

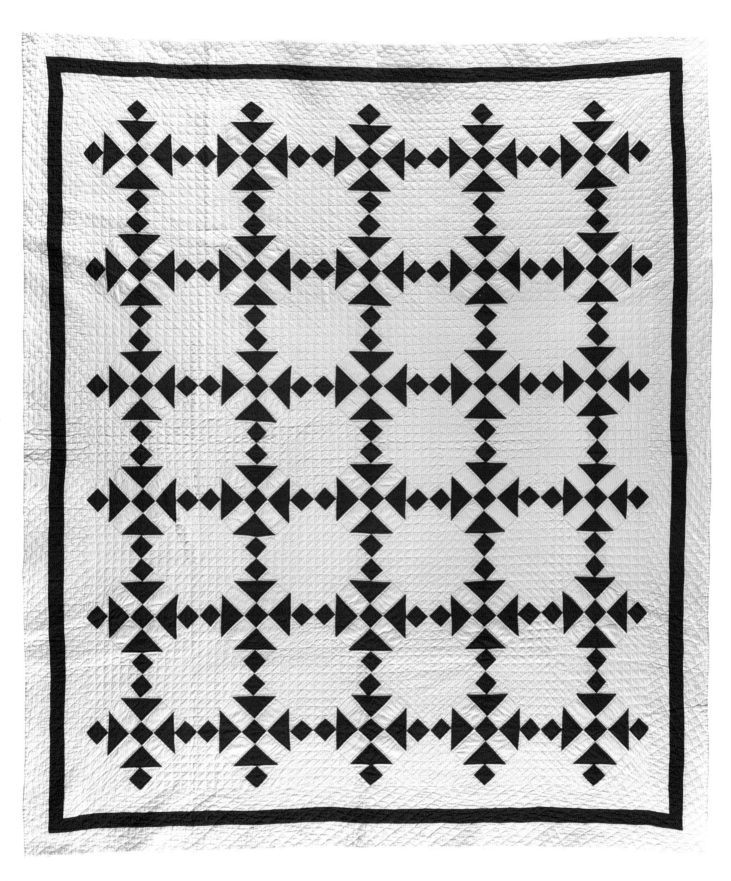

fig. 251
Shoofly Chain Variation
Quilt with double border,
85 x 74 ½ inches.

Arrows are made from strips and triangles. The
use of this shape, with its implied sense of fast
movement, enlivens a block enormously.

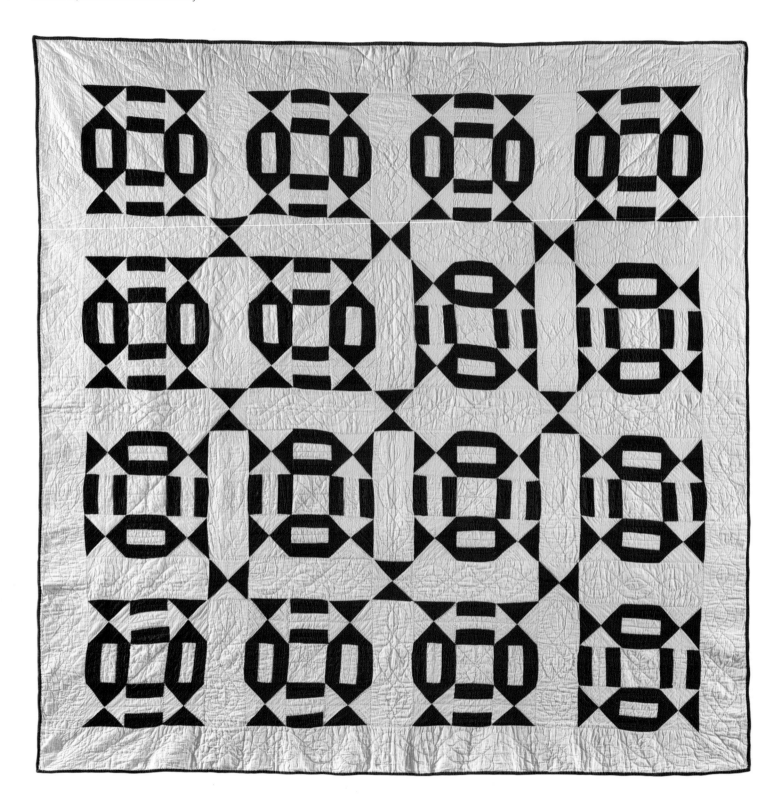

fig. 252
Double Arrow Variation
Quilt with single border,
75 x 74 ½ inches.

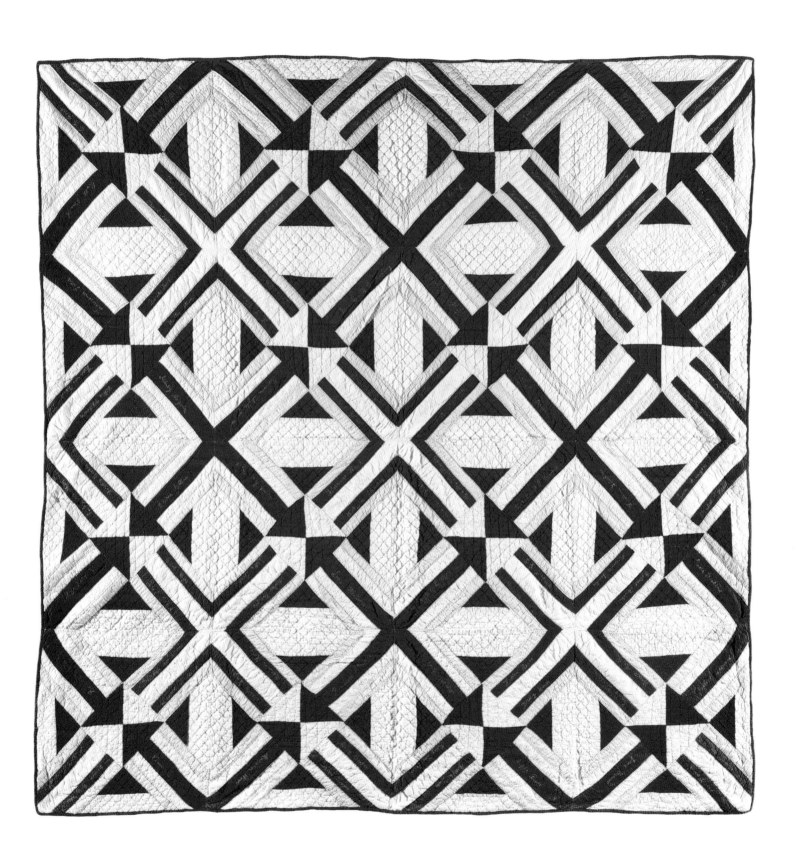

fig. 253
Arrow Quilt,
82 x 79 inches.

T shapes can be arranged in any number of ways.
Different orientations and groupings create highly
varied overall compositions.

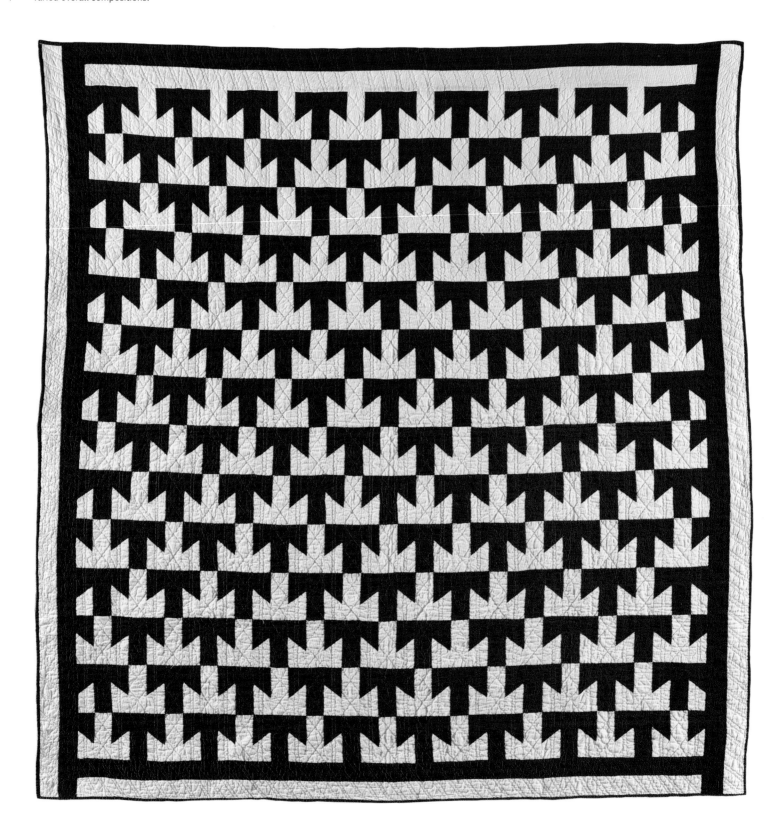

fig. 254
Double T Quilt with double
border, 78 ½ x 75 ½ inches.

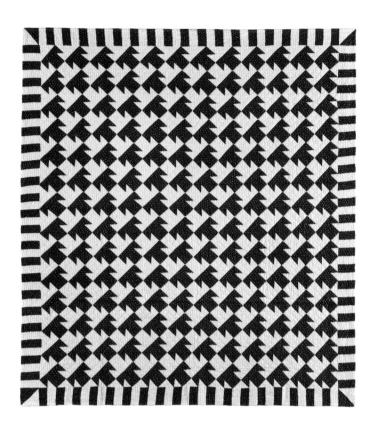

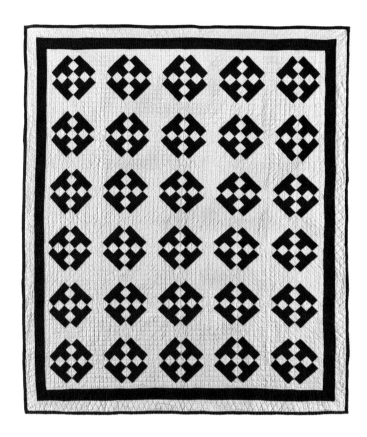

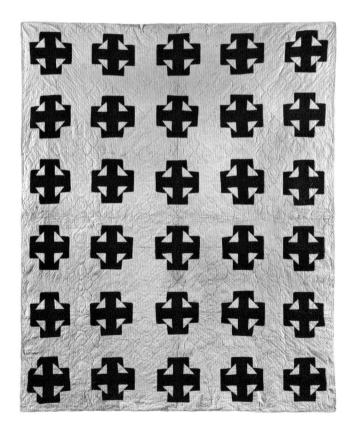

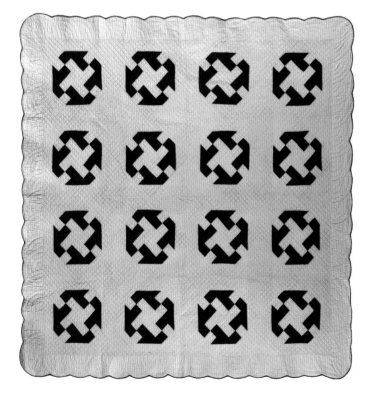

fig. 255
Diagonal Double T Quilt
with striped border,
69 ½ x 63 inches.

fig. 256
Double T on Point Quilt with
sashing, 86 ¼ x 68 ½ inches.

fig. 257
Double T Chain Variation
Quilt with double border,
83 ½ x 73 ½ inches.

fig. 258
Prairie Queen Quilt with
partial T blocks and scalloped
edge, western Pennsylvania,
c. 1930, 81 ¼ x 77 ½ inches.

LADY OF THE LAKE (figs. 259–266)
The triangle squares in Lady of the Lake are edged
with sawtooth sashing. Delectable Mountain is a
popular variation.

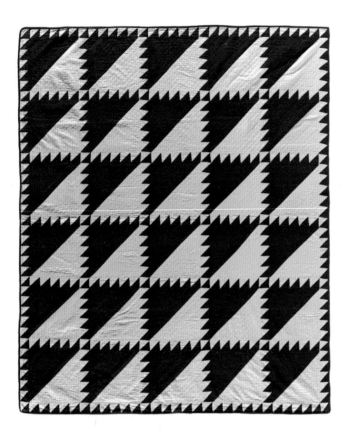

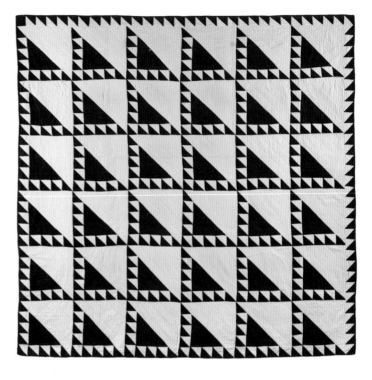

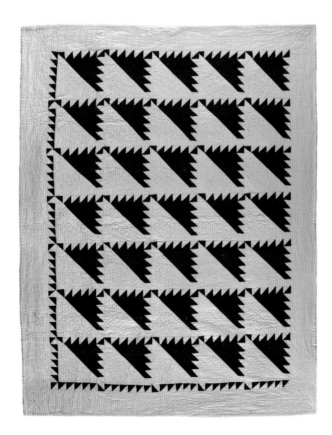

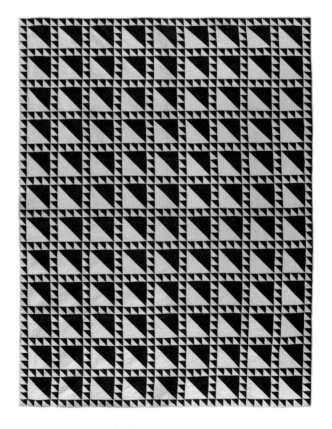

fig. 259
Delectable Mountain Quilt
with sawtooth border,
81 ½ x 67 ½ inches.

fig. 260
Delectable Mountain Quilt
with sawtooth inner border,
midwestern United States,
84 ½ x 65 inches.

fig. 261
Lady of the Lake Quilt with
sawtooth border, Penn-
sylvania, 81 x 79 inches.

fig. 262
Lady of the Lake Quilt,
92 ½ x 70 ½ inches.

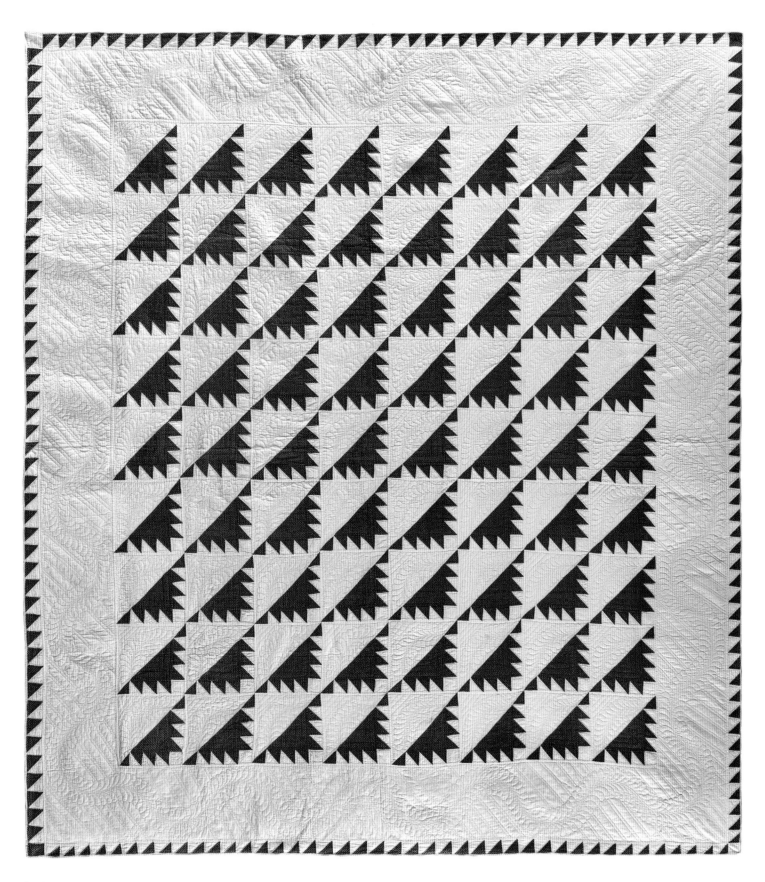

fig. 263
Delectable Mountain
Quilt with wide border
and sawtooth edging,
97½ x 87½ inches.

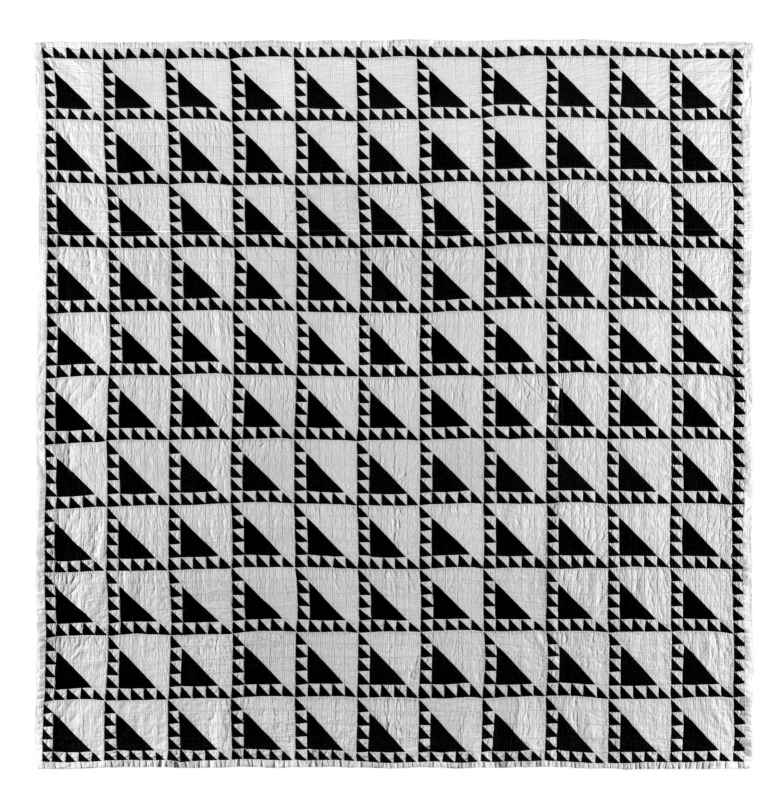

fig. 264
Lady of the Lake Quilt,
82 x 80 ½ inches.

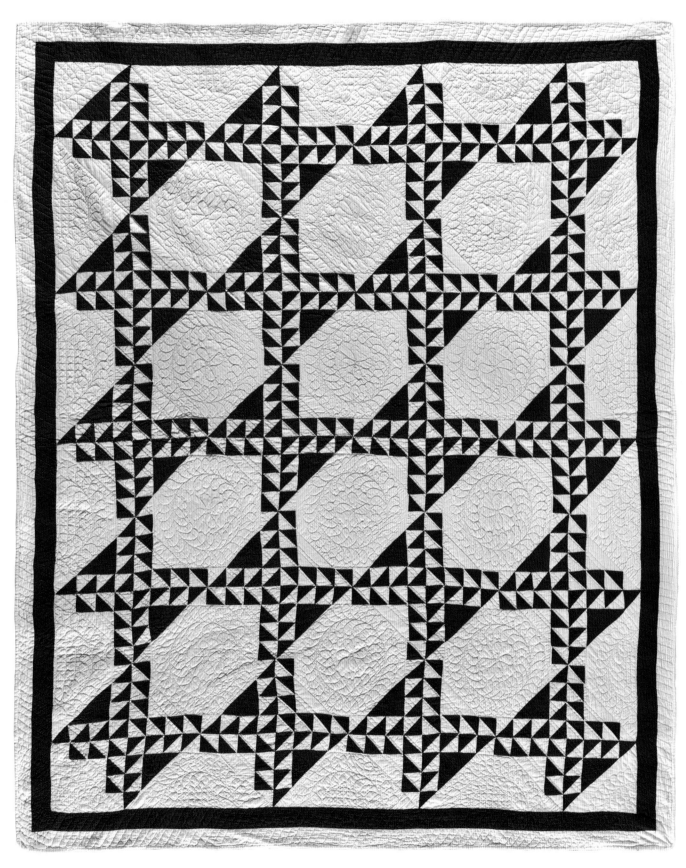

fig. 265
Lady of the Lake Variation
Quilt with setting squares
and double border,
87½ x 73½ inches.

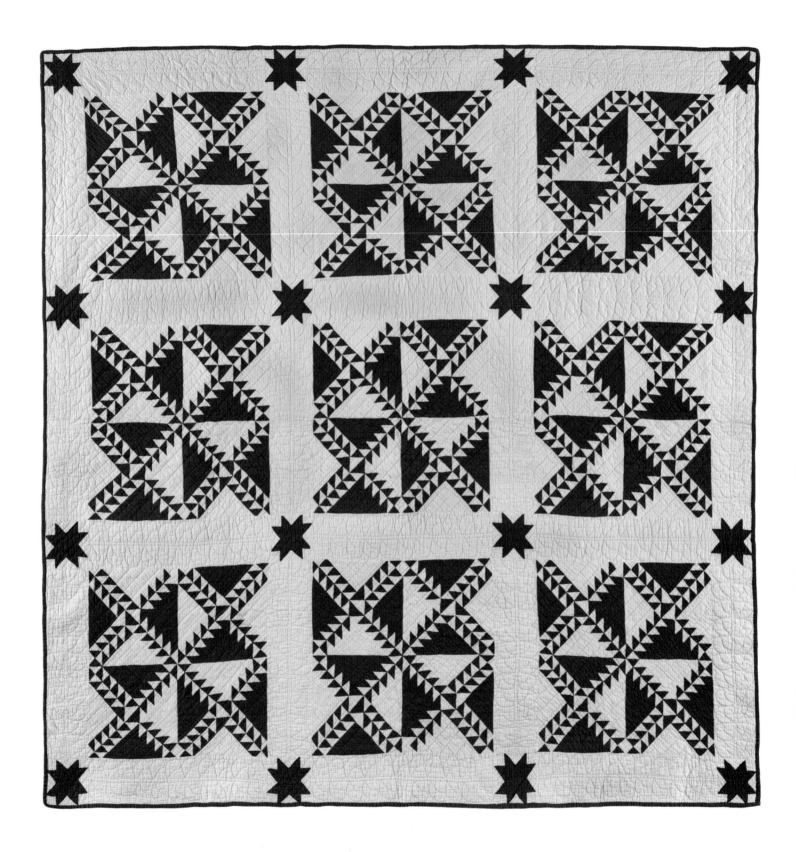

fig. 266
Lady of the Lake Variation
Quilt with eight-point corner
stars, 71 ½ x 71 inches.

In this vibrant and energetic pattern, two rows of
smaller, alternating triangles border each central
hourglass block.

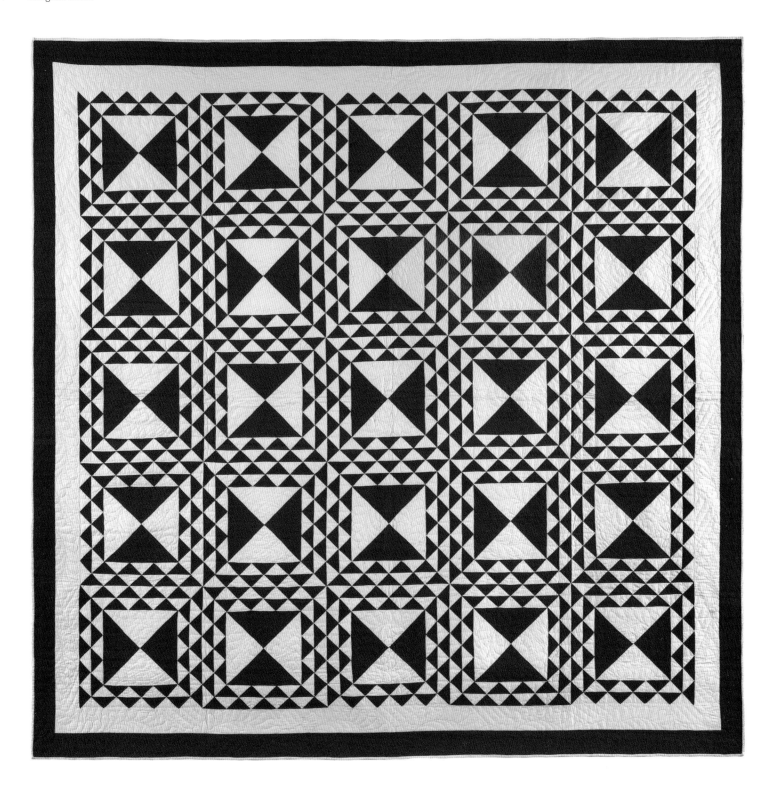

fig. 267
Corn and Beans Quilt
with double border,
86 x 85½ inches.

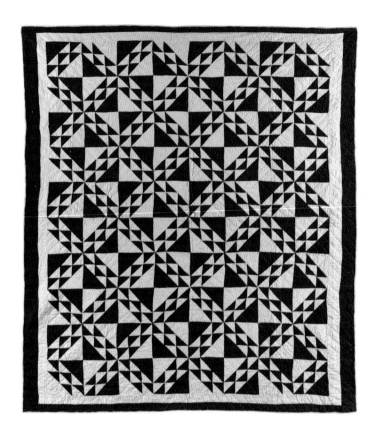

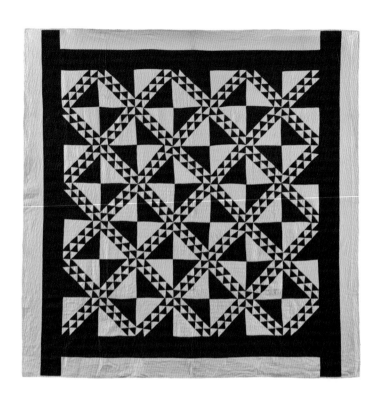

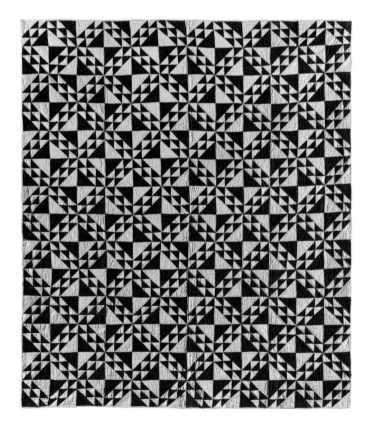

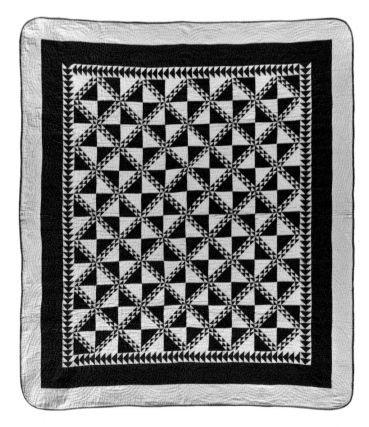

fig. 268
Corn and Beans Quilt
with double border,
80 ½ x 71 ½ inches.

fig. 269
Corn and Beans Quilt,
78 ½ x 68 ½ inches.

fig. 270
Corn and Beans Quilt with
double border, Lancaster
County, Pennsylvania,
90 x 88 inches.

fig. 271
Corn and Beans with Flying
Geese Quilt with double
border, Ohio, 78 x 69 inches.

OCEAN WAVES (figs. 272–279)
The name of this pattern is interchangeable with several others, including Broken Dishes and Yankee Puzzle.

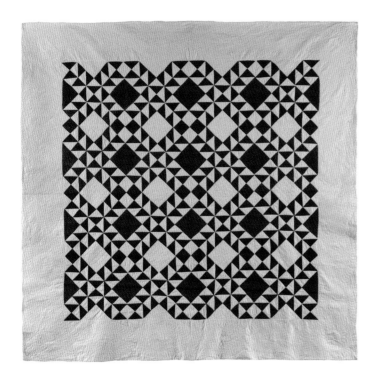

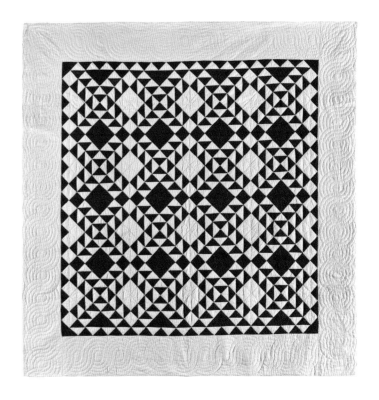

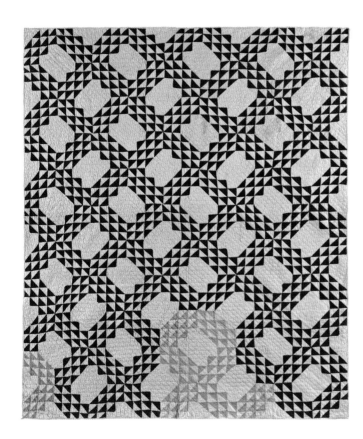

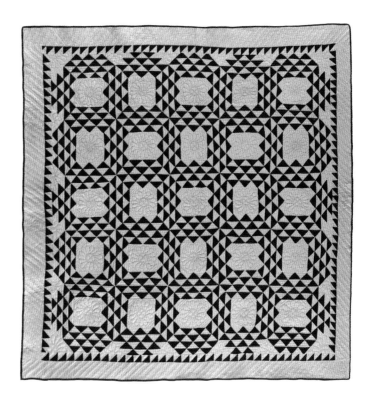

fig. 272
Ocean Waves Quilt with wide border, Indiana, Pennsylvania, 83 x 85 inches.

fig. 273
Ocean Waves Quilt, 85 x 69 inches.

fig. 274
Ocean Waves Quilt with wide border, 80 ½ x 79 inches.

fig. 275
Ocean Waves Quilt with sawtooth border, central Pennsylvania, 73 x 72 inches.

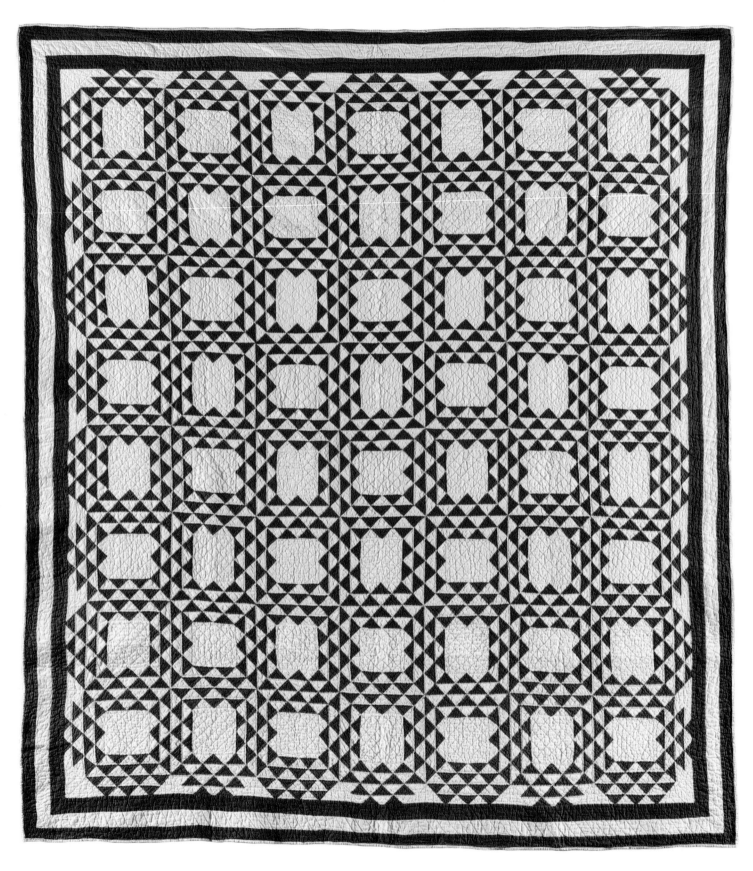

fig. 276
Ocean Waves Quilt with
triple border, 82 x 72 inches.

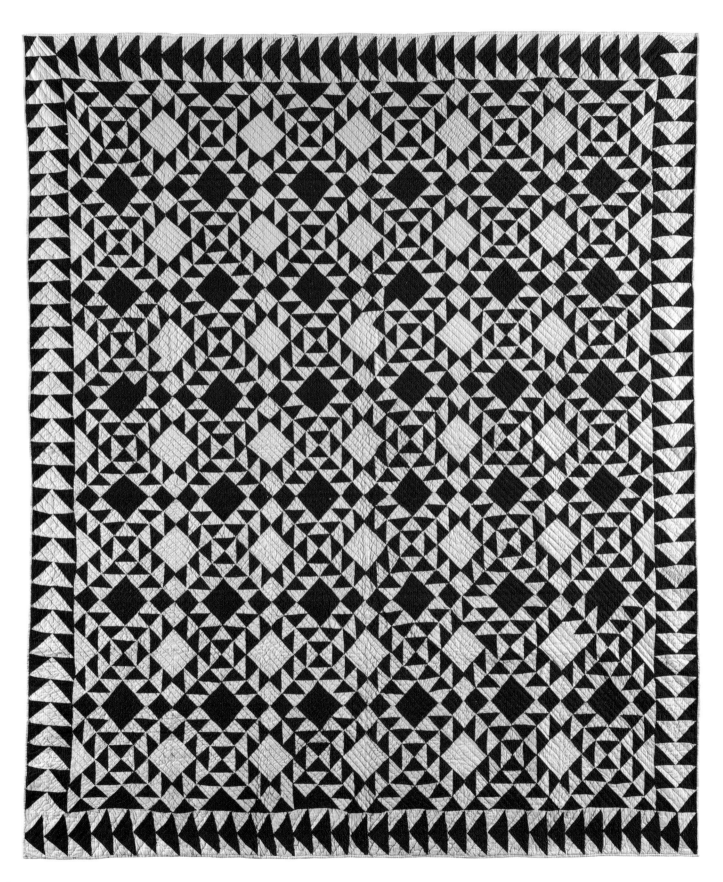

fig. 277
Ocean Waves Quilt with
wild goose chase border,
Hagerstown, Maryland,
81½ x 68 inches.

Designs that incorporate the hourglass shape are the basis for many Double X blocks. The five quilts in this section are each a different variation.

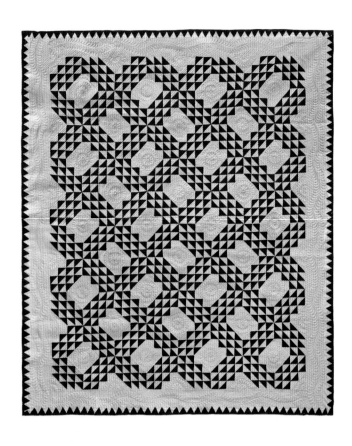

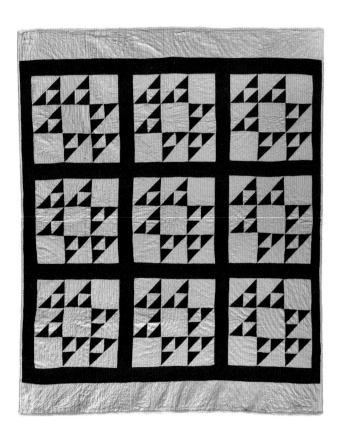

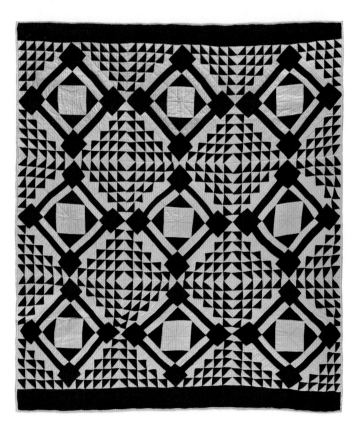

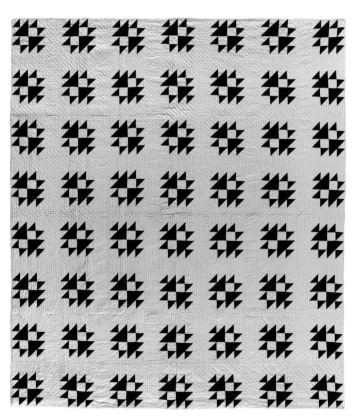

fig. 278
Ocean Waves Quilt with single border and sawtooth edging, 95½ x 75½ inches.

fig. 279
Ocean Waves Quilt (Diamond in a Square Variation) with single top and bottom borders, c. 1930, 78½ x 70½ inches.

fig. 280
Double X Quilt (Cat's Cradle Variation) with single top and bottom borders, New Hampshire, c. 1930, 80 x 63½ inches.

fig. 281
Double X Quilt (Crosses and Losses/Fox and Geese Variations), Pennsylvania, 79 x 71 inches.

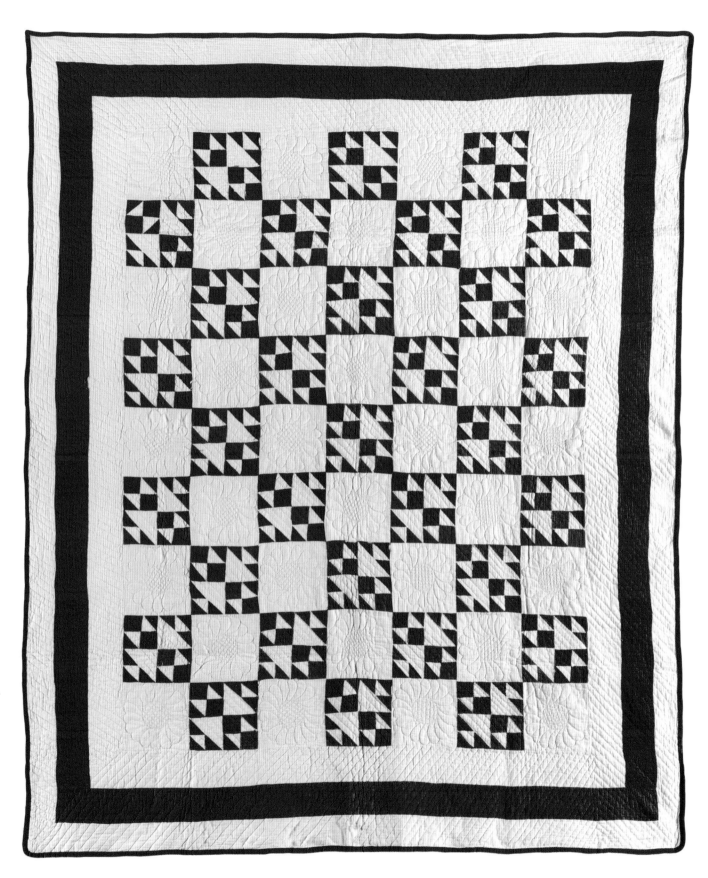

fig. 282
Double X Variation
Quilt with triple border,
76 x 63 inches.

TRADITIONAL PATCHWORK QUILTS: TRIANGLES

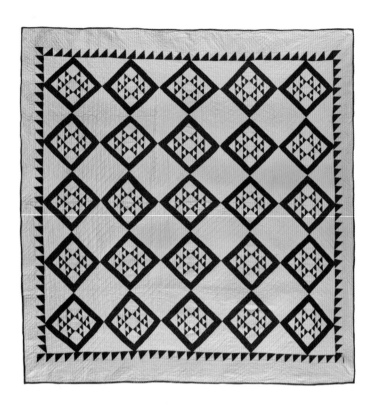

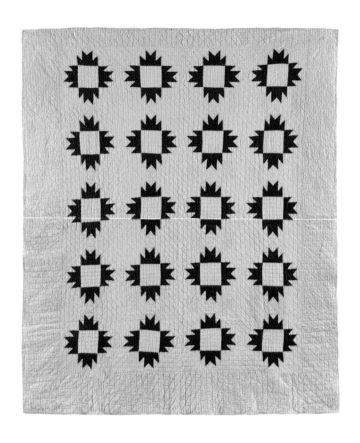

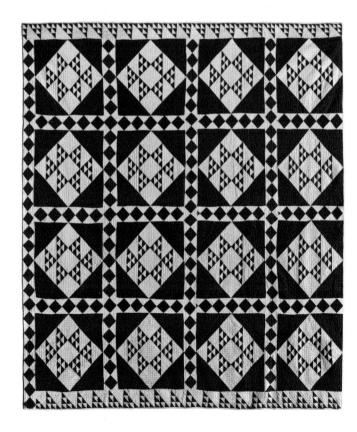

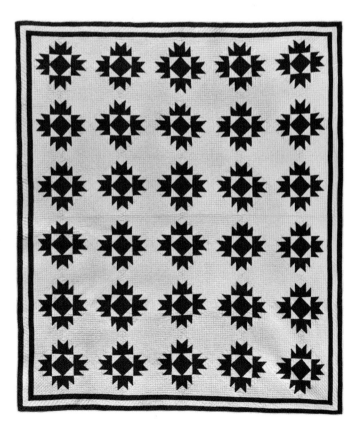

fig. 283
Double X Variation Quilt
with sawtooth inner border,
80 x 79 inches.

fig. 284
Double X Variation Quilt
with diamond sashing
and complex borders,
92 x 85 inches.

fig. 285
Union Square Variation on
Point Quilt with wide border,
Cumberland County, Penn-sylvania, 76½ x 64 inches.

fig. 286
Union Square Quilt
with triple border,
76½ x 67 inches.

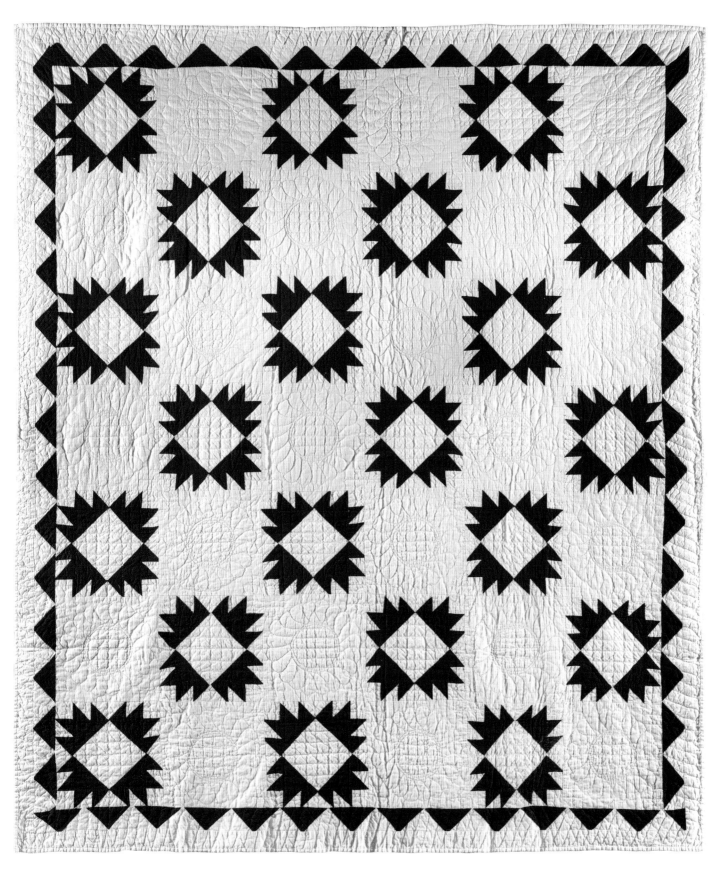

fig. 287
Union Square Variation
Quilt with setting squares
and triangle border,
72 ½ x 61 ½ inches.

TRADITIONAL PATCHWORK QUILTS: TRIANGLES

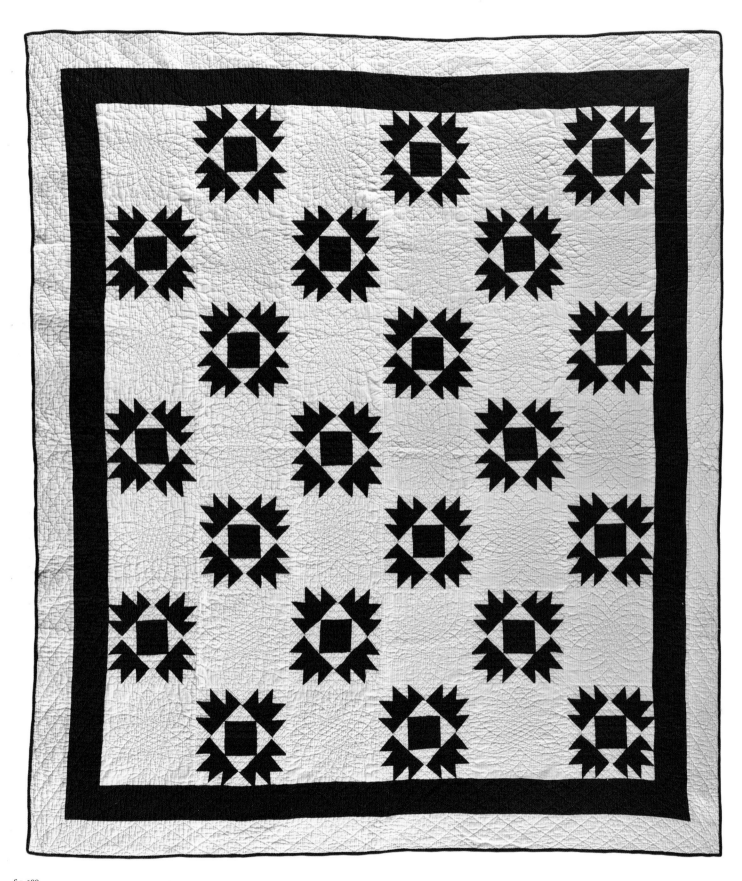

fig. 288
Union Square Quilt with
setting squares and double
border, 76 ½ x 66 ½ inches.

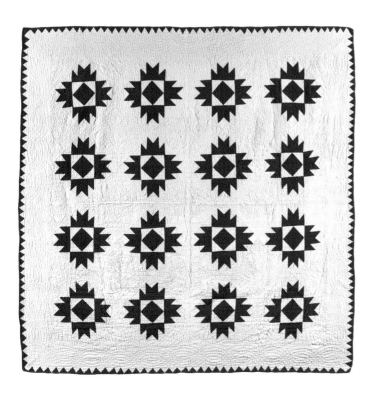

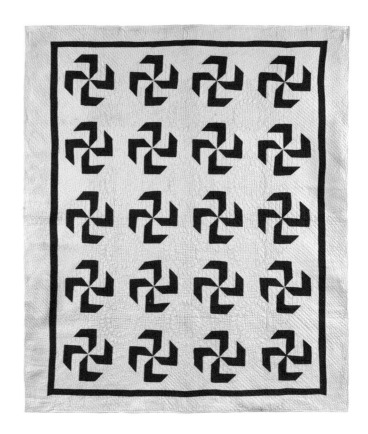

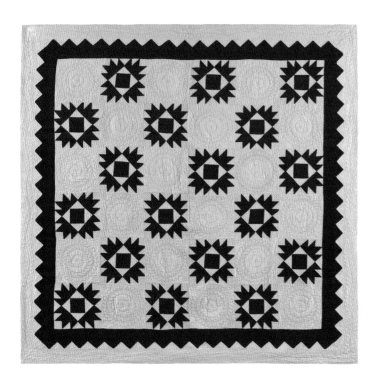

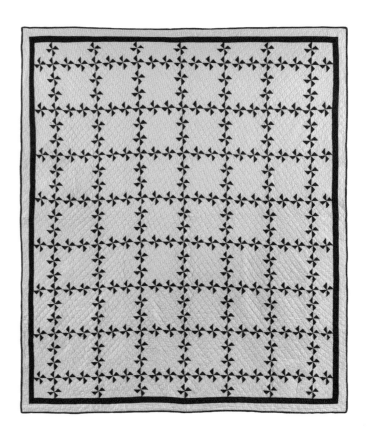

fig. 289
Union Square Quilt with wide border and sawtooth edging, 80½ x 79½ inches.

fig. 290
Union Square Quilt with setting squares and zigzag border, 74 x 76½ inches.

fig. 291
Pinwheel Quilt (Fly Foot Variation) with double border, 82 x 70 inches.

fig. 292
Pinwheel Quilt (Miniature Flutterwheel Chain Variation) with double border, Pennsylvania, 82½ x 72 inches.

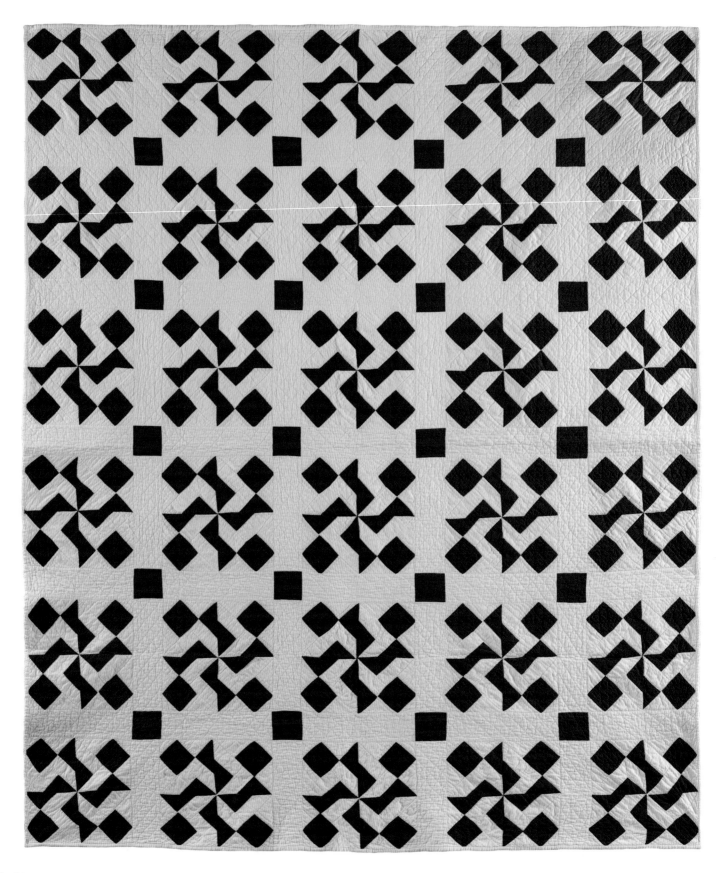

fig. 293
Pinwheel Variation Quilt,
82 ½ x 72 inches.

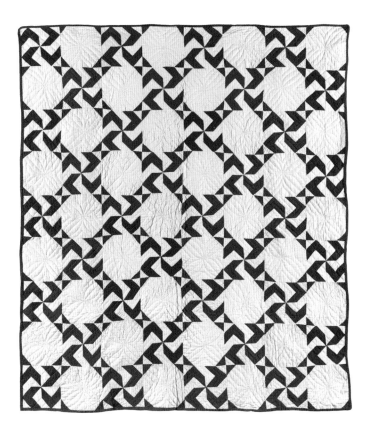

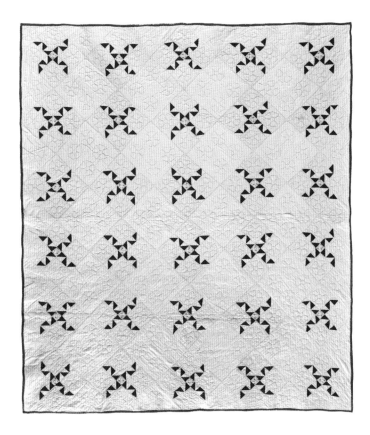

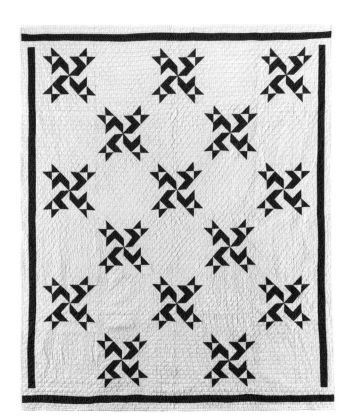

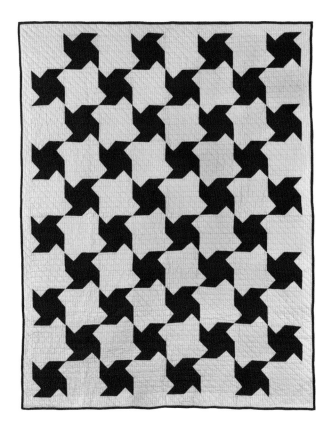

fig. 294
Pinwheel Quilt (Fly Foot or Whirligig Variation), York, Pennsylvania, 79 x 68½ inches.

fig. 295
Pinwheel Variation Quilt with setting squares and double border, 89 x 74½ inches.

fig. 296
Pinwheel Variation Quilt, 79½ x 67½ inches.

fig. 297
Pinwheel Quilt with single border, 80 x 63 inches.

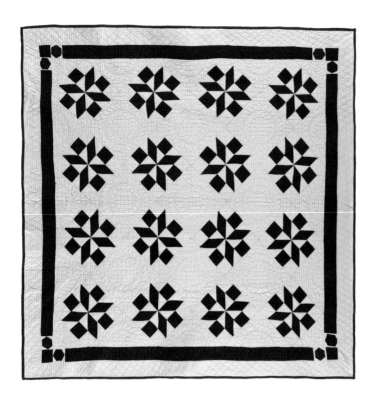

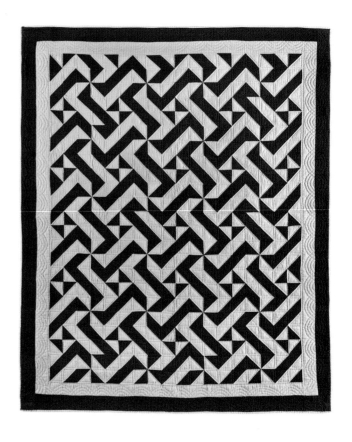

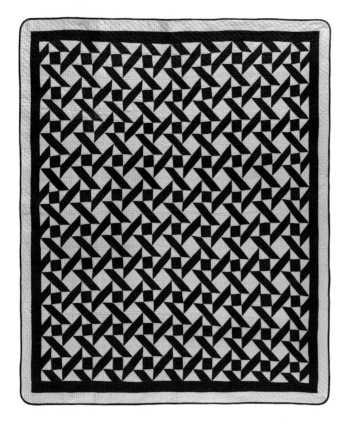

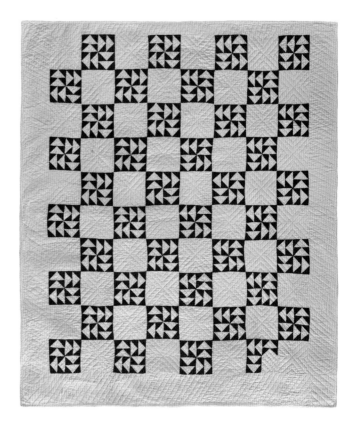

fig. 298
Pinwheel Variation
Quilt with double border,
77 x 74 ½ inches.

fig. 299
Pinwheel Quilt (Windmill
Variation) with double
border, 80 x 74 inches.

fig. 300
Pinwheel Variation
Quilt with double border,
81 ½ x 69 inches.

fig. 301
Dutchman's Puzzle Quilt
with setting squares and
single border, York County,
Pennsylvania, 82 x 70 inches.

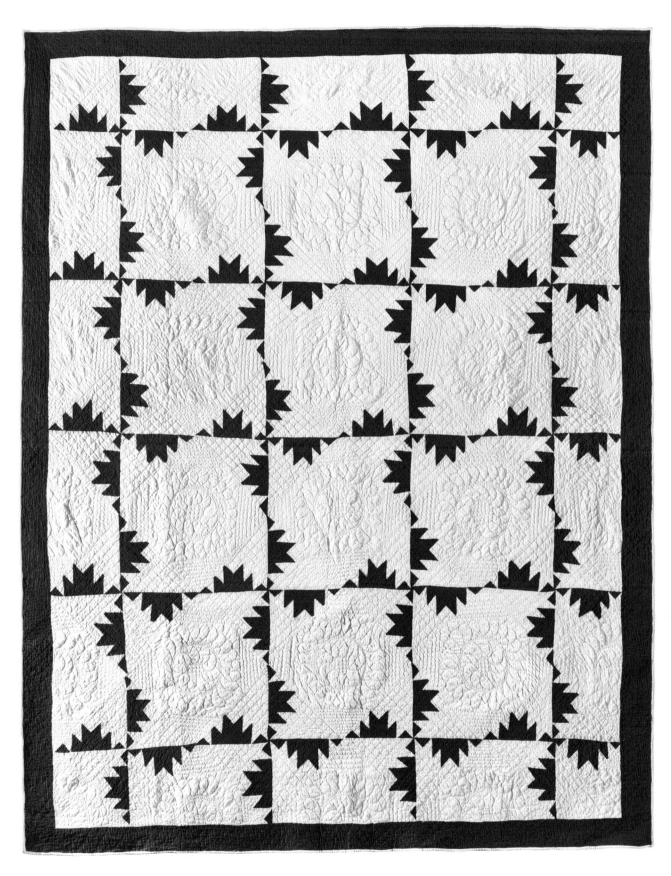

fig. 302
Kansas Troubles Quilt with
setting squares and single
border, coastal Maryland,
91 x 72 inches.

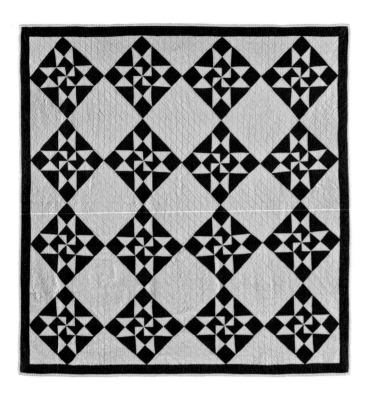

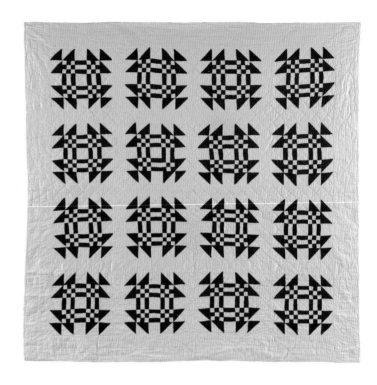

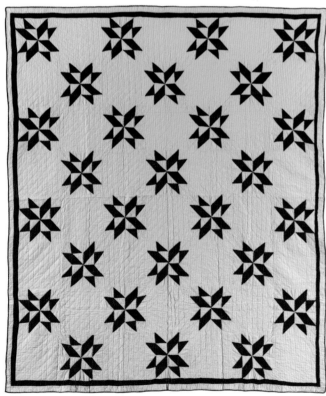

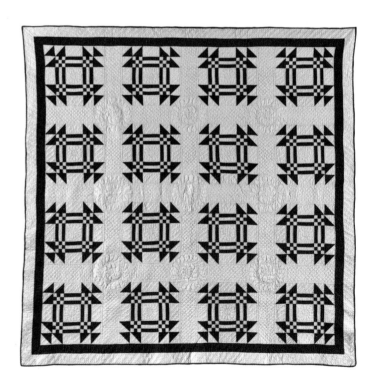

fig. 303
Pinwheel Stars Quilt with setting squares and single border, 67 x 65½ inches.

fig. 304
Pinwheel Stars Quilt with setting squares and double border, 82 x 70 inches.

fig. 305
Goose in the Pond Quilt (Young Man's Fancy Variation) with sashing and single border, c. 1930, 64¾ x 64¼ inches.

fig. 306
Goose in the Pond Quilt with sashing and double border, western Pennsylvania, 79 x 79 inches.

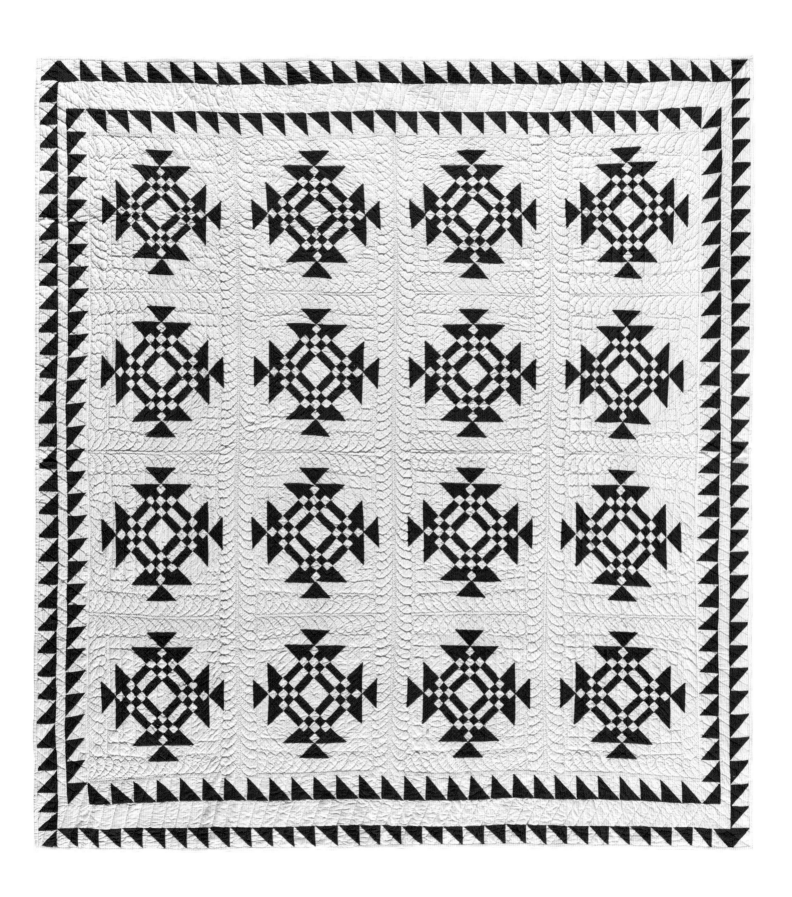

fig. 307
Goose in the Pond Quilt
with double sawtooth
border, 75 x 72 inches.

BIRDS IN THE AIR (figs. 310–311)

This straightforward pattern conveys a poignant sense of movement and perhaps symbolizes a flock of birds in flight.

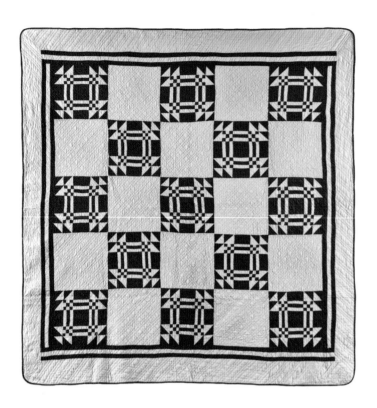

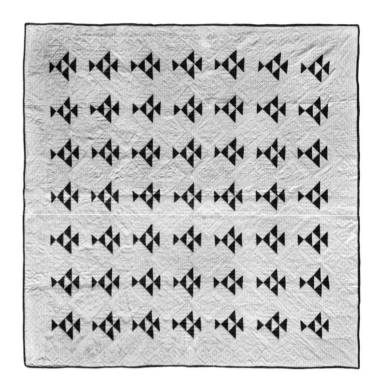

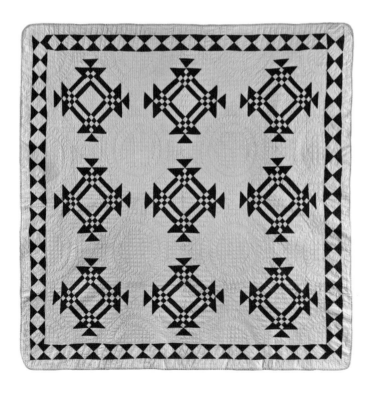

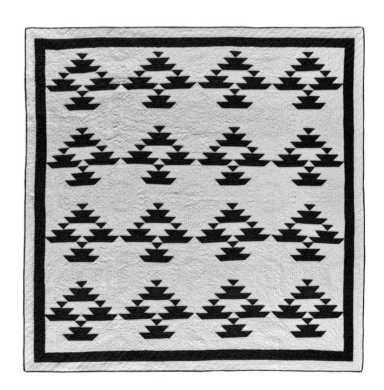

fig. 308
Goose in the Pond Quilt with setting squares and complex border, 78½ x 74½ inches.

fig. 309
Goose in the Pond Quilt with setting squares and diamond border, 76 x 77 inches.

fig. 310
Birds in the Air Variation Quilt with wide border, 76 x 74 inches.

fig. 311
Birds in the Air Variation on Point Quilt with setting squares and double border, 75 x 76½ inches.

WILD GOOSE CHASE (figs. 312–328)
Stacking Flying Geese blocks in strips creates Wild
Goose Chase, which is a pattern in its own right and
is often used in sashing and borders.

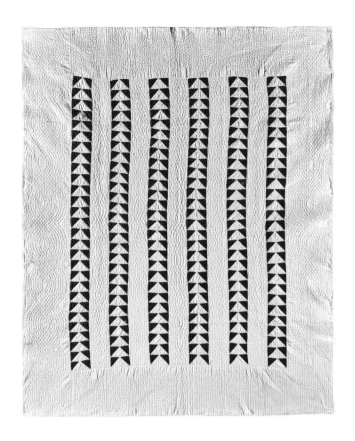

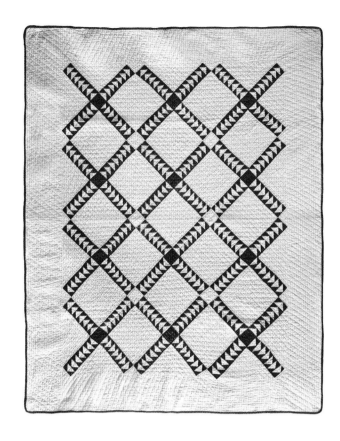

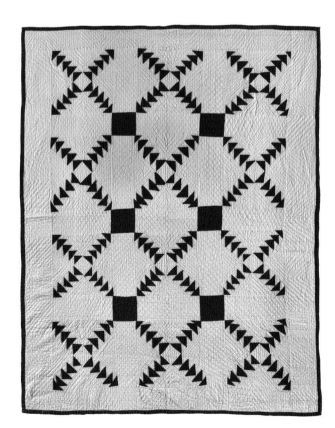

fig. 312
Wild Goose Chase Strippy
Quilt with wide border,
82 x 69 inches.

fig. 313
Wild Goose Chase Quilt with
single border, 76 x 59 inches.

fig. 314
Wild Goose Chase Quilt
with wide border, c. 1930,
81 x 65 inches.

fig. 315
Wild Goose Chase Quilt,
87 x 75½ inches.

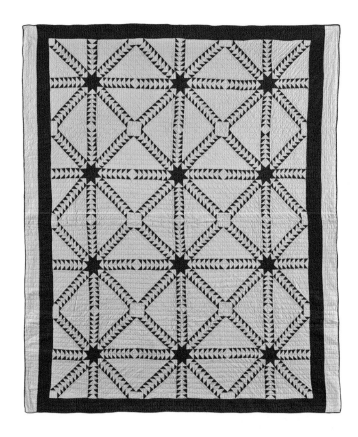

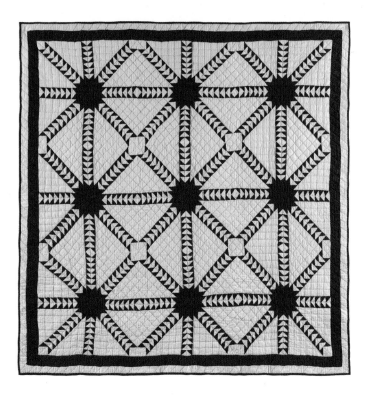

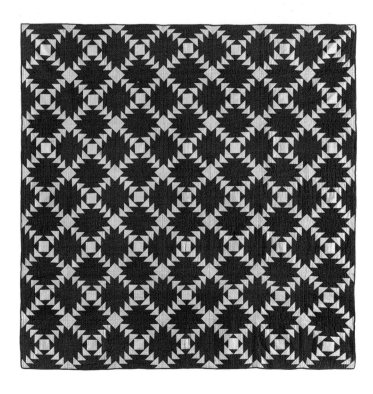

fig. 316
Wild Goose Chase Quilt with triple border, 89 x 72 inches.

fig. 317
Wild Goose Chase Quilt with stars and double border, 79 x 78 inches.

fig. 318
Wild Goose Chase Quilt with Eight-Point Stars, single inner border, and single side borders, 85½ x 69½ inches.

fig. 319
Wild Goose Chase Quilt, 76 x 76 inches.

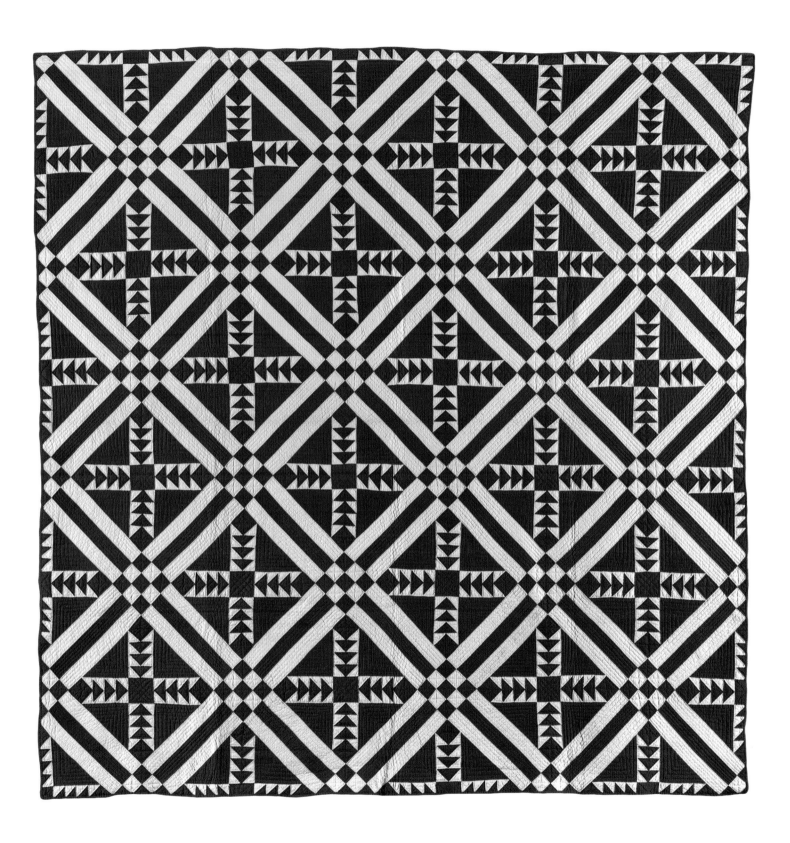

fig. 320
Wild Goose Chase Quilt
(Odd Fellows variation),
80 x 80 inches.

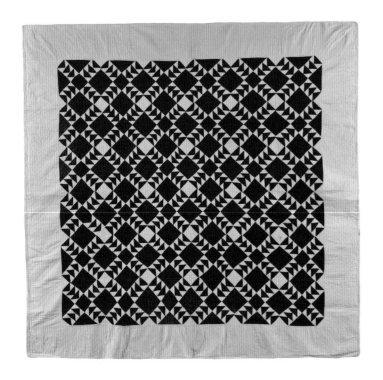

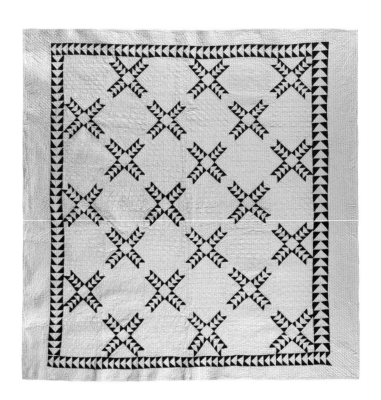

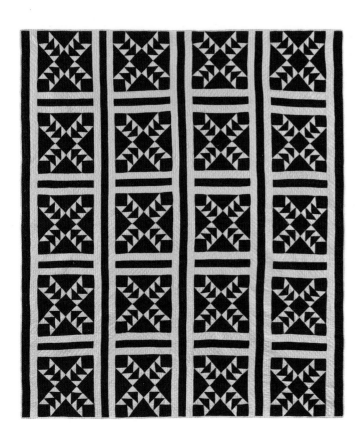

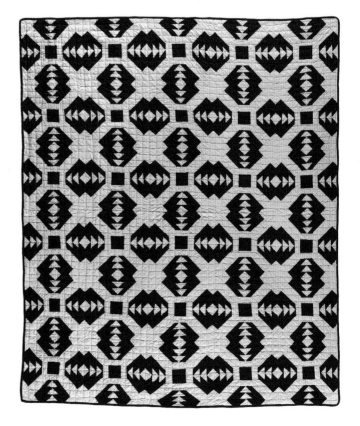

fig. 321
Wild Goose Chase
Quilt with wide border,
79 ½ x 77 ½ inches.

fig. 322
Wild Goose Chase Quilt
(Odd Fellows Variation)
with triple sashing,
82 x 72 ½ inches.

fig. 323
Odd Fellows Quilt with
wild goose chase border,
75 x 74 inches.

fig. 324
Broken Heart Quilt,
79 x 65 inches.

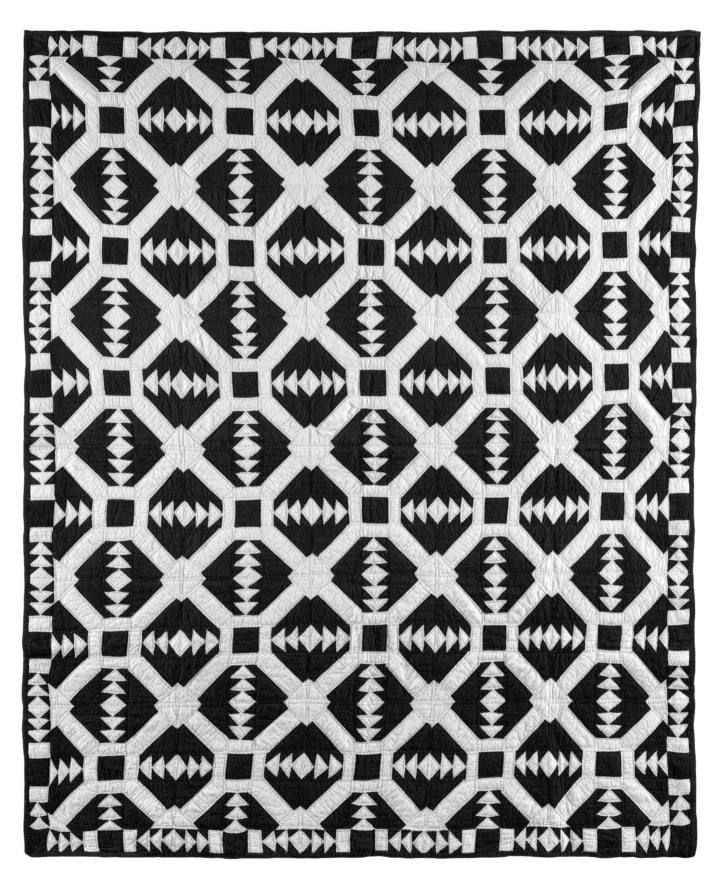

fig. 325
Broken Heart Quilt
with broken heart border,
78 x 66 inches.

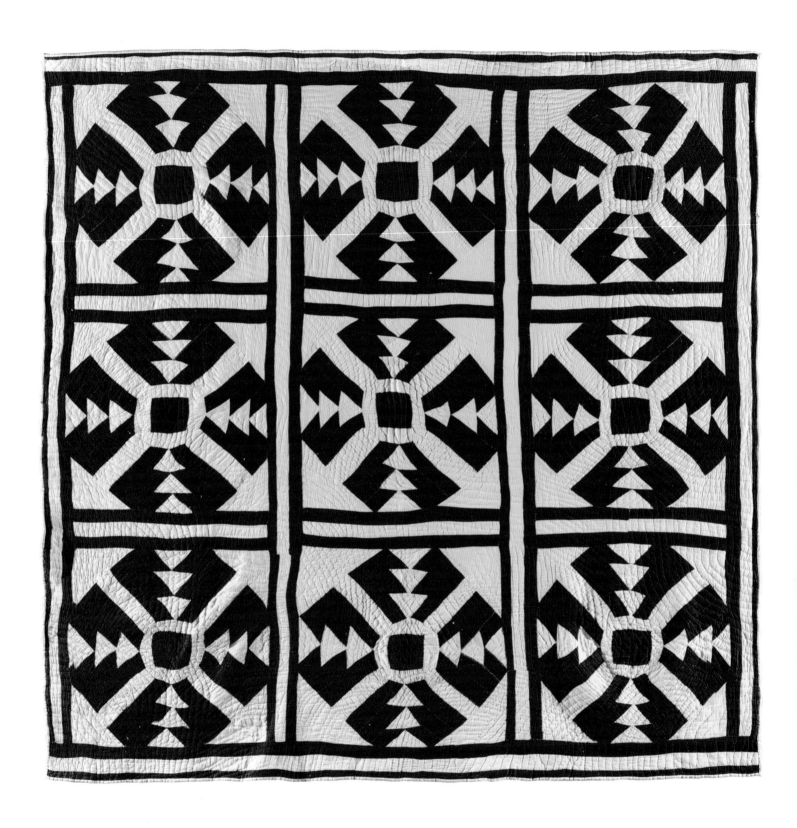

fig. 326
Broken Heart Quilt
with triple sashing,
73 ½ x 72 ½ inches.

SAWTOOTH SQUARE (figs. 329–331)
Squares bordered by sawtooth edging have a
variety of names, some of which are similar to
unrelated blocks.

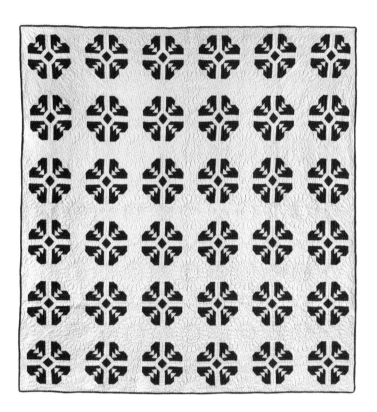

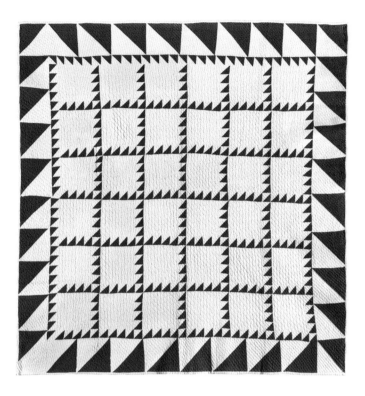

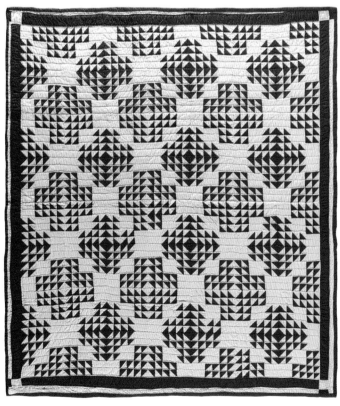

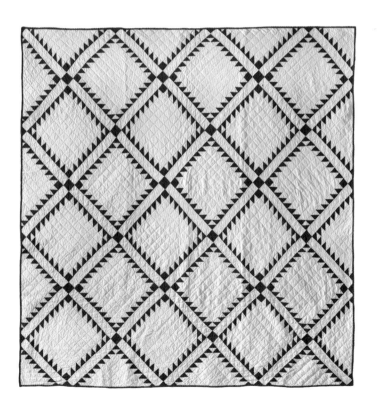

fig. 327
Broken Heart
Quilt, Maryland,
79 ½ x 74 ½ inches.

fig. 328
Geese in Flight Quilt with
double border and corner
squares, 75 x 65 ½ inches.

fig. 329
Star of Home Quilt with
wide sawtooth border,
72 x 68 inches.

fig. 330
The Pennsylvanian
Variation Quilt,
76 ½ x 73 ½ inches.

TRADITIONAL PATCHWORK QUILTS: TRIANGLES

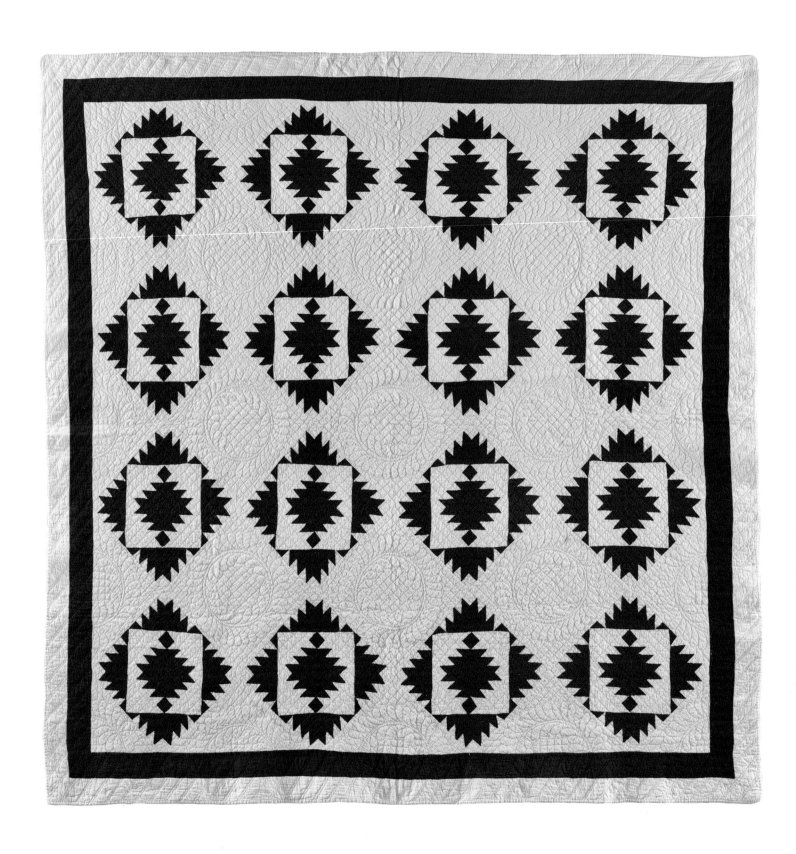

fig. 331
Delectable Mountain
Variation Quilt with setting
squares and double border,
79 x 78 inches.

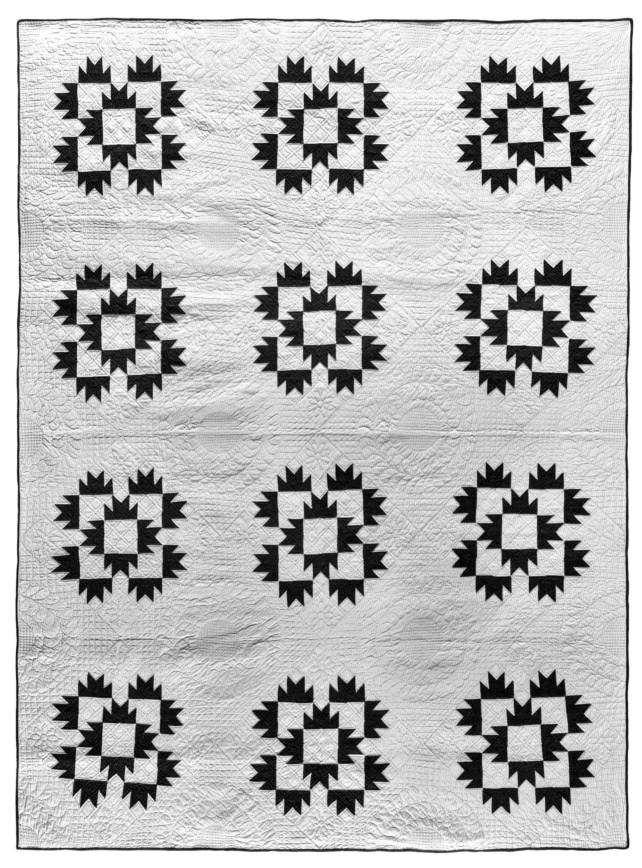

fig. 332
Twelve Crowns Quilt
with setting squares,
96 x 73½ inches.

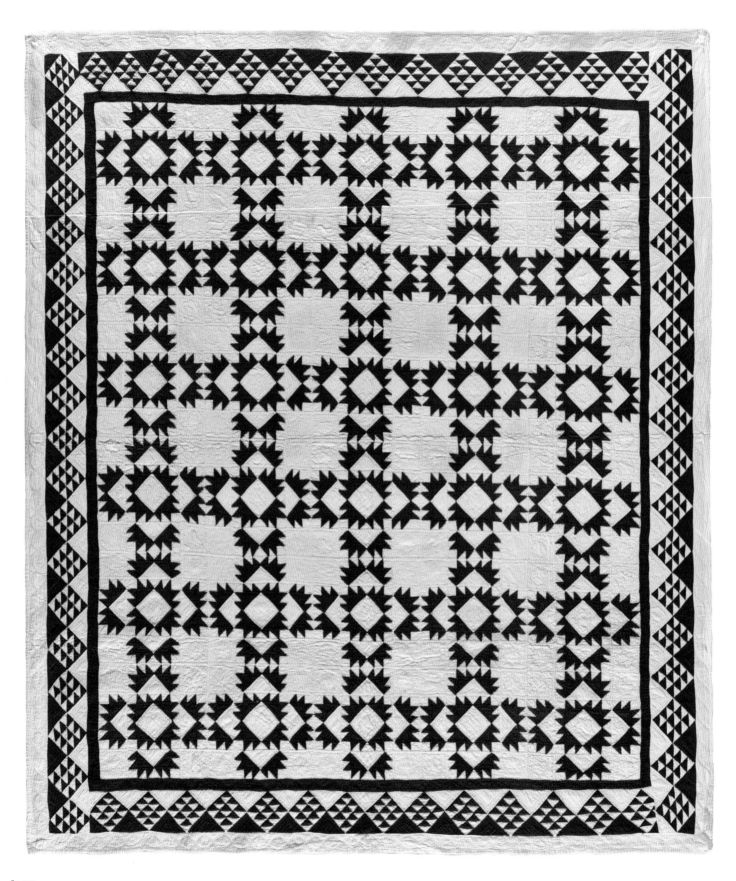

fig. 333
Twelve Crowns Quilt with
complex diamond border,
82 x 71 inches.

BARRISTER'S BLOCK (figs. 334–337)

Like most blocks, these can be set straight or turned on point for a different look. Certain ways of setting the blocks can create an hourglass shape in the secondary pattern.

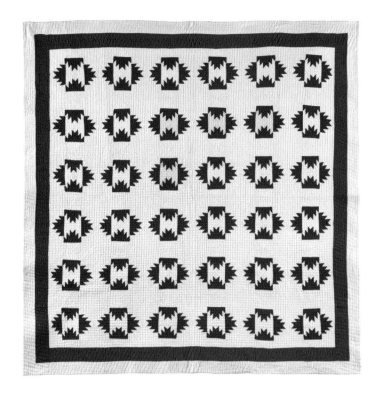

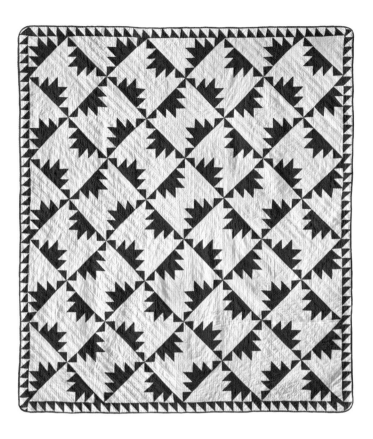

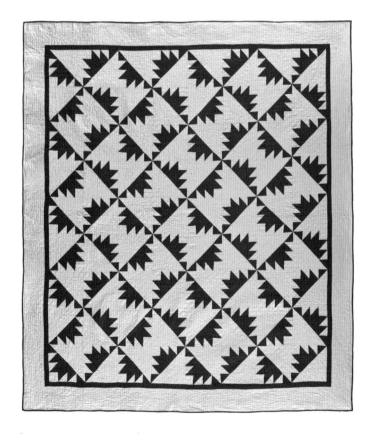

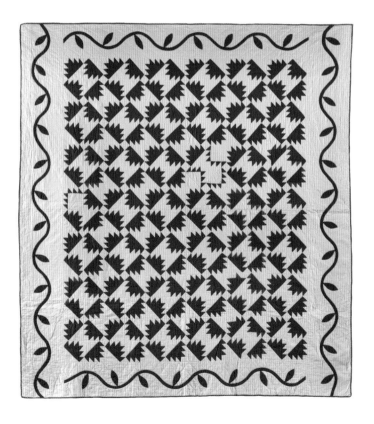

fig. 334
Barrister's Block Quilt with double border, Pennsylvania, 74 x 72½ inches.

fig. 335
Barrister's Block Quilt (Kansas Troubles Variation) with double border, western Pennsylvania, 84½ x 76½ inches.

fig. 336
Barrister's Block Quilt (Kansas Troubles Variation) with sawtooth border, 77 x 70 inches.

fig. 337
Barrister's Block Quilt with vine appliqué border, 76 x 71 inches.

CROSS (figs. 338–344)

Many patterns, such as Railroad and Lattice, form crosses when they are set together. Compare these to square-based crosses (figs. 168–172½, pages 125–126).

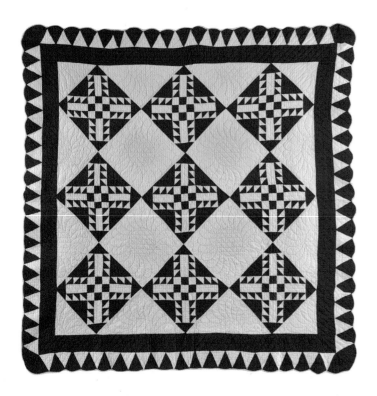

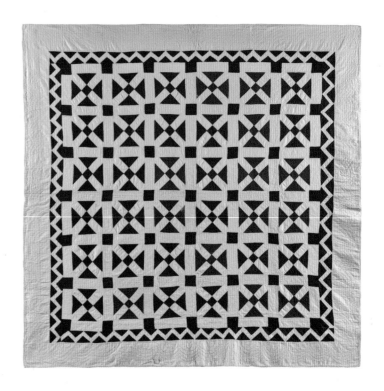

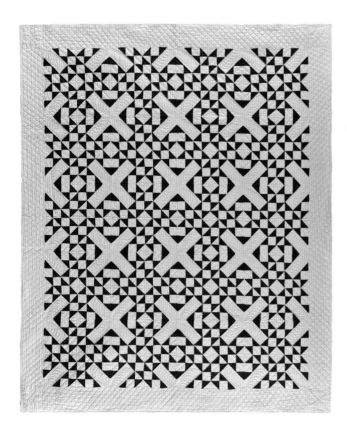

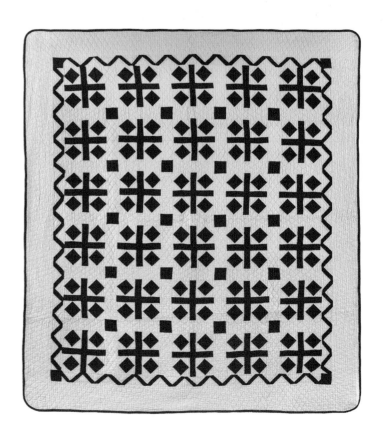

fig. 338
Upright Cross Quilt with setting squares and ice cream cone border, 78 x 77½ inches.

fig. 339
Crossroads Variation Quilt with single border, 92 x 76½ inches.

fig. 340
Red Cross Variation Quilt with zigzag inner border and single outer border, 78 x 78½ inches.

fig. 341
Red Cross Variation Quilt with zigzag inner border and single outer border, 75½ x 67 inches.

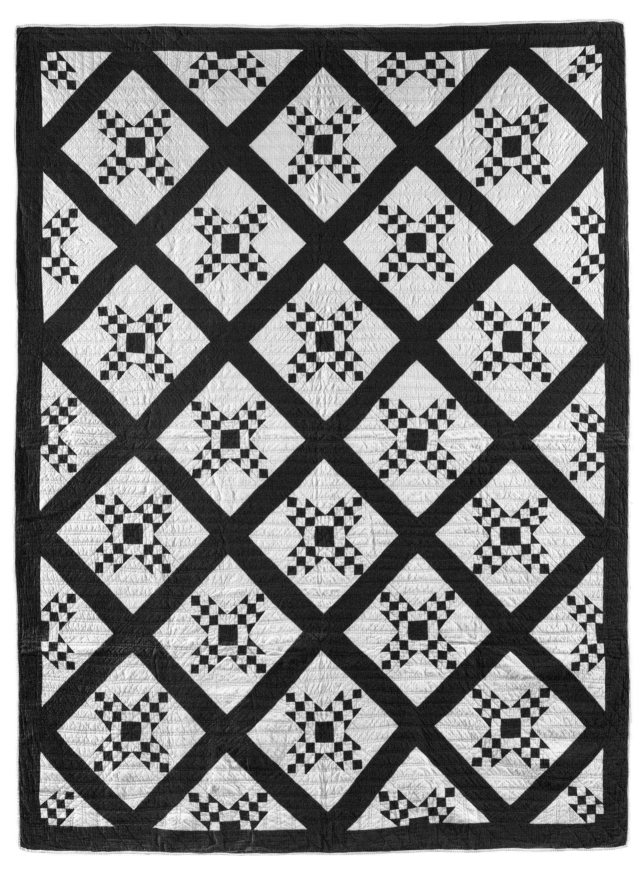

fig. 342
Crossroads Variation Quilt
with sashing and single border,
Lancaster County, Penn-
sylvania, 87½ x 66½ inches.

Unlike Pine Tree patterns, which tend to look more realistic, Pine Burr is a complex geometric block made from strips, squares, and triangles.

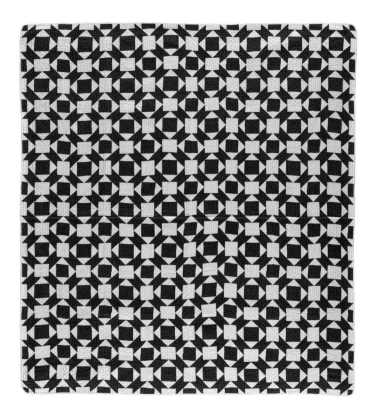

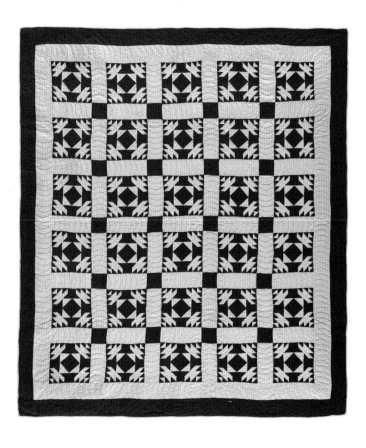

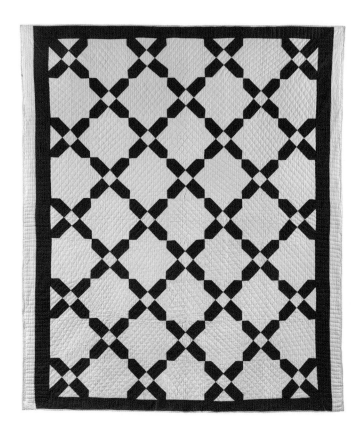

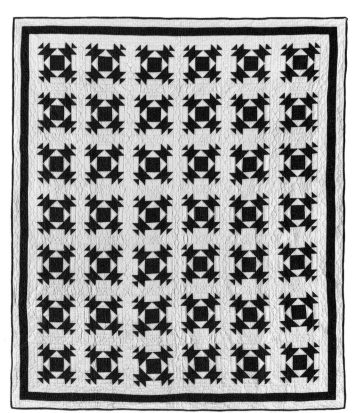

fig. 343
Square in a Square Variation
Quilt, 78 x 69 inches.

fig. 344
Grandmother's Own
Quilt with single border
and single side borders,
82½ x 70 inches.

fig. 345
Pine Burr Quilt with corner-
block sashing and double
border, 82 x 71 inches.

fig. 346
Mother's Favorite Variation
Quilt with sashing and triple
border, 84 x 72 inches.

OCTAGON (figs. 347–362)

Eight-sided shapes occur when the four corners of a square are cut off. They add a lively look to many blocks.

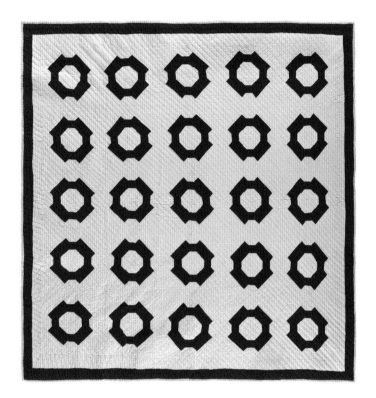

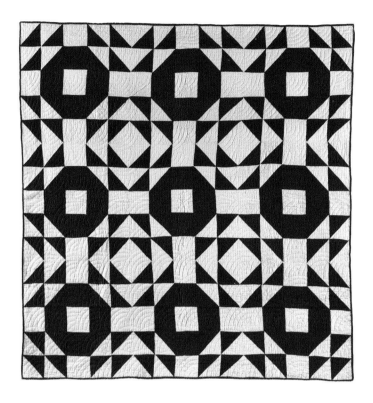

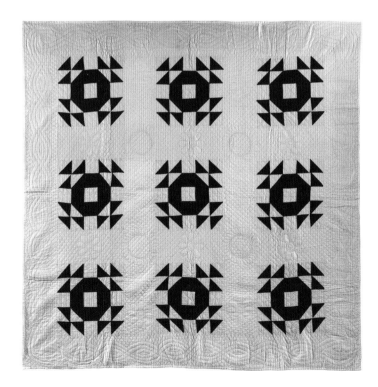

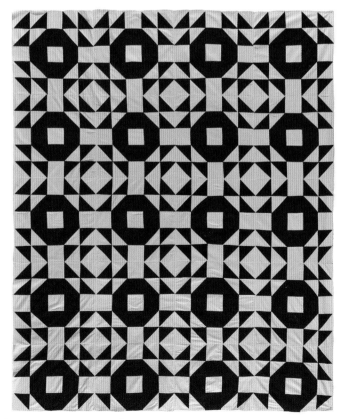

fig. 347
Unnamed Pattern Quilt with sashing and double border, 88½ x 86½ inches.

fig. 348
Crown of Thorns Quilt with wide sashing and single border, 84 x 84 inches.

fig. 349
Crown of Thorns Quilt, western Pennsylvania, 75 x 73 inches.

fig. 350
Crown of Thorns Quilt Top (unfinished), c. 1930, 87 x 72 inches.

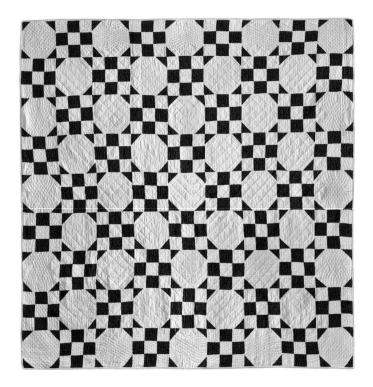

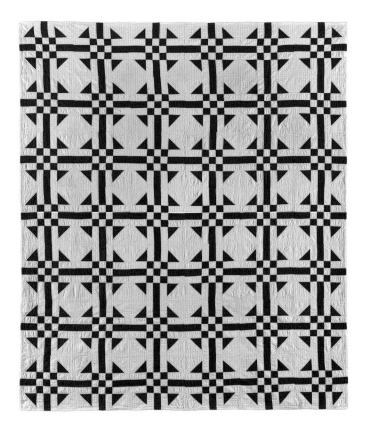

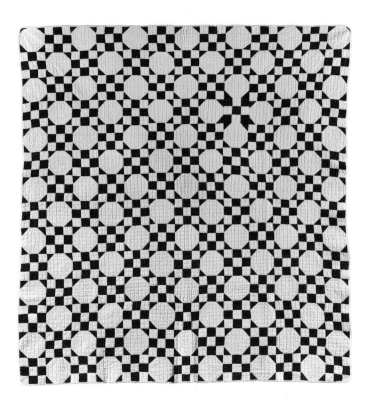

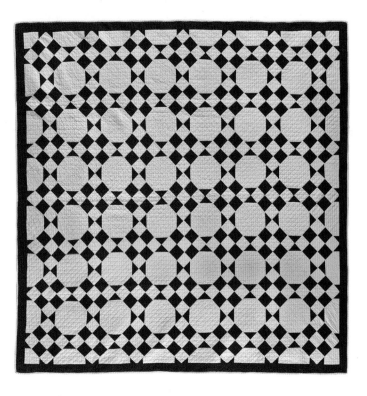

fig. 351
Nine Patch and Octagons
Quilt, 79 ½ x 77 inches.

fig. 352
Nine Patch and Octagons
Quilt, 76 ½ x 71 inches.

fig. 353
Far West Quilt,
88 ½ x 76 inches.

fig. 354
Nine Patch and Oct-
agons Quilt with single
border, New England,
75 ¼ x 73 ½ inches.

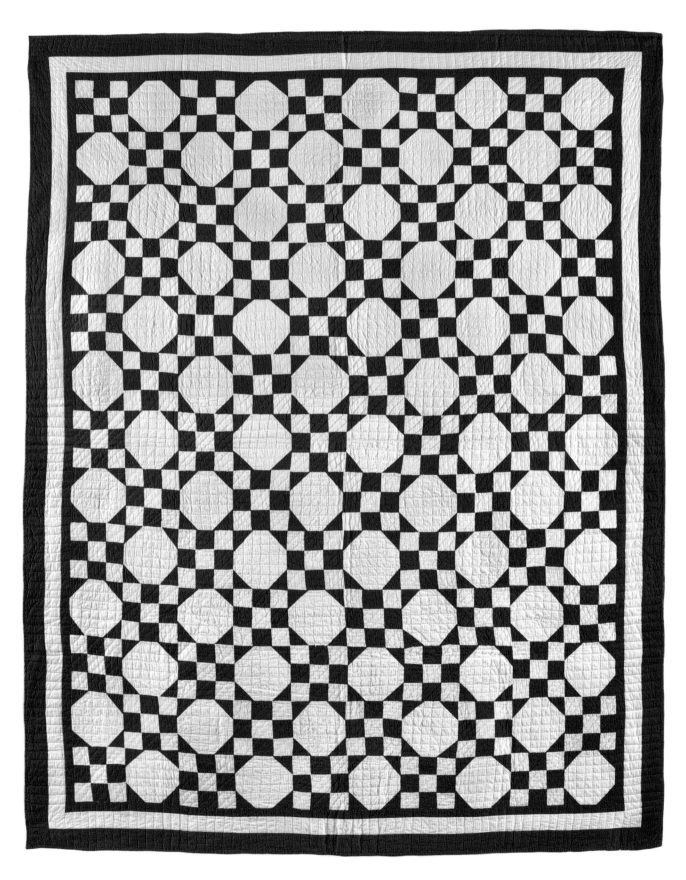

fig. 355
Nine Patch and Octagons
Quilt (Flagstone Variation)
with triple border, Kansas,
88 x 69 inches.

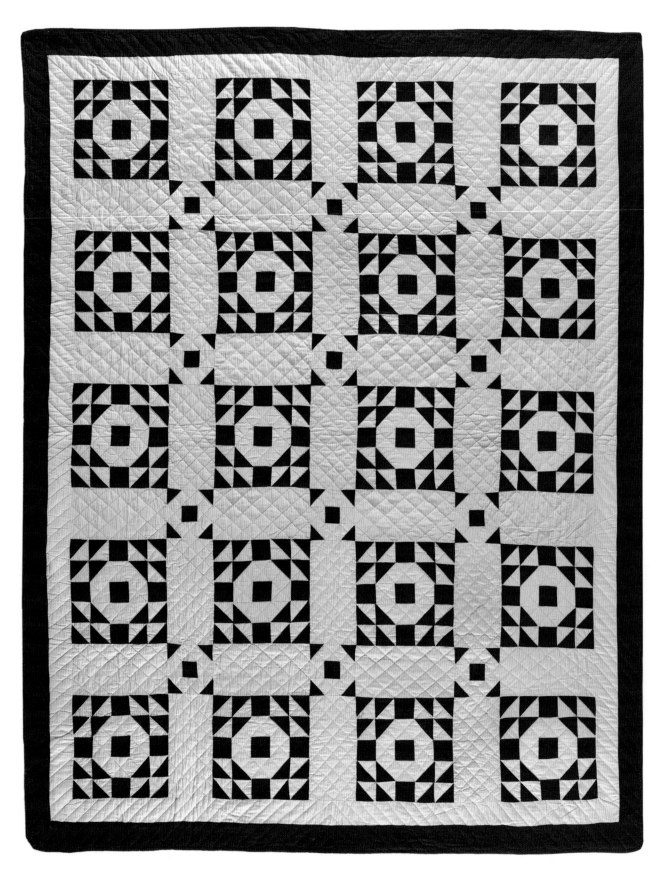

fig. 356
Crown of Thorns Quilt with
octagon corner-block
sashing and double border,
93 x 75½ inches.

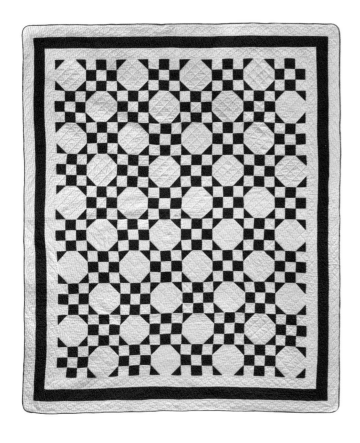

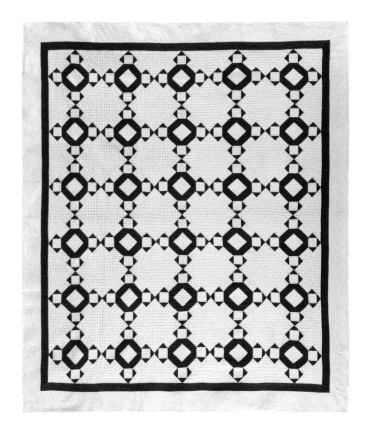

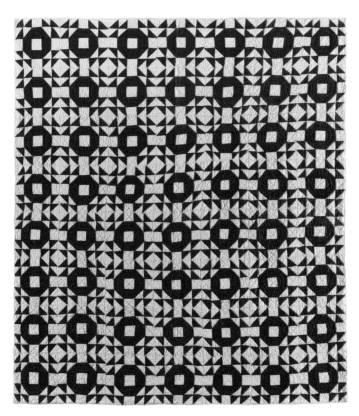

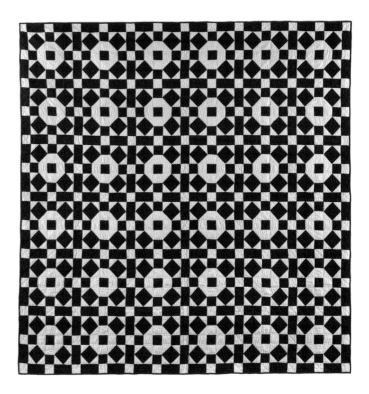

fig. 357
Nine Patch and Octagons
Quilt with triple border,
Woodward, Pennsylvania,
89 ½ x 76 inches.

fig. 358
Crown of Thorns Variation
Quilt, 76 ½ x 66 ½ inches.

fig. 359
Rolling Stone Variation Quilt
with double border, c. 1860,
83 ¼ x 72 ½ inches.

fig. 360
Rolling Stone Variation
Quilt, 82 ½ x 81 ½ inches.

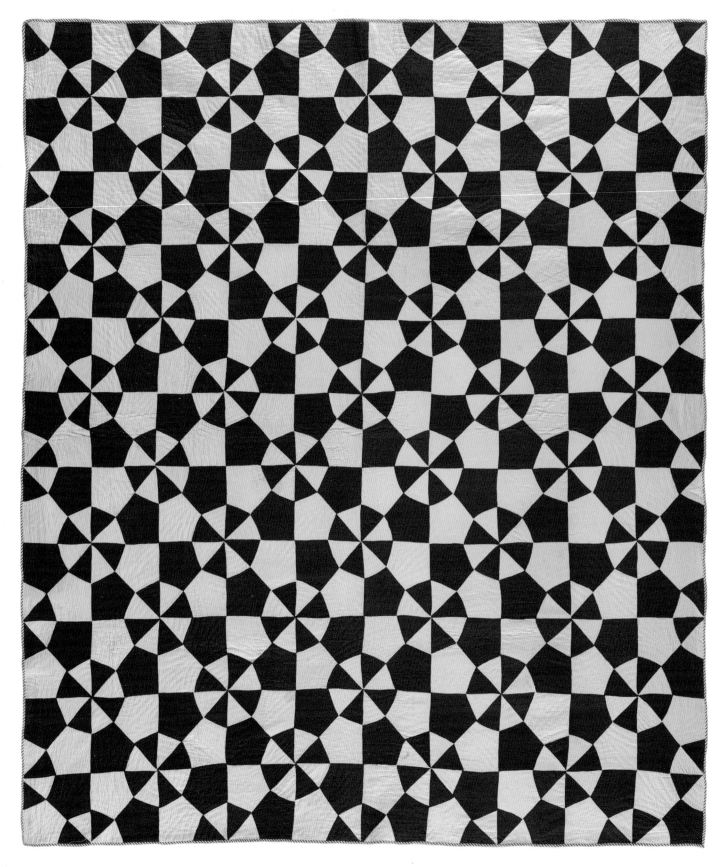

fig. 361
Unnamed Octagon Pattern
Quilt, 75 ½ x 70 inches.

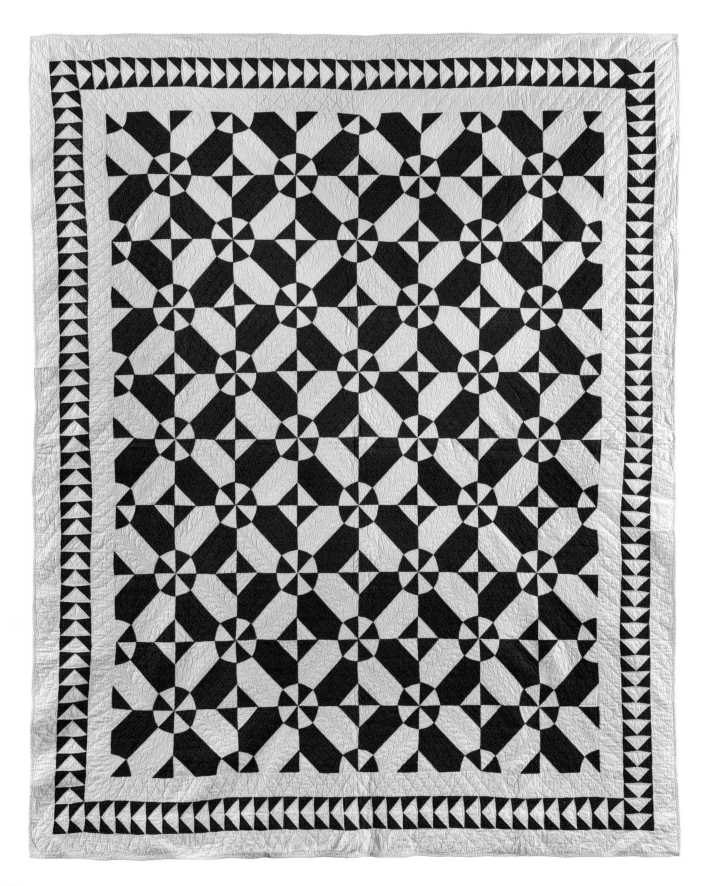

fig. 362
Old Maid's Comb Quilt with
wild goose chase border,
Texas, 86 ½ x 71 ½ inches.

Traditional Patchwork Quilts: Stars

There are probably more named patchwork Star patterns than any other category. To make stars requires pointed shapes—either triangles or diamonds—and many Star patterns can be tricky to sew. The quilts in this chapter have been divided into groups depending on the number of points in the star or on the style of construction.

By the late 1700s, stars—which can be as simple as those with four points or as complex as a many-pointed Mariner's Compass—began to appear frequently in American quilts. This may have been a response, in part, to the use of five-point stars found in the flag of the newly formed United States after the end of the American Revolution in 1783.

Wholetop quilts in the early nineteenth century were often made with a single large eight-point star as a medallion in the center with borders framing the main motif (figs. 41–42, page 61, are examples). As the century progressed, the popularity of star patterns increased, with red and white versions seen more and more. Some of the quilts in the collection are made with printed reds (figs. 410–411, pages 230–231), but the availability of stable red dye meant that vast numbers were fashioned from solid reds of varying intensity.

Stars with an even number of points are simpler to piece than the five-point version, which is usually worked in appliqué, and so they became more widespread as design elements. Half-square triangles—those divided diagonally into two halves, one of each color—form the basis for many eight-point star designs, whereas diamonds are the building blocks for many four-point stars, Lone Star quilts, and most six-point stars such as Seven Sisters (fig. 46, page 63).

A number of Star patterns are named for a specific person or event. Dolley Madison, wife of the fourth president of the United States, has a star named for her, as does the unknown Barbara Bannister—perhaps she created the design named for her? The LeMoyne Star, sometimes called Lemon Star, is thought to have been named for Jean-Baptiste and Pierre Le Moyne, the early nineteenth-century founders of New Orleans; and the Lone Star commemorates the Republic of Texas—the design was incorporated into the state flag when Texas joined the Union in 1845.

Stars created in red and white combinations are striking, and the effect can change depending on how the two colors are positioned. The same block can look completely different when one color is dominant.

The mathematics of creating a four-point star often (but not always) mean that the negative or white space results in octagons (fig. 368, page 212, is an excellent example).

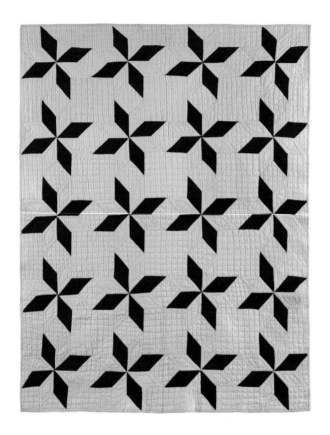

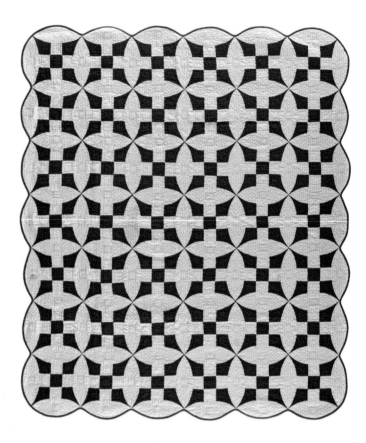

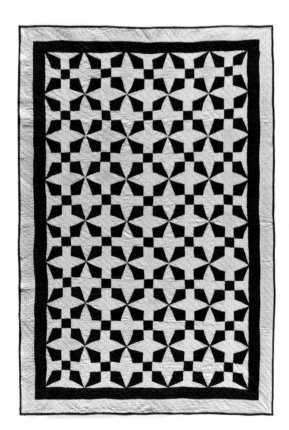

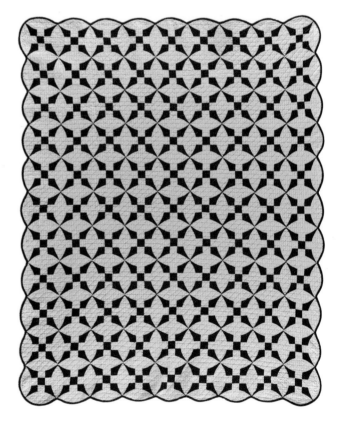

fig. 363
Florentine Diamond Quilt,
96 ½ x 59 inches.

fig. 364
Maltese Cross Quilt (Improved
Nine Patch Variation) with
double border, 89 x 61 inches.

fig. 365
Maltese Cross Quilt (Improved
Nine Patch Variation) with
scalloped border, c. 1930,
80 x 69 inches.

fig. 366
Maltese Cross Quilt (Improved
Nine Patch Variation)
with scalloped edge, c. 1930,
91 x 74 inches.

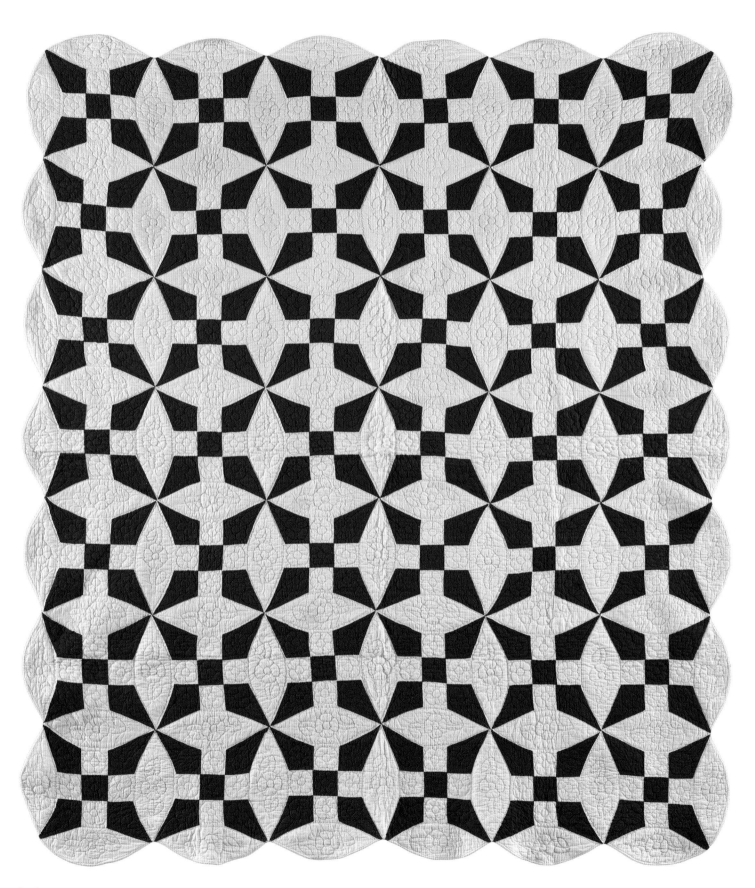

fig. 367
Maltese Cross Quilt (Improved Nine Patch Variation) with scalloped edge, c. 1930, 80 x 72 inches.

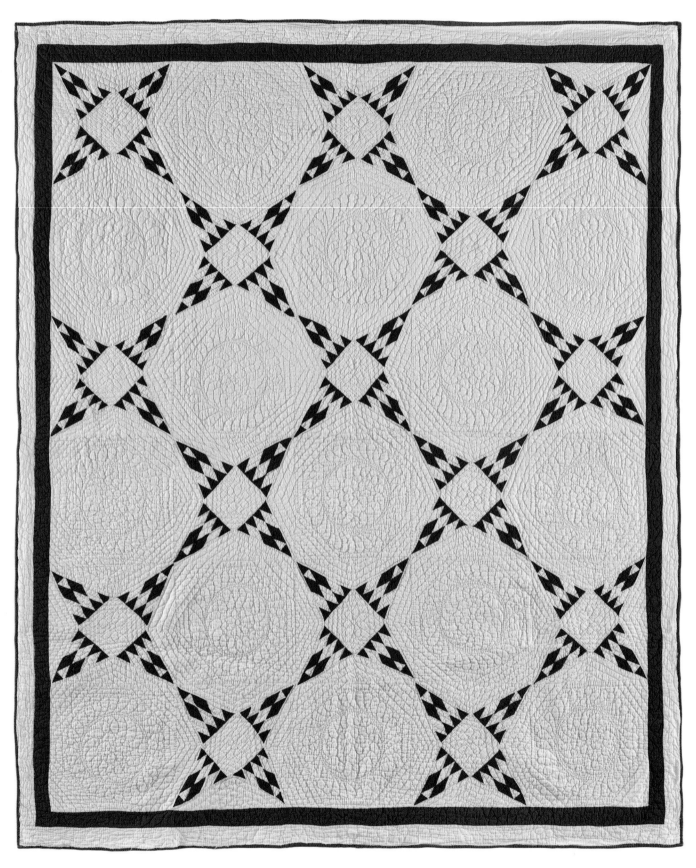

fig. 368
Lost Children Quilt (Four-
Point Stars Variation) with
double border, signed "Clara
Stone," 74 x 62½ inches.

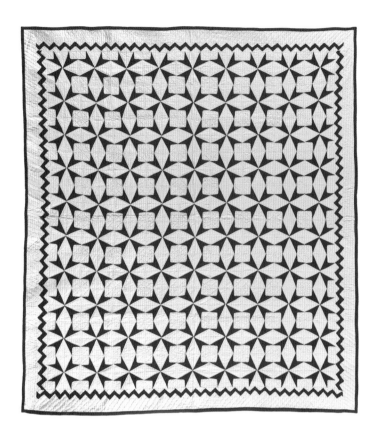

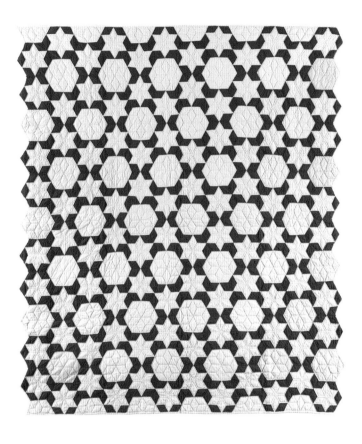

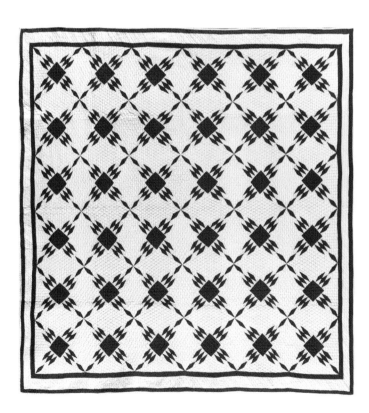

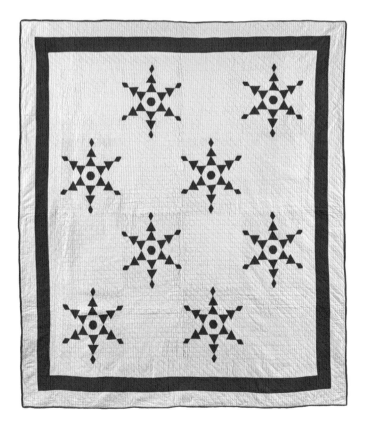

fig. 369
Four Petals Quilt with zigzag inner border, 87 x 77 inches.

fig. 370
Rockingham's Beauty Quilt with triple border, 76 ½ x 71 ½ inches.

fig. 371
Tumbling Stars and Hexagons Quilt with shaped side edges, Lancaster County, Pennsylvania, 84 x 72 inches.

fig. 372
Stylized Stars Quilt with setting squares and double border, 86 ½ x 77 ½ inches.

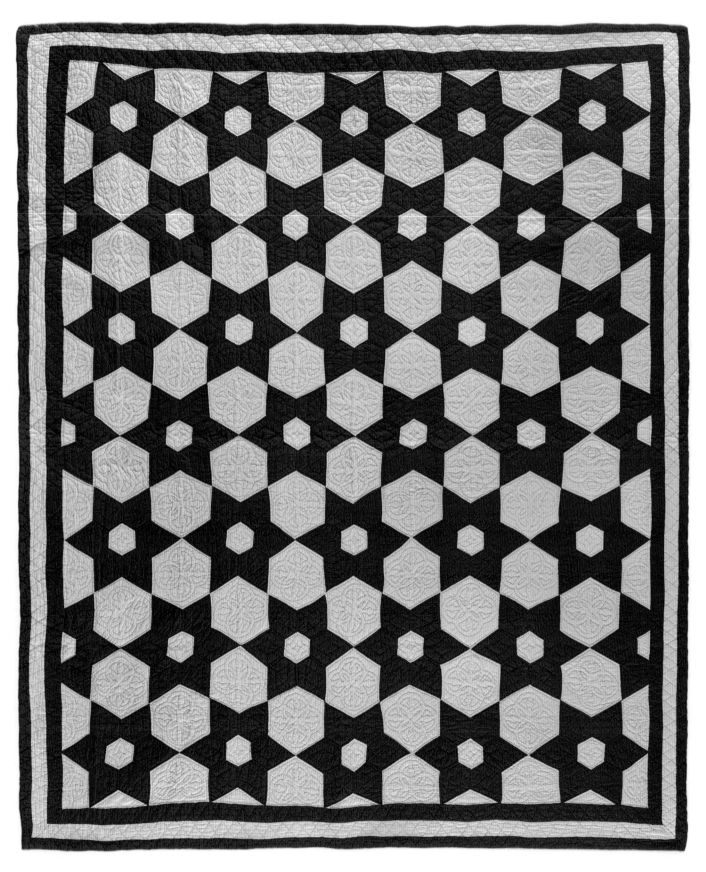

fig. 373
Texas Stars Quilt with
triple border, c. 1930–1940,
80 x 66½ inches.

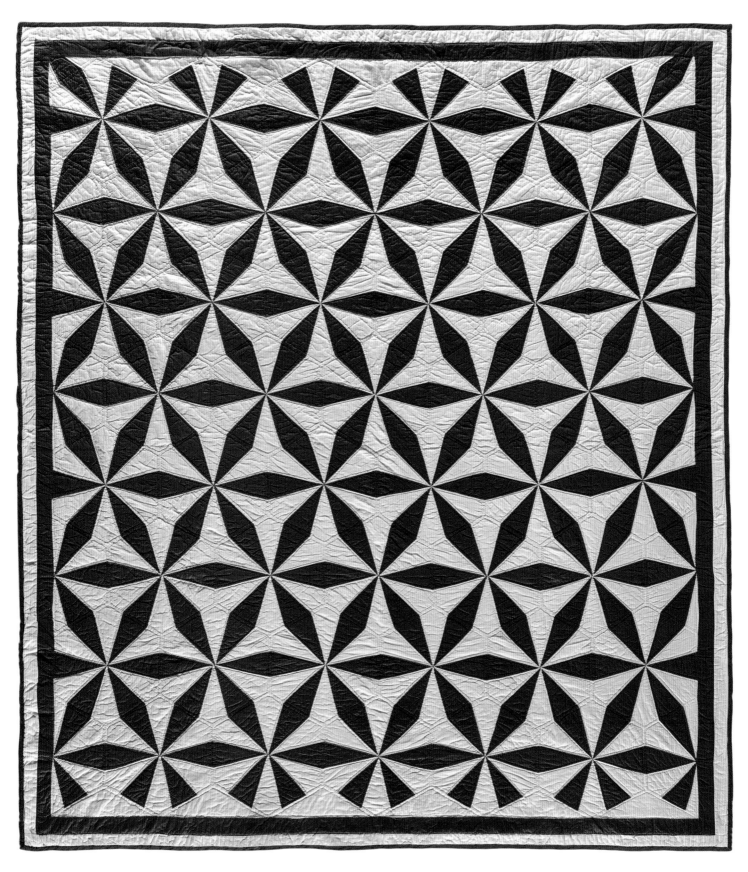

fig. 374
Diamond Stars Variation
Quilt with double border,
81½ x 73 inches.

SIX-POINT STAR

Eight-point stars are the most numerous examples, and many, such as Ohio Stars, are nine-patch blocks. Some are composed entirely of triangle squares.

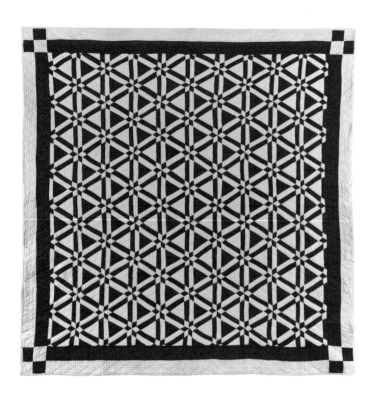

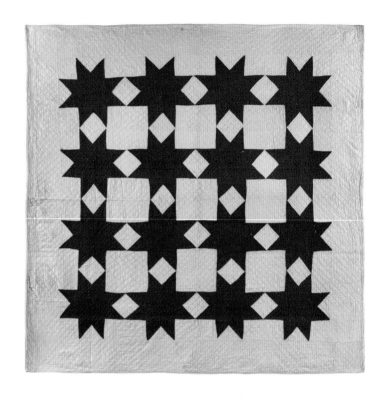

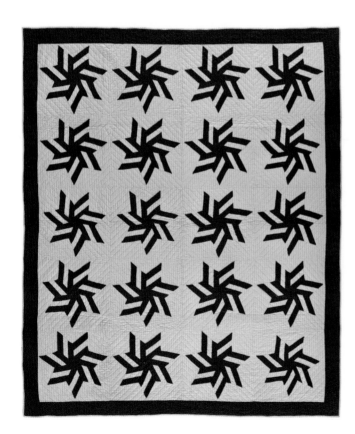

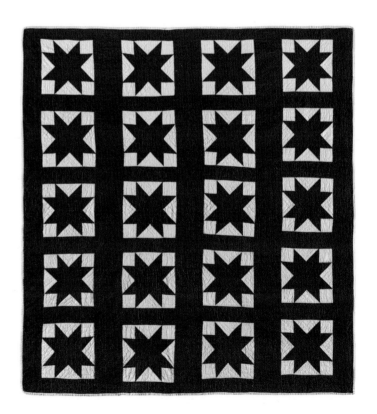

fig. 375
Six-Point Stars and Triangles Quilt with double border and four patch corner blocks, 81 x 80 inches.

fig. 376
Liberty Stars Quilt with single border, 89 x 76 inches.

fig. 377
Simple Eight-Point Stars Quilt with wide border, 82 x 81 inches.

fig. 378
Simple Eight-Point Stars Quilt with sashing and single border, 75½ x 70 inches.

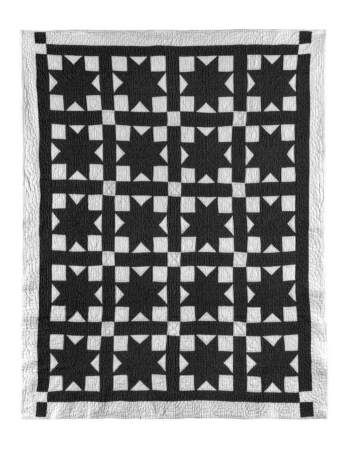

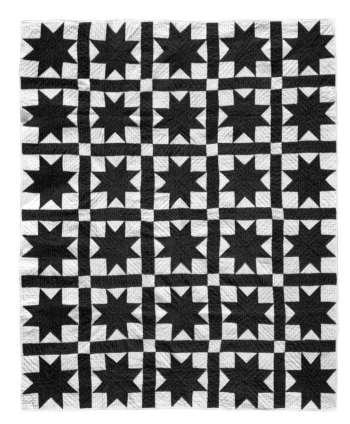

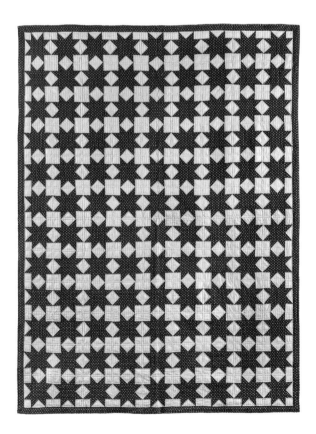

fig. 379
Simple Eight-Point Stars
Quilt with corner block
sashing and single border,
77 x 61 inches.

fig. 380
Simple Eight-Point Stars
Quilt with corner-block
sashing, 85 x 72 inches.

fig. 381
Simple Eight-Point Stars
Quilt with setting squares
and quadruple border,
68 x 65 inches.

fig. 382
Simple Eight-Point Stars
Quilt with single border,
90 ½ x 68 ½ inches.

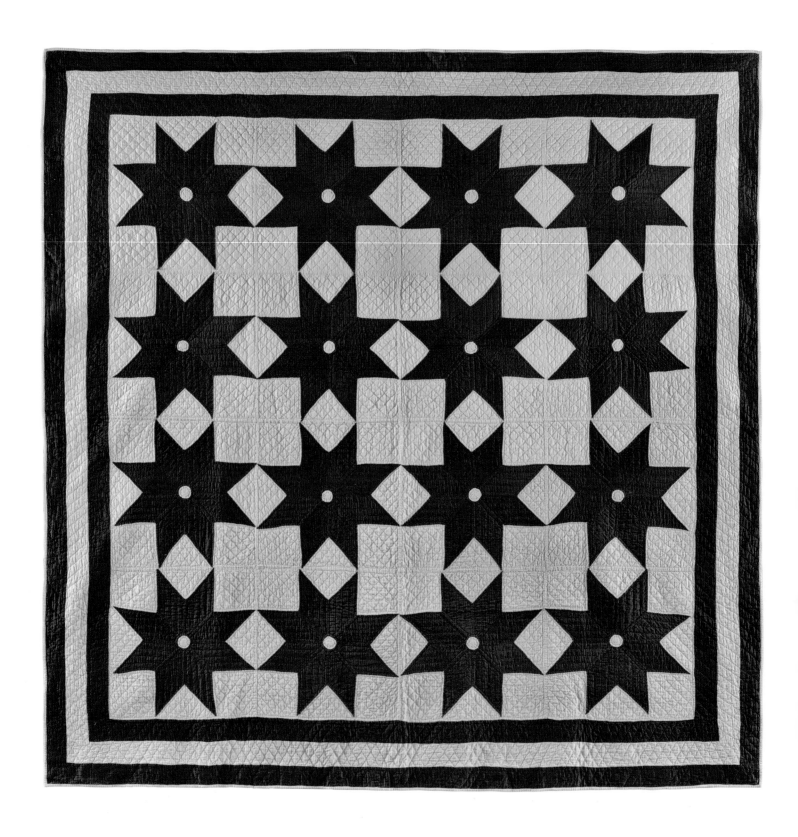

fig. 383
Simple Eight-Point
Stars Quilt with appliqué
center and triple border,
78 x 76 inches.

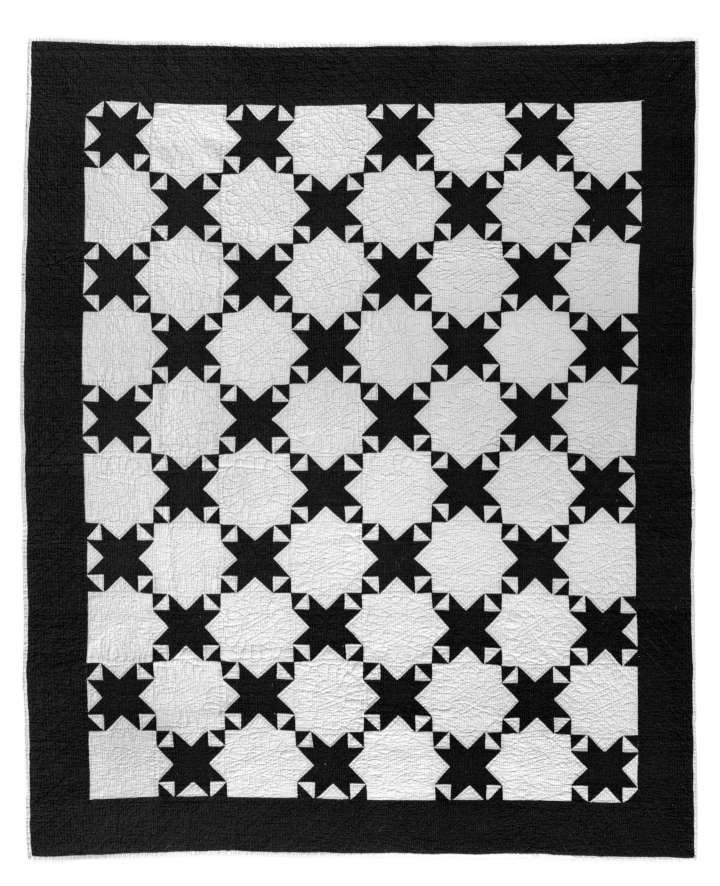

fig. 384
Eight-Point Stars and
Hourglass Chain Quilt
with single border, c. 1930,
76¾ x 66¼ inches.

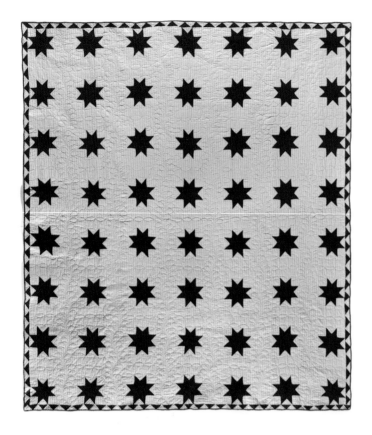

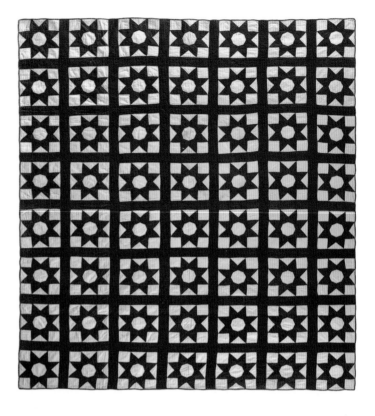

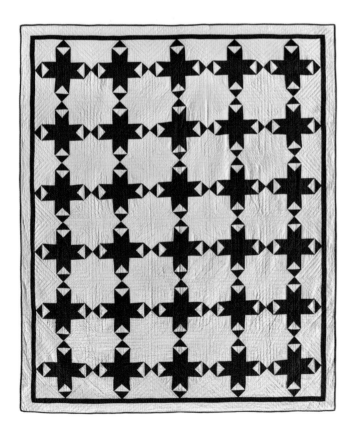

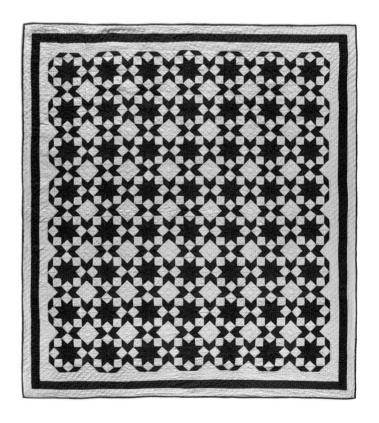

fig. 385
Simple Eight-Point Stars
Quilt with triangle border,
1860–1890, 85 x 75 inches.

fig. 386
Magic Stars Quilt with
double border, western
Pennsylvania, 91 x 77 inches.

fig. 387
Eight-Point Stars Quilt with
center octagon and sashing,
90 x 78 inches.

fig. 388
Rolling Stars Quilt (Star of
Bethlehem Variation) with
triple border, York, Penn-
sylvania, 85 x 79 inches.

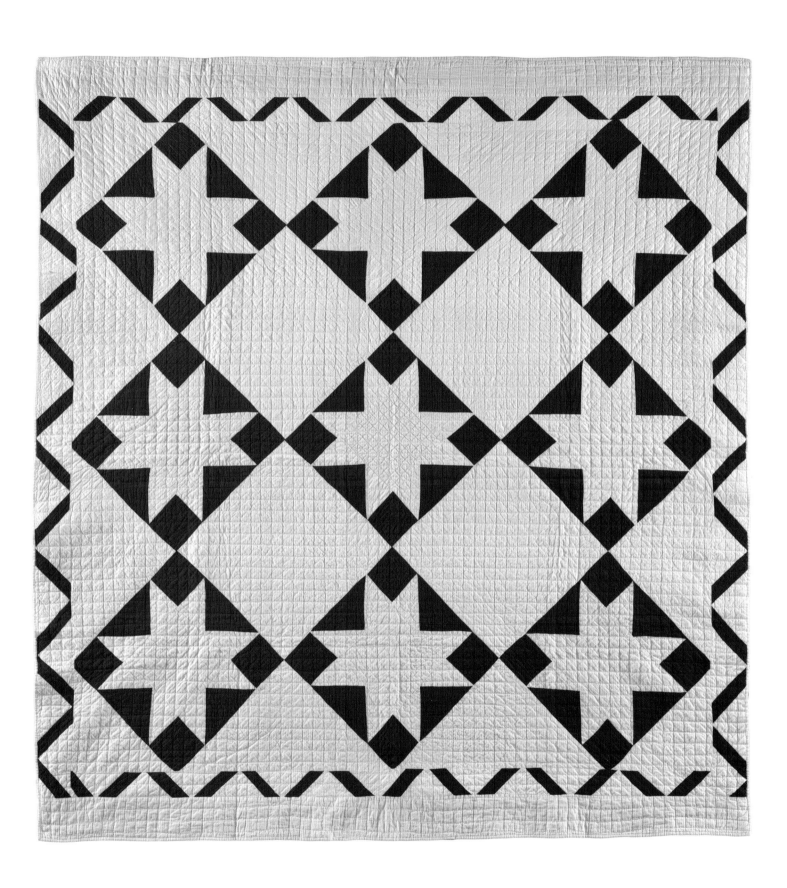

fig. 389
Simple Eight-Point Stars
on Point Quilt with setting
squares and interlaced
border, 75 x 71½ inches.

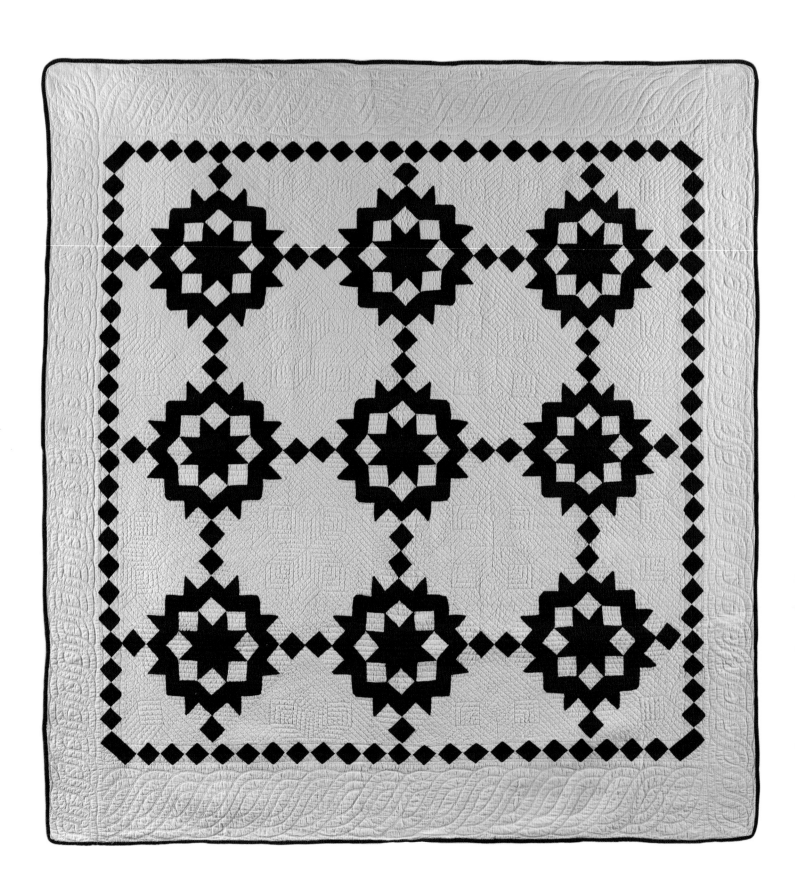

fig. 390
Carpenter's Wheel Quilt
(Star of Bethlehem Variation)
with diamond inner border,
Ohio, 82 x 77 inches.

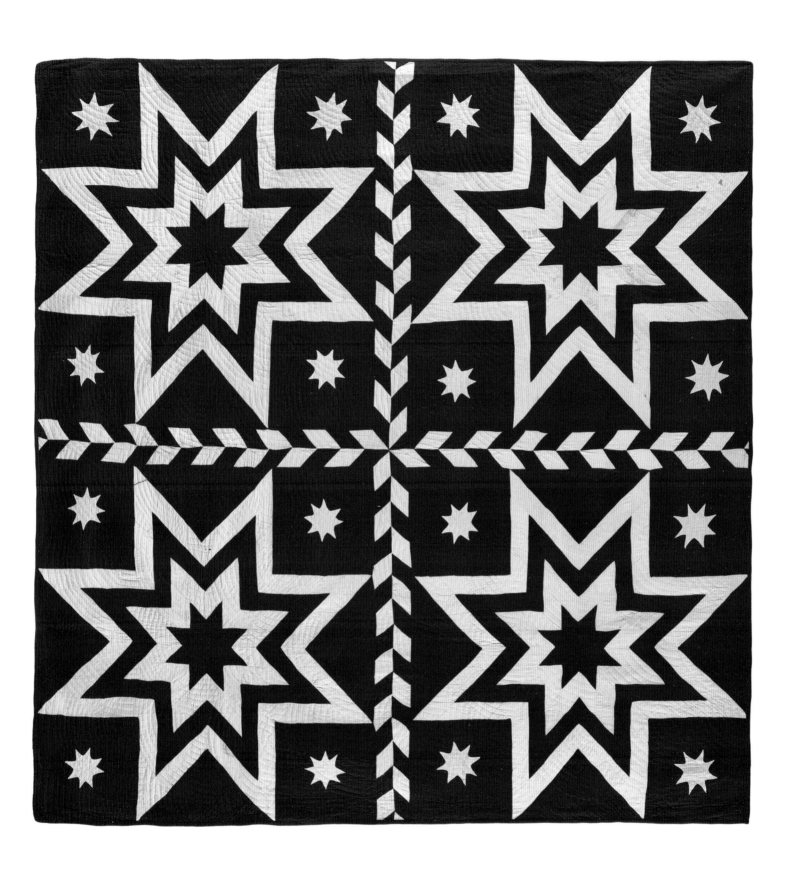

fig. 391
Exploding Simple Stars
Quilt (Star and Chevron
Variation) with complex

sashing, signed "Mary
Pallace," Brockport, New
York, 90 x 88½ inches.

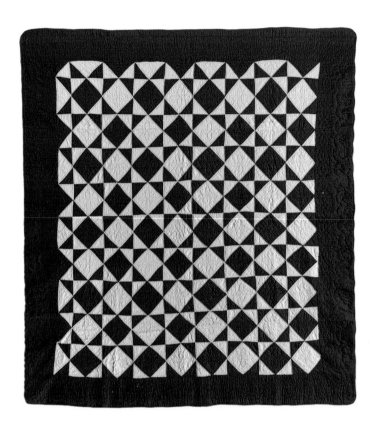

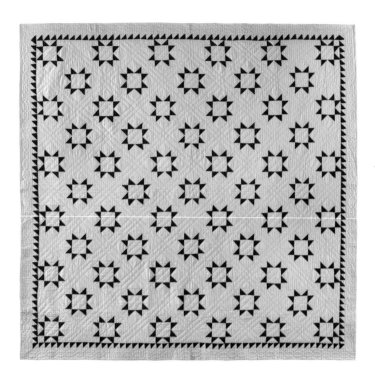

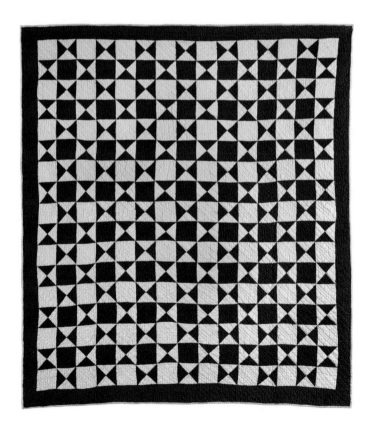

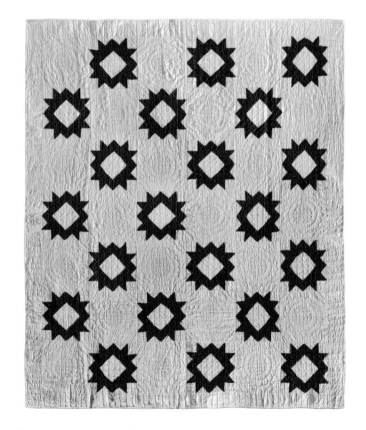

fig. 392
Square in a Square
Quilt (Shoofly Stars and
Diamonds/Ohio Stars

Variations) with
single border, Ohio,
81½ x 72 inches.

fig. 393
Square and Hourglass
Quilt with single border,
79 x 70½ inches.

fig. 394
Evening Stars Quilt with
setting squares and sawtooth
inner border, Pittsburgh,
Pennsylvania, 81 x 80 inches.

fig. 395
Arrowhead Stars
Quilt (Diamond Star
Variation), Pennsylvania,
75 x 63½ inches.

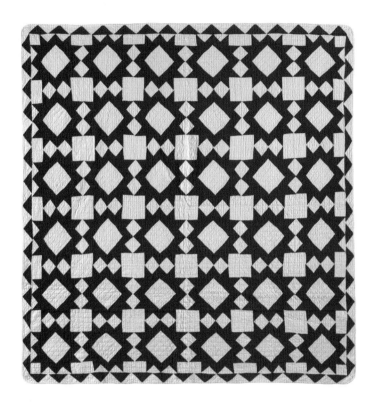

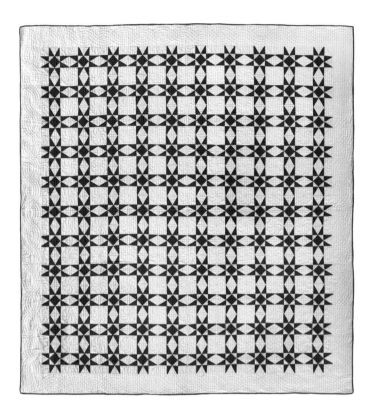

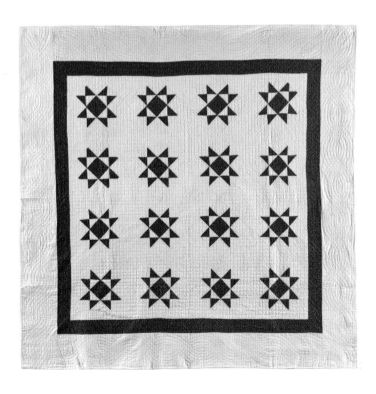

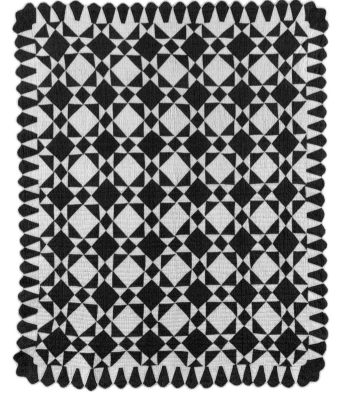

fig. 396
Arrowhead Stars Quilt
with triangle border,
67 ½ x 64 ½ inches.

fig. 397
Ohio Stars Quilt with double
border, 73 ½ x 73 ½ inches.

fig. 398
Ohio Stars Quilt with single
border, 91 ½ x 85 inches.

fig. 399
Aunt Eliza's Stars Quilt
(Diamonds and Stars
Mosaic Variation) with ice

cream cone edge, mid-
western United States,
81 x 67 inches.

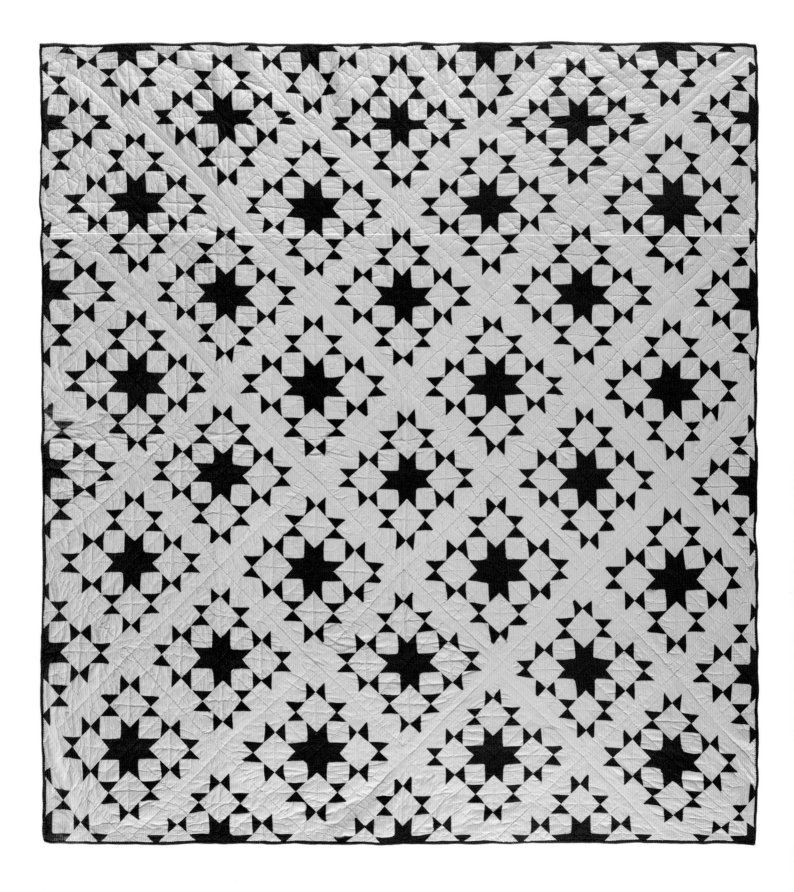

fig. 400
Complex Eight-Point Stars
Quilt, 75 ½ x 68 inches.

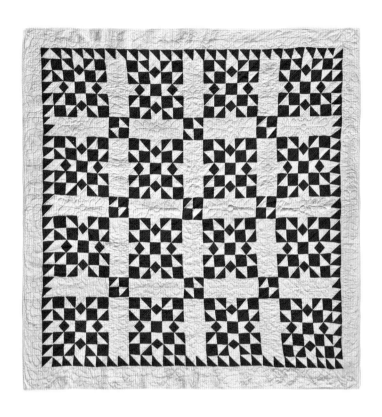

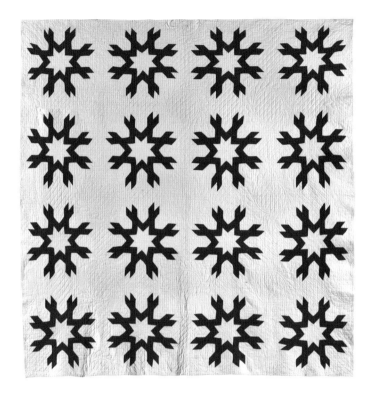

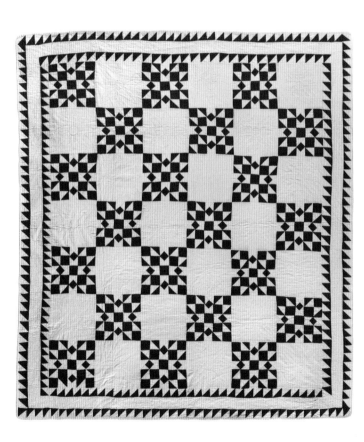

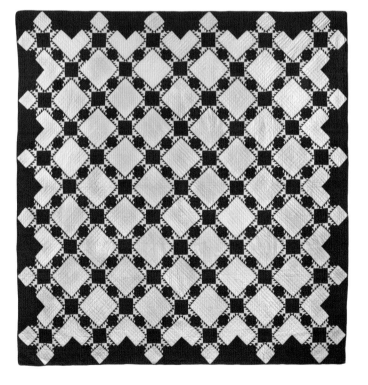

fig. 401
Presentation Stars Blocks
Quilt with sawtooth
border, Texas, c. 1930,
81 x 78½ inches.

fig. 402
Mosaic Stars Quilt with
double sawtooth border,
Washington County, Penn-
sylvania, 79½ x 70½ inches.

fig. 403
Eight-Point Stars Variation
Quilt, 74 x 72 inches.

fig. 404
Feathered Eight-Point Stars
Quilt, 86 x 84 inches.

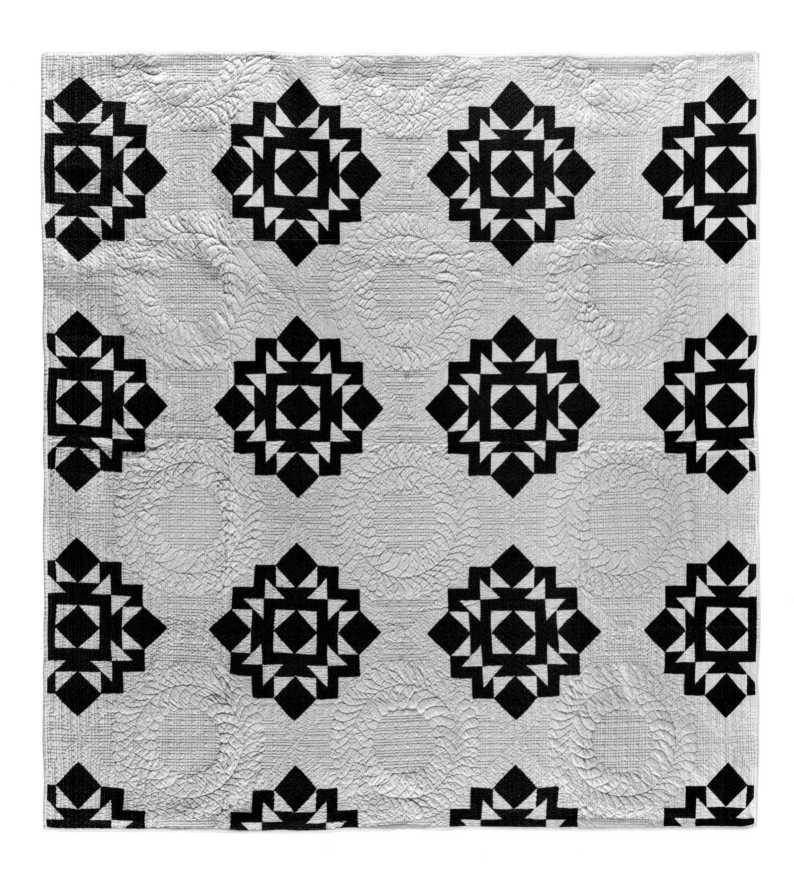

fig. 405
Evening Star Quilt
(Morning Star Variation)
with setting squares,
78 ½ x 75 inches.

LONE STAR (figs. 406–413)

Lone Star patterns begin with a central star and radiate outward in concentric rows of diamonds. See also the wholetop Lone Star examples (figs. 47–51, pages 64–65).

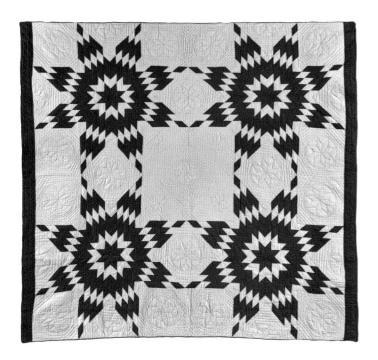

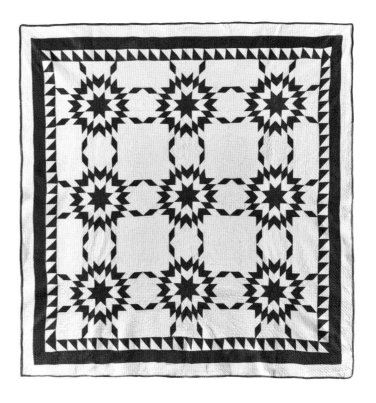

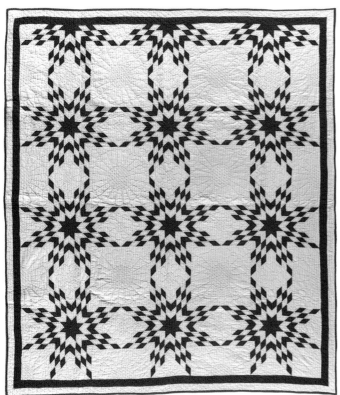

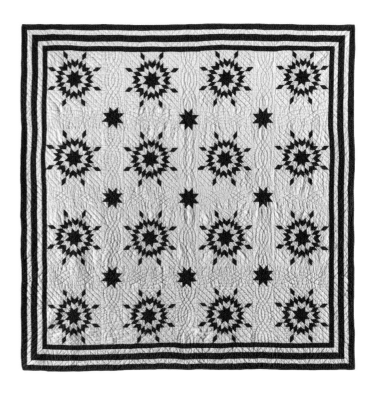

fig. 406
Touching Lone Stars Quilt
with single side borders,
c. 1930, 87 x 80 ½ inches.

fig. 407
Touching Lone Stars
Quilt with double border,
84 x 73 inches.

fig. 408
Star of Bethlehem Quilt
with sawtooth inner border
and double outer border,
82 x 80 inches.

fig. 409
Star of Bethlehem and
Eight-Point Stars Quilt
with quintuple border,
75 x 75 inches.

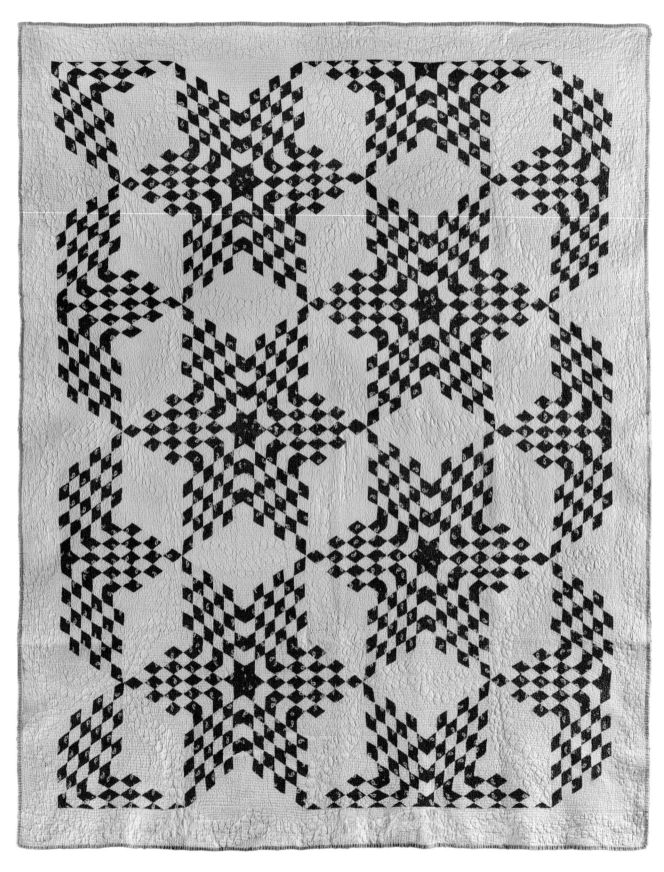

fig. 410
Touching Six-Point Lone
Stars Quilt with single
border, 90 x 71 inches.

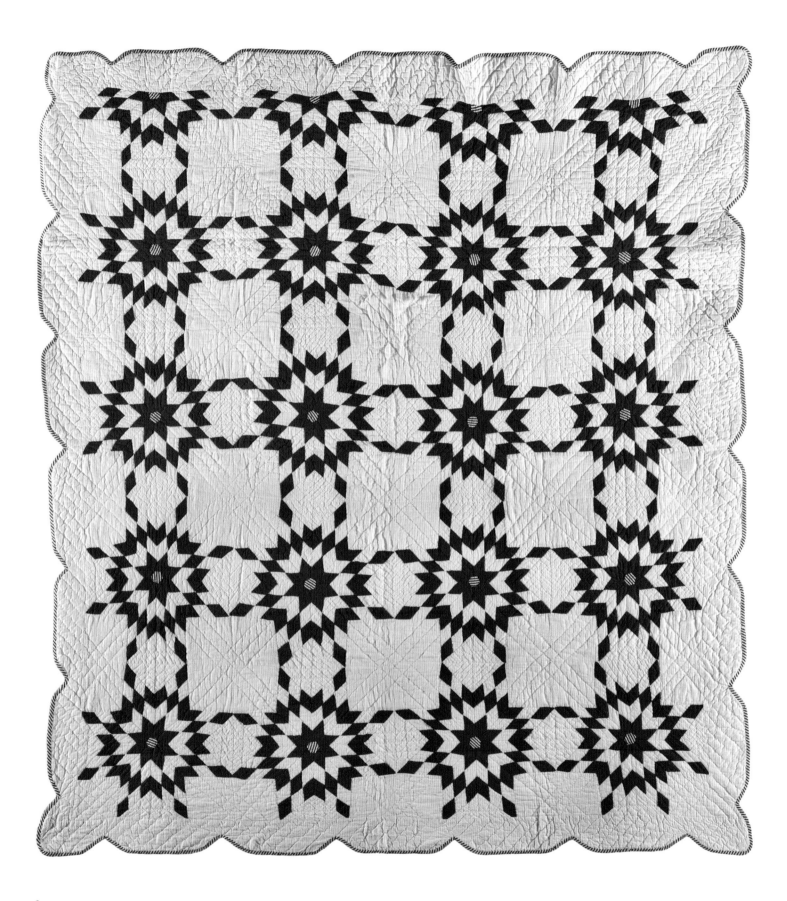

fig. 411
Star of Bethlehem Quilt with
shaped edge, 70 x 63 inches.

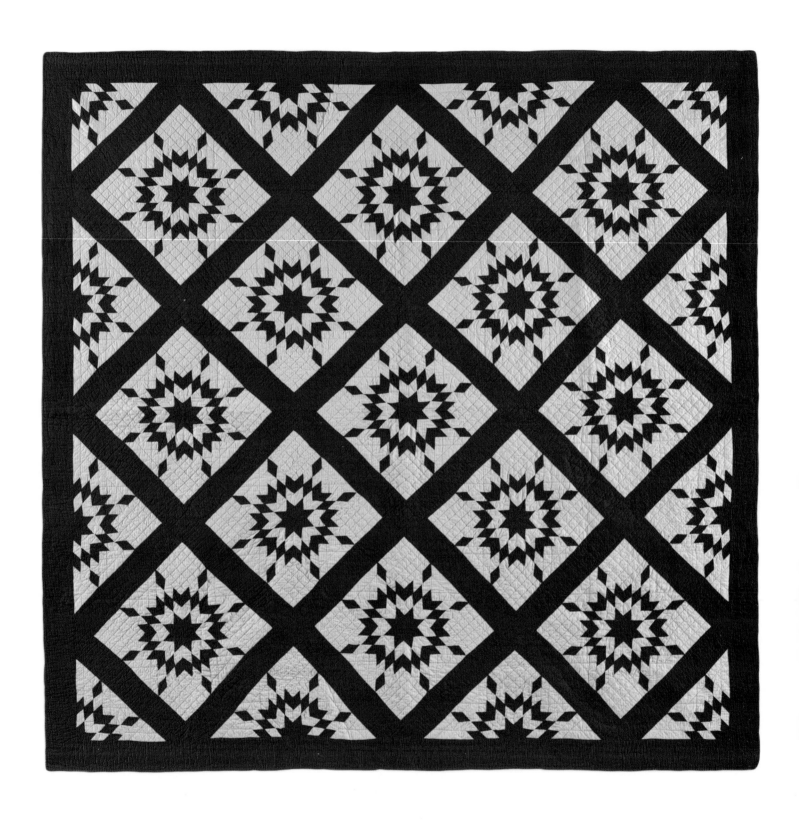

fig. 412
Star of Bethlehem on
Point Quilt with sashing
and single border,
79 ½ x 77 ½ inches.

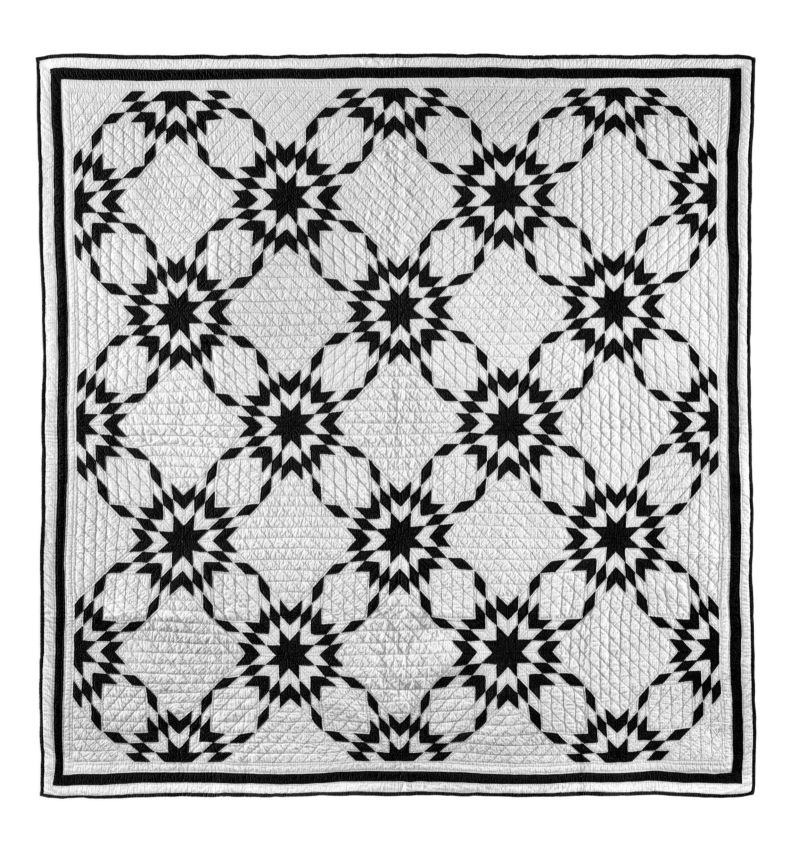

fig. 413
Star of Bethlehem Quilt with
triple border, 76 x 74 inches.

FEATHERED STAR (figs. 414–432)
Edging stars of any number of points with tiny
triangles creates intricate designs that dance across
the surface of a quilt and conjure movement.

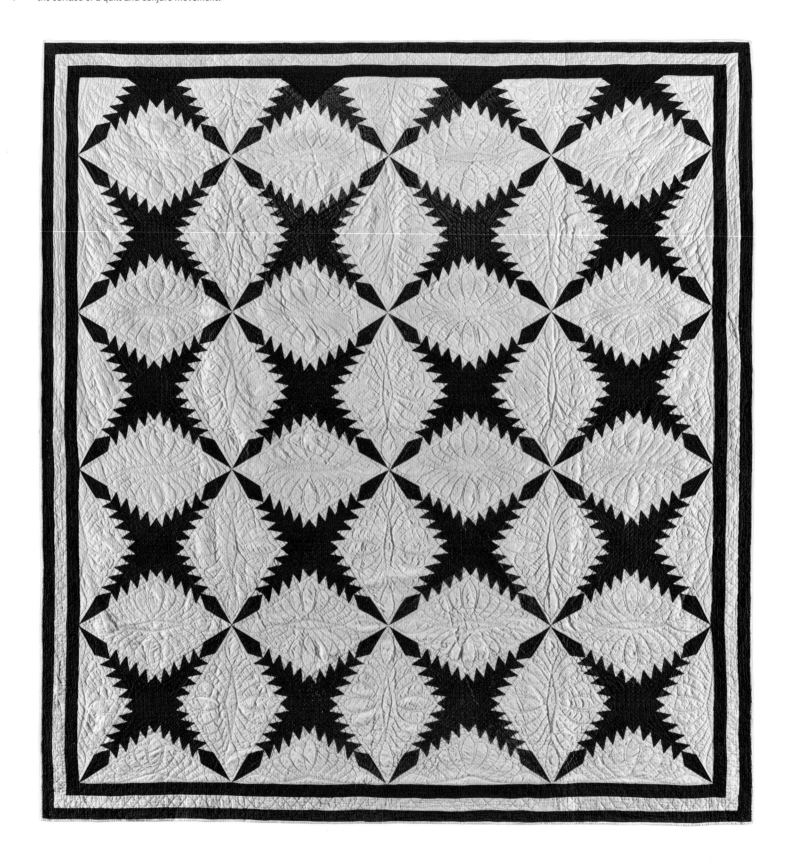

fig. 414
Feathered Four-Point
Stars Quilt with triple
border, 88 x 80½ inches.

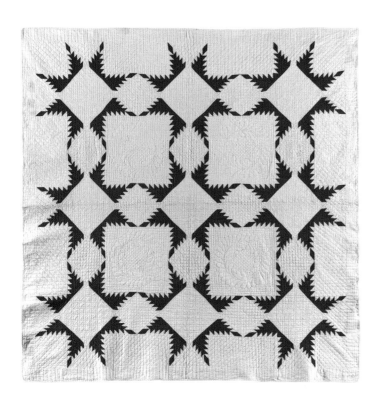

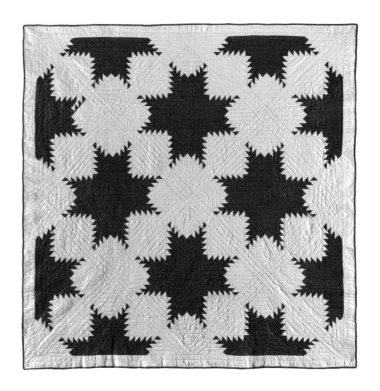

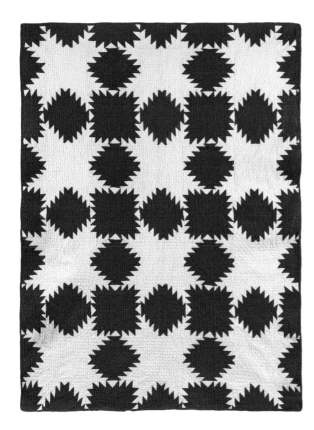

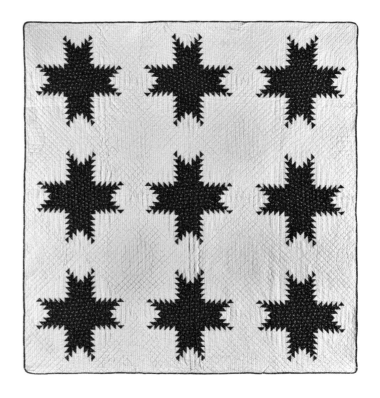

fig. 415
Feathered Eight-Point
Stars Quilt with single
border, 78 x 75½ inches.

fig. 416
Snowflakes Quilt,
86½ x 65½ inches.

fig. 417
Feathered Eight-Point Stars
Quilt with single border,
labeled "Eleanor Nildram,"
70 x 70 inches.

fig. 418
Feathered Eight-Point
Stars Quilt, c. 1860,
70½ x 69¾ inches.

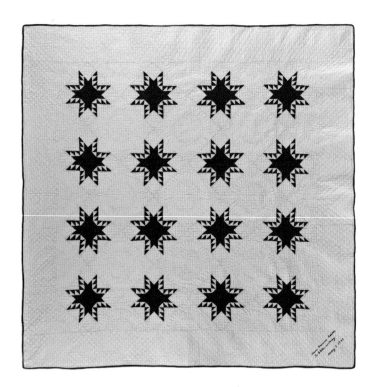

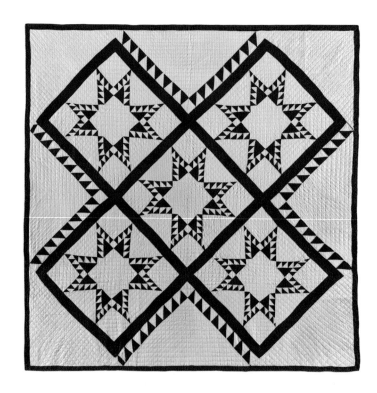

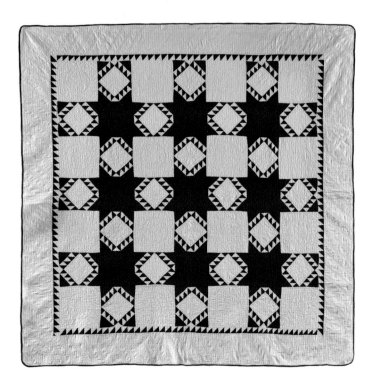

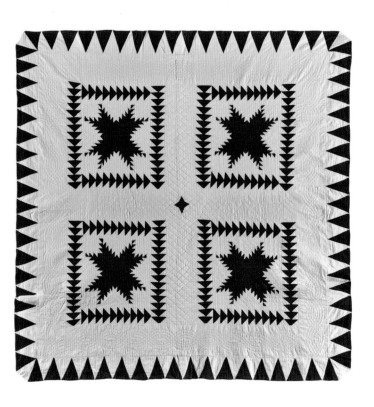

fig. 419
Continental Stars Quilt
with single border, signed
and dated in embroidery

"From Gramma Reeder
to Claton and May, May 3,
1927," 71 x 71 inches.

fig. 420
Feathered Eight-Point Stars
Quilt with sawtooth inner
border, 74 ½ x 74 inches.

fig. 421
Feathered Eight-Point Stars
on Point Quilt with sawtooth
sashing, 87 x 86 inches.

fig. 422
Feathered Eight-Point Stars
Quilt in Wild Goose Chase
blocks with triangle border,
83 ½ x 82 inches.

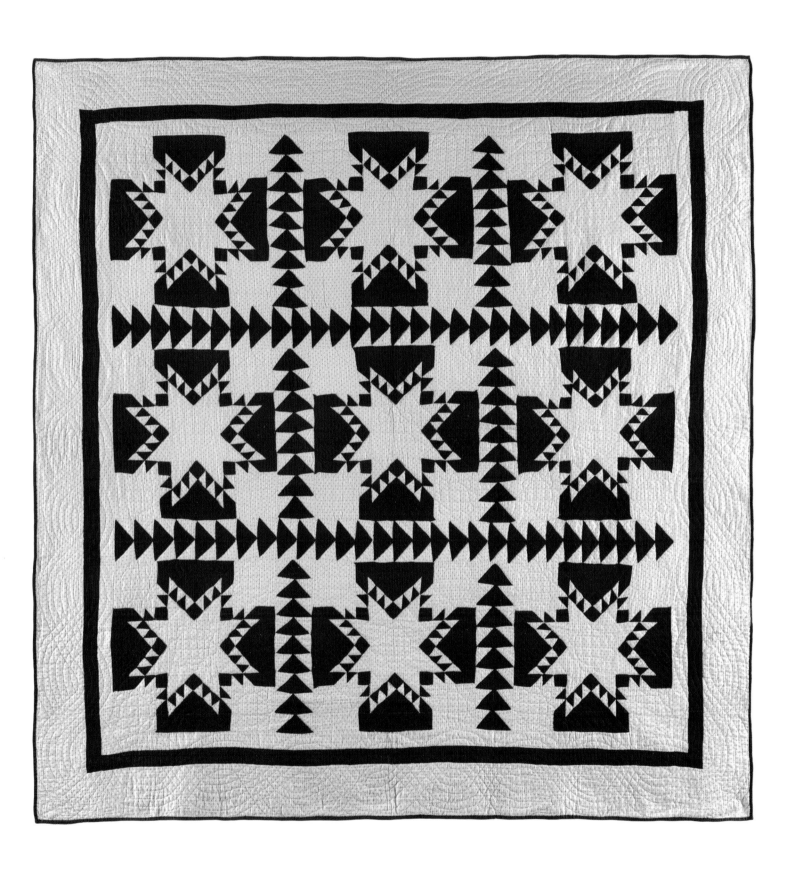

fig. 423
Feathered Eight-Point Stars
Quilt with Wild Goose Chase
sashing and triple border,
71 x 68 ½ inches.

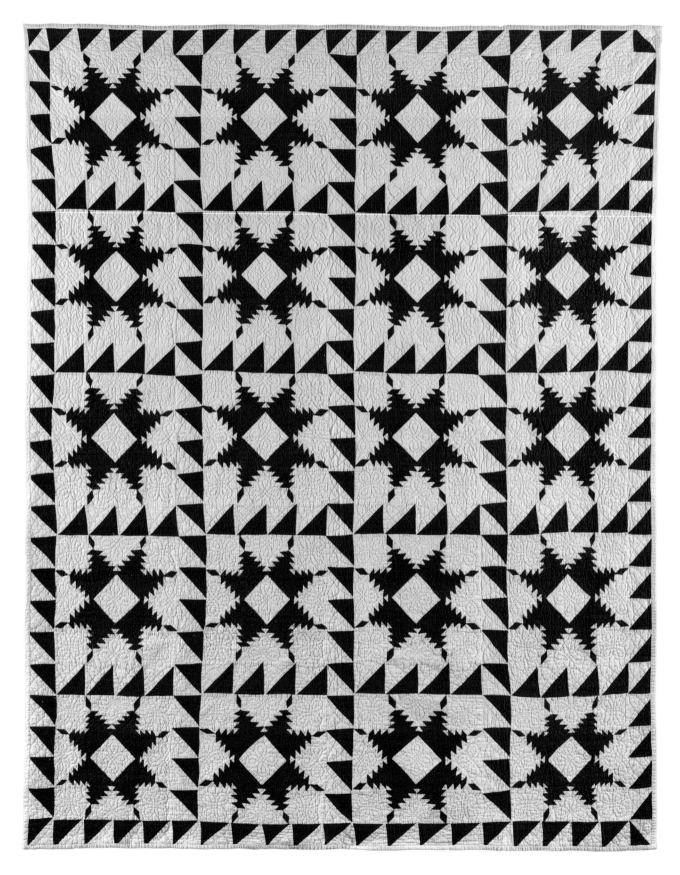

fig. 424
Feathered Eight-Point Stars
Quilt with sawtooth sashing
and border, 89 x 70 inches.

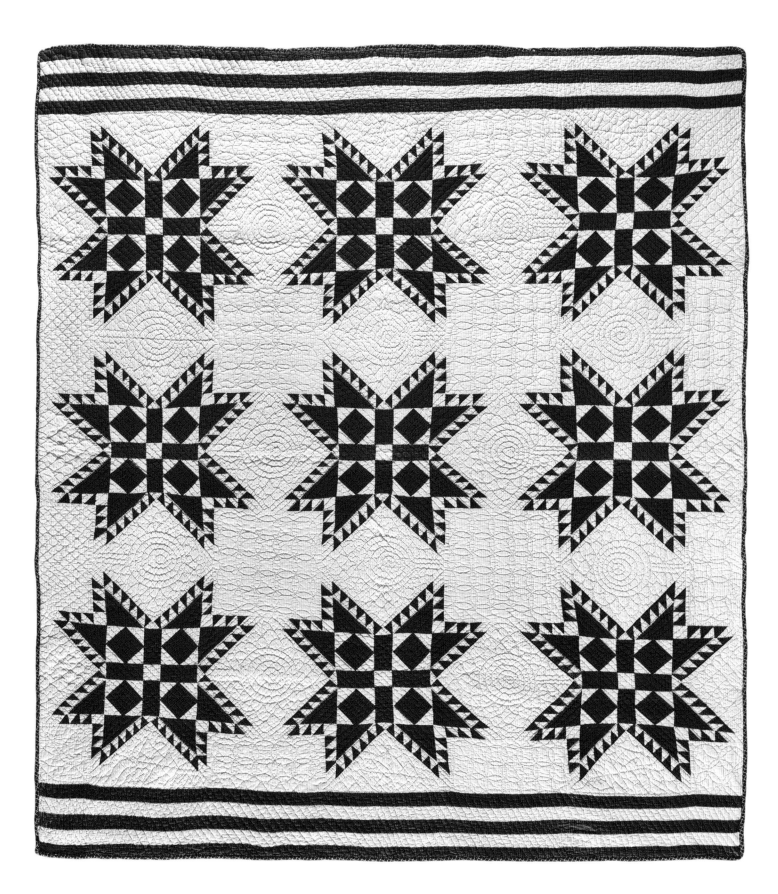

fig. 425
Garden of Eden Feathered
Stars Quilt with quintuple
top and bottom borders,
Maryland, 81 x 68 inches.

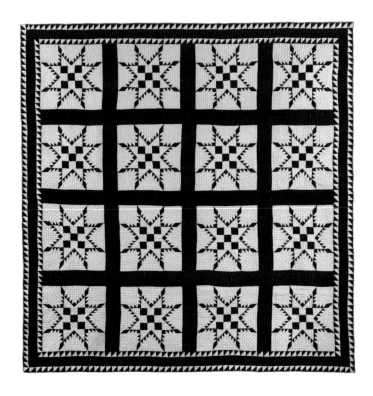

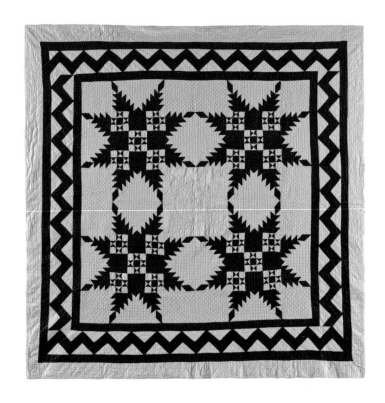

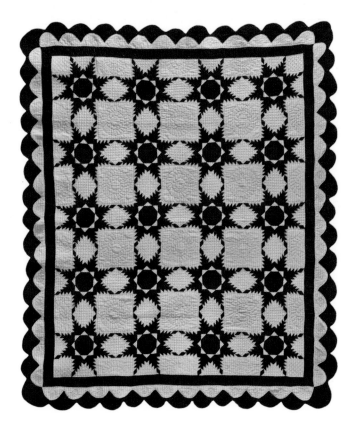

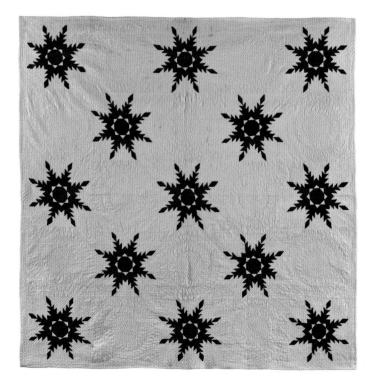

fig. 426
California Feathered
Star Quilt with double
sawtooth border,

Washington County,
Pennsylvania,
79 ½ x 79 ½ inches.

fig. 427
Complex Feathered
Eight-Point Stars Quilt
with double scalloped
border, 85 x 72 inches.

fig. 428
Feathered Stars Quilt
with Double Nine Patch
centers and zigzag border,
72 ½ x 71 inches.

fig. 429
Feathered Eight-Point Stars
Quilt with setting squares,
84 x 82 ½ inches.

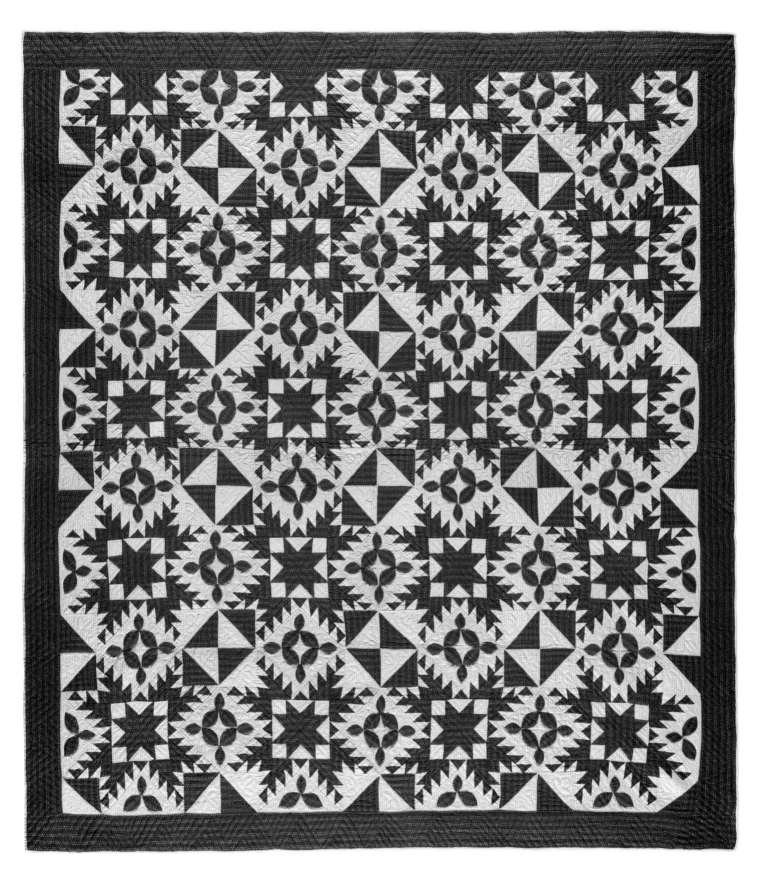

fig. 430
California Feathered Stars and
Friendship Reels Quilt with single
border, Virginia, c. 1870, pieced
and appliquéd, 81 x 74 inches.

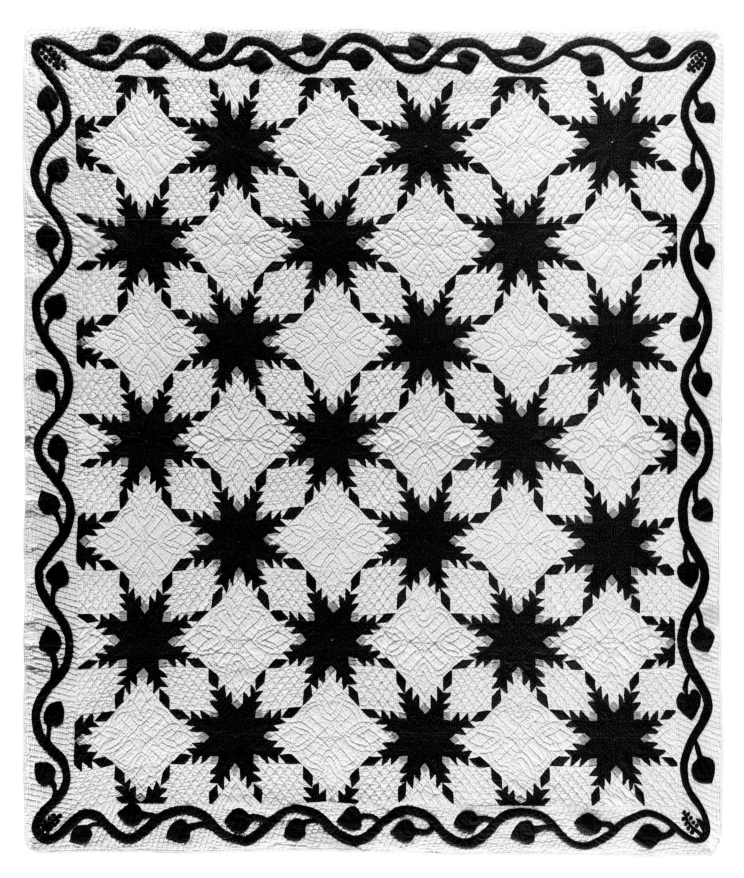

fig. 431
Feathered Eight-Point Stars
Quilt with vine appliqué
border, 81 x 71 inches.

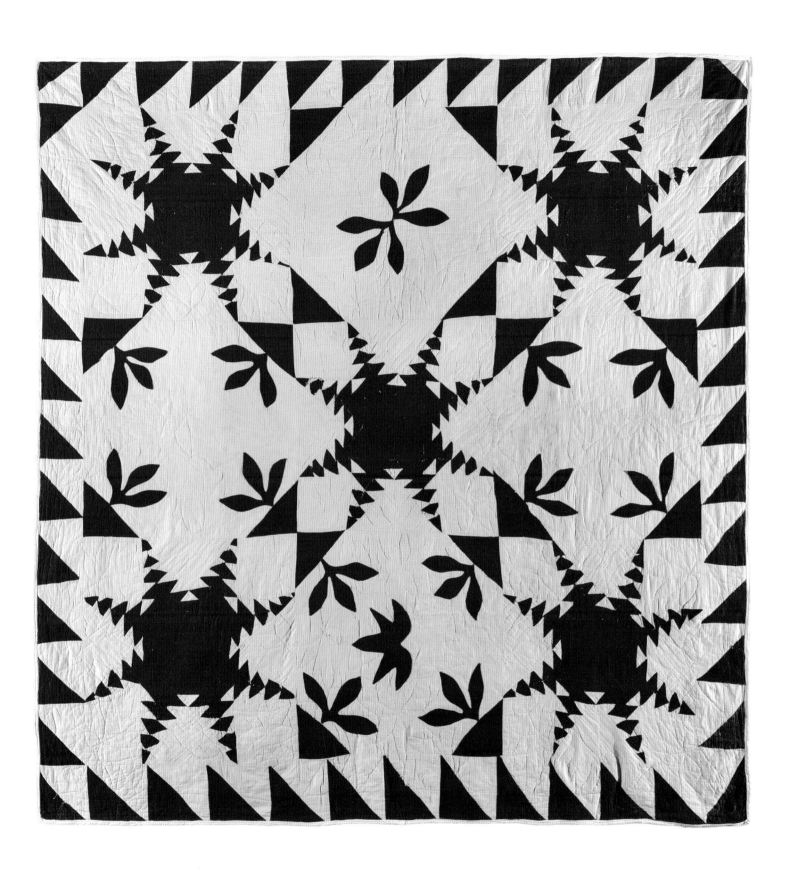

fig. 432
Feathered Eight-Point
Stars Quilt with appliqués
and wide sawtooth border,
77 x 74 ½ inches.

Traditional Patchwork Quilts: Curves

Like triangles, curves are cut on the bias, and their very curvature creates the potential for even more stretchiness. The careful attention needed in stitching curving shapes together is rewarded with the amazing effects that can be created in the blocks. Curves provide a sense of movement and liveliness that can't be matched in patterns with straight lines. Though they are more often found in appliqué designs, some of the best-loved patchwork blocks are curved patterns, including Snowballs, Hearts and Gizzards, Robbing Peter to Pay Paul, and Double Wedding Ring.

Among the most popular curved patterns is Drunkard's Path, which is at its best in two-color combinations. Basically a square with a "bite" taken out of one corner, this unit can be arranged into a number of different named patterns, from Falling Timbers and Chain Link to Love Ring and Snake in the Hollow. The origin of these names is lost to time; some are descriptive while others are fanciful.

But perhaps the most prevalent and well known of all quilt patterns is Double Wedding Ring, shown here with one of its many variations (figs. 469–471, pages 264–265). The pattern is emblematic of the Quilt Revival that flourished in the United States in the first half of the twentieth century. Based on published patterns, dated examples, and oral histories, Double Wedding Ring is believed to have risen to popularity in the 1920s, although there are examples of overlapping circles in textiles that date to the late nineteenth century. Quilts made during the height of the pattern's popularity frequently featured scalloped edges, as can be seen in fig. 470, page 265.

Many quilt patterns have more than one name. Pattern names began to be standardized in the late nineteenth and early twentieth centuries when commercial patterns were regularly published in newspapers and magazines and sold by mail order and at retail outlets. Variations abound, and we need only to look at the quilts contained in any chapter of this book to see how different even red and white quilts of the same design can be.

SNOWBALLS (figs. 433–437)
Though snowballs are usually round, some of these examples are less than perfect circles. All five quilts shown make use of half-circles on the border.

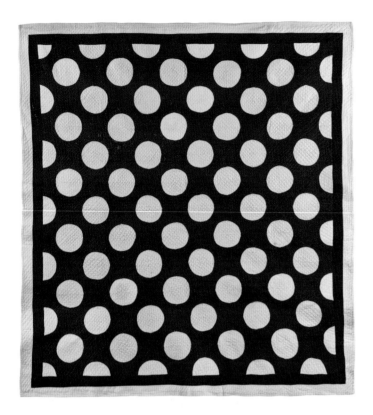

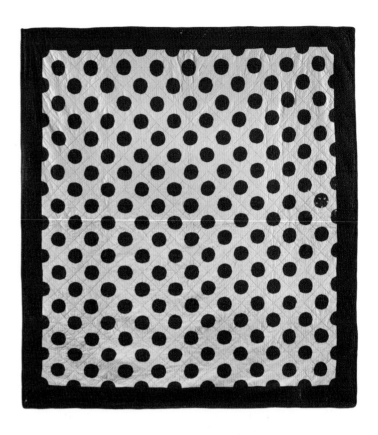

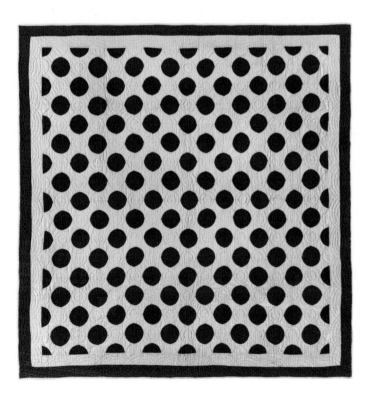

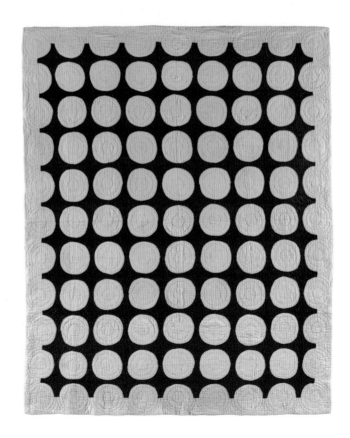

fig. 433
Snowballs Quilt with double border, 83 ½ x 78 inches.

fig. 434
Snowballs Quilt with double border, 79 x 76 inches.

fig. 435
Snowballs Quilt with single border, 77 x 71 inches.

fig. 436
Snowballs Quilt with single border, 74 x 59 ½ inches.

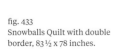

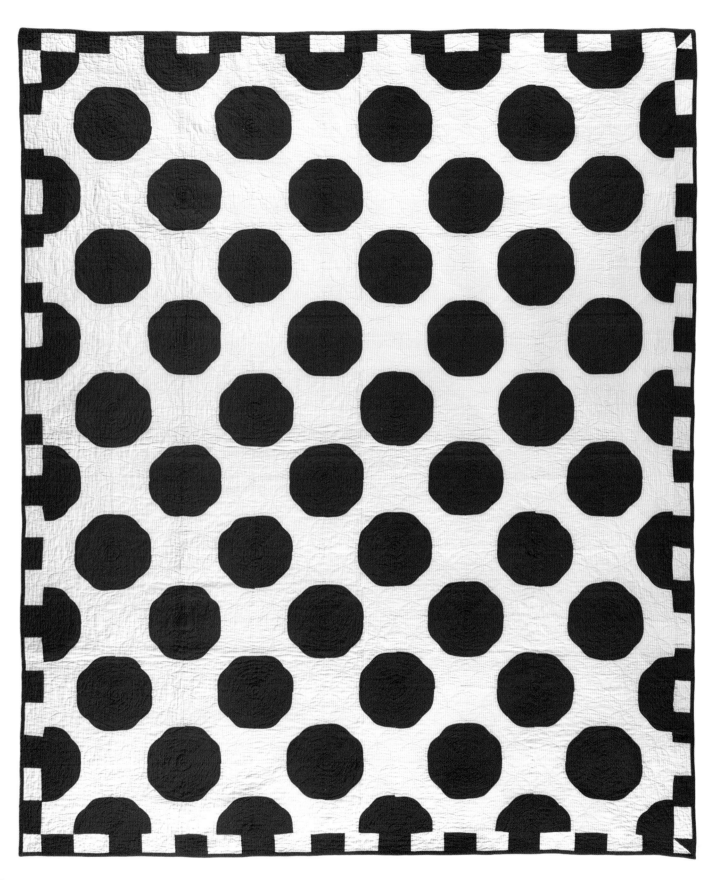

fig. 437
Snowballs Quilt with
single pieced border,
84 x 72 inches.

HEARTS & GIZZARDS (figs. 438–440)
Hearts set with the points adjoining are connected
by pieces of different size and shape. Fig. 438,
on this page, features impressive batting, or filling.

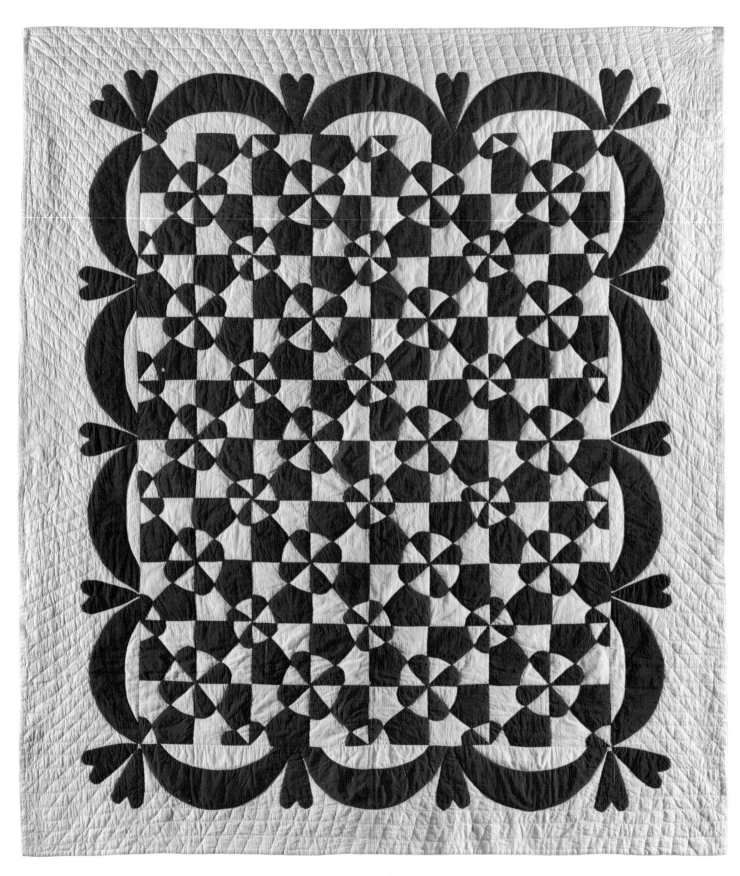

fig. 438
Hearts and Gizzards Quilt
with swag border, c. 1950,
76 x 68 inches.

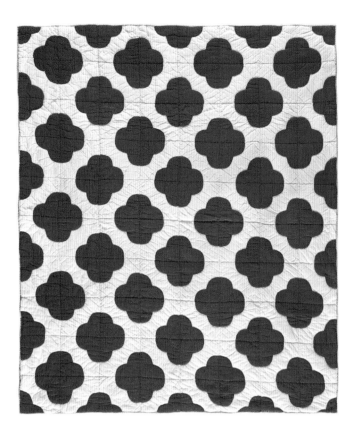

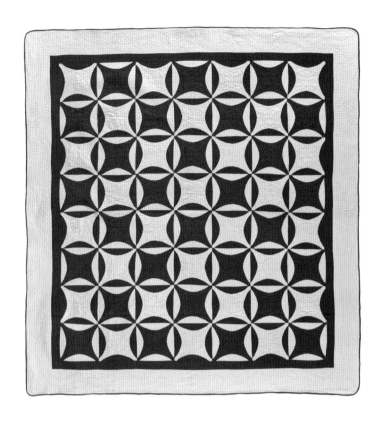

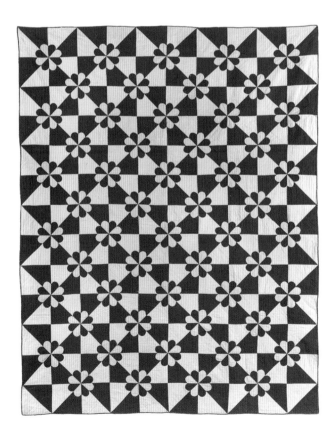

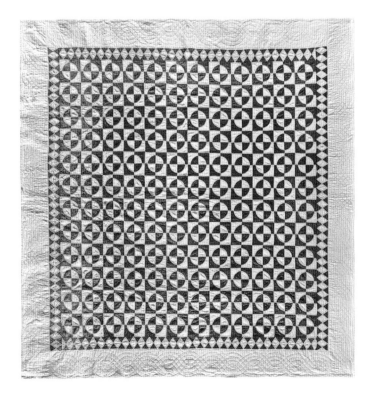

fig. 439
Hearts and Gizzards Quilt,
73 x 62 ½ inches.

fig. 440
Hearts and Gizzards Quilt,
84 x 66 inches.

fig. 441
Robbing Peter to Pay Paul
Quilt with double border,
81 x 76 inches.

fig. 442
Steeplechase Variation
Quilt with diamond inner
border and wide outer
border, 82 x 80 ½ inches.

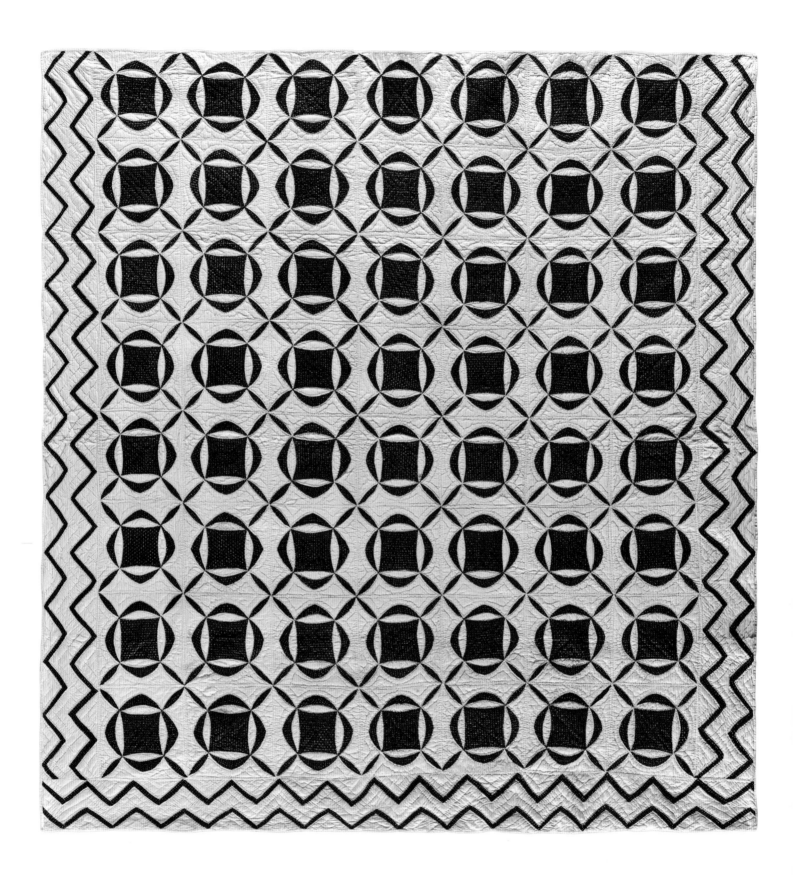

fig. 443
Robbing Peter to Pay
Paul Variation Quilt with
double zigzag border,
77½ x 75 inches.

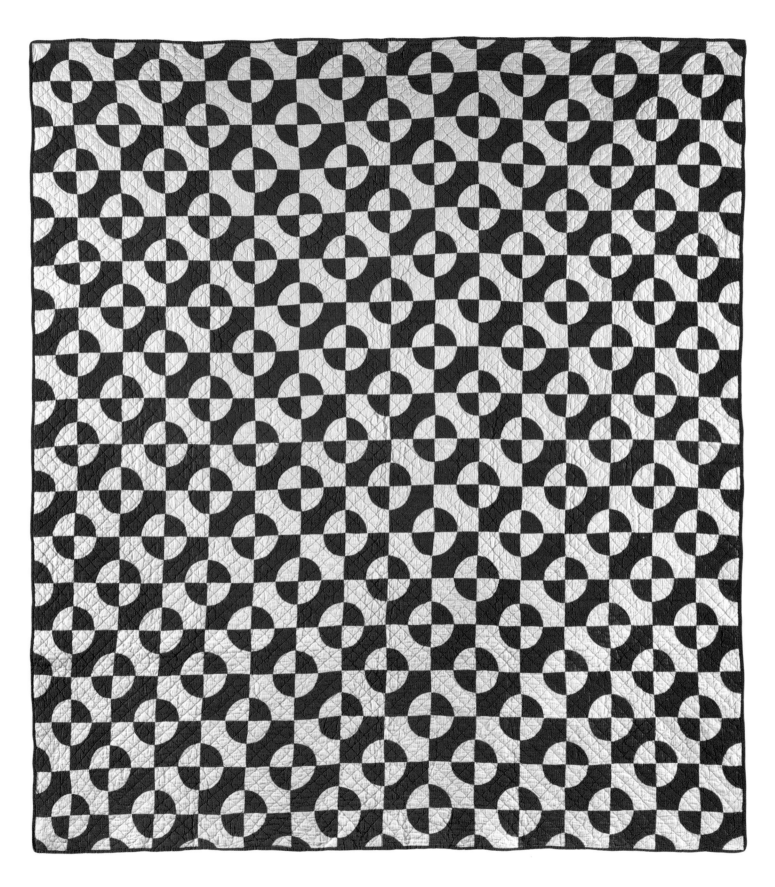

fig. 444
Robbing Peter to Pay Paul
Quilt (Steeplechase
Variation), Lewisburg,
Pennsylvania, 74 x 67 inches.

TRADITIONAL PATCHWORK QUILTS: CURVES

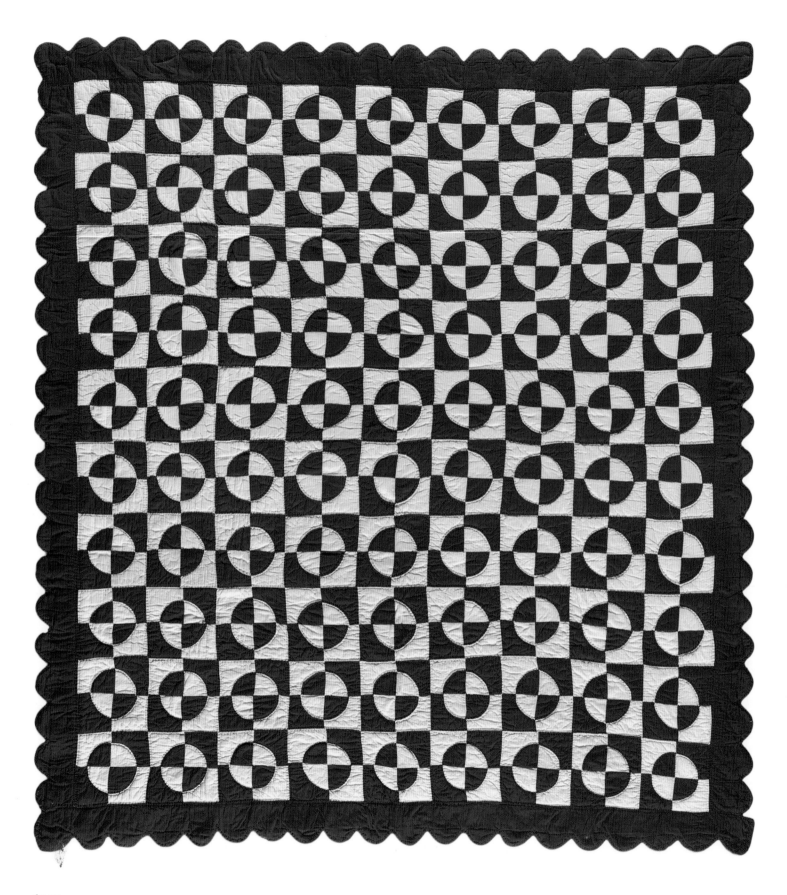

fig. 445
Steeplechase Quilt
with scalloped edge,
75 x 69 inches.

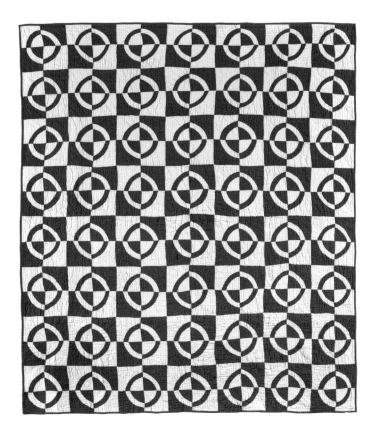

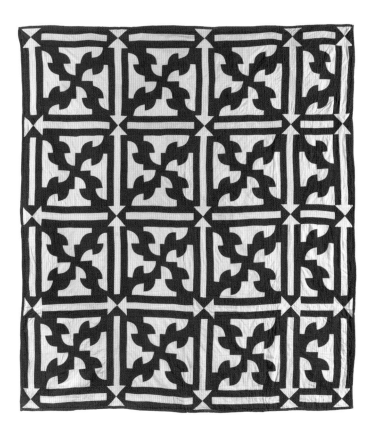

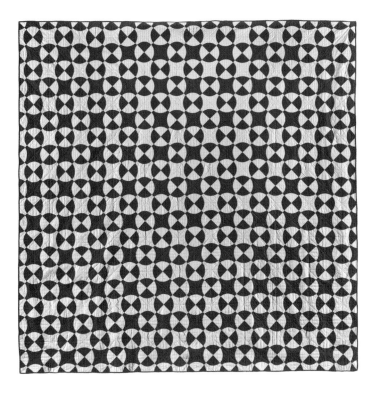

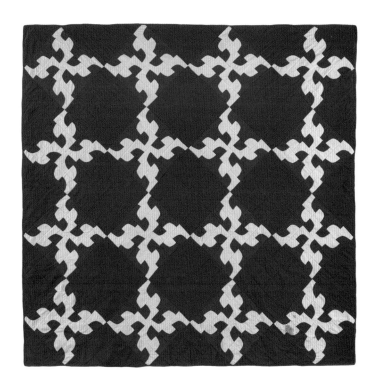

fig. 446
Fair Play Quilt,
75 x 66 ½ inches.

fig. 447
Mill Wheel Quilt,
102 x 100 inches.

fig. 448
Drunkard's Path Quilt with quarter-square corner-block sashing, 76 ½ x 68 ½ inches.

fig. 449
Drunkard's Path on Point Quilt with setting squares, 75 x 74 ½ inches.

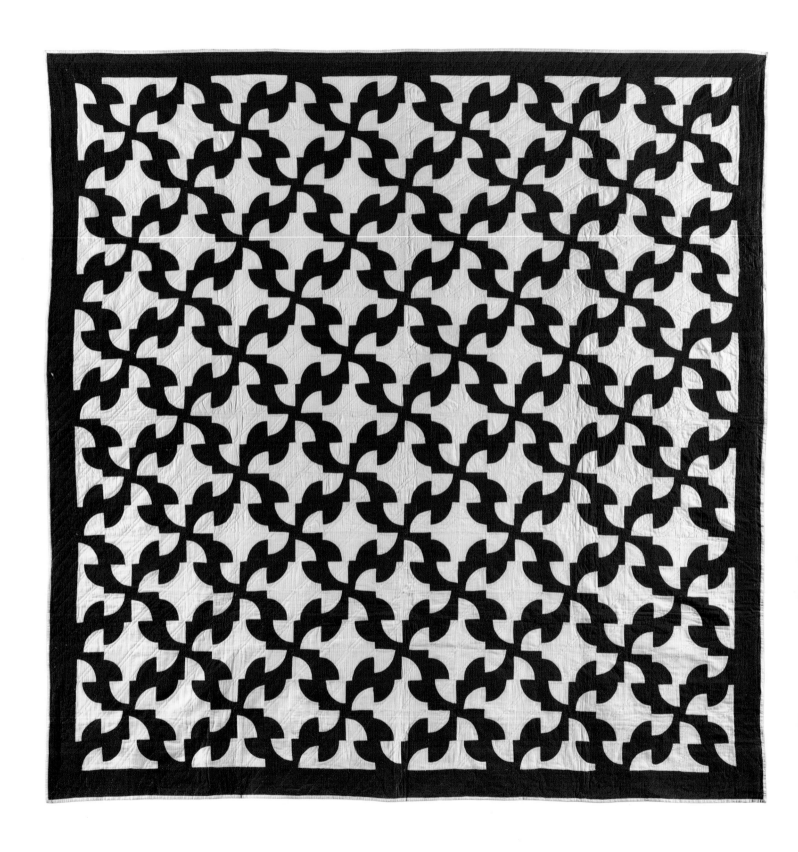

fig. 450
Drunkard's Path Quilt
with single border,
87½ x 86½ inches.

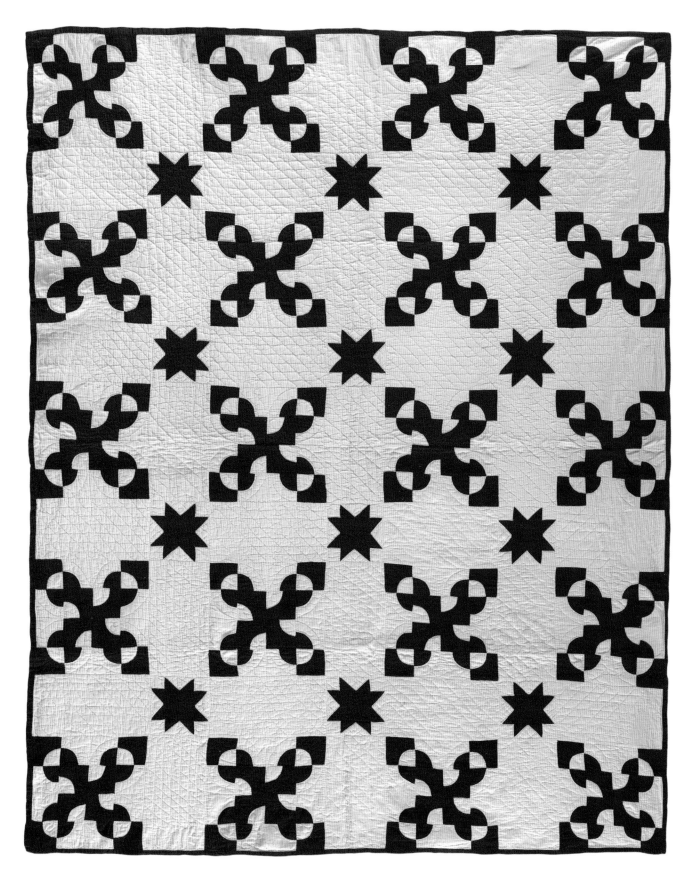

fig. 451
Drunkard's Path Quilt
with Eight-Point Star
corner-block sashing,
82 x 65½ inches.

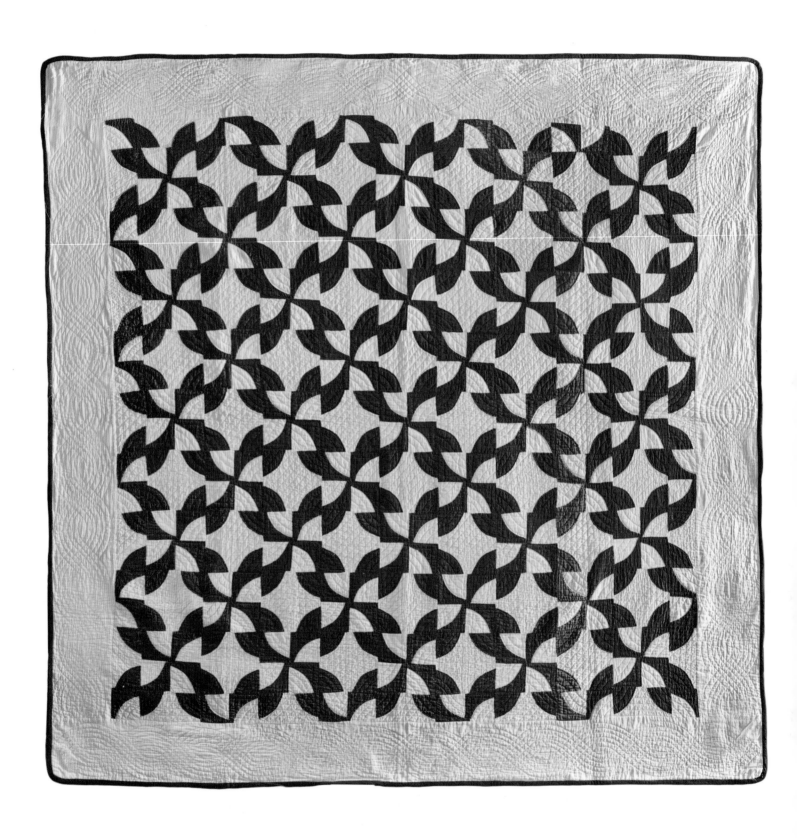

fig. 452
Drunkard's Path Quilt
with wide border,
75 ½ x 75 ½ inches.

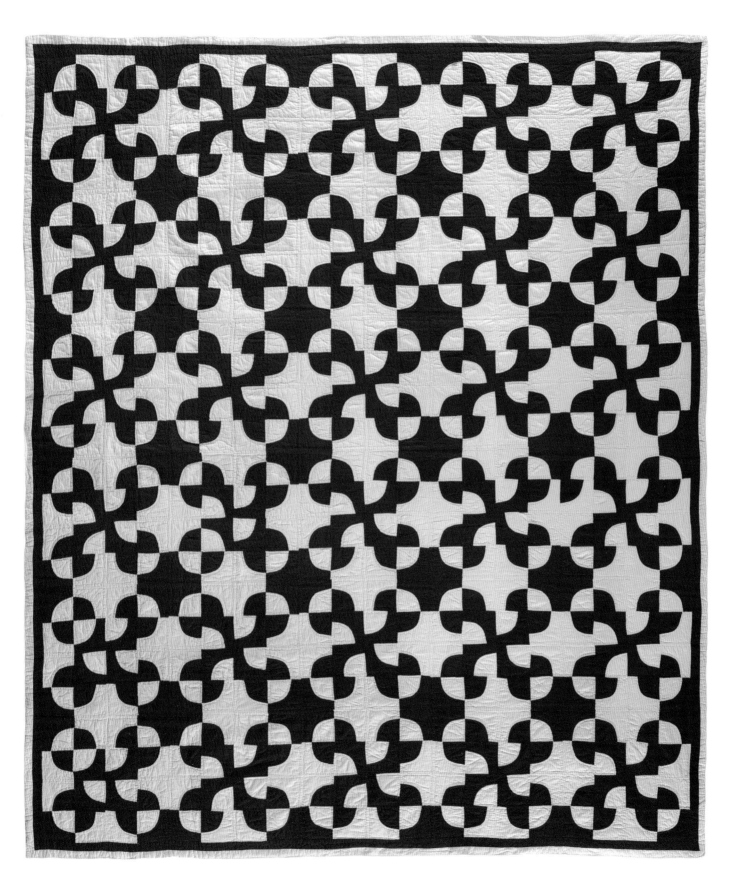

fig. 453
Drunkard's Path and
Robbing Peter to Pay Paul
Quilt, 90 ½ x 77 inches.

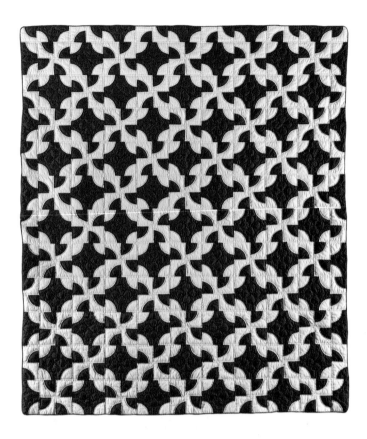

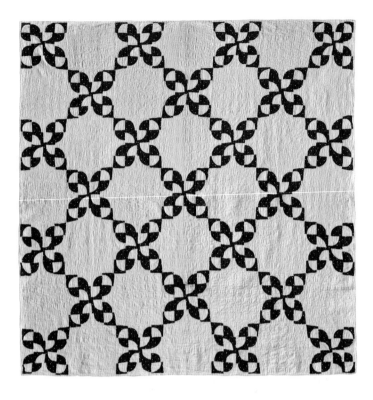

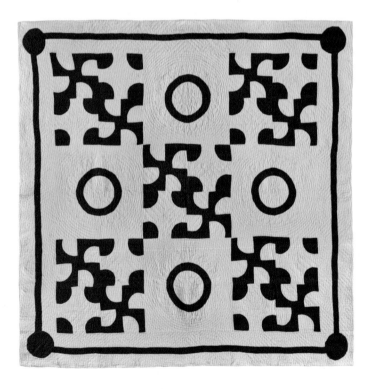

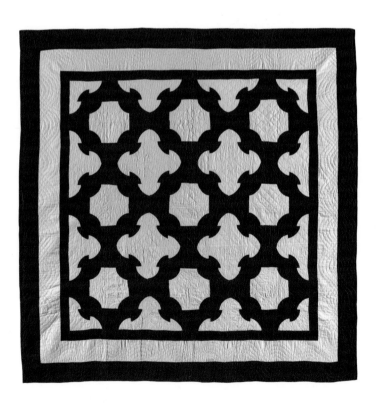

fig. 454
Drunkard's Path Quilt,
88 x 77 inches.

fig. 455
Drunkard's Path Quilt
(Big Block Nine Patch
Variation) with triple
border, 75 ½ x 75 inches.

fig. 456
Drunkard's Path Chain
Quilt, 74 x 72 inches.

fig. 457
Chain Links Quilt with triple
border, 82 ½ x 81 inches.

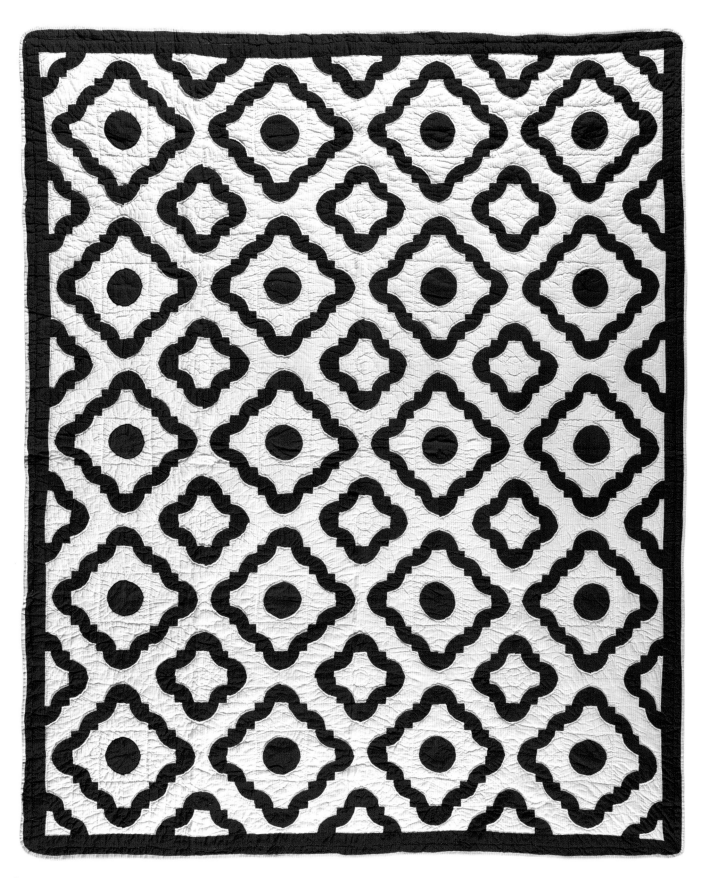

fig. 458
Love Rings Quilt with
single border, c. 1930,
75 x 62 ½ inches.

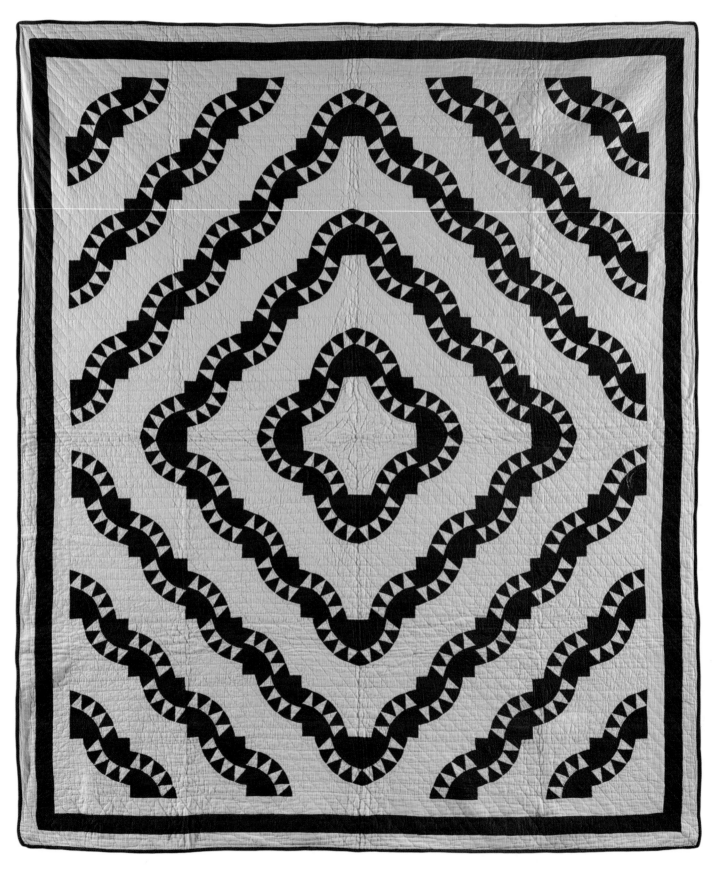

fig. 459
Snake in the Hollow
Quilt (Baby Bunting
Variation) with triple
border, 82 ½ x 70 inches.

Fan patterns are made when a quarter circle is placed in the corner of a square. The "fan" can be simple or highly elaborate.

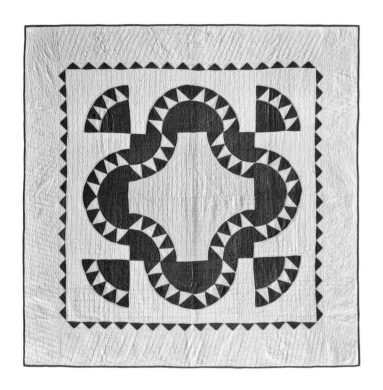

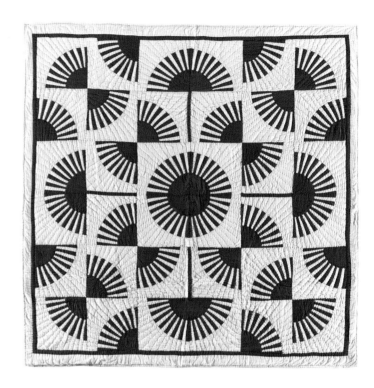

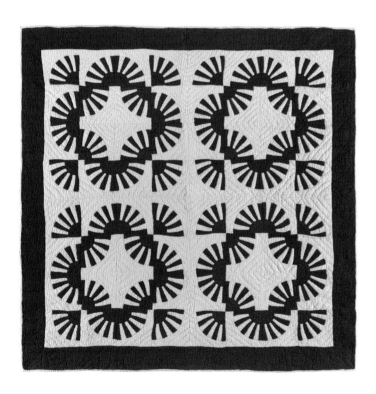

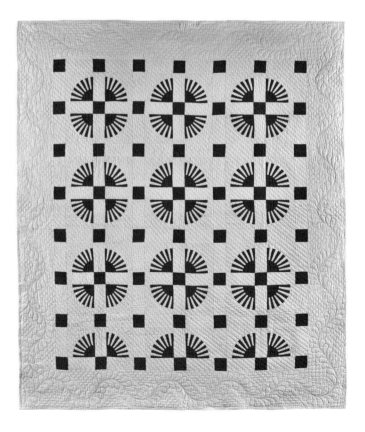

fig. 460
Chinese Fans (Sawtooth Fan Ring) Quilt with triangle border, Adams County, Pennsylvania, 75 x 75 inches.

fig. 461
Swirling Fans Quilt (Chinese Fan Variation) with single border, Pennsylvania, 70 ½ x 68 inches.

fig. 462
Art Deco Fans Quilt with double border, commercially manufactured in India, late 20th century, 76 x 77 inches.

fig. 463
Art Deco Fans Quilt with corner-block sashing and single border, 81 ½ x 72 inches.

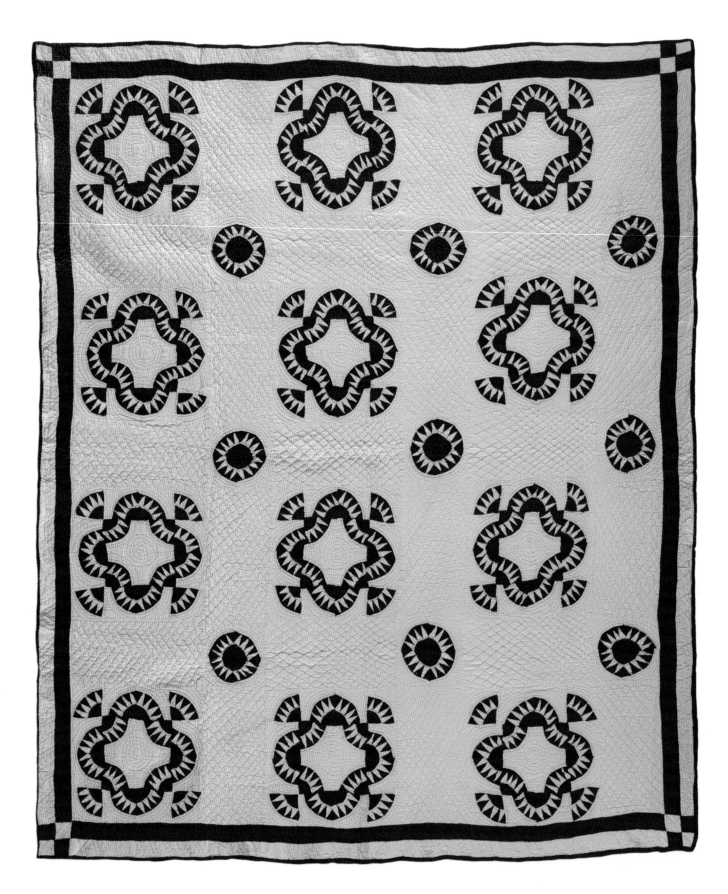

fig. 464
Chinese Fans Quilt
with corner-block
sashing and double
border, 84 x 70 inches.

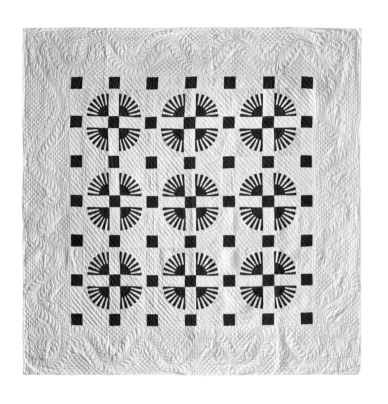

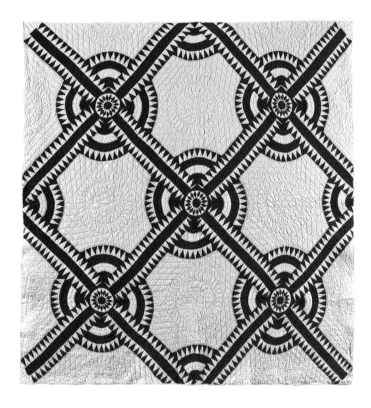

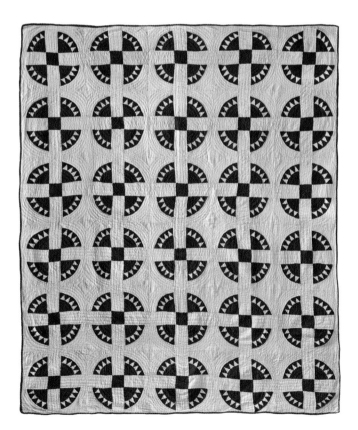

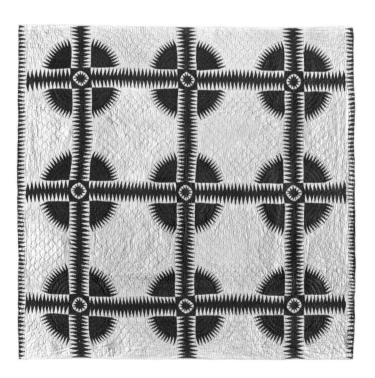

fig. 465
Art Deco Fans Quilt
with corner-block
sashing and single
border, 80 x 80 inches.

fig. 466
New York Beauty Quilt,
82½ x 69½ inches.

fig. 467
New York Beauty Quilt,
74½ x 72 inches.

fig. 468
New York Beauty Quilt
with triangle side borders,
77½ x 81 inches.

TRADITIONAL PATCHWORK QUILTS: CURVES

Patterns for Double Wedding Ring and its variation,
Pickle Dish, first appeared in the 1920s and have
remained popular.

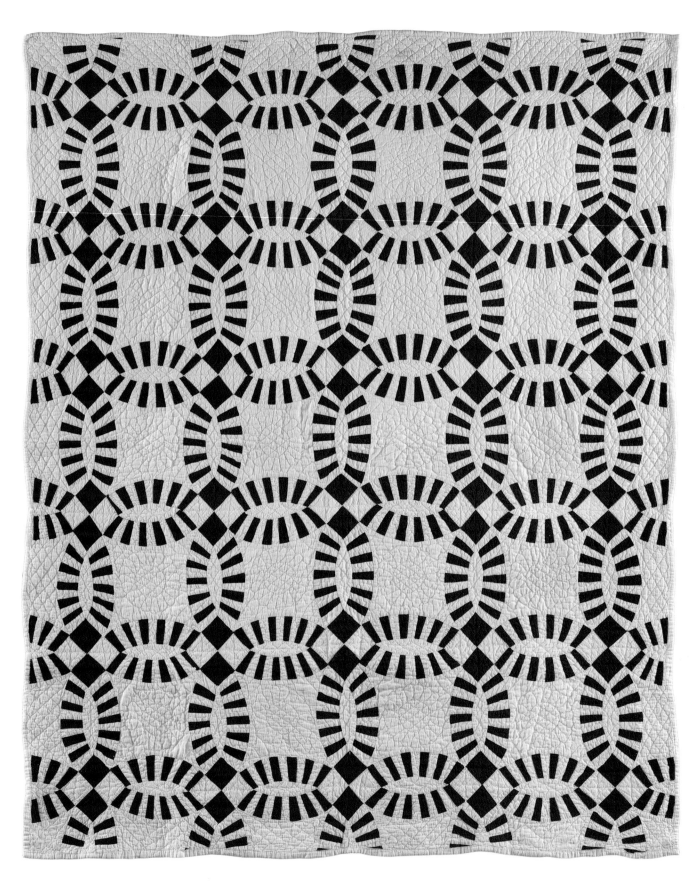

fig. 469
Double Wedding Ring Quilt,
c. 1930, 75 ½ x 61 ½ inches.

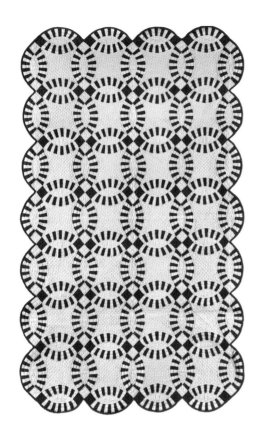

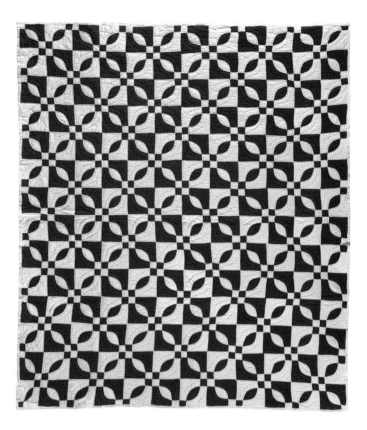

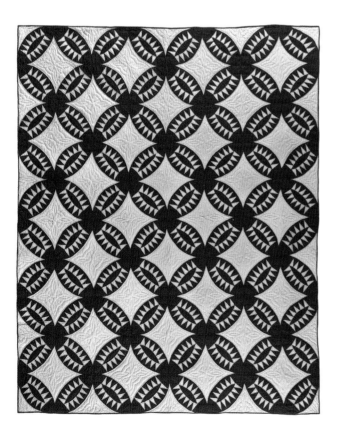

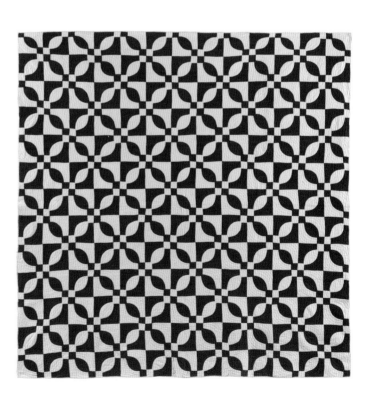

fig. 470
Double Wedding Ring Quilt with scalloped edge, Lancaster County, Pennsylvania, c. 1930, 83½ x 50 inches.

fig. 471
Pickle Dish Quilt (Indian Wedding Ring Variation), Fort Worth, Texas, c. 1930, 88 x 69 inches.

fig. 472
Rose Dream Quilt, 83 x 73½ inches.

fig. 473
Rose Dream Quilt (True Lover's Knot Variation), York County, Pennsylvania, 75 x 75 inches.

TRADITIONAL PATCHWORK QUILTS: CURVES

Truly round patterns are especially challenging to construct. The examples in this section took great and delicate care to make.

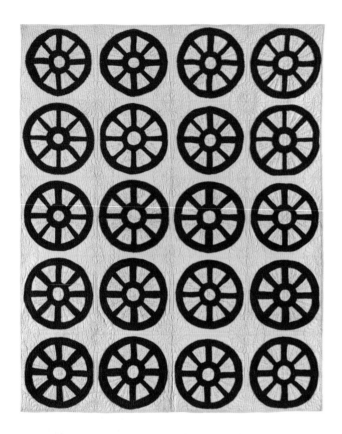

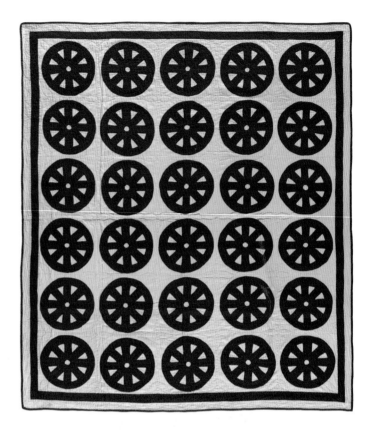

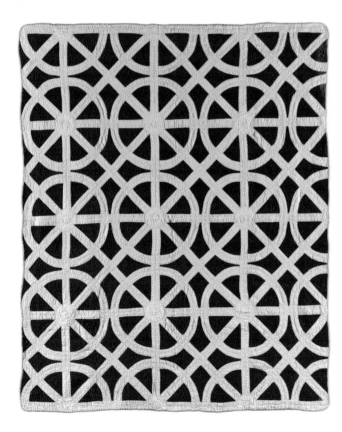

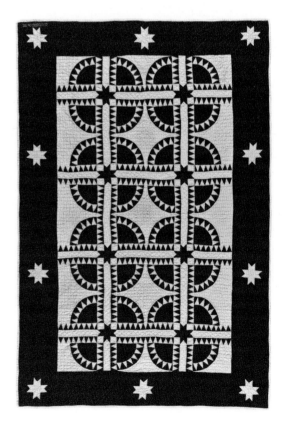

fig. 474
Wagon Wheel Quilt,
Illinois, 72 x 58 inches.

fig. 475
Wagon Wheel Quilt,
74 ½ x 61 inches.

fig. 476
Wagon Wheel Quilt
with double border,
72 x 63 inches.

fig. 477
Wheel of Fortune Quilt with
sawtooth and star corner-
block sashing and eight-point
star border, commercially
manufactured by Judi
Boisson, 1991, 91 ½ x 61 inches.

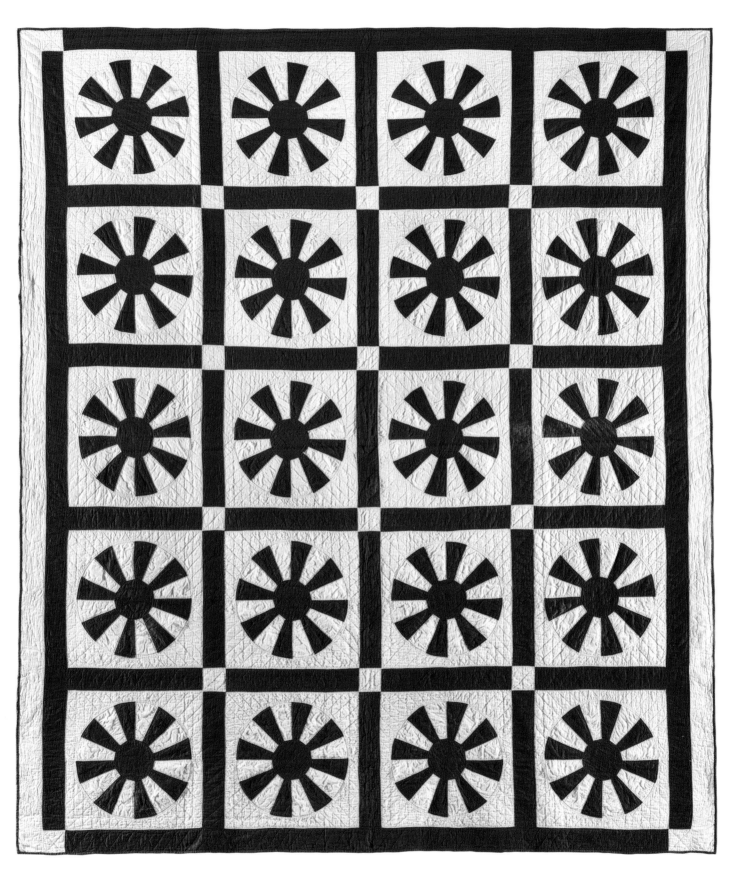

fig. 478
Wheel of Fortune Quilt (Wagon
Wheel Variation) with corner-block
sashing and single side borders,
New England, 88 x 77 inches.

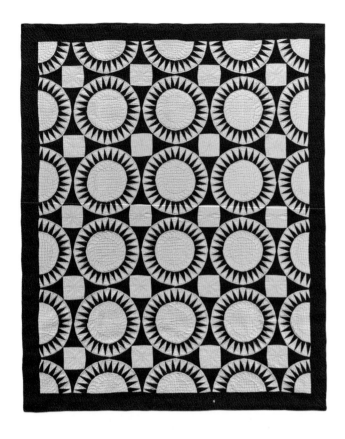

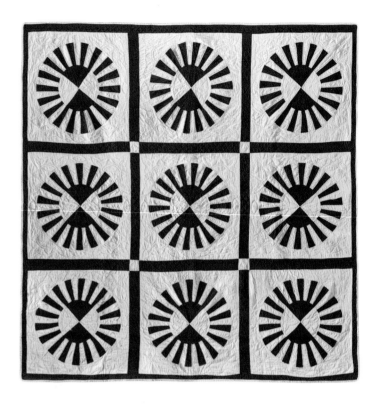

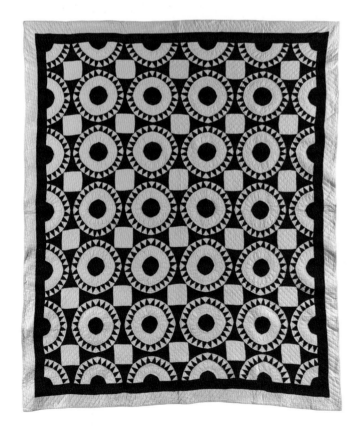

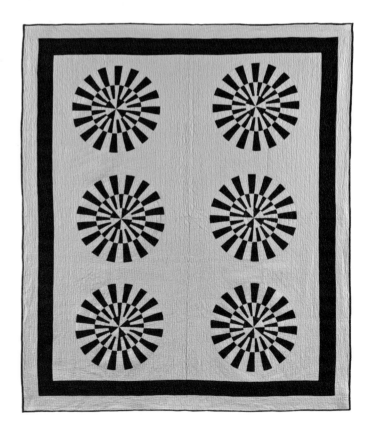

fig. 479
Sunburst Quilt with single
border, 82 x 67½ inches.

fig. 480
Sunburst Quilt with double
border, 88½ x 73½ inches.

fig. 481
Fan Wagon Wheel Quilt with
corner-block sashing,
Illinois, 81½ x 79½ inches.

fig. 482
Chariot Wheel Quilt
(Fortune's Wheel Variation)
with double border, Ohio,
83 x 72 inches.

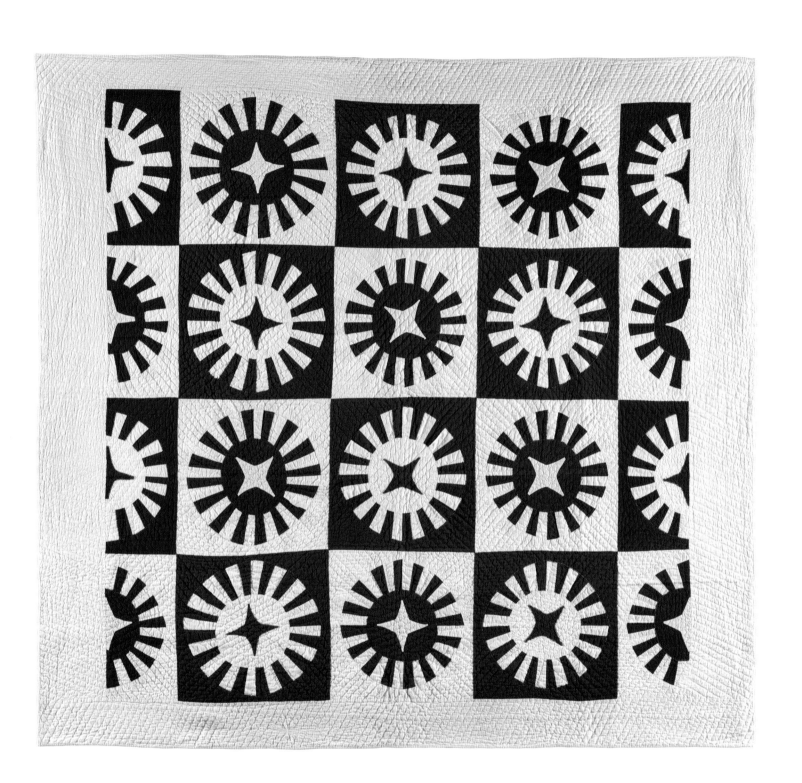

fig. 483
Wagon Wheel Quilt
with center appliqué
stars and single border,
71 ½ x 67 ½ inches.

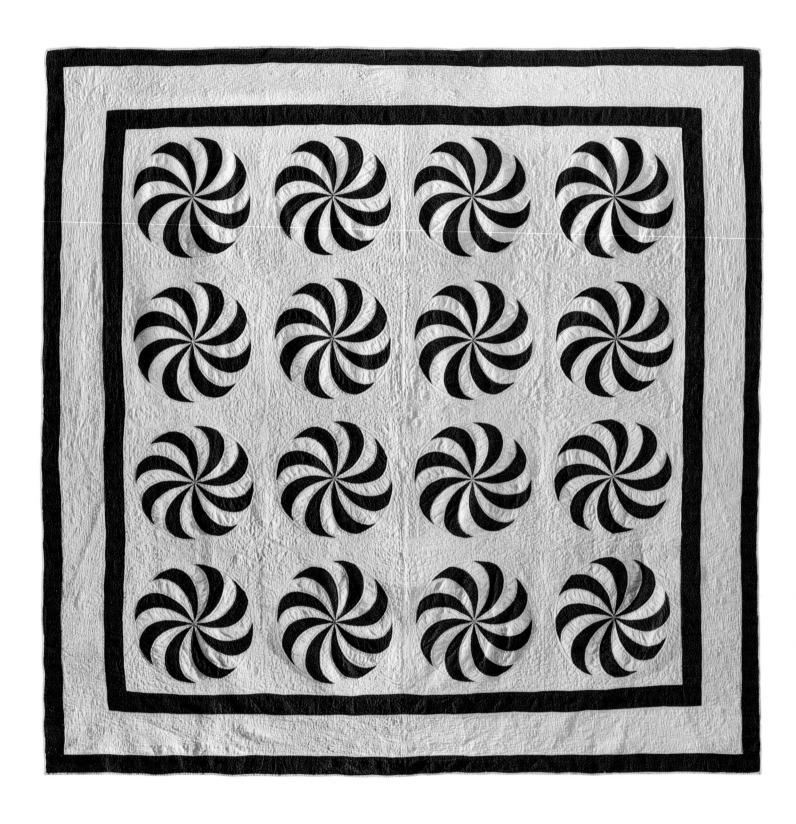

fig. 484
Whirling Wheel of Fortune
Quilt with triple border,
68 x 67 inches.

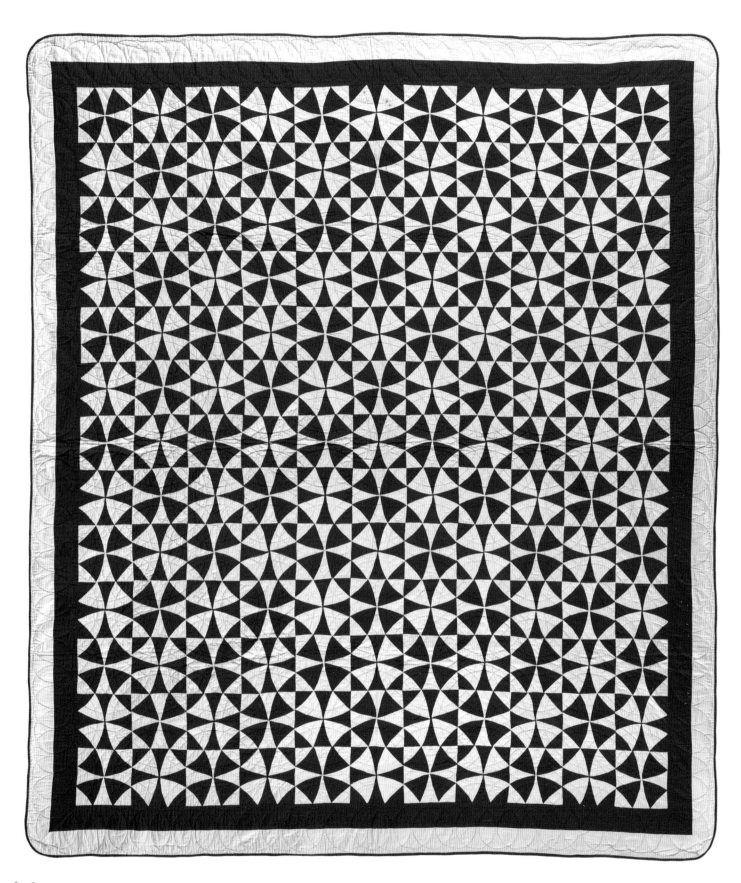

fig. 485
Winding Ways Quilt
with double border,
91 x 82 inches.

Mariner's Compass, with its sharp points and narrow needles, involves challenging construction, but its beauty is worth the effort.

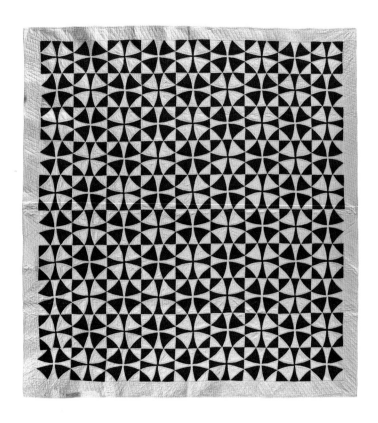

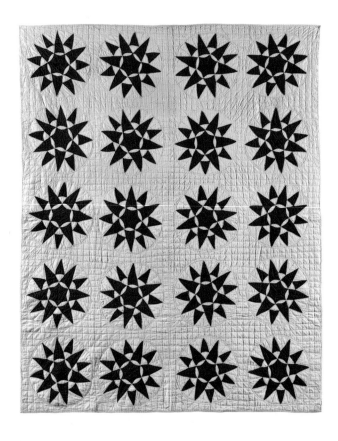

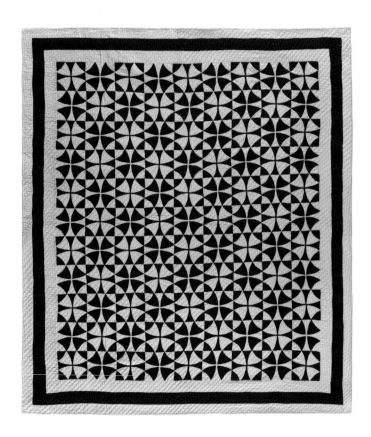

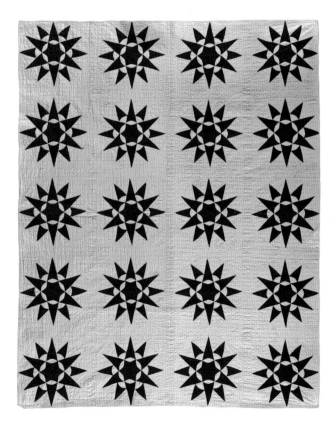

fig. 486
Winding Ways Quilt with single border, 82 x 76 inches.

fig. 487
Winding Ways Quilt (Wheel of Mystery Variation) with triple border, Missouri, 90 x 78½ inches.

fig. 488
Twelve-Point Mariner's Compass Quilt, 81½ x 66 inches.

fig. 489
Twelve-Point Mariner's Compass Quilt, 86 x 68½ inches.

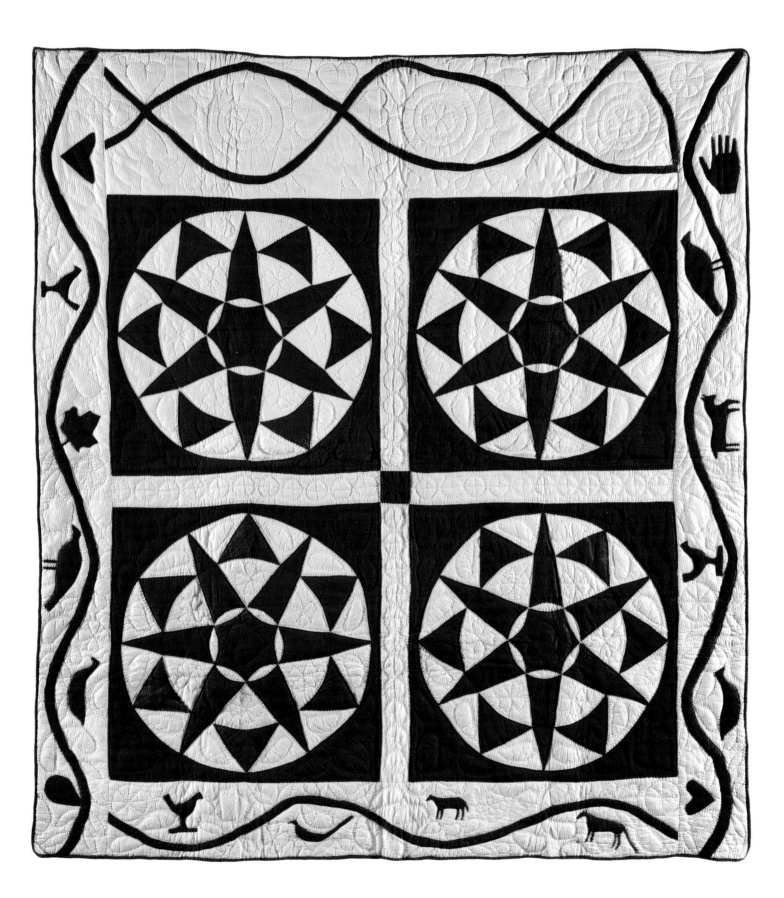

fig. 490
Twelve-Point Mariner's
Compass Quilt with vine
appliqué border and pictorial
motifs, 76½ x 69½ inches.

TRADITIONAL PATCHWORK QUILTS: CURVES

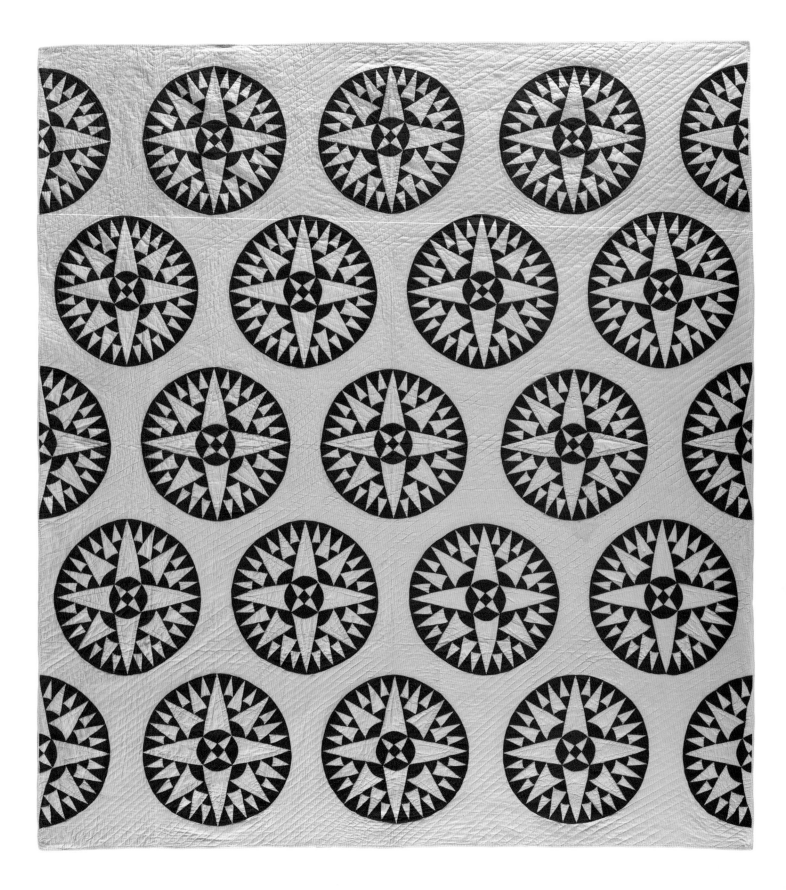

fig. 491
Thirty-Two-Point
Mariner's Compass
Quilt, 83 x 70 ½ inches.

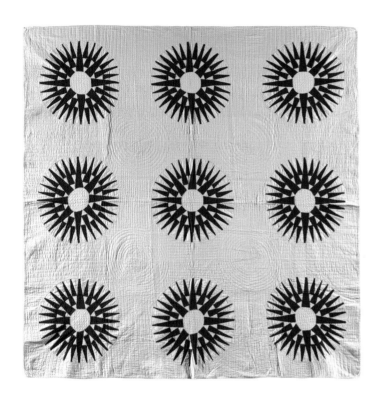

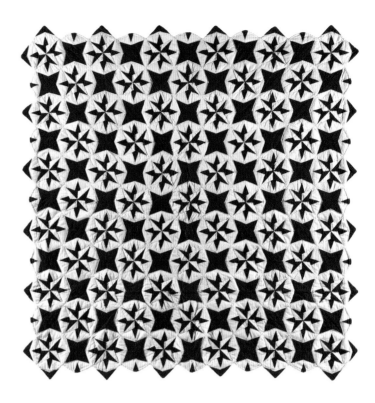

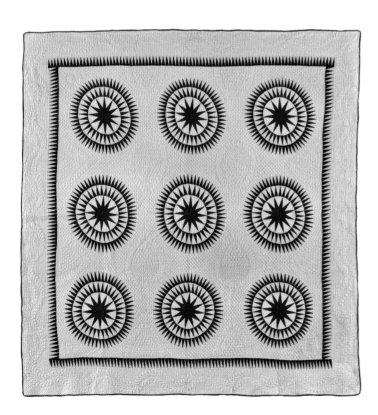

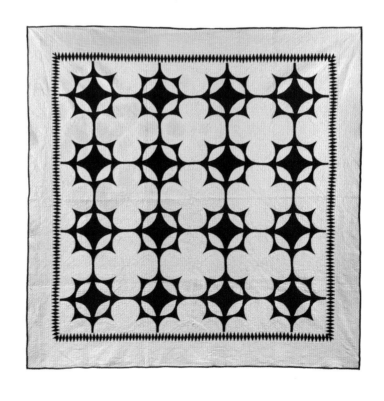

fig. 492
Thirty-Two-Point
Mariner's Compass
Quilt, 76 x 74 ½ inches.

fig. 493
Sixty-Four-Point
Mariner's Compass Quilt
with sawtooth inner
border, 74 ½ x 71 ½ inches.

fig. 494
Eight-Point Mariner's
Compass Quilt (Quilt of
Illusion / World Without

End Stars Variations)
with shaped edge, c. 1950,
85 x 83 inches.

fig. 495
Double Clover Quilt with
diamond border, dated
1878, 86 x 86 inches.

Decorative Appliqué Quilts

Appliqué, the technique in which one piece of fabric is applied to another with stitching, is one of the oldest textile methods, its origins lost to time. It can be found in almost every culture worldwide. Before its adaptation to decorative uses, perhaps it was developed originally as a way to repair worn or torn clothing or household items.

Appliqué is often regarded as an embroidery technique, but it is also a favorite among quiltmakers. There are many decorative effects that can be achieved using appliqué that are not possible, or at least do not work nearly as well, in patchwork. The abstract shapes found in Hawaiian appliqué and Scherenschnitte, which uses folded paper cutting and was practiced by Germanic immigrants in particular, could not be produced except as appliqué.

Multiple traditional appliqué block designs have been developed over the years, from Princess Feather to Oak Leaf and Reel, and numerous variations of all these patterns exist. Many work best in more than two colors, but as can be seen from the examples in this chapter, the bicolor plan is a beautifully effective way to create stark contrasts that enhance the overall look of a quilt.

Most appliqué involves cutting a shape or motif from one fabric and stitching it to a background by hand or machine. A technique called needleturning is the most common method for applying motifs by hand. Shapes are pinned or basted to the background and a narrow raw edge is turned under and slipstitched in place; most of the quilts in this chapter were worked this way. Turned-under edges can also be secured with a hand-sewn blanket stitch. Raw-edge appliqué is occasionally found on older quilts but is generally considered a more modern method, with the edges pinked or

stabilized before the shape is applied. Machine-worked motifs can also be applied by turning under the edges and topstitching in place, but most machine appliqué today is secured along the edges of the shape with a tight zigzag stitch.

Appliqué and patchwork are often combined on a quilt, with the geometric style of pieced blocks providing an interesting contrast to the more fluid shapes found in most appliqué. Sometimes plain blocks of fabric are placed between blocks with designs. Those blocks, when combined with elaborate appliqué work, can provide a canvas for intricate quilting patterns, which often echo the design of the applied motifs, as well as a place for the eye to rest in a complicated composition.

Quilts with elaborate appliqué can be time-consuming to create, and many existing quilts were probably kept for "best use" or for when company came to call, such as the circuit-rider parsons who tended several churches and traveled from one to the next, staying in parishioners' homes along the way. Since they were seldom used, many of these quilts have survived in excellent condition for us to enjoy, and in some cases to marvel over.

BLOCK APPLIQUÉ (figs. 496–521)
Much appliqué is worked on separate blocks and
then combined to make a quilt top. Each block is
usually the same or similar for a repeating pattern.

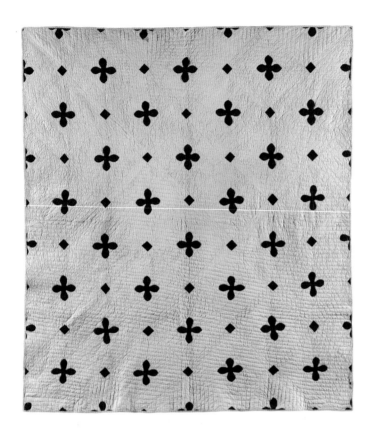

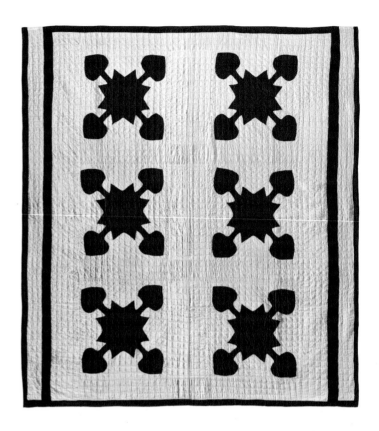

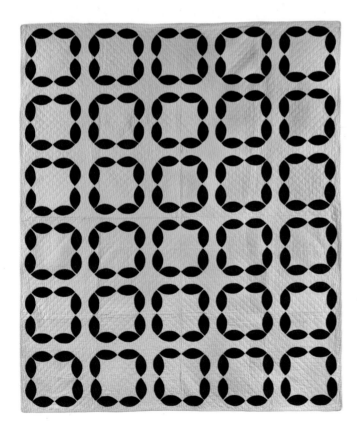

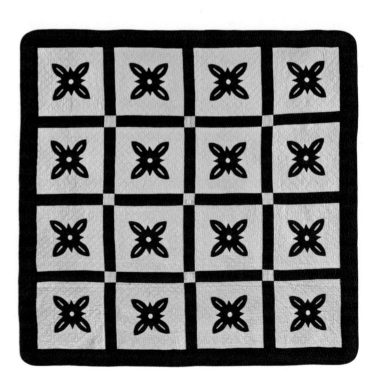

fig. 496
Block Appliqué on Point
Quilt with corner-block
sashing, 84½ x 73¾ inches.

fig. 497
Block Appliqué Quilt,
84 x 68 inches.

fig. 498
Star and Leaf Block Appliqué
Quilt with double side
borders, 74 x 68½ inches.

fig. 499
Block Appliqué Quilt with
corner-block sashing and
single border, 78 x 78 inches.

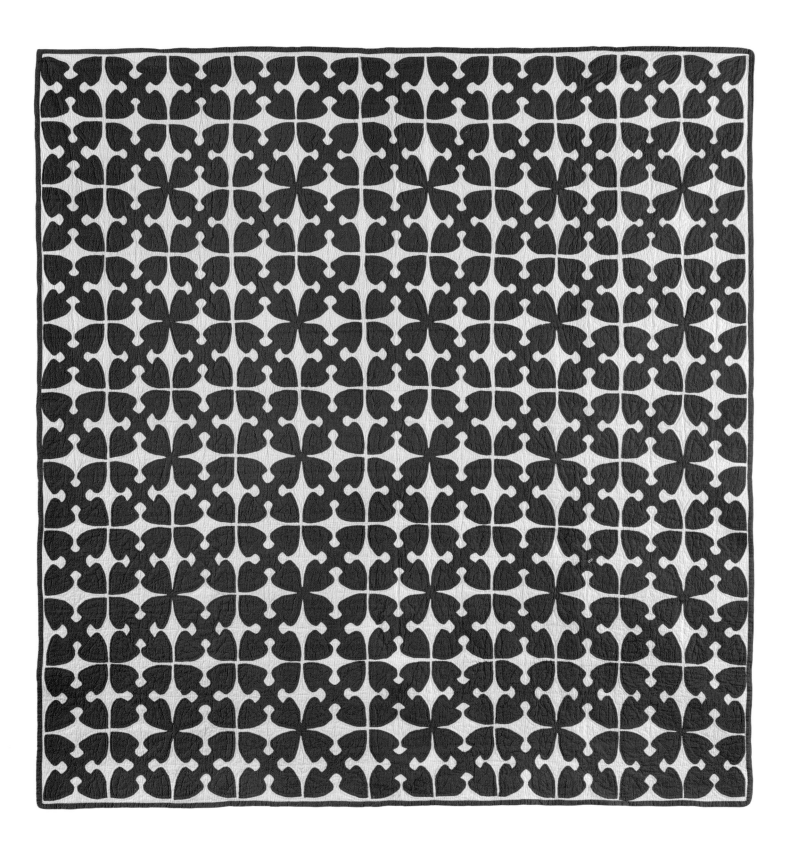

fig. 500
Floral Block Appliqué
Quilt, 80 x 78 ½ inches.

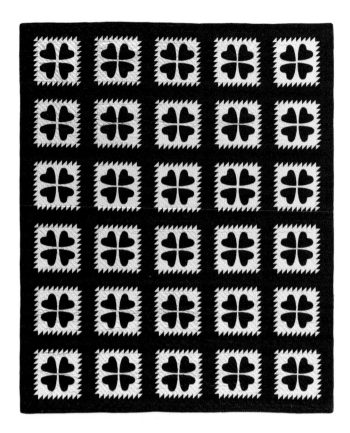

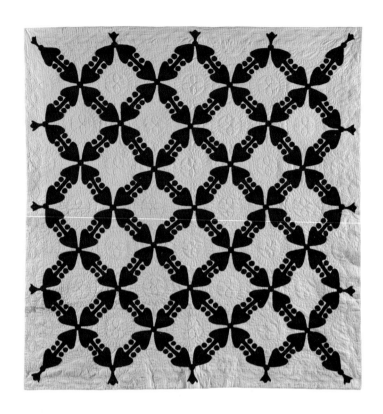

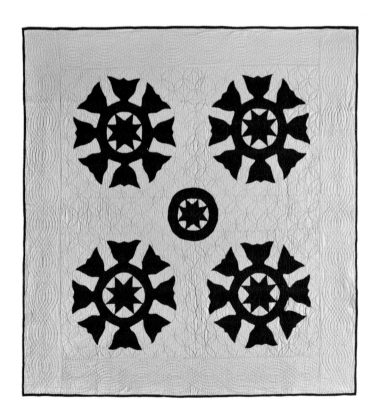

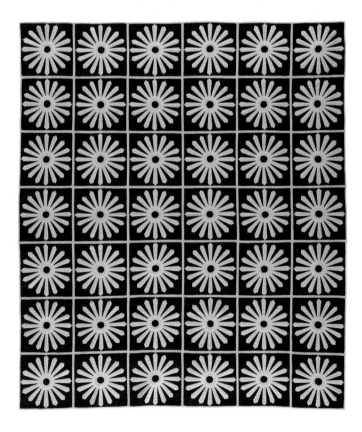

fig. 501
Hearts Appliqué Quilt with
sawtooth sashing and single
border, 83 x 69 inches.

fig. 502
Tulip Wheel Appliqué Quilt
with wide border, Lancaster
County, Pennsylvania,
72 x 68 inches.

fig. 503
White Rose Appliqué
Variation Quilt,
73 x 69 ½ inches.

fig. 504
Daisy Appliqué Summer
Quilt with narrow
sashing, New York State,
76 x 66 ½ inches.

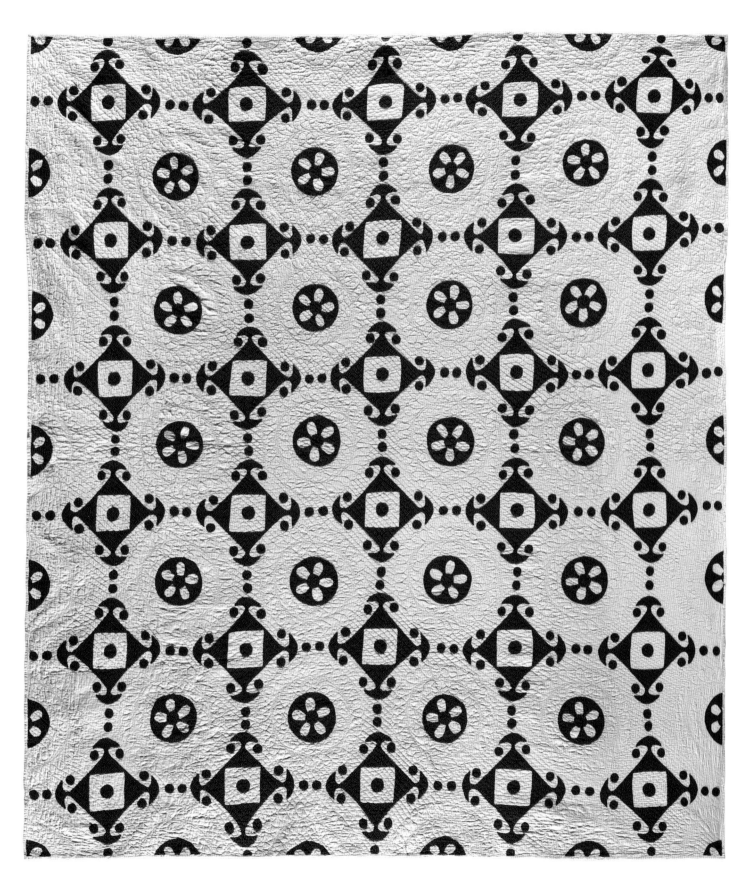

fig. 505
Unnamed Pattern
Appliqué Quilt, New
Salem, Pennsylvania,
94 ½ x 83 inches.

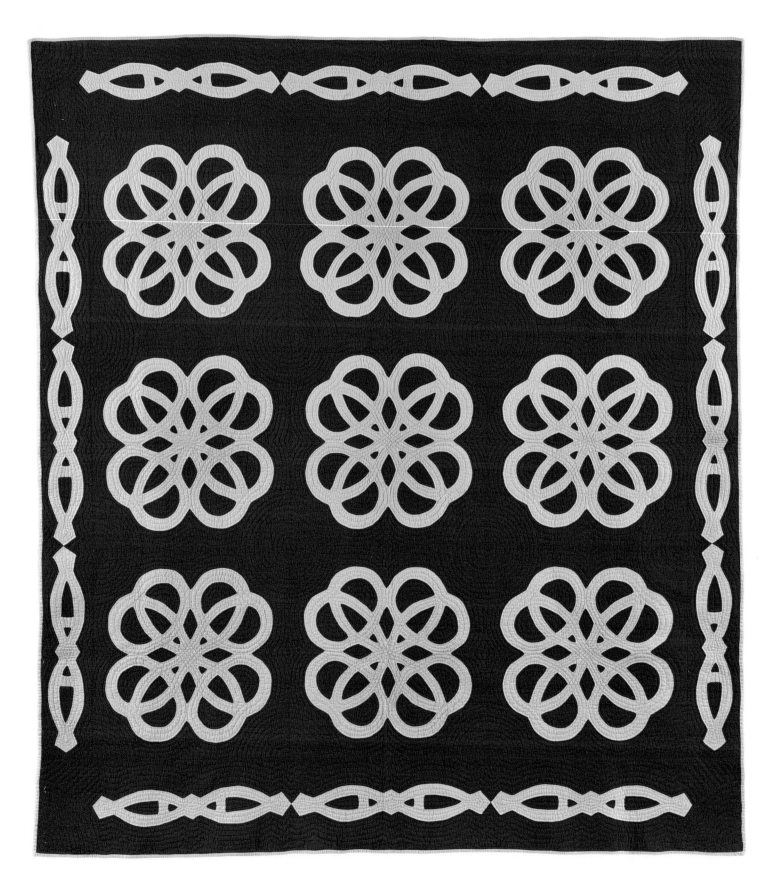

fig. 506
Celtic Knot Appliqué Quilt
with appliqué chain border,
80 ½ x 72 inches.

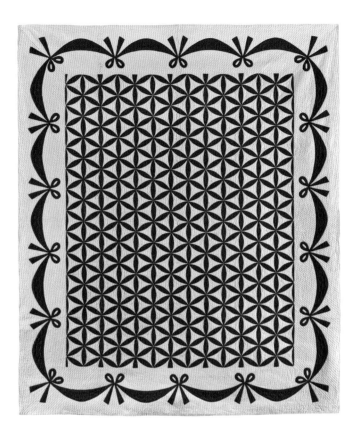

fig. 507
Unnamed Floral Pattern
Appliqué Quilt with
swag and bow border,
99 ½ x 85 inches.

fig. 508
Floral Block Appliqué Quilt
with swag border, c. 1870,
82 ½ x 82 ½ inches.

fig. 509
Turkey Tracks Appliqué
Quilt (Swinging Corners
Variation), New Hampshire,
c. 1870, 79 ½ x 65 inches.

fig. 510
Turkey Tracks Variation
Appliqué Quilt with double
border, Philadelphia, Penn-
sylvania, 99 x 84 inches.

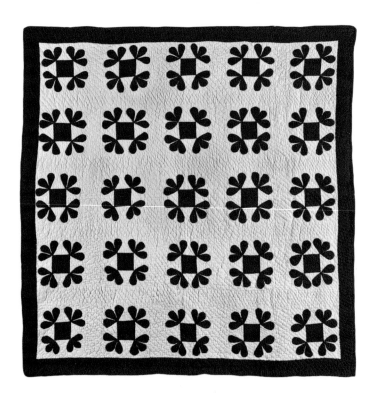

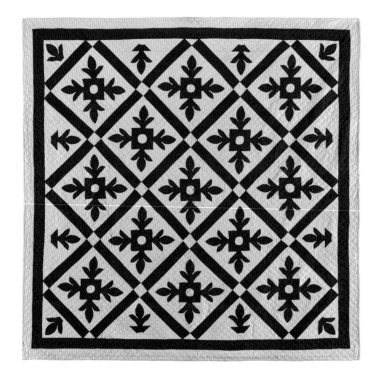

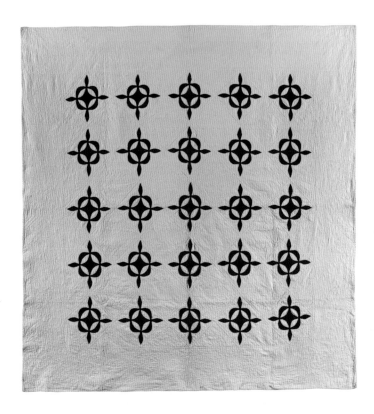

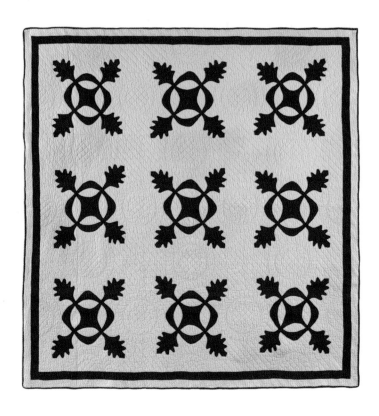

fig. 511
Wandering Foot Variation
Appliqué Quilt with single
border, 66½ x 66½ inches.

fig. 512
The Reel Appliqué
Quilt with wide border,
90 x 87 inches.

fig. 513
Golden Corn on Point
Variation Appliqué Quilt
with corner-block sashing

and double border,
78½ x 77½ inches.

fig. 514
Oak Leaf and Reel Appliqué
Quilt with double border,
81 x 77½ inches.

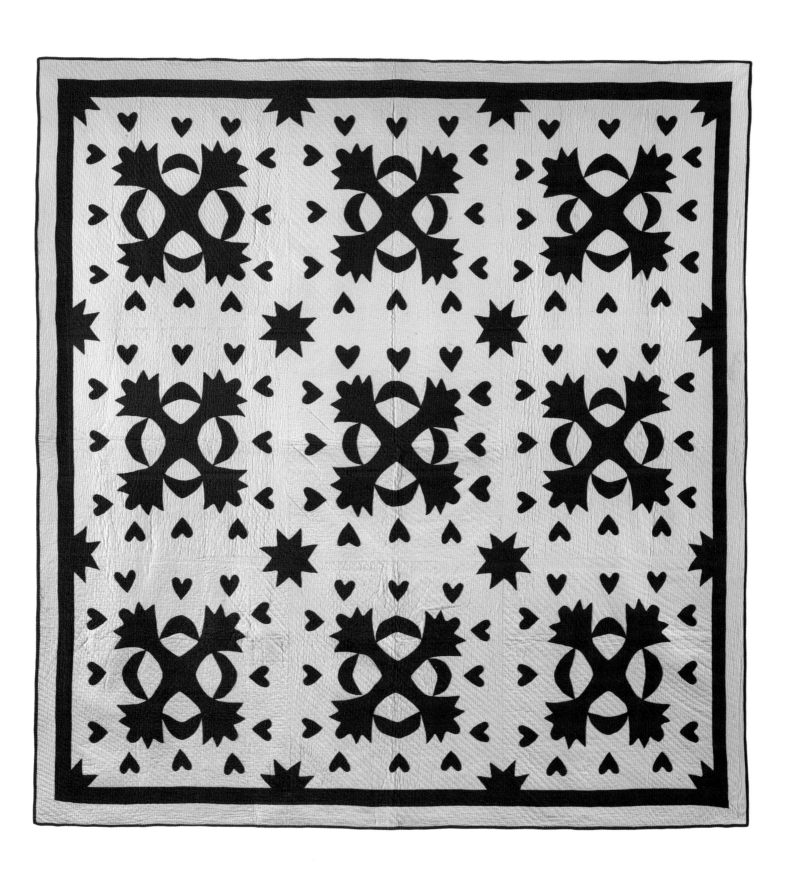

fig. 515
Oak Leaf and Reel with Hearts
and Stars Appliqué Quilt with
double border, Martinsburg,
West Virginia, 86 x 84 inches.

DECORATIVE APPLIQUÉ QUILTS

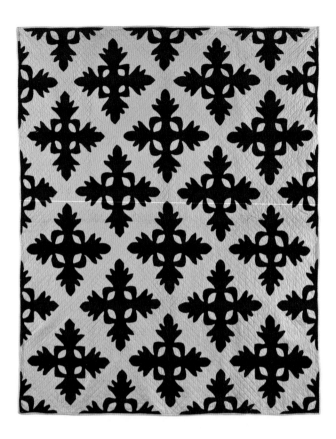

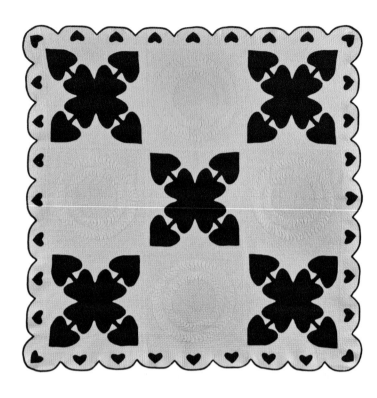

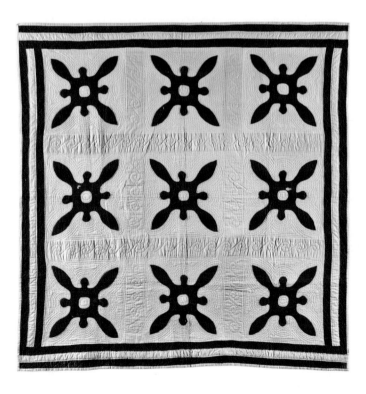

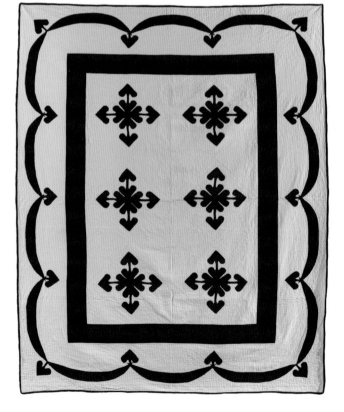

fig. 516
Oak Leaf and Reel on
Point Appliqué Quilt,
85½ x 69½ inches.

fig. 517
Snowflakes Appliqué Quilt
with sashing and triple
border, 70 x 69¼ inches.

fig. 518
Snowflakes Appliqué
Quilt (Double Hearts
Variation) with scalloped
edge, 75 x 75 inches.

fig. 519
Snowflakes Appliqué
Quilt (Double Hearts
Variation) with swag
border, 83 x 69 inches.

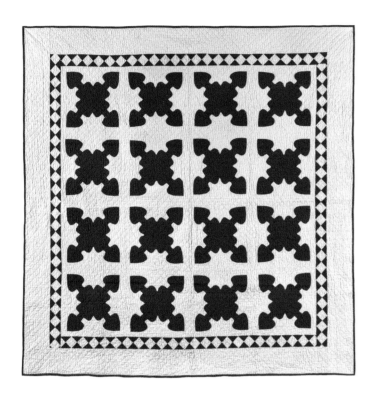

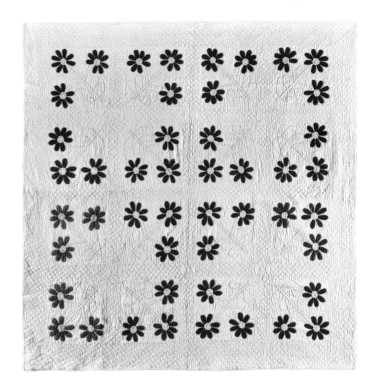

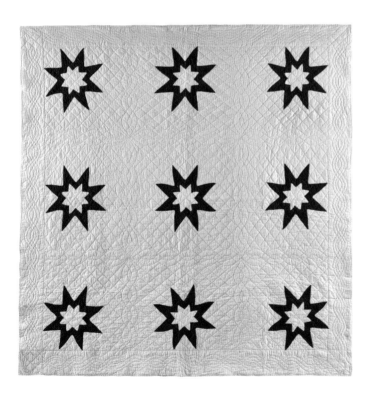

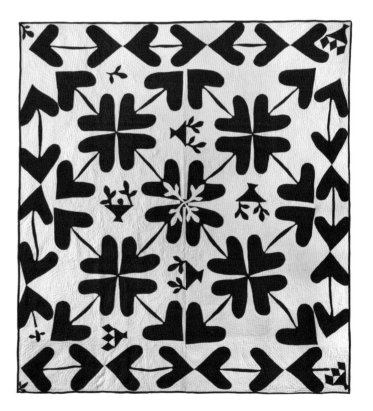

fig. 520
Crossed Hearts Appliqué Quilt with diamond border, Allentown, Pennsylvania, 73 x 72 inches.

fig. 521
Eight-Point Star Quilt (Reverse-Appliqué Stars Variation), Pennsylvania, 76 x 74 inches.

fig. 522
Daisy Appliqué Quilt with single border, 73 x 72 inches.

fig. 523
Double Hearts and Flowers Appliqué Quilt, Pennsylvania, 91 x 83 inches.

DECORATIVE APPLIQUÉ QUILTS

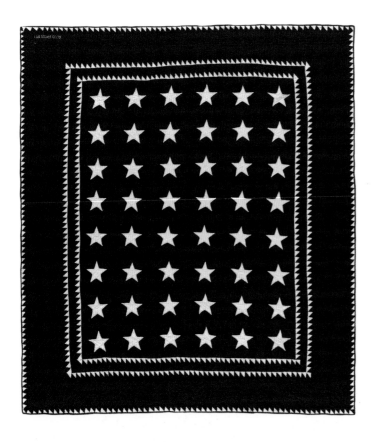

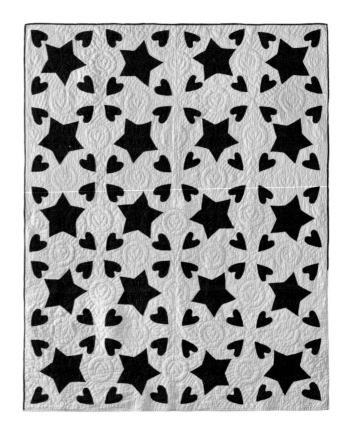

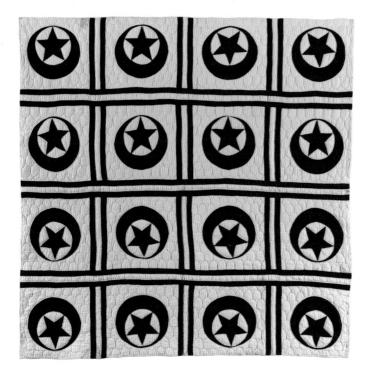

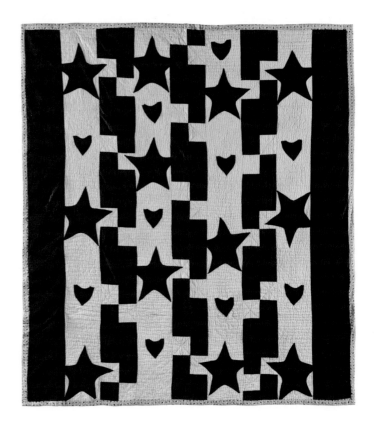

fig. 524
Five-Point Star Appliqué
Quilt with double sawtooth
borders and sawtooth edging,

designed and commercially
produced by Judi Boisson,
1991, 97 x 91 inches.

fig. 525
Stars in Circles Appliqué
Quilt with triple sashing,
74 ½ x 73 ½ inches.

fig. 526
Stars and Hearts Appliqué
Quilt, 82 x 67 inches.

fig. 527
Stars and Hearts Appliqué
Quilt with stepped sashing,
single side borders, and

calico patterned binding,
84 x 76 ½ inches.

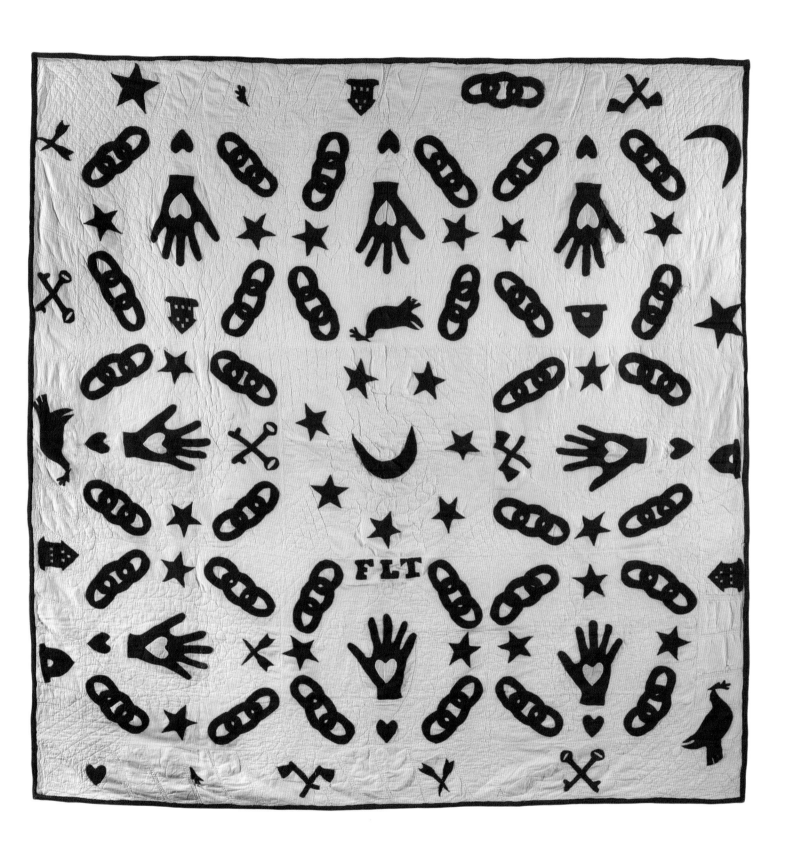

fig. 528
Odd Fellows Quilt (Hearts
in Hands and Chain Link
Appliqué Variation), labeled

"FLT" (Friendship, Love,
Truth), 74 ½ x 73 ½ inches.

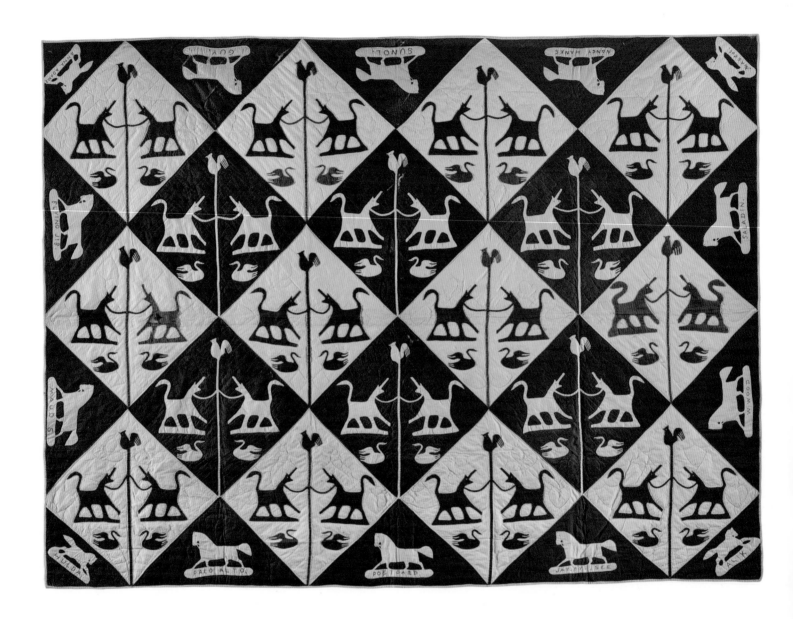

fig. 529
Racehorses and Unicorns
Appliqué Quilt with
embroidered racehorse
names and appliqué

unicorns, roosters, and
swans, possibly England,
66 ½ x 91 inches.

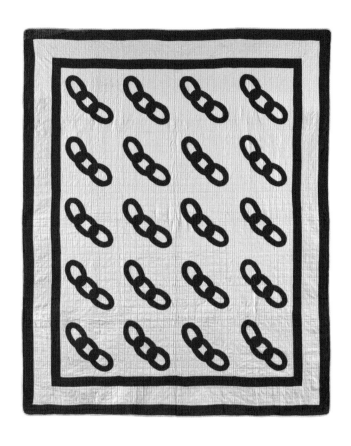

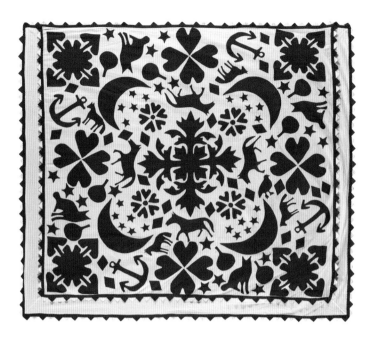

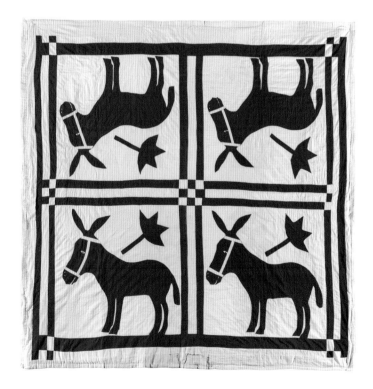

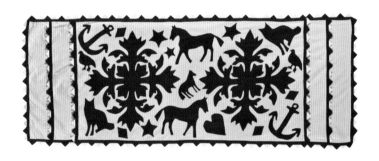

fig. 530
Three-Link Chain Appliqué
Quilt with triple border,
signed and dated "RAY,
2/19/29," 81 x 67 inches.

fig. 531
Donkeys Appliqué Quilt
with triple corner-block
sashing, 80 ½ x 79 inches.

fig. 532
Pictorial Appliqué
Summer Spread with
double prairie point
binding, 68 ½ x 82 inches.

fig. 533
Pictorial Appliqué
Pillow Cover with triple
prairie point binding,
33 x 85 inches.

DECORATIVE APPLIQUÉ QUILTS

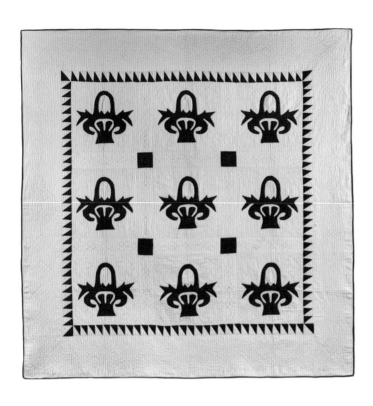

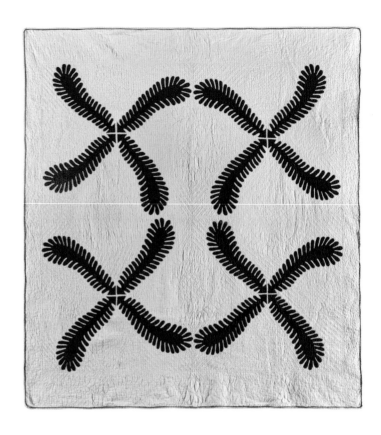

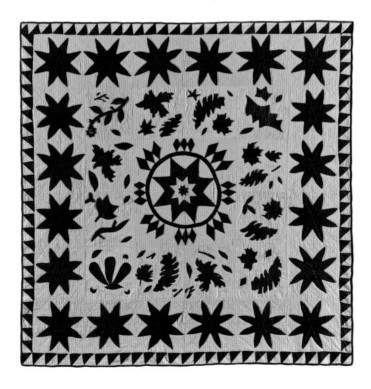

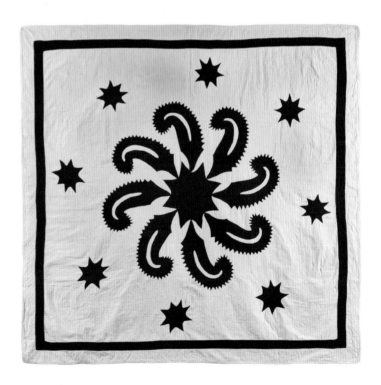

fig. 534
Baskets Appliqué
Quilt with sawtooth
border, Pennsylvania,
74 x 75 ½ inches.

fig. 535
Stars and Leaves Center
Medallion Quilt with saw-
tooth border, Rhinebeck,
New York, 71 x 71 inches.

fig. 536
Princess Feather Four
Block Appliqué Quilt with
single border, signed "Irma
Sailor" on back, York,
Pennsylvania, 1916,
79 x 72 inches.

fig. 537
Princess Feather and Stars
Appliqué Quilt with double
border, 80 x 79 inches.

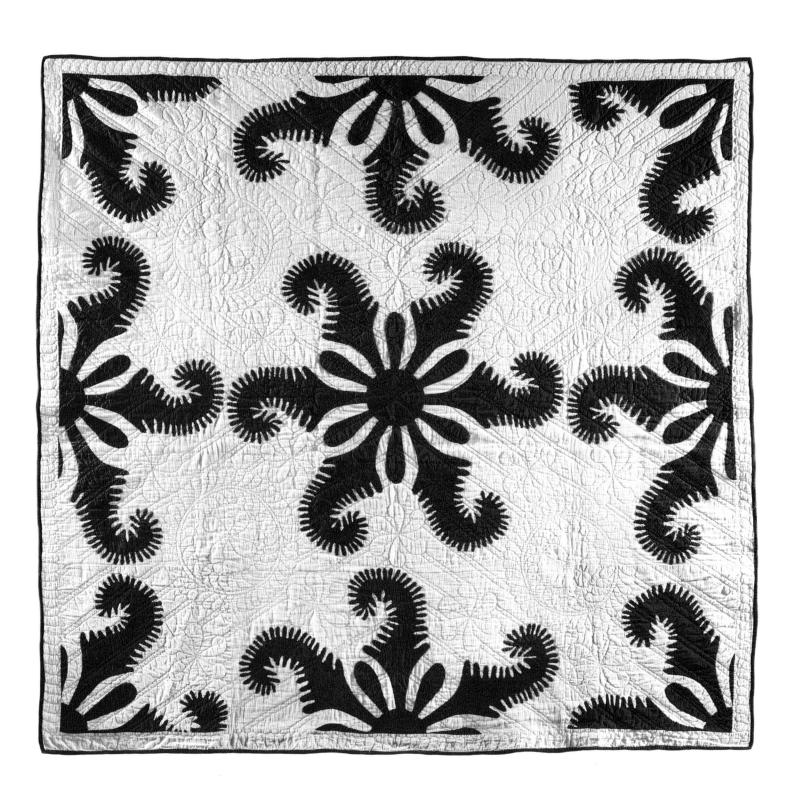

fig. 538
Princess Feather Appliqué Quilt
(Ben Hur's Chariot Wheel Varia-
tion) with single border, Waynes-
burg, Pennsylvania, 68 x 65 inches.

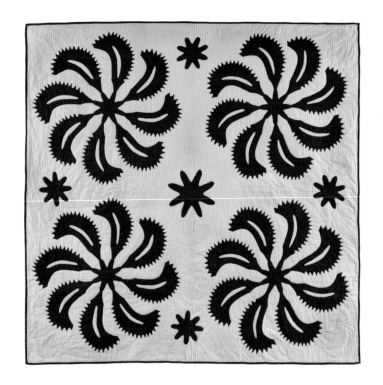

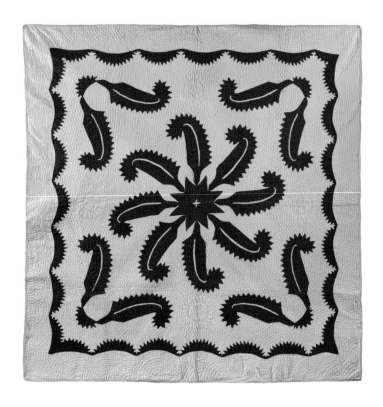

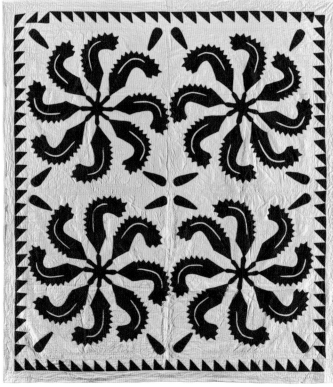

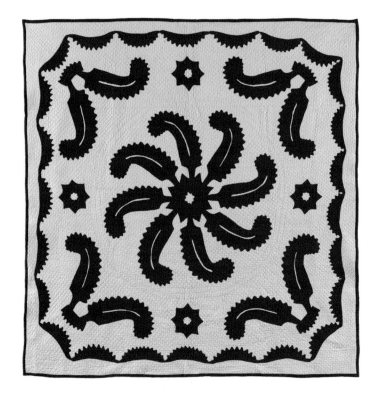

fig. 539
Princess Feather Four
Block Appliqué Quilt,
77½ x 76 inches.

fig. 540
Princess Feather Four Block
Appliqué Quilt with saw-
tooth border, Pennsylvania,
88 x 80 inches.

fig. 541
Princess Feather Appliqué
Quilt with appliqué border,
70 x 68½ inches.

fig. 542
Princess Feather Appliqué
Quilt (Star and Plume
Variation) with appliqué

border, Martinsburg, West
Virginia, 76½ x 73 inches.

SNOWFLAKE (figs. 543–575)

Snowflake and "Scherenschnitte" patterns are based on folded paper cutting, popularized by German settlers in the nineteenth century.

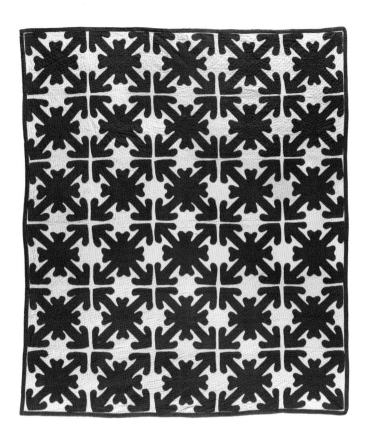

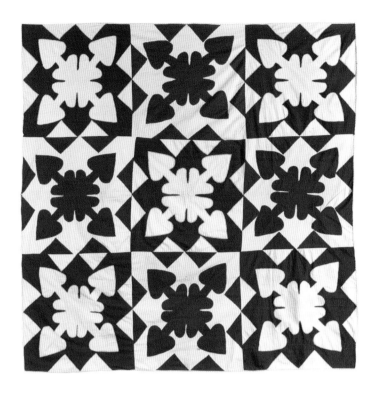

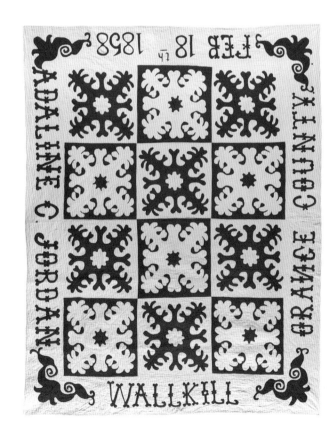

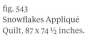

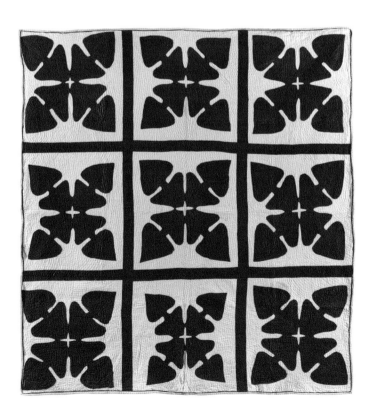

fig. 543
Snowflakes Appliqué Quilt, 87 x 74 ½ inches.

fig. 544
Adaline Jordan Wedding Appliqué Quilt, Adaline C. Jordan (1828–?), Wallkill, New York, 1858, 94 x 73¾ inches.

fig. 545
Snowflakes Appliqué Quilt Top, 77 x 74 inches.

fig. 546
Snowflakes Appliqué Quilt with sashing, 81 x 78 inches.

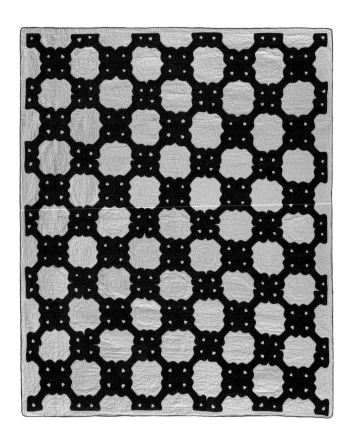

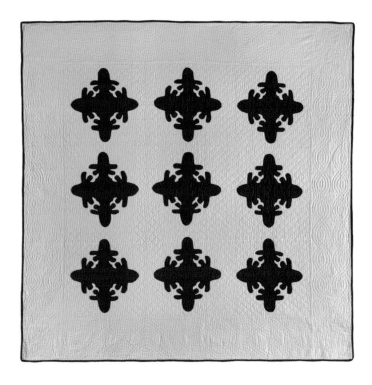

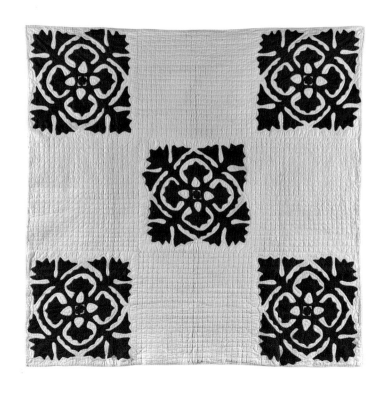

fig. 547
Tiny Hearts Appliqué Quilt
with single border, c. 1930,
86 ½ x 74 inches.

fig. 548
Snowflakes Appliqué
Quilt with wide border,
71 x 71 inches.

fig. 549
Snowflakes Appliqué
Quilt with wide border,
83 x 83 inches.

fig. 550
Snowflakes Appliqué
Quilt with setting squares,
71 ½ x 70 ½ inches.

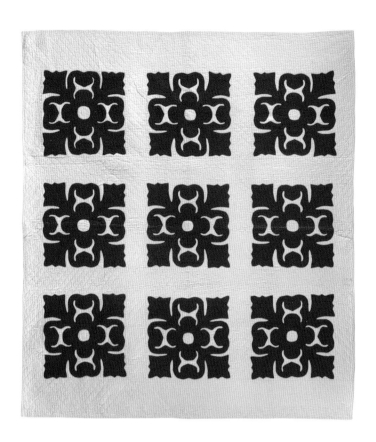

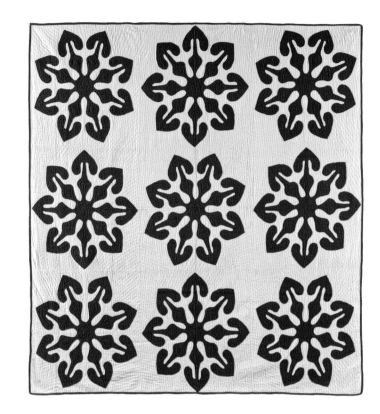

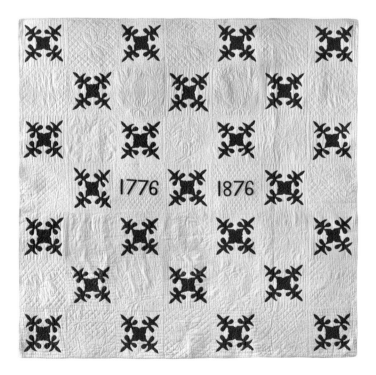

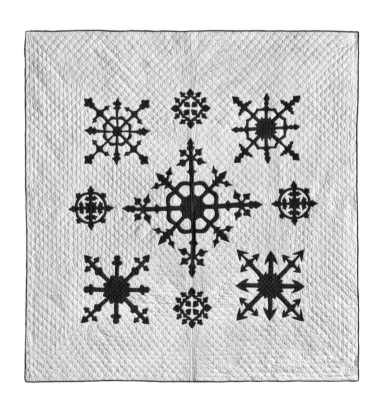

fig. 551
Snowflakes Appliqué Quilt
with sashing and single
border, 86 ½ x 76 ½ inches.

fig. 552
Centennial Snowflakes
Appliqué Quilt, c. 1876,
79 ½ x 77 inches.

fig. 553
Snowflakes Appliqué
Quilt, 79 ½ x 76 inches.

fig. 554
Snowflakes Appliqué
Quilt with wide border,
83 x 82 inches.

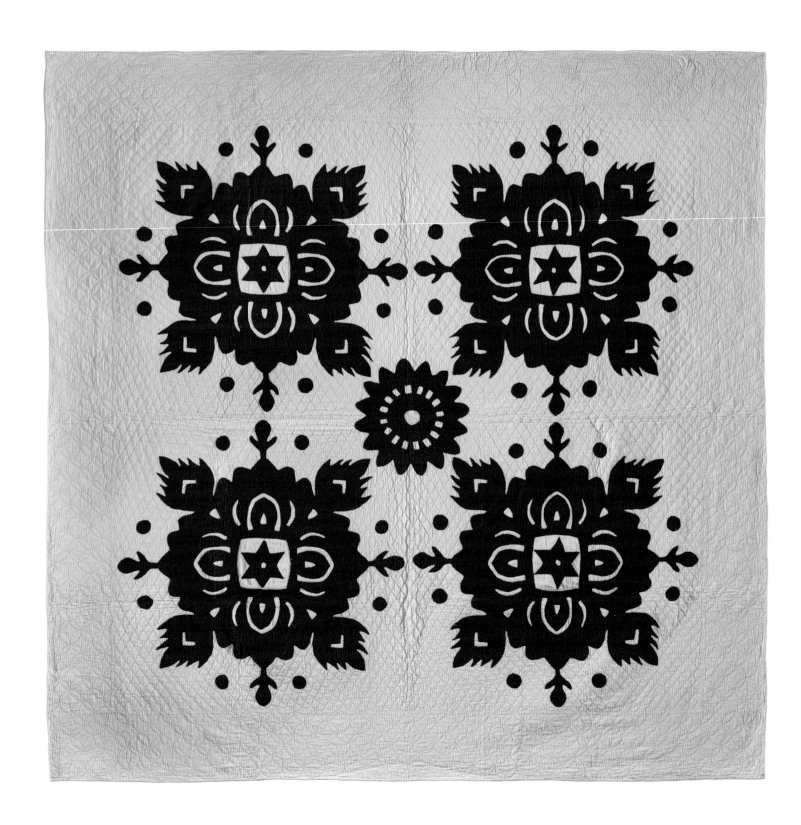

fig. 555
Snowflakes Appliqué
Quilt with wide border,
82 x 81 inches.

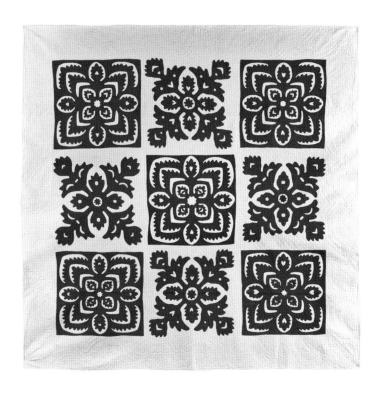

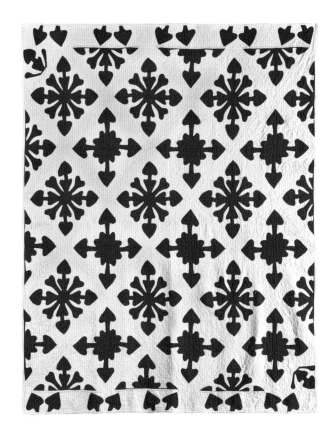

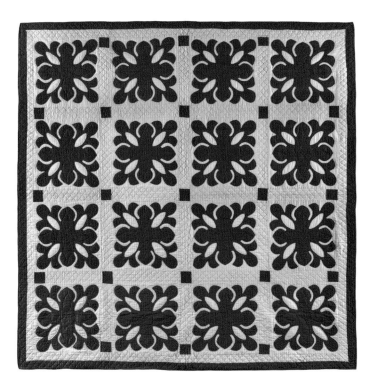

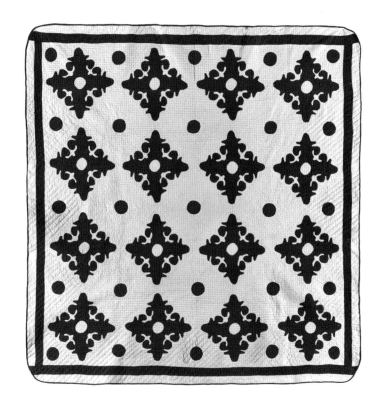

fig. 556
Snowflakes Appliqué Quilt with wide border, Sarah Elizabeth (Milleisen) Mumma, labeled "Sarah Elizabeth (Milleisen) Mumma for her granddaughter, Sarah Elizabeth Mumma," 1857, 88 x 88 inches.

fig. 557
Snowflakes Appliqué Quilt with corner-block sashing and double border, 84 ½ x 83 ½ inches.

fig. 558
Snowflakes on Point Appliqué Quilt (Hearts and Flowers Variation) with sashing and single top and bottom borders, 83 x 65 ½ inches.

fig. 559
Snowflakes and Snowballs Appliqué Quilt with double border, 84 x 81 inches.

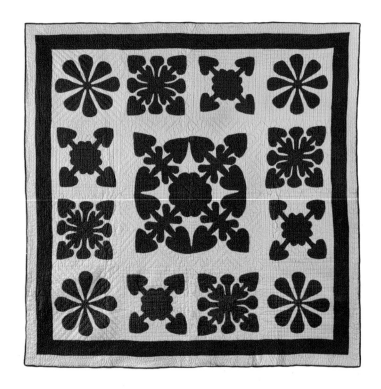

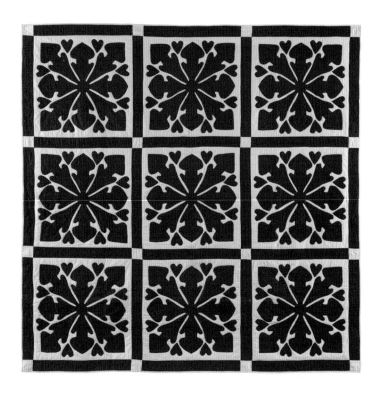

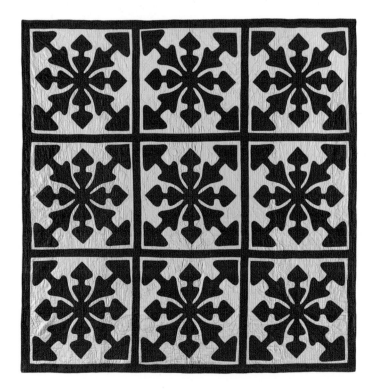

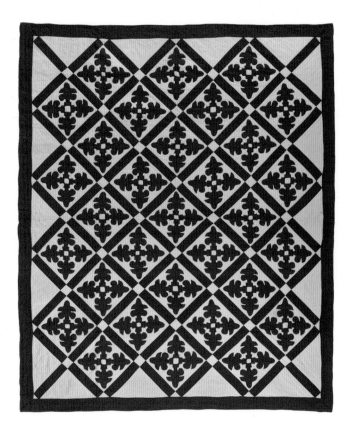

fig. 560
Snowflakes Appliqué
Quilt (Crossed Hearts and
Spades Sampler Variation)

with double border,
western Pennsylvania,
72 ½ x 71 inches.

fig. 561
Snowflakes Appliqué Quilt
with sashing and single
border, 85 x 82 ½ inches.

fig. 562
Snowflakes Appliqué
Quilt with corner-block
sashing and single border,
77 ½ x 76 ½ inches.

fig. 563
Snowflakes on Point Appliqué
Quilt (Fleur-de-Lis Variation)
with corner-block sashing and
single border, labeled "Grand-

mother Musselman's Mother
as a Wedding Gift for Grand-
mother," Chestnut Hill, Penn-
sylvania, 1892, 90 x 76 inches.

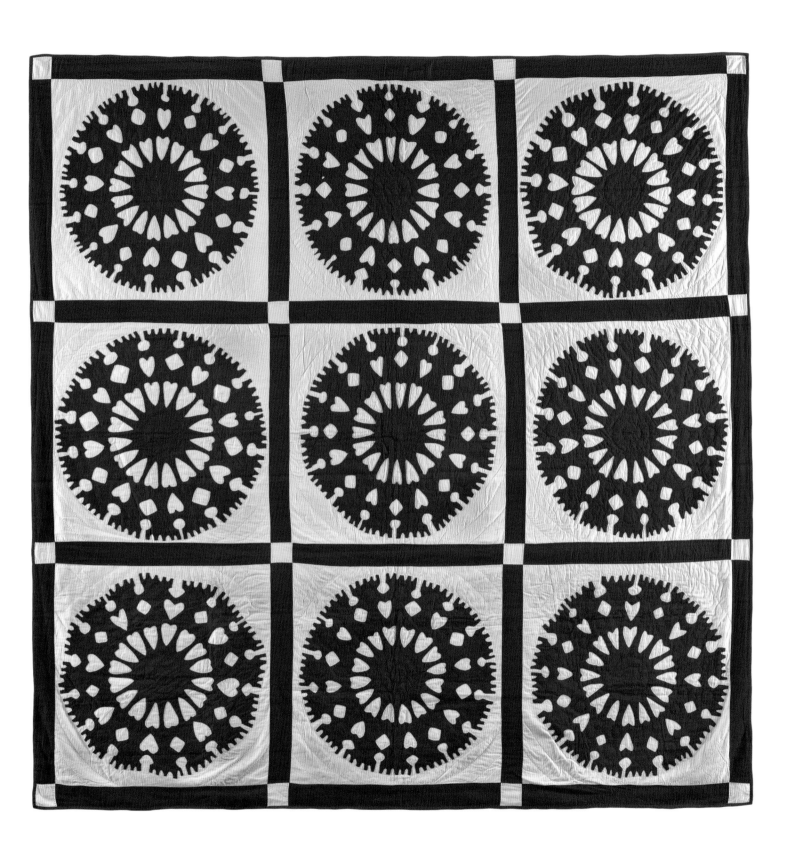

fig. 564
Scherenschnitte Appliqué
Quilt with corner-block
sashing and single border,
81½ x 81 inches.

DECORATIVE APPLIQUÉ QUILTS

301

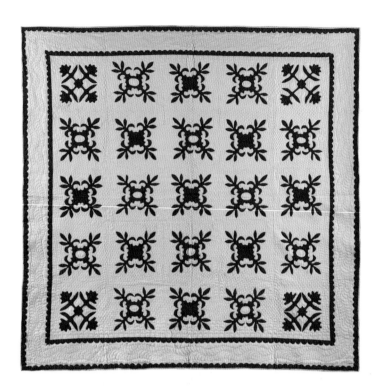

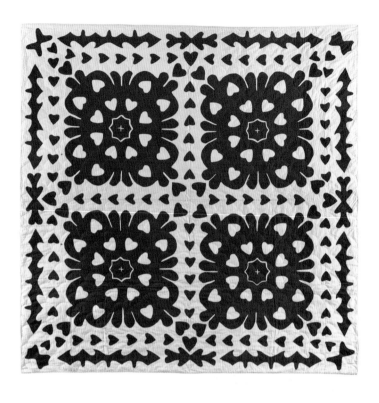

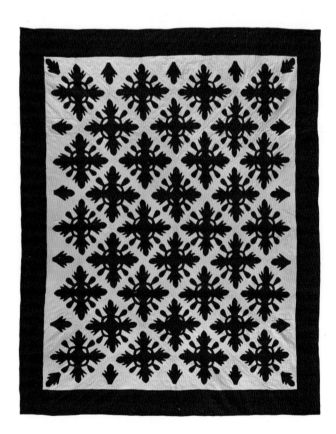

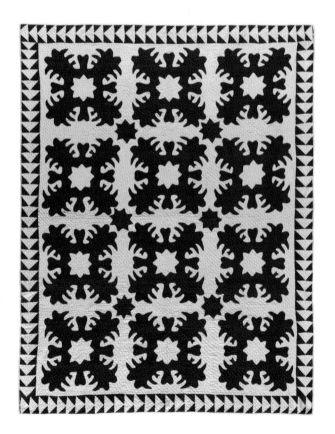

fig. 565
Snowflakes Appliqué Quilt
with scalloped border,
89 x 88 inches.

fig. 566
Snowflakes on Point
Appliqué Quilt with single
border, 93 ½ x 74 ½ inches.

fig. 567
Scherenschnitte Appliqué
Quilt (Hearts Variation)
with elaborate sashing and
single appliqué border,
84 x 84 inches.

fig. 568
Snowflakes Appliqué Quilt
with wild goose chase
border, 88 x 70 ½ inches.

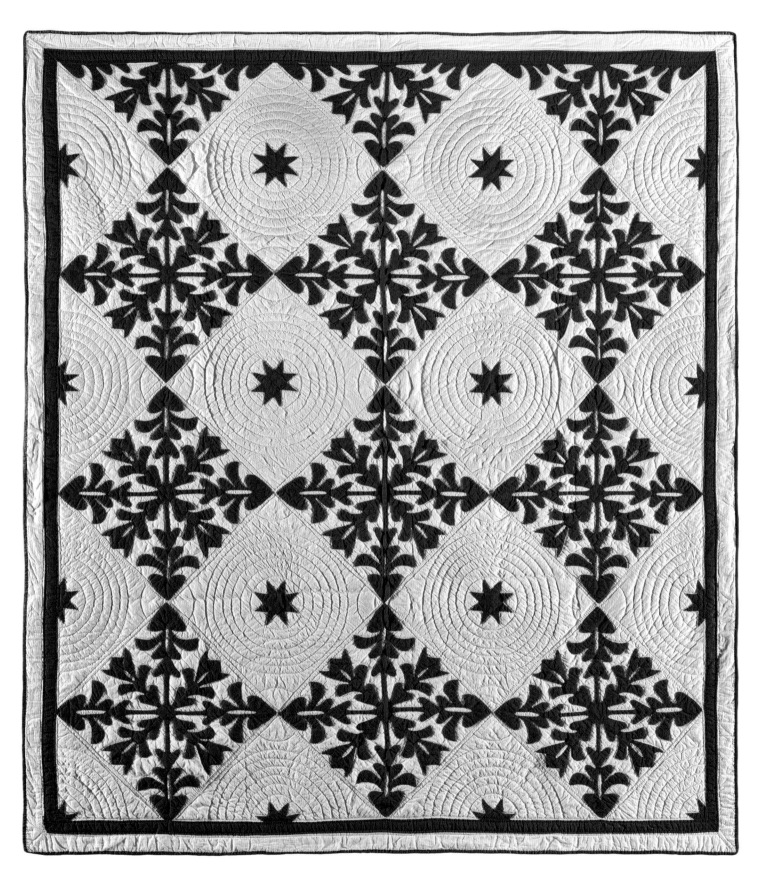

fig. 569
Scherenschnitte and
Stars on Point Appliqué
Quilt with double border,
83½ x 73 inches.

DECORATIVE APPLIQUÉ QUILTS

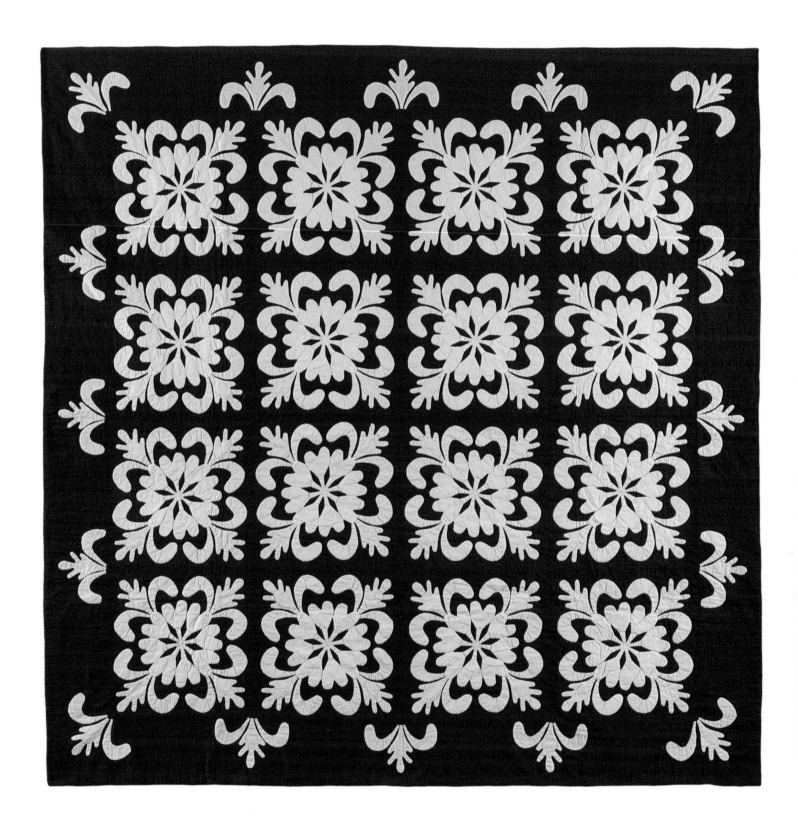

fig. 570
Snowflakes Appliqué
Quilt with appliqué
border, 75 x 75 inches.

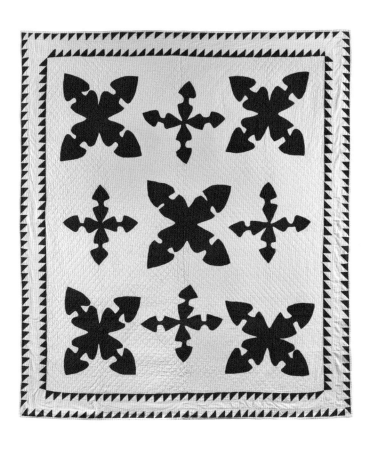

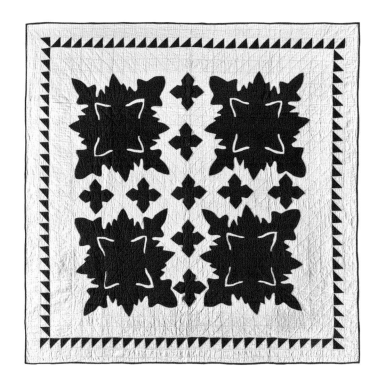

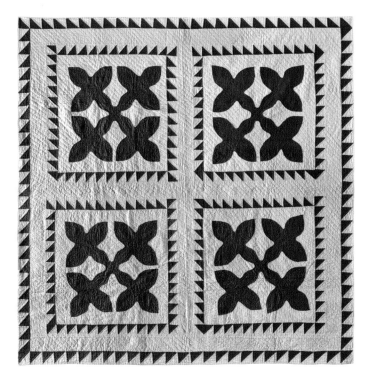

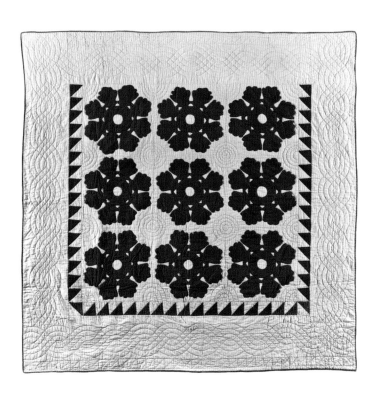

fig. 571
Double Hearts Appliqué
Quilt with double sawtooth
border, 84 x 74 inches.

fig. 572
Snowflakes Appliqué Quilt
with sawtooth sashing and
border, 76 x 75 inches.

fig. 573
Snowflakes Appliqué
Quilt with sawtooth border,
c. 1930, 74 x 71 inches.

fig. 574
Snowflakes Appliqué Quilt
with three-sided sawtooth
inner border and wide outer
border, 77 x 76 inches.

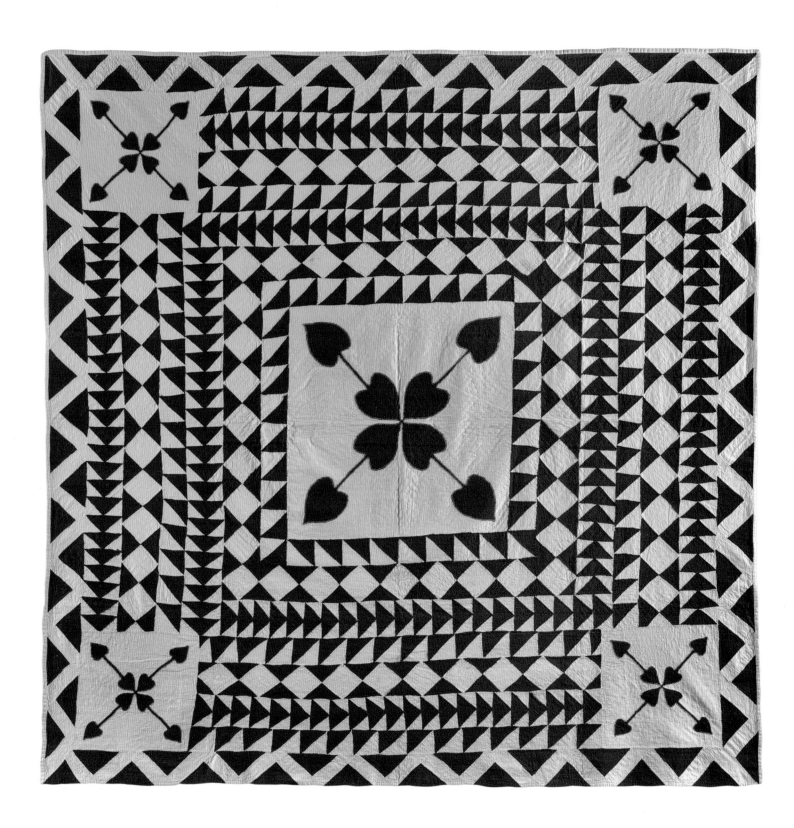

fig. 575
St. Valentine's Patch Quilt
(Crossed Hearts and Spades
Appliqué Variation), with
zigzag border, 74 x 74 inches.

HAWAIIAN (figs. 576–591)

Hawaiian appliqué, like Snowflake, uses paper cutting to create a design but is usually reverse appliqué; snowflakes are applied to a background.

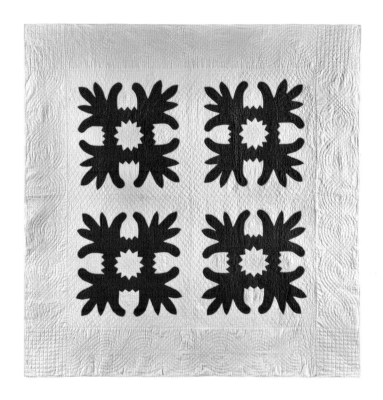

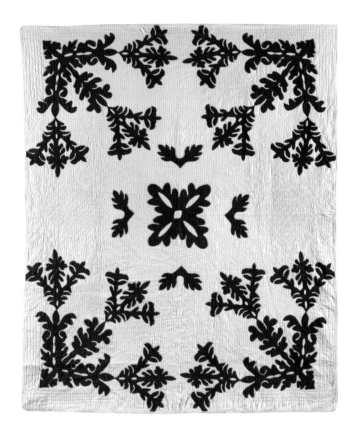

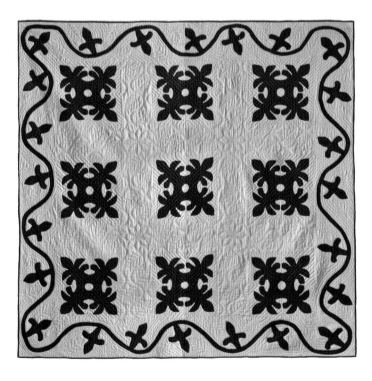

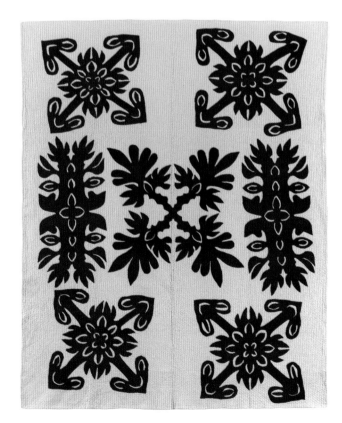

fig. 576
Hawaiian Appliqué
Quilt with wide border,
77 x 75 ½ inches.

fig. 577
Hawaiian Appliqué Quilt
with vine appliqué border,
Labeled "Sarah Bigger

Kithcart, 1824–1925, D. K.
McC.," 76 ½ x 75 inches.

fig. 578
Hawaiian Appliqué
Quilt, 87 ½ x 72 inches.

fig. 579
Hawaiian Appliqué
Quilt, 81 ½ x 66 ½ inches.

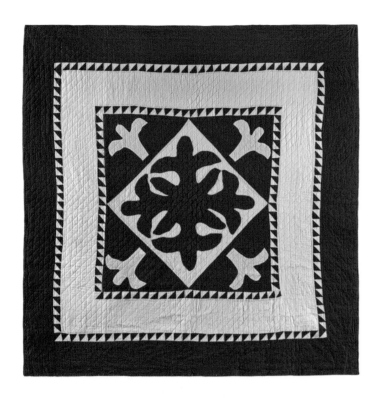

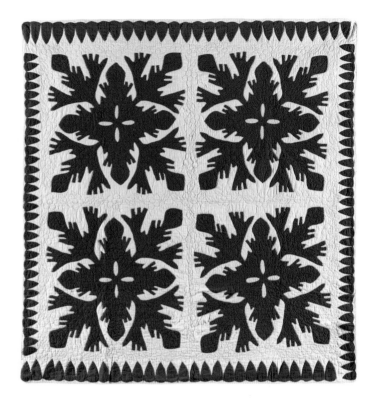

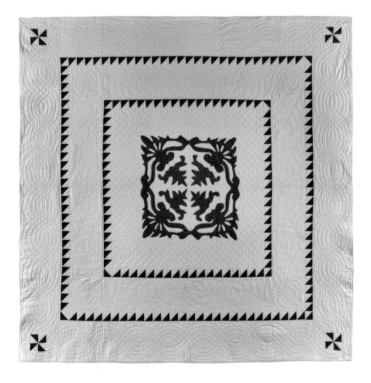

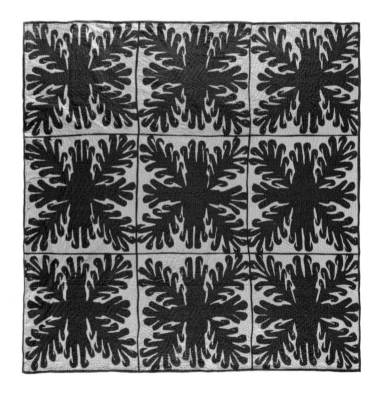

fig. 580
Hawaiian Appliqué Center
Medallion Quilt with
double sawtooth borders,
81 x 79¾ inches.

fig. 581
Hawaiian Appliqué Center
Medallion Quilt with double
sawtooth borders and

pinwheel corners, Berks
County, Pennsylvania,
72½ x 71½ inches.

fig. 582
Hawaiian Appliqué Quilt
with single appliqué border,
76 x 73½ inches.

fig. 583
Hawaiian Appliqué Quilt
with narrow sashing,
85 x 82 inches.

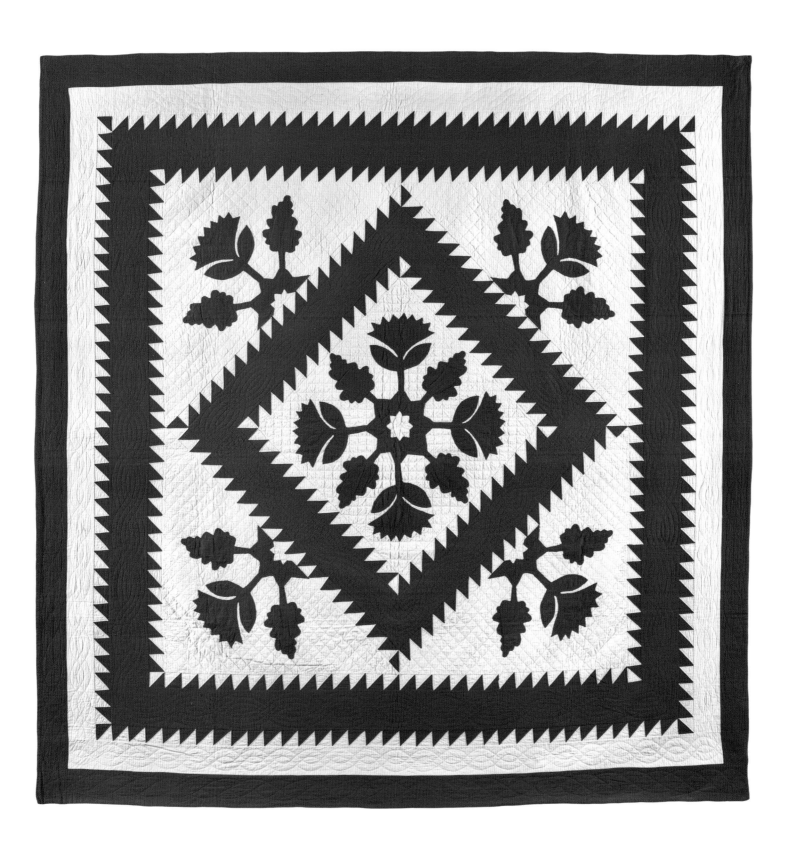

fig. 584
Center Diamond Hawaiian
Appliqué Quilt with triple
sawtooth borders, Lancaster

County, Pennsylvania,
83 ½ x 81 ½ inches.

DECORATIVE APPLIQUÉ QUILTS

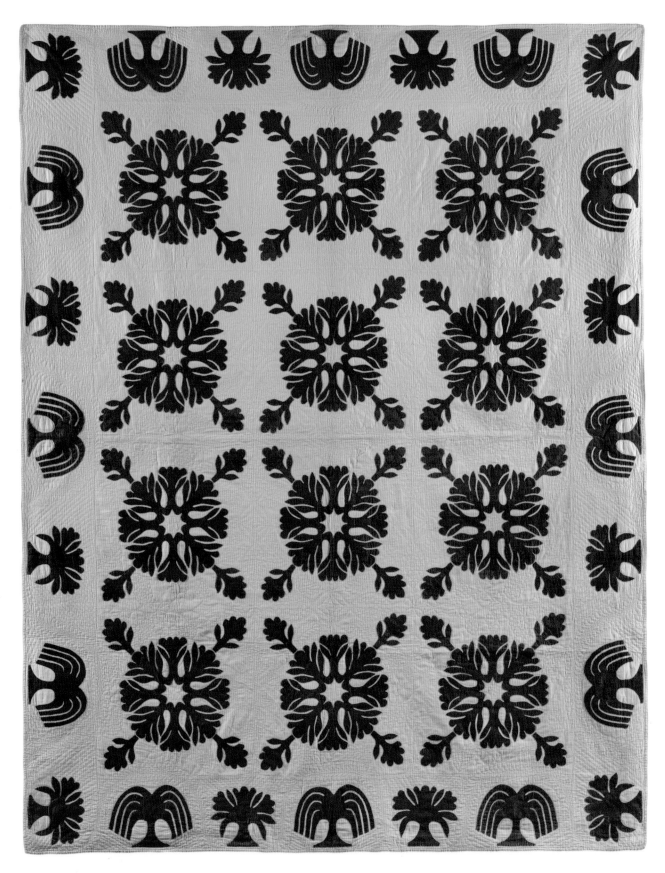

fig. 585
Hawaiian Appliqué Quilt
with tree border, possibly
New York State, c. 1860,
91 x 71 inches.

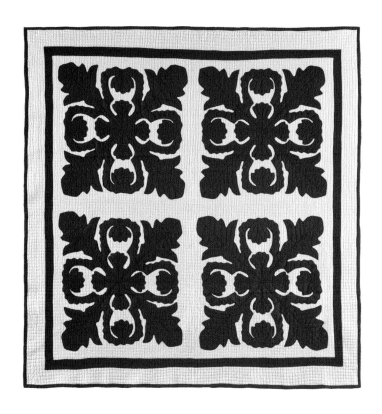

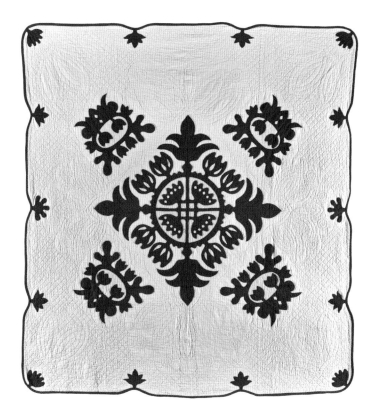

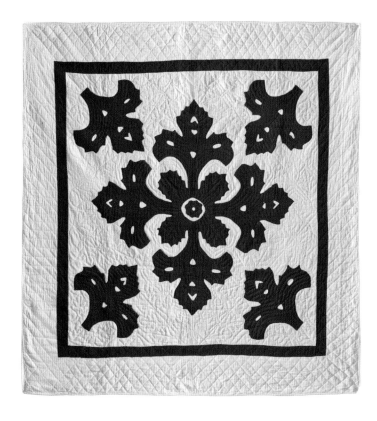

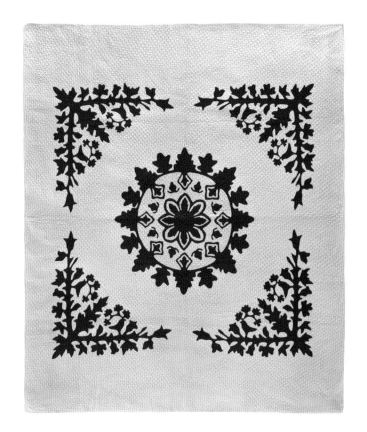

fig. 586
Hawaiian Appliqué
Quilt with double
border, 79 x 76 inches.

fig. 587
Hawaiian Appliqué
Quilt with double
border, 72 x 70 inches.

fig. 588
Hawaiian Appliqué
Quilt with scalloped
edge, 81 x 73 ½ inches.

fig. 589
Hawaiian Appliqué Center
Medallion Quilt with
appliqué corner motifs and
wide border, 80 ½ x 71 inches.

DECORATIVE APPLIQUÉ QUILTS

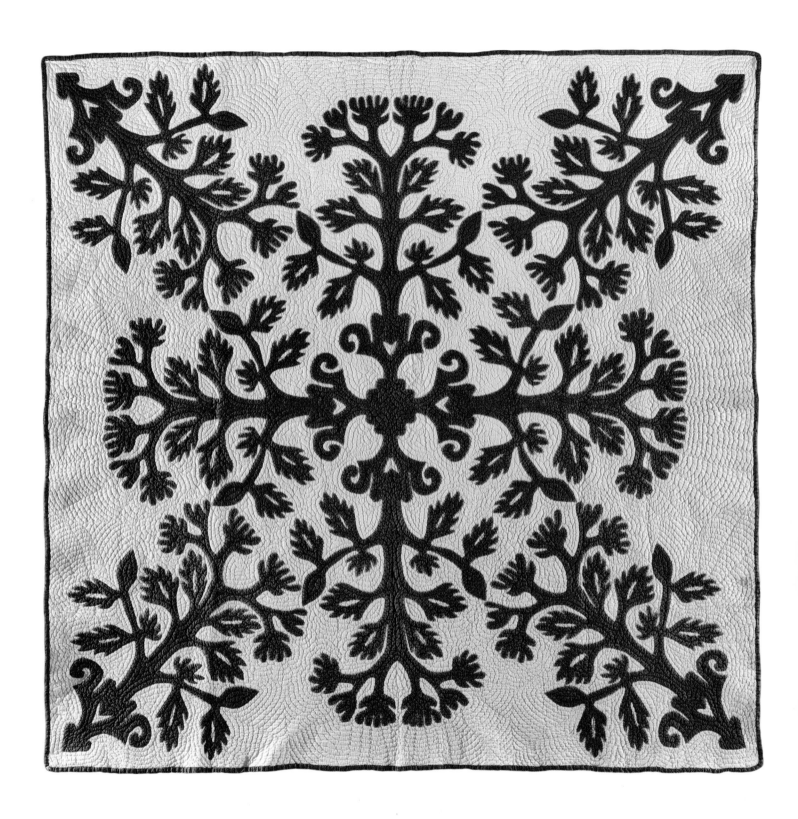

fig. 590
Hawaiian Appliqué
Wholetop Quilt,
81 x 81 inches.

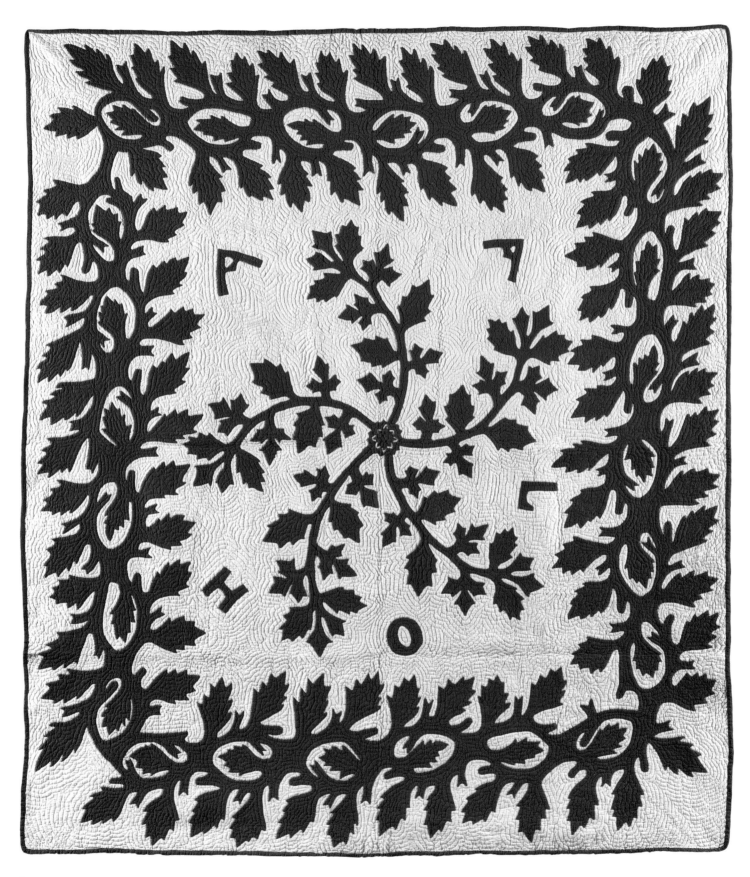

fig. 591
Hawaiian Appliqué
"Aloha" Wholetop Quilt,
90 x 81 inches.

Signature Quilts

A signature adds a personal touch to a message. Signature quilts, also called friendship quilts or autograph quilts, extend this idea by including more than one name and are intended to comfort or celebrate the recipient. Such quilts have been made for about two hundred years and are still a popular way for groups to come together to create a project.

In the late nineteenth century signature quilts were often created by members of a community group, such as a church congregation, for sale or auction to raise funds. Some were intended as a memorial to a person, to commemorate an event, or to mark an occasion. Others, particularly those dating from the first half of the nineteenth century, were made by relatives and friends for an individual or family relocating to another area as a token of remembrance, to bridge the distance. Many pioneers settling in newly opened land west of the Appalachian Mountains carried treasured signature quilts to the frontier, knowing that they would probably never see many of the signers again. The signature quilts that survived the rigors of arduous journeys and unforgiving weather conditions were probably valued possessions held in high regard by the recipients and therefore looked after carefully.

Signature quilts are not the same as signed quilts. The latter indicates that the maker has added her or his name or, in some cases, initials to a finished quilt, whereas signature quilts carry the names of people who may or may not have had a hand in creating them. One popular type of signature quilt was designed to garner many signatures, each of which was added when a donation or fee—often a dime—was paid to the organizing group, usually a church or other charitable institution. Among those was the Red Cross, founded in 1863 in Switzerland and established in the United States in 1881. Its humanitarian efforts became the focus of a huge fund-raising campaign during World War I. Many signature quilts found today are red and white and have red crosses as the main motif.

In some cases, the reason for a signature quilt's creation is stitched into the fabric, or documentation exists to confirm why it was made. In others, clues can be gleaned from the names on the quilt. Sometimes multiple makers created a signed block for inclusion in the finished quilt. The names on a signature quilt can prove very useful for those doing historical research. Early signature quilts were often signed in permanent ink, but on most of the known red and white signature quilts the names are embroidered in red or white thread, usually by one person working from a list of contributors, so the "hand" is consistent. Sometimes the donor signed the fabric directly, and the name was embroidered on top by someone with that skill. A large number of red and white quilts were created after the Civil War, when stable red dye became widely available, and the signatures on these are generally embroidered with a chain stitch or stem stitch.

Signature quilts are still widely made by charitable organizations to raise money—either by selling individual blocks or being raffled—to perform service or help promote awareness of a group's mission.

TRADITIONAL BLOCKS (figs. 592–612)
The blocks in signature quilts are chosen to give
enough open space for the placement of a signature,
or for something more.

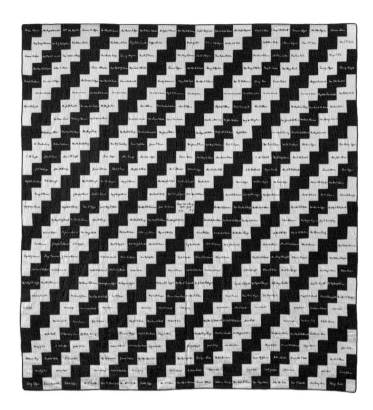

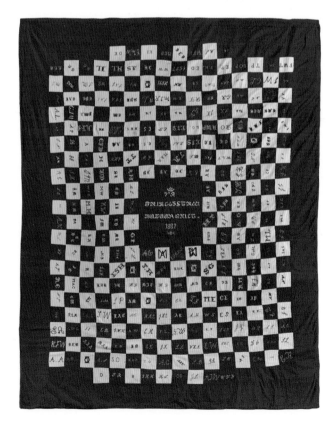

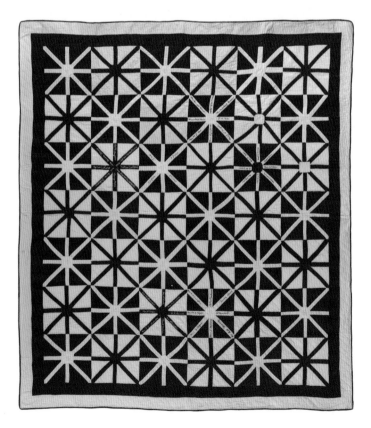

fig. 592
Streak of Lightning Quilt,
Ladies Aid Society of
Little York, New Jersey, 1912,
92 x 86 ½ inches.

fig. 593
Initialed Squares Quilt Top
with single border, possibly
England, 90 x 72 ½ inches.

fig. 594
Nine Patch Blocks on
Point Quilt with double
border, embroidered

"Samuel G Kendrew,
50 c" in center,
82 ½ x 67 inches.

fig. 595
Crossroads Friendship
Quilt with double
border, Pennsylvania,
89 x 78 inches.

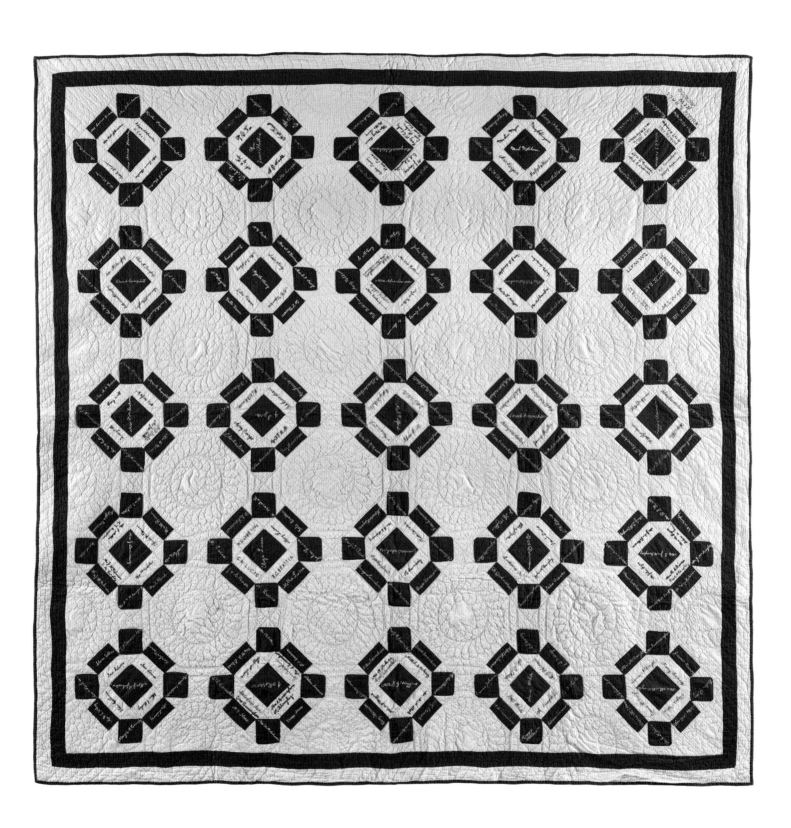

fig. 596
Rolling Stones Quilt with
double border, Mollie Hall
for Mrs. Telford and Herbert
Telford and signed by their
friends (signatures from
Indiana, Pennsylvania, and
New Mexico), New Mexico,
82 x 82 inches.

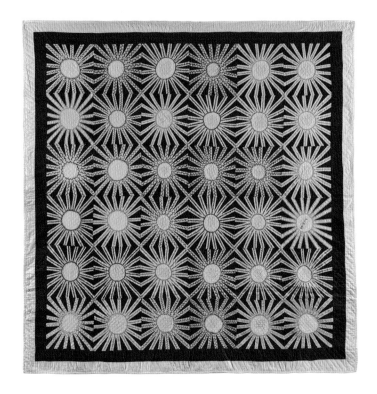

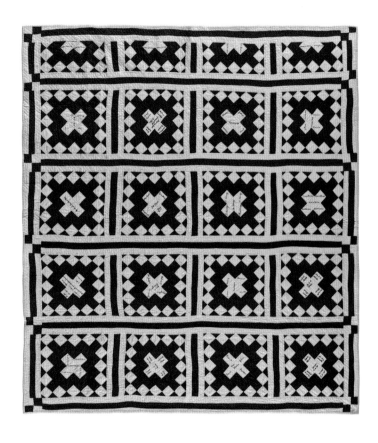

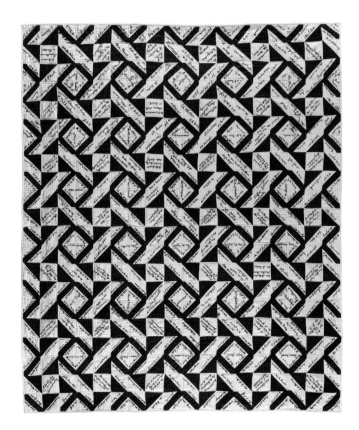

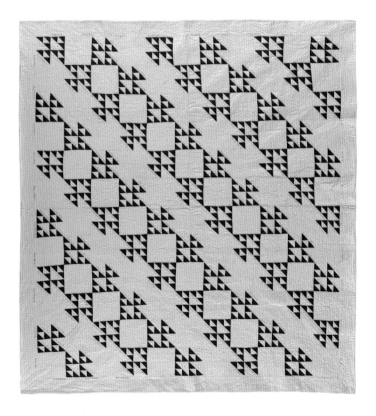

fig. 597
Original Sunburst Quilt with double border, New York State, 77 x 74 ½ inches.

fig. 598
Pinwheels Quilt, New York State, 77 ¾ x 66 inches.

fig. 599
Courthouse Square Quilt with triple sashing and four patch corner-block border, Beulah Ladies Aid of Dumfries, Virginia, c. 1918, 80 ½ x 72 inches.

fig. 600
Birds in the Air Variation Quilt with single border, 90 x 84 inches.

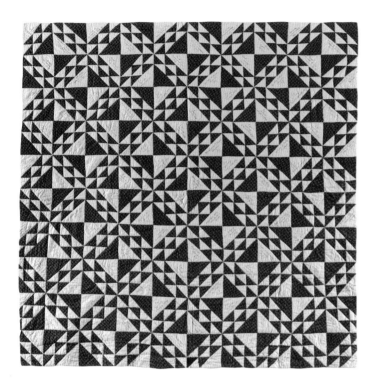

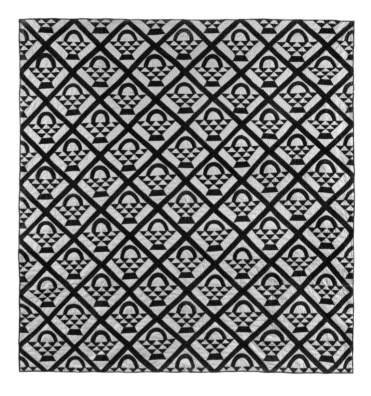

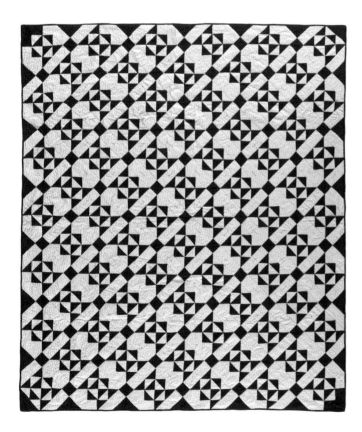

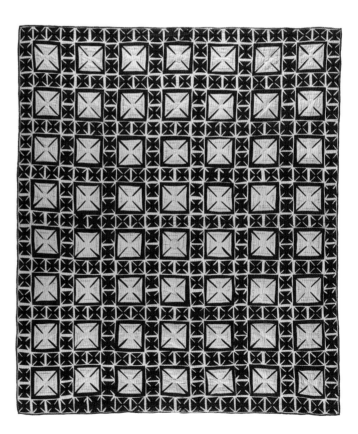

fig. 601
Corn and Beans Quilt,
Signatures from New York,
New Jersey, Washington, DC,
and England, 77 x 77 inches.

fig. 602
Broken Dishes Variation
Quilt, Bucks County,
Pennsylvania, 85 x 73 inches.

fig. 603
Baskets on Point Quilt with
sashing, 85 x 81 inches.

fig. 604
Iron Cross Quilt, dated
July 1897, 85 ½ x 75 inches.

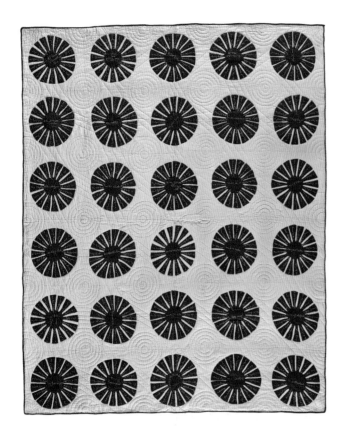

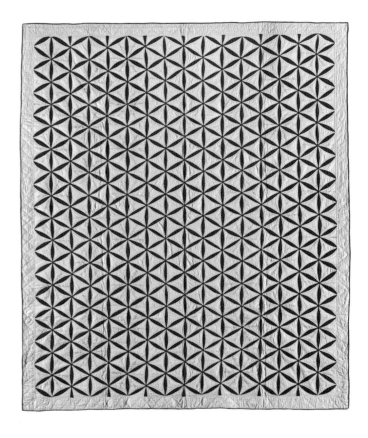

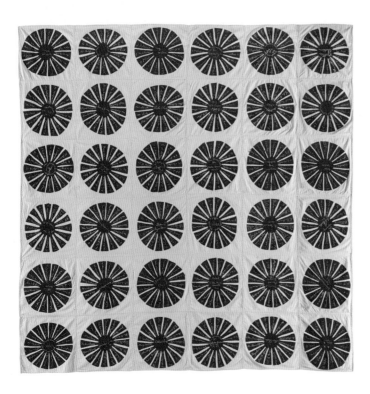

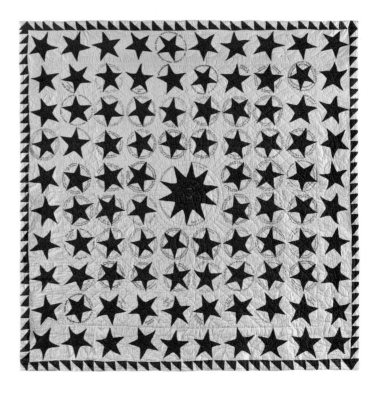

fig. 605
Wheels Quilt, Nankim,
China, and Wisconsin,
85½ x 69½ inches.

fig. 606
Wheels Quilt, Ontario,
Canada, dated 1903,
78 x 78 inches.

fig. 607
Reverse Appliqué Quilt with
single border, 80 x 70 inches.

fig. 608
Five-Point Stars Quilt with
sawtooth border, dated 1917,
72 x 72 inches.

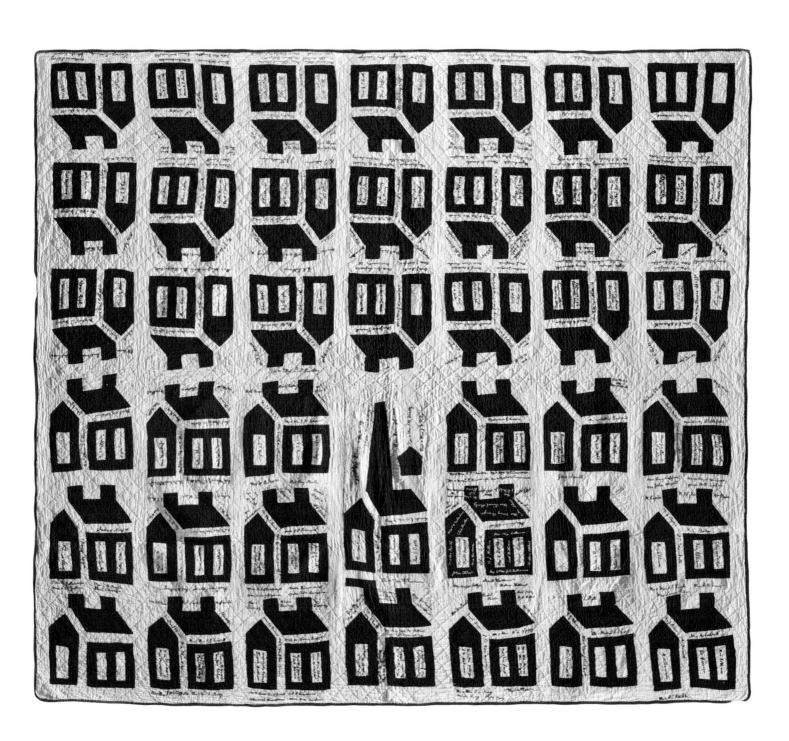

fig. 609
Houses and Church
Quilt, 74 x 83½ inches.

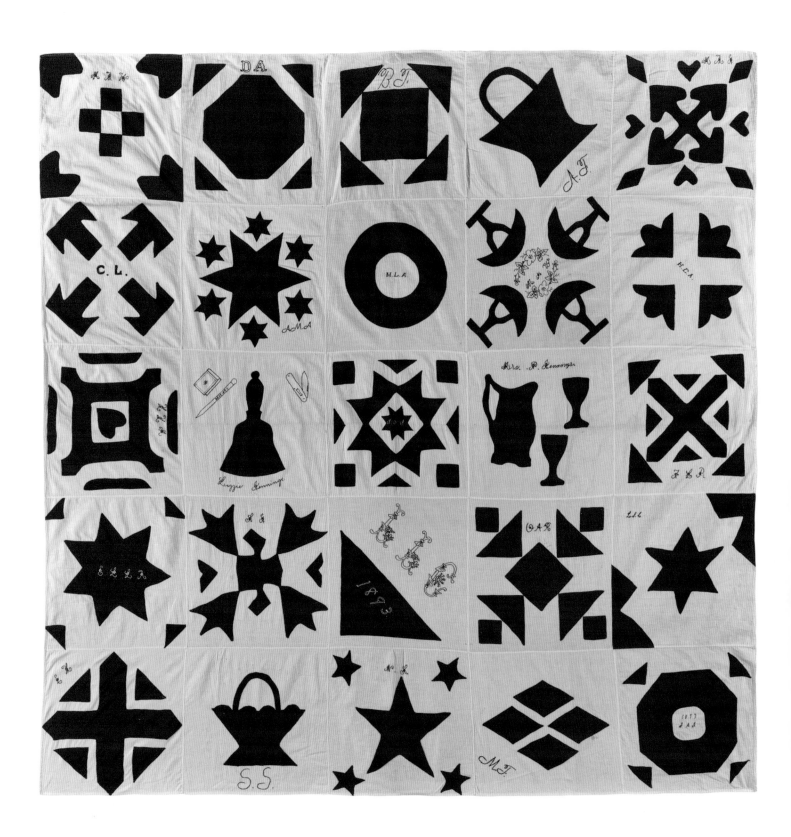

fig. 610
Pieced and Appliquéd
Sampler Quilt, dated 1893,
82 x 82 inches.

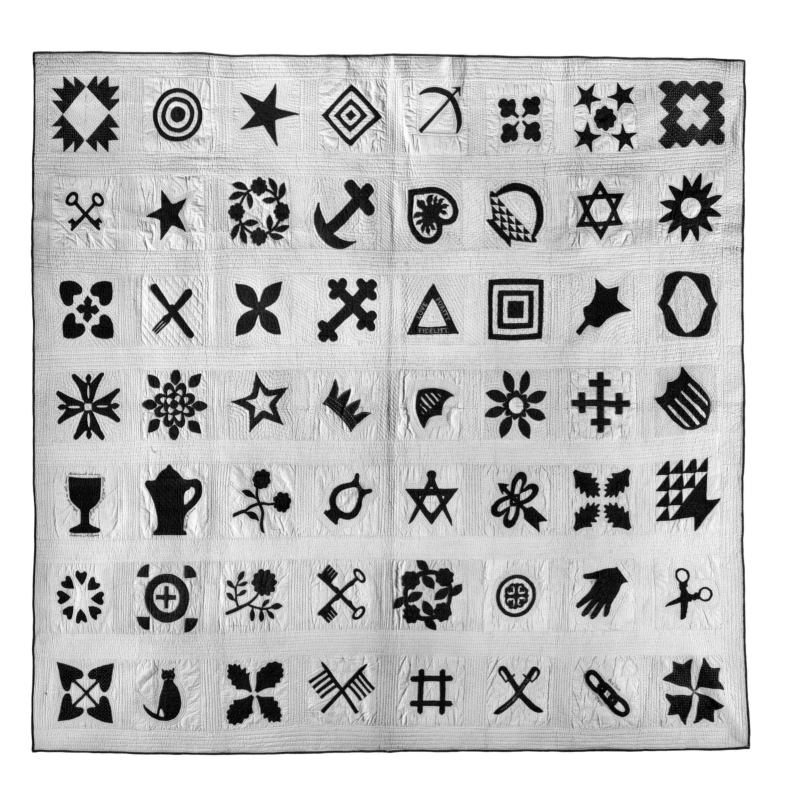

fig. 611
Pieced and Appliquéd
Sampler Quilt with single
border, 87 x 79 ½ inches.

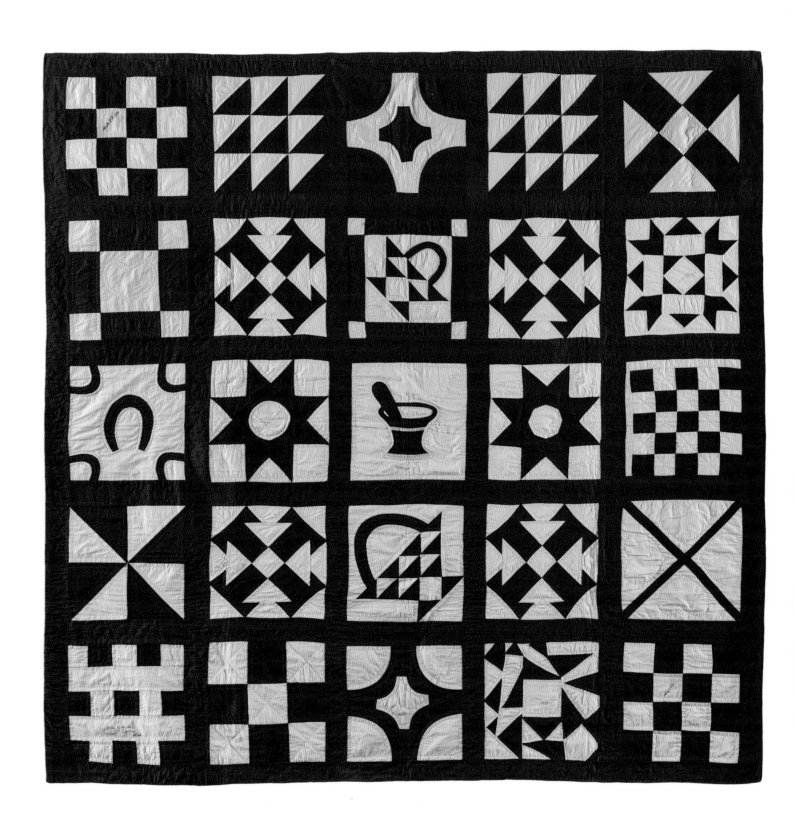

fig. 612
Pieced and Appliquéd
Sampler Quilt with sashing,
Lancaster County, Pennsylvania (includes names

from Ohio, Massachusetts,
and Pennsylvania),
pieced 1882, quilted later,
71 x 70 ½ inches.

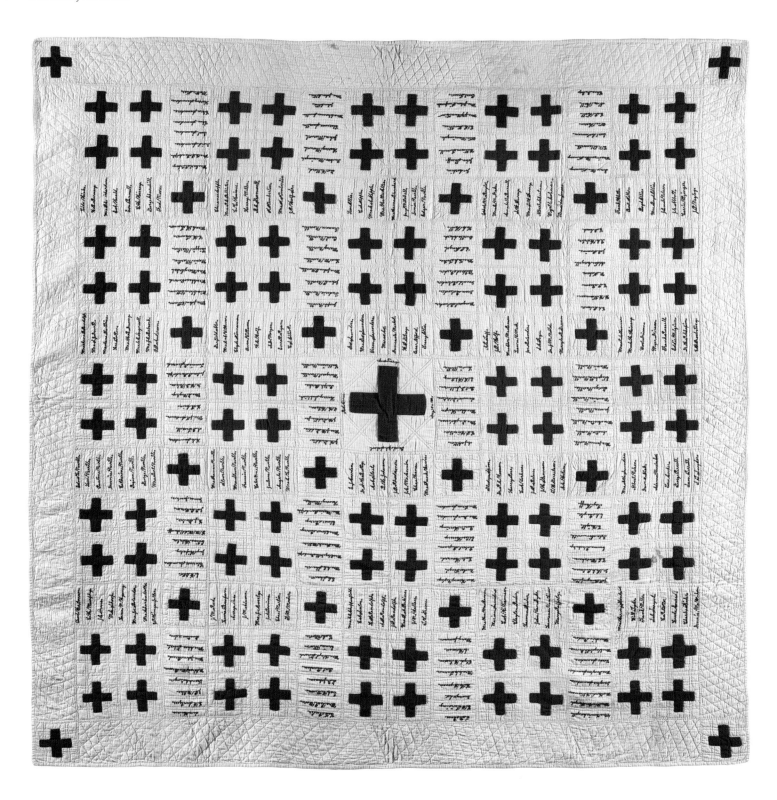

fig. 613
Red Cross Quilt with single border and corner crosses, Randolph School Red Cross Auxiliary, 1918, 77¼ x 77¼ inches.

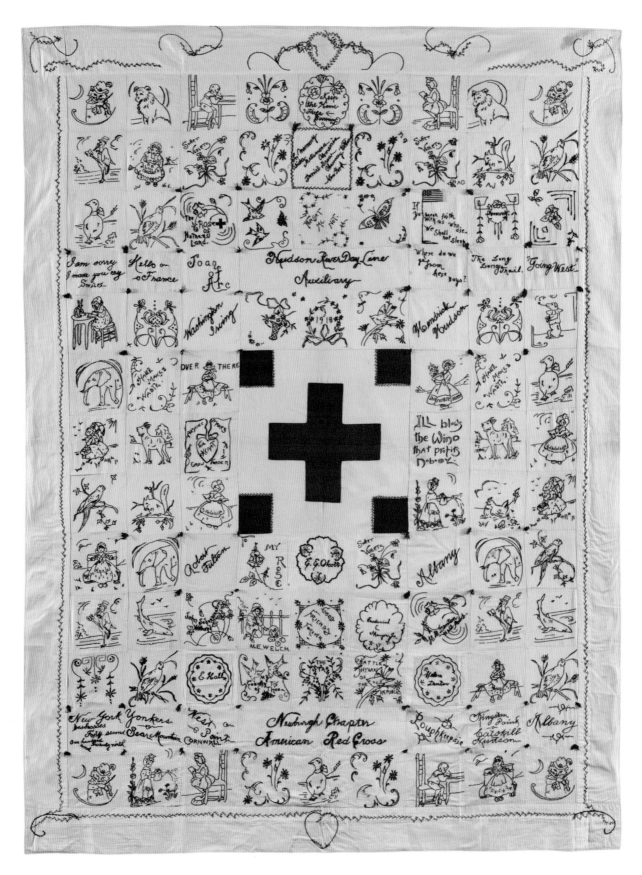

fig. 614
Embroidered Red Cross
Quilt with single border,
Hudson River Day Liner

Auxiliary, Newburgh, New
York, Chapter American Red
Cross, 1918, 80 x 59½ inches.

EMBROIDERED (figs. 615–620)
Many signature quilts were neither pieced
nor appliquéd but, rather, relied on embroidery
to create the design.

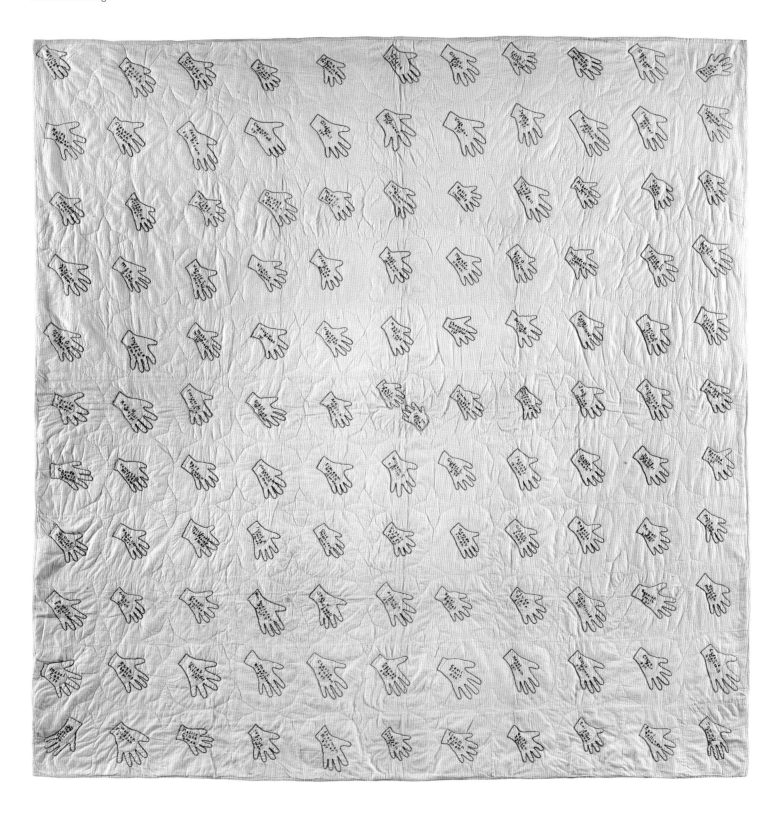

fig. 615
Embroidered Hands Quilt,
Newfoundland, Canada,
1881, 77 x 75½ inches.

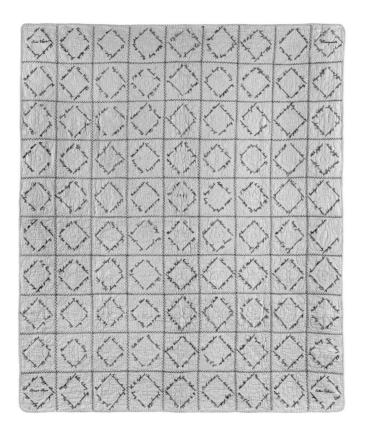

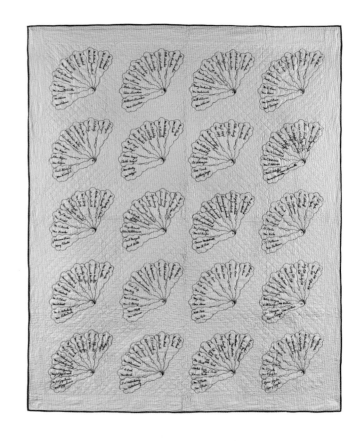

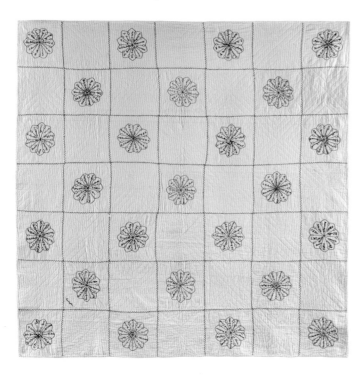

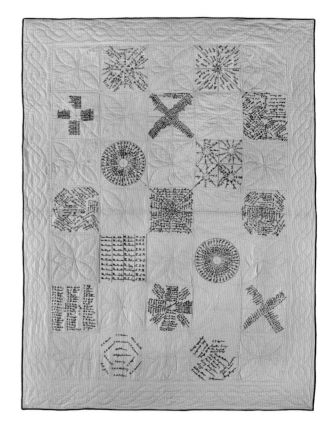

fig. 616
Diamonds Quilt with
embroidered sashing,
dated 1903, 80 x 70 inches.

fig. 617
Daisies Quilt with setting
squares and embroidered
sashing, 74 x 75 inches.

fig. 618
Fans Quilt with single
border, 75 ½ x 62 ½ inches.

fig. 619
Sampler Block Signature
Quilt with setting
squares and single border,

Boston Ladies Bethel
Society, c. 1900,
89 ½ x 68 inches.

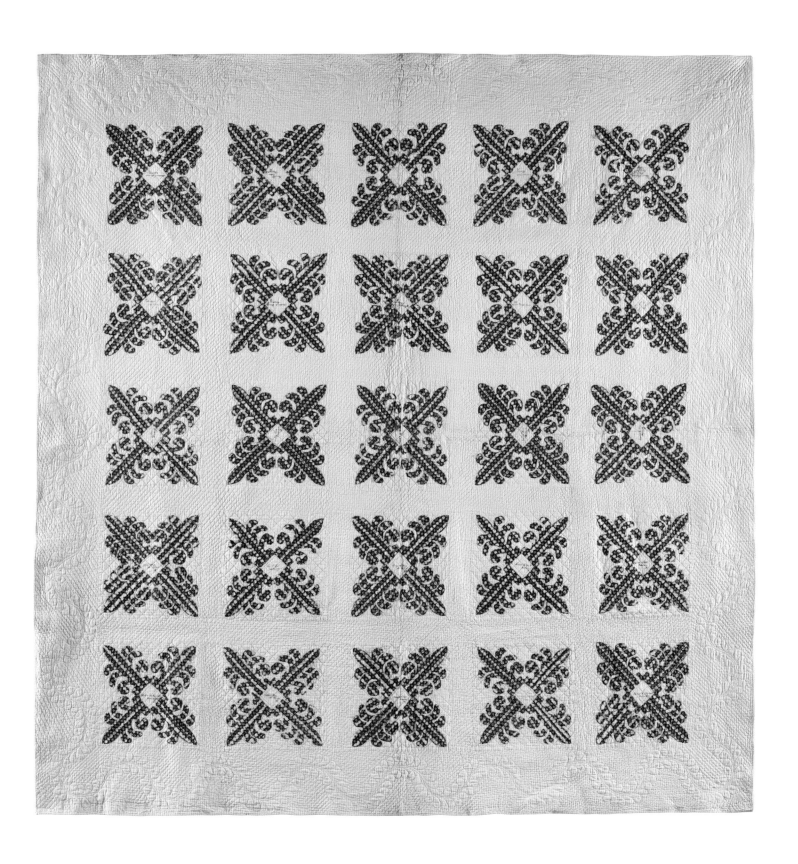

fig. 620
Fleur-de-Lis Quilt with
single border, dated 1849,
84 x 84 inches.

Redwork Quilts

Embroidery has long been used to embellish quilts, but few types have proved as popular, enduring, and collectible as those that bear the technique known as redwork. While many quilts have been enhanced with other styles of embroidery, from the cross stitch that is commonly found on quilts made in the early nineteenth century to the elaborate machine-applied couching in today's art quilts, redwork quilts display a particular style that makes them instantly recognizable.

The genre became popular in the last quarter of the nineteenth century and reached its height in the 1920s and '30s. Blocks are worked in stem stitch or backstitch with additional touches of satin stitch, feather stitch, and French knots in particular. Generally each block contains a different motif, and many quilts have an overall theme such as plants, animals, children's games, architecture, alphabets, or patriotic images. Most blocks show an individual image, but some contain several pictures in a single block.

Almost all the designs are worked in an outline stitch, and, as exemplified by the name, red thread on a white or cream background is usual, though examples worked with threads of other colors, including blue, green, and black, can be found. The redwork craze began in the 1880s following two developments: thread dyed with colorfast Turkey red (see "A History of Red & White Quilts," page 24), and the process by which a motif could be heat-transferred to almost any fabric, credited to William Briggs and Company in Great Britain in 1874. Iron-ons were made commercially available, followed by preprinted muslin squares, cut and ready to stitch. These "penny squares," one of the hits of the 1901 Pan-American Exposition in Buffalo, New York, could be purchased as individual pieces or in thematic sets; a quilt made with penny squares is included in this chapter (fig. 626, page 334).

Motifs on early redwork quilts were borrowed from decorative stitchery found on Victorian Crazy quilts, which were popular in the last quarter of the nineteenth century. Crazies are usually composed of irregular-shaped pieces and heavily embellished with elaborate embroidery outlining separate pieces of fabric, or delineating individual designs ranging from fans and horseshoes to plant and animal life. Many of the enormous number of images on later redwork quilts were available commercially, and the presence of these images in a quilt can help with its dating.

Blocks could be assembled edge to edge, or separated by strips of sashing. Some edge-to-edge settings have faux sashing of red stitching, usually either cross stitch, chain stitch, or feather stitch. Fabric sashing is almost always red or red and white, and can be simple strips or elaborate patterns with corner squares. Sometimes embroidered elements are used as the center of a traditional block (fig. 632, page 336), and occasionally a quiltmaker would use redwork motifs to embellish a traditional patchwork or appliqué quilt, as on an elaborate Feathered Star quilt (fig. 631, page 336).

Redwork has enjoyed a modern gain in popularity, with numerous books and patterns published and wide availability of preprinted panels similar to those that began the craze more than a century ago.

REDWORK EMBROIDERED BLOCKS (figs. 621–630)

Most redwork quilts are composed of embroidered squares with pictorial scenes of daily life or familiar objects. Many contain embroidered words as well.

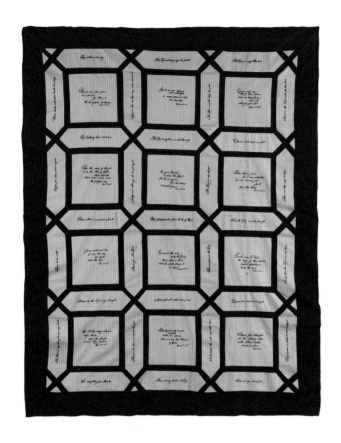

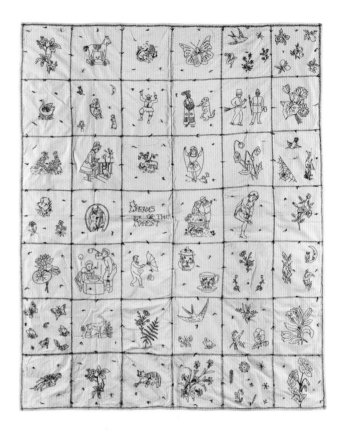

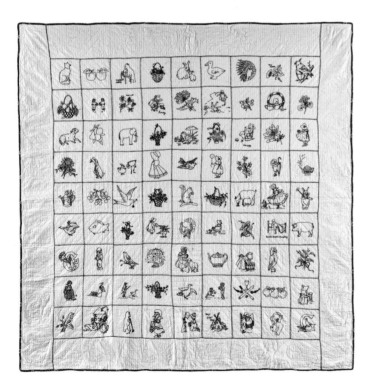

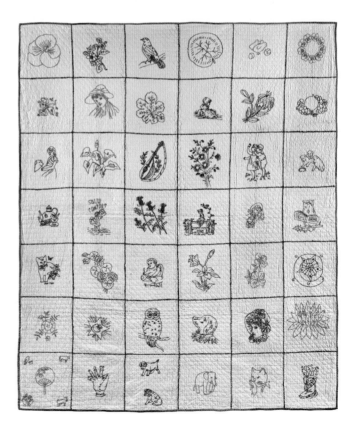

fig. 621
Religious Texts Quilt
Top with embroidered
sashing and single border,
89 x 71 inches.

fig. 622
Nursery Rhyme Characters
Quilt with embroidered
sashing and single border,
85 x 84 inches.

fig. 623
"Dreams of the Forest,"
Summer Spread with
embroidered sashing,
66 x 53½ inches.

fig. 624
"Puss in Boots" and
Other Motifs Quilt with
embroidered sashing,
82 x 62 inches.

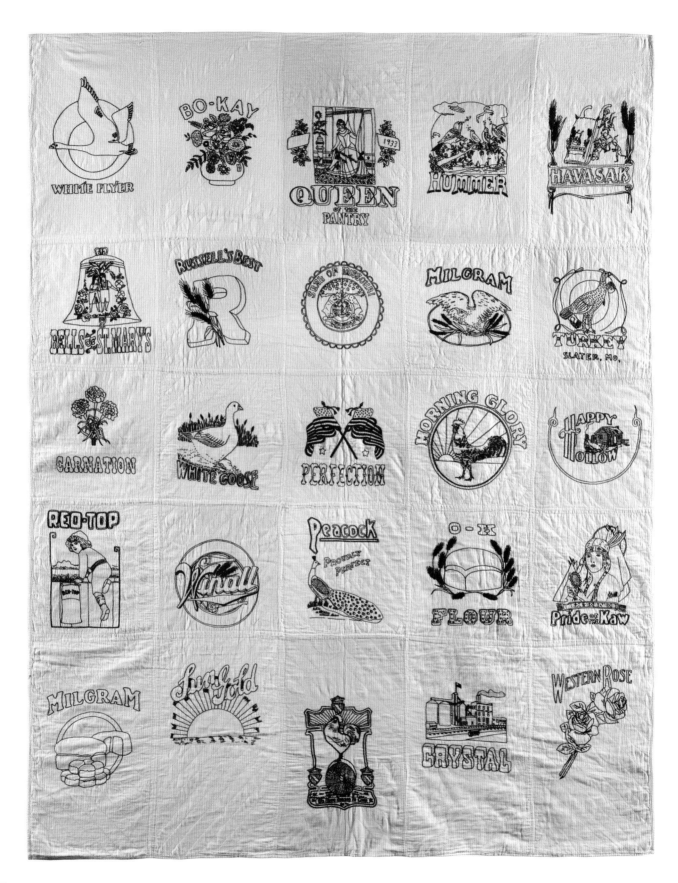

fig. 625
Flour Sack Logos
Quilt, Missouri, 1933,
89½ x 71 inches.

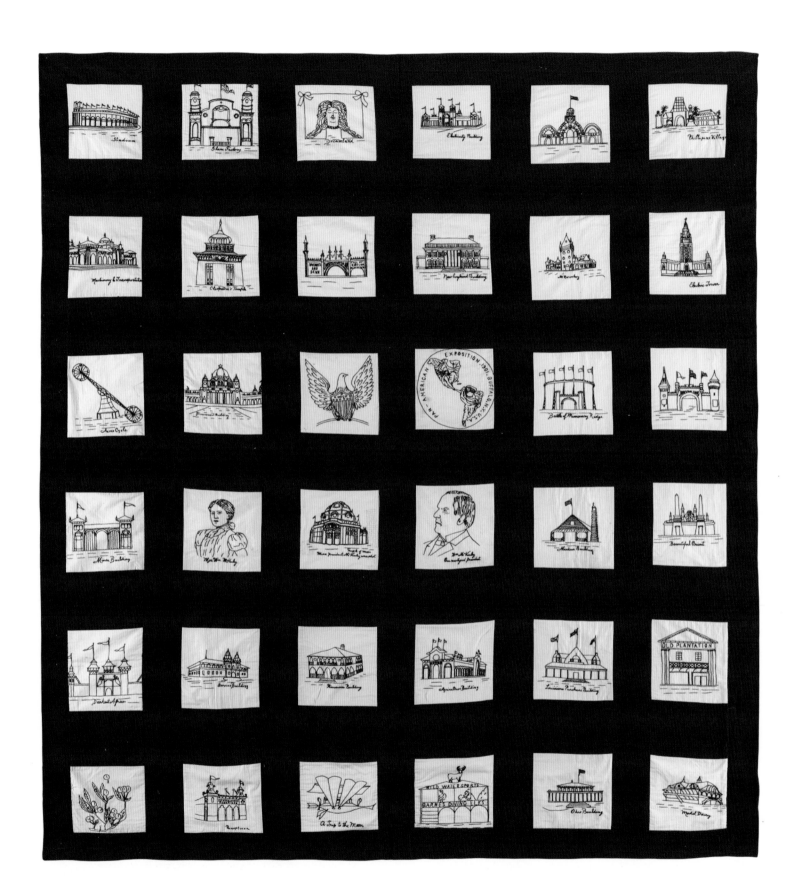

fig. 626
Pan-American Exposition
Penny Squares Quilt with
sashing and single border,
c. 1901, 81 x 74 ½ inches.

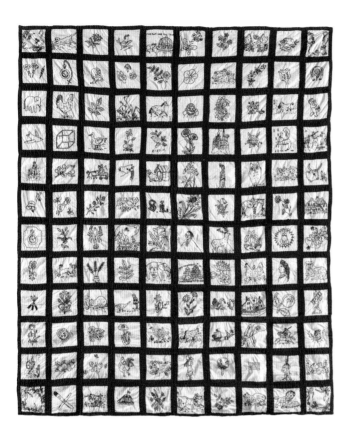

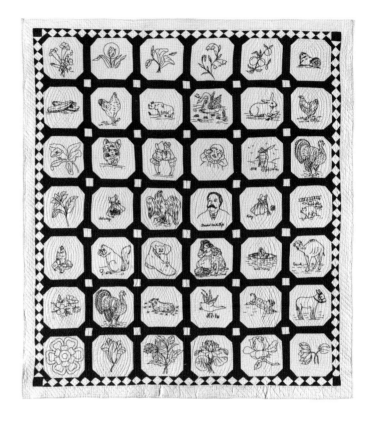

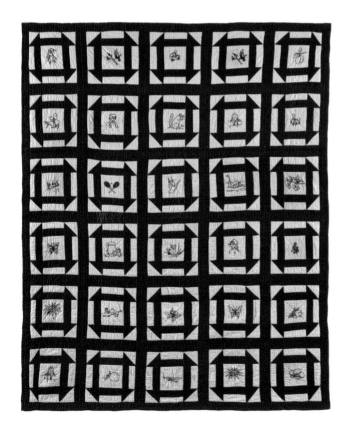

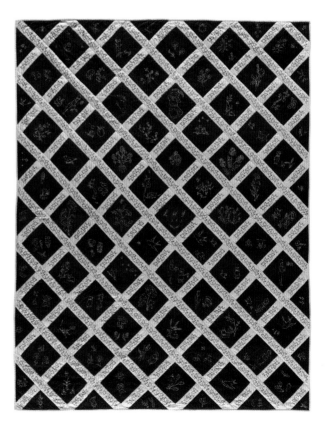

fig. 627
Childhood Themes Quilt
with sashing and single
border, initialed "S. L.,"
75 ½ x 63 inches.

fig. 628
Pictorial Monkey Wrench
Quilt with sashing and
single border, Woolrich,

Pennsylvania, c. 1930,
83 x 67 ½ inches.

fig. 629
"President Taft" Quilt
with corner-block sashing
and diamond border,
67 x 60 inches.

fig. 630
Leaf-Border Embroidery
Quilt with squares on point
and embroidered sashing,

initialed "IWS," Monmouth,
Maine, dated 1890 (finished
1930–1950), 95 x 74 inches.

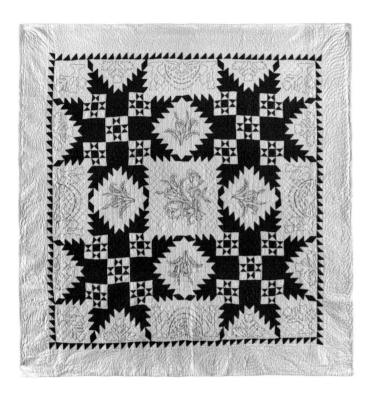

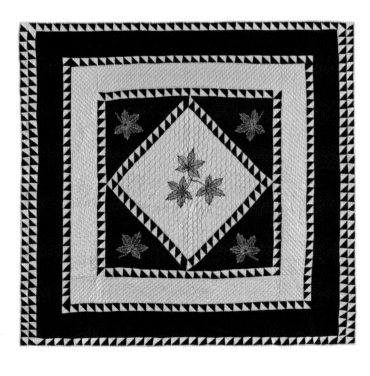

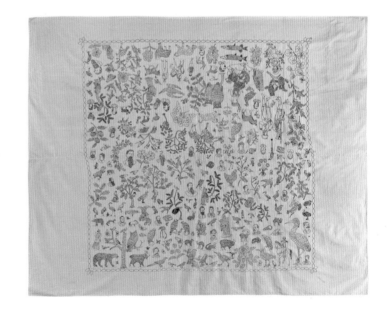

fig. 631
Redwork Embroidery and Feathered Double Nine Patch Star Quilt with sawtooth inner border, 87 x 85 ½ inches.

fig. 632
Sawtooth Diamond in a Square and Embroidered Maple Leaves

Quilt with sawtooth borders, 71 x 67 ½ inches.

fig. 633
Floral Embroidery Center Medallion Quilt with wide border, 89 ½ x 79 ½ inches.

fig. 634
Flora and Fauna Quilt with embroidered chain outline and wide border, 70 ½ x 87 inches.

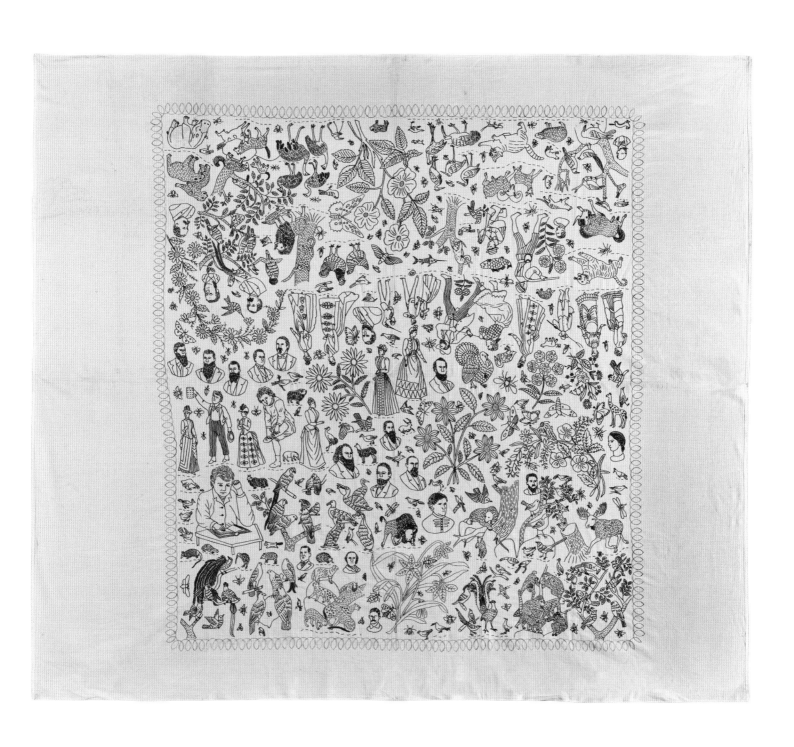

fig. 635
People and Animals Quilt
with embroidered diamond
chain outline and wide
border, 71 x 80 inches.

Crib & Other Small Quilts

In the past, most small-size quilts were created for babies and small children. Generally measuring less than 60 inches on each side, these quilts were designed to fit a crib or a child's bed. Some of the smallest examples, though, are more suitable for a cradle or a doll's quilt, and were often made by the doll's owner and served as practice pieces for a child to sew.

Small antique quilts run the gamut of quiltmaking styles and patterns. Many are exquisitely fashioned scaled-down versions of larger blocks using tiny pieces to replicate a maker's favorite patterns. Others make use of leftover pieces from a full-size quilt project, and some are simply pieces cut from an older quilt that is worn or damaged. The undamaged section could be rebound and repurposed to cover a smaller member of the family.

Small quilts today are used in many ways: as art to hang on a wall, as table linens, as decorative covers for throw pillows, and of course as quilts for babies and toddlers. Large numbers of small quilts are made by individuals and groups and given to charitable projects for use in hospital nurseries, orphanages, and shelters. Often the quilts are auctioned to raise money for charitable organizations of all kinds.

The small quilts included in *Infinite Variety,* from the simple Bars Quilt (fig. 636, page 340) to the charming appliquéd alphabet quilt (fig. 650, page 345), are all antique, and were most likely made to be used by a baby or child special to the quiltmaker. As with full-size quilts, pieced versions are more commonly found than those that have been appliquéd. The small quilts in this collection are all smaller-scale interpretations of larger patterns. Most are finely worked, and their condition indicates that they were well cared for by their owners. The only rough-and-ready piece is a Railroad doll quilt (fig. 642, page 342) that was quilted by tying, one of the techniques referred to as "utility quilting." It is one of the quickest ways to finish a quilt, carried out by pulling a strong thread, yarn, or even string through the quilt layers, then tying it with a double knot. These knotted stitches are repeated throughout the quilt at spaced intervals to hold the batting in place. It is an excellent way to finish a quilt with many seams, such as in the Log Cabin pattern, and very useful on quilts with thick or firm batting, but it is not the most elegant way to complete a quilt. The Railroad quilt is one of the few tied quilts in the *Infinite Variety* collection, and the tying and slightly imprecise piecing indicate that it was made by a beginner, perhaps a child learning the craft. All the other quilts in this section are executed with some skill.

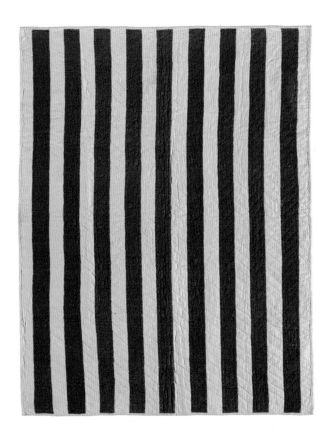

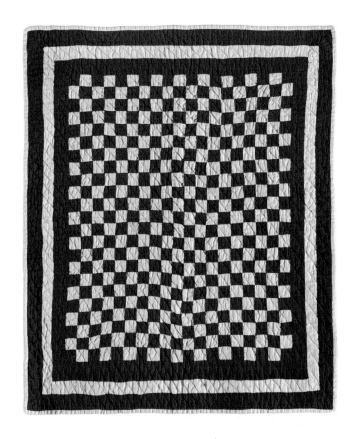

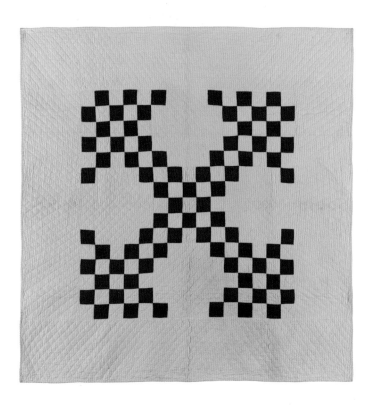

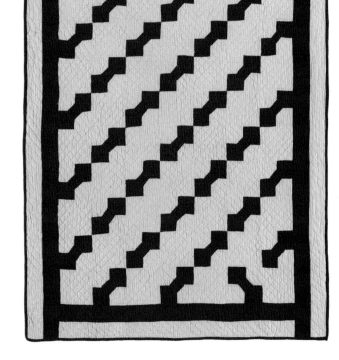

fig. 636
Bars Quilt,
38 x 29½ inches.

fig. 637
Double Irish Chain
Quilt with wide border,
54½ x 54½ inches.

fig. 638
Checkerboard Quilt with
triple border, labeled "T. L.
Ethel Reynolds, Aug. 26,
1893," 29 x 24 inches.

fig. 639
Bow Ties Quilt with double
border, 46½ x 37¼ inches.

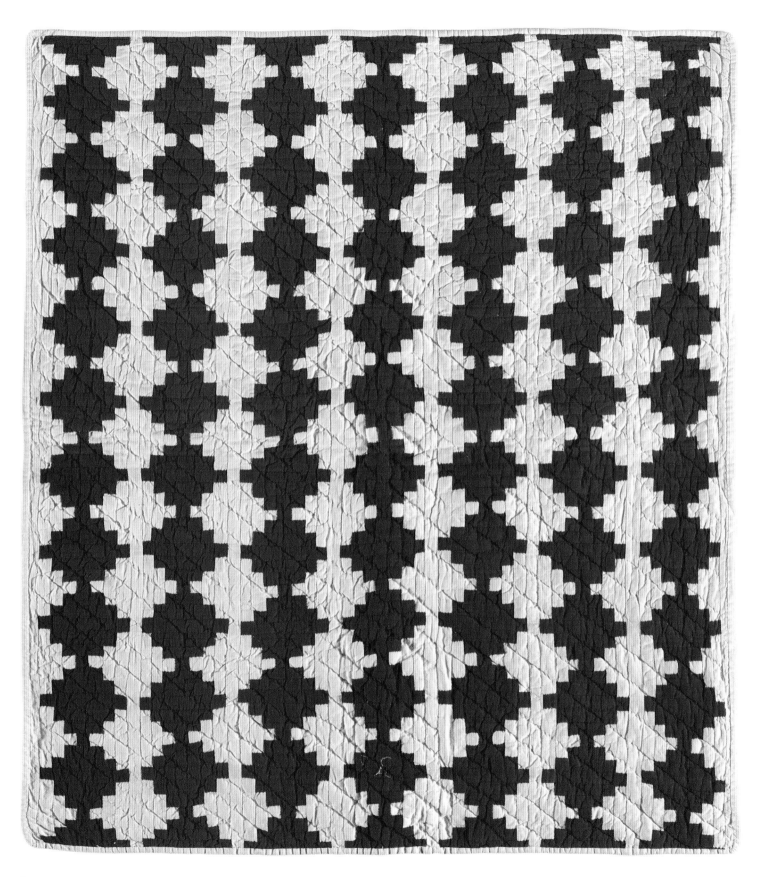

fig. 640
Log Cabin Quilt (Court-
house Steps Variation),
33 x 29¼ inches.

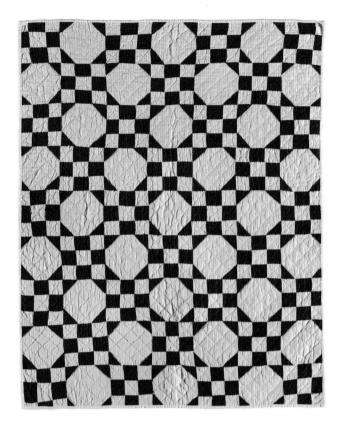

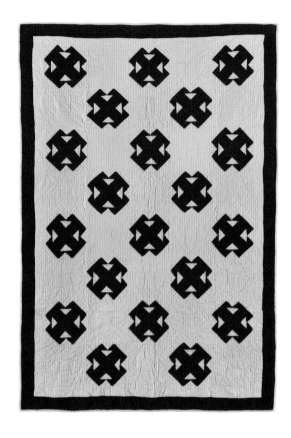

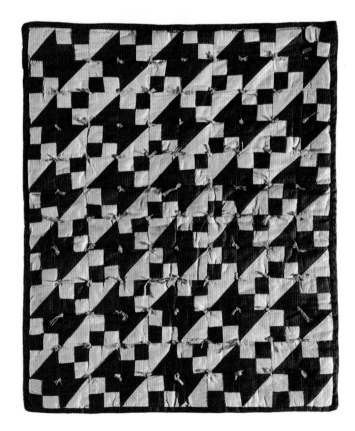

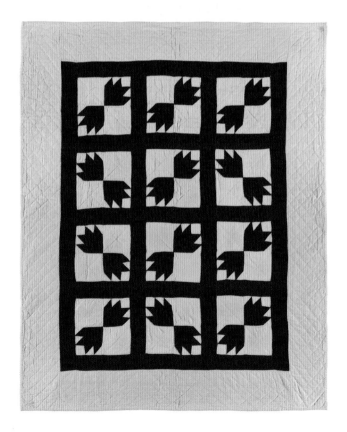

fig. 641
Nine Patch and Octagons
Quilt, 34 x 27 inches.

fig. 642
Underground Railroad Doll
Quilt with tied quilting,
New York State, c. 1850,
22½ x 18¼ inches.

fig. 643
Double T Quilt with
single border, Texas,
58½ x 39 inches.

fig. 644
Tulip Variation Quilt with
sashing and single border,
47 x 38 inches.

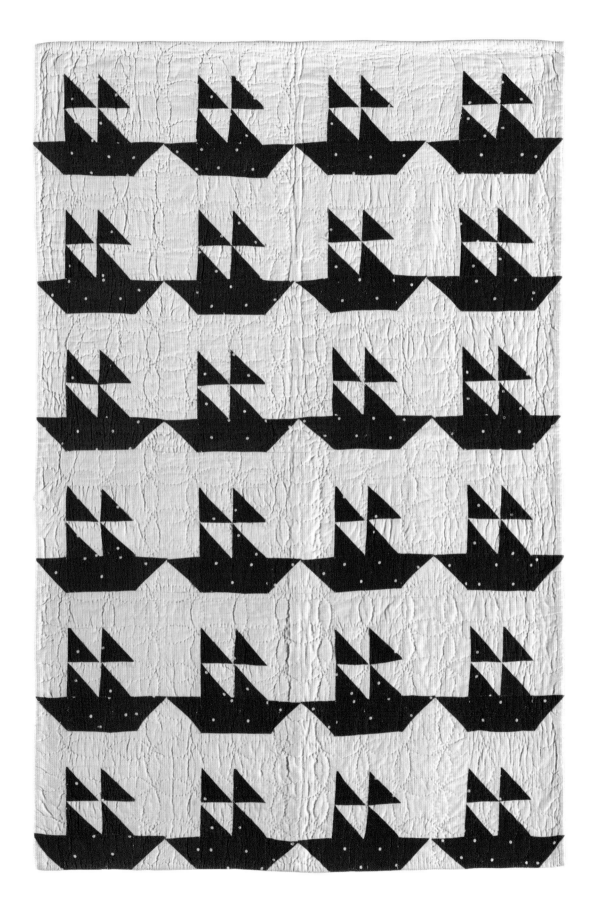

fig. 645
Sailboats Quilt,
35½ x 23 inches.

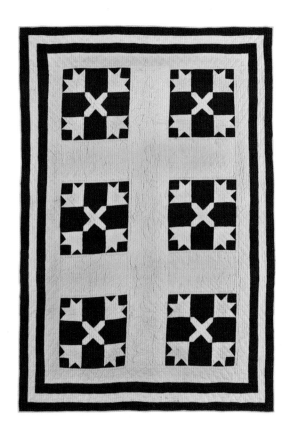

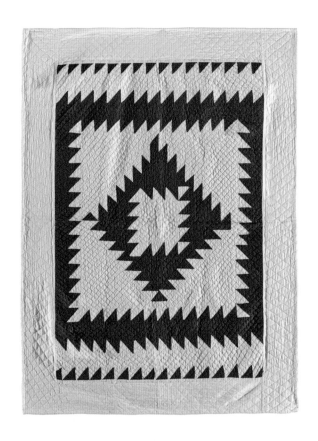

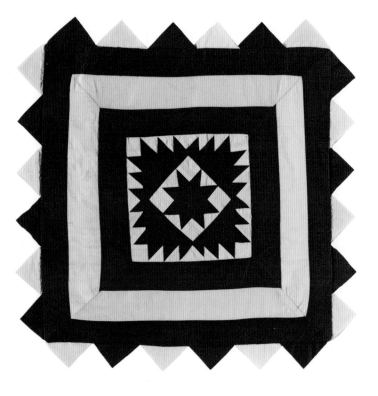

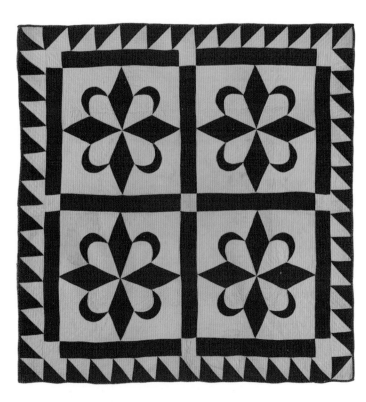

fig. 646
Lily Corners Quilt with
sashing and quadruple
border, 53½ x 37 inches.

fig. 647
Eight-Point Star Pillow
Cover with triple border
and prairie point edging,
20 x 20 inches.

fig. 648
Sawtooth Square in a Square
Quilt with single top and
bottom sawtooth borders,
51 x 38 inches.

fig. 649
Stars and Crescents Quilt
with corner-block sashing
and sawtooth border,
43½ x 42½ inches.

APPLIQUÉ (figs. 650–653)
The possibilities inherent in appliqué can be put to good use in small quilts; the *Alphabet and Circus Animals 48 Quilt* could not have been made any other way.

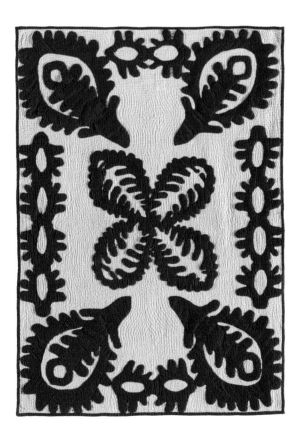

fig. 650
Alphabet and Circus
Animals Quilt with triple
sashing, 48 ½ x 34 ¼ inches.

fig. 651
Hawaiian Appliqué
Quilt, 37 x 26 ½ inches.

fig. 652
Five-Point Stars Quilt
with single border,
37 ½ x 36 inches.

fig. 653
Crosses and Floral
Appliqué Quilt (unquilted)
with complex borders,
54 x 46 ½ inches.

Infinite Gratitude Quilt

Of all the quilts inspired by the *Infinite Variety* exhibition, the *Infinite Gratitude Quilt* probably has the most meaning for Joanna Rose. It was conceived by her niece, Deborah Bingham, and based on the well-known *Jane Stickle Quilt*, made during the Civil War with 169 different blocks and 5,602 pieces. Deborah enlisted her own teachers, Judy Doenias and Diane Rode Schneck, both volunteers at the exhibition, to round up thirty-five quilters, including Brenda Manges Papadakis, author of *Dear Jane: The Two Hundred Twenty-Five Patterns from the 1863 Jane A. Stickle Quilt* (1996). A detailed spreadsheet was required to keep track of the different block assignments, and the finished quilt is an adaptation of the original, with 169 squares and a mix of machine- and hand-quilting. The *Infinite Gratitude Quilt* was presented to Joanna and Daniel Rose on December 17, 2011.

Infinite Gratitude Quilt,
Deborah Bingham and mem-
bers of the "Dear Jane" City
Quilters class, New York City,
2011, cotton, 80 x 80 inches.

Pattern Index

Acknowledgments

Infinite Variety, both the exhibition and the book, was created by a team of teams: I call them Team Joanna, Team Thinc, and Team AFAM. Over time, the project became so all-inclusive that almost anyone who had any connection to any of these three teams became caught up in the excitement and contributed to its success. I apologize if I have left out anyone who participated on any of the teams.

Team Joanna: First, I have to thank Joanna Semel Rose for conceiving this extraordinary enterprise and for inviting the American Folk Art Museum to produce it. Joanna had both the foresight to see what an astounding event *Infinite Variety* could be, and the generosity to want to share her collection of red and white quilts with the world. She was supported in her vision by her wonderful husband, Daniel, as well as their four children and their families. I would also like to acknowledge the tireless work of Joanna's assistant, Karen Hunt-Kolczynski. Thanks, Karen, for searching through years of files to help me find any information about specific quilts.

I would particularly like to thank David S. Rose for envisioning the *Infinite Variety* mobile app and for finding Aaron Rothstein to make it a reality. David also provided the tablets that were lent for free at the exhibition; they came fully loaded with the app so that anyone could zoom in on detailed photographs of the quilts.

Thanks are also due to Lita Solis-Cohen, Joanna's classmate and an antiques columnist, who helped make the match between Joanna and the museum.

Team Thinc: It is hard for me to imagine a more talented design group than the one Thinc founder and creative director Tom Hennes assembled to work with him on *Infinite Variety*: design director Steve Shaw, digital strategist Sherri Wasserman (certainly the world's most organized person), graphic designer Aki Shigemori, and materials specialists Bix Biederbeck and Joe Ruster. Thinc also coordinated with John Wolf at PRG for fabrication and production of the exhibition, and Paul Palazzo of Palazzo Lighting Design, who arranged for every one of the 653 quilts to be individually lit. But it is not necessary to take my word for the outstanding work the Thinc team provided—the many awards won by the design team for this exhibition attest to the project's success. Thank you all for taking an idea and making it a reality.

Team AFAM: *Infinite Variety* started with a small working group at the American Folk Art Museum that eventually grew to encompass the entire staff, along with dozens of dedicated volunteers. Leading the team (with her usual attention to every detail) was Stacy C. Hollander, then the museum's senior curator, along with Ann-Marie Reilly, chief registrar and director of exhibition production. Also involved from day one were Susan Flamm, public relations director; Tanya Heinrich, director of publications, and Mareike Grover, managing editor; Marie S. DiManno, director of museum shops; and executive director Maria Ann Conelli and deputy

director Linda Dunne. Simply listing these names and titles does not begin to explain the work this exceptional group did on a daily basis for months—all the while continuing to execute their "day jobs" flawlessly. As opening day grew closer, other staff members were called upon for their expertise: Lee Kogan and Jennifer Kalter for educational programming; Sandy B. Yun, Richard Ho, and a large group of their friends and family members to man the shop all day, each day; Katie Hush, who organized the opening night gala and made sure that the hordes of people who came to the exhibition could be fed; and Elizabeth Kingman, Courtney Wagner, and Christine Corcoran, who seemed to be everywhere, taking on any job that was needed. Karen DiSaia came on board as floor manager and was always the first to arrive in the morning and the last to leave at night. Barbara Stephen managed the many volunteers who so graciously gave their time to stand on the floor and protect the quilts. And, of course, the members of the museum's board of trustees, who supported the event with their time, money, and enthusiasm, even when they had only my word to take that *Infinite Variety* was going to be something really special. Anne-Imelda Radice, the museum's current executive director, has maintained that enthusiasm with her support for this book.

Neither the exhibition nor the book could have been produced without the help of the interns who worked so hard on what often entailed physically and mentally exhausting tasks. Miranda Peters Keagle and Lauren Arnold, then students in the Bard Graduate Center's decorative arts program, helped Ann-Marie Reilly to unpack, hang, steam, and repack 653 quilts. Lauren also kept the spreadsheet that enabled me to identify each of the quilts for this catalog (and helped with the book project in her present position as deputy registrar at the museum). Amalia Scott spent much of her junior year at Columbia University identifying quilt patterns and helping to organize and name each of the quilts for this book. Michelle Stein came in at just the right time to aid the public relations department in disseminating correct information to all the news outlets that came to cover the show. And, by wonderful coincidence, Qianni Zhu, an intern on the project who carefully edited the complex spreadsheets necessary for production of this book, is (like Joanna Rose and me) a graduate of Bryn Mawr College.

This book could not have been possible, however, if it were not for Maggi Gordon. Maggi flew in from London to see the exhibition and, in an amazing demonstration of fate, was introduced to me when her husband, David, was hired as a consultant to the museum. "My wife," David told me, "knows about quilts." I'll say she does: Maggi especially knows the part about quilts that I have never learned—how to sew them. An experienced quilt book writer and editor, Maggi also knows how to identify the patterns in a way that makes sense to quilters. Maggi supervised Amalia's work, then took over the job when Amalia's internship ended. Without Maggi's help, I would probably still be staring at piles of quilt photographs on my floor and wondering how to arrange them. Editing and production of this book was managed gracefully by Megan Conway, director of publications and website at the American Folk Art Museum, with the invaluable assistance of Tanya Heinrich. This publication's stunning final product is due in large part to the team at Rizzoli Publications. I am grateful to them all, and especially publisher Charles Miers, editor Julie Schumacher, and designer Emily CM Anderson. Thanks also to Eric Pumroy, director of special collections at Bryn Mawr College, who supplied scans of the "Quilts at Bryn Mawr" brochure.

The photographs of every one of the quilts, as well as the beautiful installation shots, are the work of the incomparable Gavin Ashworth. Gavin is simply the best. Not only are his photographs works of art, but every moment spent in his company is a true pleasure. I include Gavin in Team AFAM because I consider him part of the museum family.

Many other people helped to make *Infinite Variety* a success. My thanks go to the inexhaustible Meg Cox, president of the Alliance for American Quilts and a journalist, who got advance notice about the exhibition out to quilters around the world. Thanks also to members of the Empire Quilt Guild who stood guard in the Park Avenue Armory daily, many returning for a second or third shift. Rebecca Robertson and her excellent staff at the Armory were helpful, too, in so many ways. But my greatest gratitude goes to the millions of quilters around the world who lit up the social media and told their friends about this once-in-a-lifetime experience.

I would like to pay special thanks to longtime friends of the museum Penny and Allan Katz/Allan Katz Americana for providing the funding that made the educational programs possible. Thanks to all our friends and my husband's partners at Weil, Gotshal & Manges who stepped up when asked and helped to make the opening night gala a financial, as well as an aesthetic, success. Thanks to my good friends Dr. Nancy Kollisch and Dr. Jeffrey Pressman, who flew across the country for a day just to take in the show.

Finally, I would like to thank my husband, Irwin, and our son, Mark. Irwin called in all favors to gather support for the exhibition and the museum, and is still proudly showing off the photos of the show on his Blackberry to anyone he can get to look. Mark flew in from college for just one day so he could attend the show and my lecture. And, in a true reversal of roles, Mark also copyedited every line of my essays for this book. Sorry, Irwin—Mark is now the best editor in the family.

Elizabeth V. Warren
October 15, 2014

About the Authors & Contributors

Elizabeth V. Warren was curator at the American Folk Art Museum from 1984 until 1991, and since then has served as a consulting and guest curator. She has organized a number of critically acclaimed exhibitions for the museum, many of which have been accompanied by catalogs. In 2007 she was elected to the museum's board of trustees. She has devoted the past thirty years to studying, writing about, and curating exhibitions of folk art, with a special focus on quilts. She graduated from Bryn Mawr College and earned an MA in Folk Art Studies from New York University. Mrs. Warren is currently President of the American Folk Art Society and a member of the board of trustees of Bryn Mawr College.

Maggi Gordon is an editor, collector, and quiltmaker, with a special interest in the history of quilts and quiltmaking, and the author of fifteen quilt-related books. Her interest in the needle arts began during her childhood in the American South, and she began collecting quilts while living in Britain in the 1980s. She is fascinated by the innumerable design possibilities in quilts, and particularly enjoys working with two colors, especially red and white.

Joanna S. Rose is a writer, editor, collector, and member of several humanities, arts, and education boards. She was chairman of the magazine *Partisan Review* and president of the Paper Bag Players, and is a summa cum laude graduate of Bryn Mawr College and an honorary fellow of St. Hilda's College, Oxford University. Mrs. Rose admires folk art for being useful and beautiful, and is never happier than when she is learning.

Stacy C. Hollander is deputy director for curatorial affairs, chief curator, and director of exhibitions at the American Folk Art Museum. Hollander was project coordinator for *Infinite Variety: Three Centuries of Red and White Quilts*.

Tom Hennes is founder and principal at Thinc Design, New York.

Anne-Imelda Radice, PhD, is executive director of the American Folk Art Museum.

Martha Stewart is America's most trusted lifestyle expert and teacher. She is the author of eighty-four books devoted to cooking, decorating, crafting, weddings, and lifestyle, including national bestsellers such as *Martha Stewart's Baking Handbook*, *Martha Stewart's Homekeeping Handbook*, *Martha Stewart's Cooking School*, *Meatless*, and *One Pot*. Martha's books, along with her award-winning magazines, television shows, and digital media properties have made her a household name and the go-to authority for millions of people on all aspects of everyday living.